Monseigneur

Frankrike will tie Sverige afstå den S:t
Barthelemy, men er derjemte til:
känna hurusom det til bidrar veker,
taget af en entrepot Götheborg
för alla franske producter, hvilka
en öro förädlade, och ljushet icke kan
andles fäljom ett nederlag för den,
ide n en nödig
i 17..
................
.......... tie Entrepot
...........................
.........................
af de kunna
nyttjas. Då således

BIEVNIALS

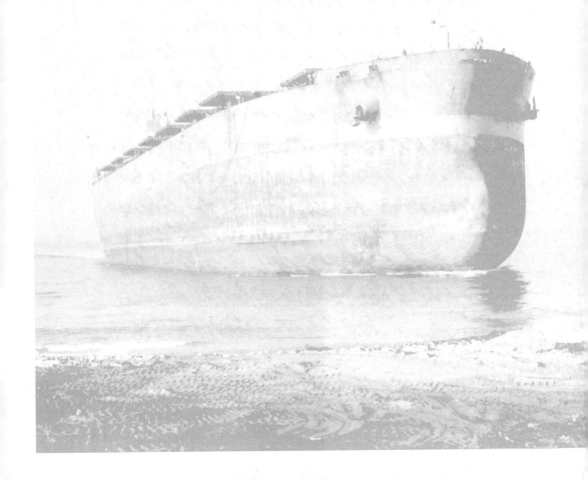

AS

SITES

OF

HISTORICAL
NARRATION

How can different ways of narrating the past impact the future? This book explores the potential of art biennials to propose forms and methods of historical narration that renegotiate the border between past and present, local and global, story and history. Commencing with the Göteborg International Biennial for Contemporary Art, this enquiry extends across temporalities and geographies, addressing the role of art and arts-based research to develop other ways of encountering collective narratives than academic history.

Göteborg International Biennial for Contemporary Art was initiated by the Gothenburg Arts and Cultural Affairs Committee in 2001 and is organized by Röda Sten Konsthall, an independent art center. Throughout the eleven editions to date, curators and artists have been invited to enter into a dialogue with the city of Gothenburg on topical questions about the here and the elsewhere. A customary practice in the framework of biennials, this invitation to address locality through curatorial and artistic processes prompts new narratives and fictions about a city—an implied outcome of biennial projects and a weighty responsibility. Even more so for us in 2021, when the Gothenburg biennial coincided with the quatercentenary of the city itself, presenting an occasion for multiple histories to be reiterated or rephrased, for possible futures to be imagined, and, at the same time, a good moment for our project to define new premises for artists and curators to meet the city. Endeavoring to serve artistic processes and initiate conversations outside the event model, we challenged the temporal convention of biennials by inviting curator Lisa Rosendahl to engage with two consecutive editions of the biennial, in 2019 and 2021.

Developed in relation to the city anniversary and, indirectly, to questions concerning the production of history, *Part of the Labyrinth* (2019) and *The Ghost Ship and the Sea Change* (2021) gave space for speculative processes, remarkable art-works, long-term collaborations, keen conversations, and an extensive public program reflecting upon the capacity of art to propose new ways of recording and experiencing history.

Tracing the curatorial strategies leading up to the eleventh edition in 2021 and documenting the resulting exhibitions, this publication is a further exploration of the biennial format as a setting for both curators and artists to undertake a nuanced and polyvalent exploration of the narration of history. Edited by Lisa Rosendahl, it approaches the two editions of the

Gothenburg biennial as a case-study and also brings forward, in dialogical and essay format, curatorial positions developed in other biennial projects across the world.

We would like to thank all the contributing authors and artists who generously reflected on their practices and shared their valuable work and thoughts in this book, as well as the dedicated teams that made these projects possible. We would also like to express our gratitude to Lisa Rosendahl, our close collaborator for more than three years, for her inspiring thoughts and the engaged research and care that enabled necessary conversations to open in Gothenburg, Sweden, and beyond.

Mia Christersdotter Norman
Director Röda Sten Konsthall

Ioana Leca
Artistic Director Göteborg International
Biennial for Contemporary Art

Biennials as Sites of Historical Narration—Thinking through Göteborg International Biennial for Contemporary Art is a book that can be read and navigated in multiple ways. Conceived as both documentation of a curatorial project engaging with the history of a particular city and an anthology addressing the broader topic of contemporary art biennials and historical narration, it consists of three parts: a collection of essays and interviews, a visual journey through the 2019 and 2021 editions of Göteborg International Biennial for Contemporary Art (GIBCA), and an index of these two exhibitions. Each section offers a particular path through the material and issues at hand, to be read separately or cross-referenced with each other.

GIBCA features in this book as both a case-study and a springboard for a wider enquiry into the relationship between contemporary art and the production of historical consciousness. The opening essay addresses the potential of the contemporary art biennial as a medium for historical narration through the curatorial work behind GIBCA's 2021 edition, *The Ghost Ship and the Sea Change*. This introductory text is followed by interviews with the architectural collective Kooperative für Darstellungspolitik and graphic designer Oskar Laurin, each discussing their contributions to the project—reflecting, respectively, on the potential of exhibition architecture as a form of spatial narration, and graphic design as a site where visual languages from different contexts and points in time can meet.

The city of Gothenburg and the two biennial editions are used as reference points in several of the following texts. Taking his encounter with Eric Magassa's artwork *Walking with Shadows* (made for GIBCA 2019) as a starting point, Michael Barrett offers a perspective on Gothenburg as interwoven with the Caribbean and the wider Atlantic world through his own family history. Sofía Gallisá Muriente & Marina Reyes Franco, on the other hand, write from a Puerto Rican perspective about the complexities of the contemporary Caribbean, giving examples of artists and activists—including a 1992 work by Silvano Lora shown outside of the Dominican Republic for the first time as part of GIBCA 2021—who have challenged the colonial history and geopolitical barriers that still define the region. Lena Sawyer & Nana Osei-Kofi address the pervasive silence on Swedish coloniality in public memory, applying Black feminist methodologies and arts-based research to a fountain in a public square in Gothenburg, which includes a depiction of an African female. Rebecka Katz Thor takes

the GIBCA project *Possible Monuments?* as an example in exploring how public monuments can be used to care for and acknowledge wounds from the past instead of trying to heal and conceal them. In their essay, Jonas (J) Magnusson & Cecilia Grönberg discuss the situated perspectives and multi-disciplinary character of local historiography as a form of resistance to hegemonic epistemologies and forms of narration—a perspective made concrete in the stratified way their text is organized on the page, in the spirit of the Westrogothian mountains where they have conducted research over the past twenty years.

Cuauhtémoc Medina's essay unmoors the book from the Gothenburg context to look more broadly at the relationship between contemporary art biennials and history, reflecting on the biennials in Venice and São Paulo, as well as his own curatorial project for Manifesta 9 in Genk. The interviews with Joanna Warsza, Oyindamola Fakeye & Tosin Oshinowo, and Natasha Ginwala discuss curatorial strategies from recent biennials in different parts of the world—including Berlin, Lagos, Prishtina, and Gwangju—focusing on the politics of memory, context-specificity, and collective historiographies.

The texts by Ariella Aïsha Azoulay and Rasheedah Phillips, each of whom participated in the Gothenburg biennial as artists, offer a contextualization of the other contributions through their interrogation of the very concepts of "history" and "the past." Azoulay highlights the imperial uses of the concept of history in the colonial annihilation of non-Western political species and modes of life, arguing for the urgent need for a different genre of narrative. Phillips, for her part, connects Western linear time consciousness to the legacy of slavery, class oppression, and racism, suggesting that different spatiotemporal experiences co-exist and raising the possibility of a language where past, present, and future can be spoken about without invoking hierarchical time structures. What would it mean, she asks, to dismantle the master's clock, both physically, spiritually, and cognitively?

In the spirit of Phillips' revocation of linear time and narrative, our book moves both backwards and forwards, and is labyrinthine in places. Hopefully, this will generate unexpected associations and mental leaps. The photographic documentation of the two biennials is organized experientially, as if moving through the exhibition venues, experiencing them firsthand, whereas the index at the back is structured chronologically and alphabetically. Soundworks by HAMN (Nasim Aghili & Malin Holgersson) and Ayesha Hameed are

represented in the book as text, using excerpts from the original scripts. In different ways, they create spaces for other modes of reading and attentive listening.

I would like to extend my deepest gratitude to the book's Managing Editor Anna Granqvist—without her diligent organizational skills and valuable input there would not have been a book—and graphic designer Oskar Laurin, whose creative vision has been a pleasure and inspiration throughout. I am also immensely grateful to GIBCA Director Mia Christersdotter Norman and Artistic Director Ioana Leca for inviting me to curate two editions of the biennial and trusting in the project, as well as to all the members of the biennial team with whom it was realized—this despite the challenges brought on by the arrival of the pandemic in 2020. My biggest thank you goes out to the fantastic biennial artists and the contributors to this book, who have taught me so much and made the journey incredibly rich and multilayered. Finally, I would like to thank my friends and family—especially Odita and Mattin—as well as my colleagues and students at Oslo National Academy of the Arts for all the support and good conversations along the way.

As with all rewarding projects, once they near completion you feel as if they, in a sense, have only just begun. I look forward to continuing the conversation in multiple ways, across time, and in more directions than one.

Lisa Rosendahl
Editor and Curator of Göteborg International
Biennial for Contemporary Art 2019–2021

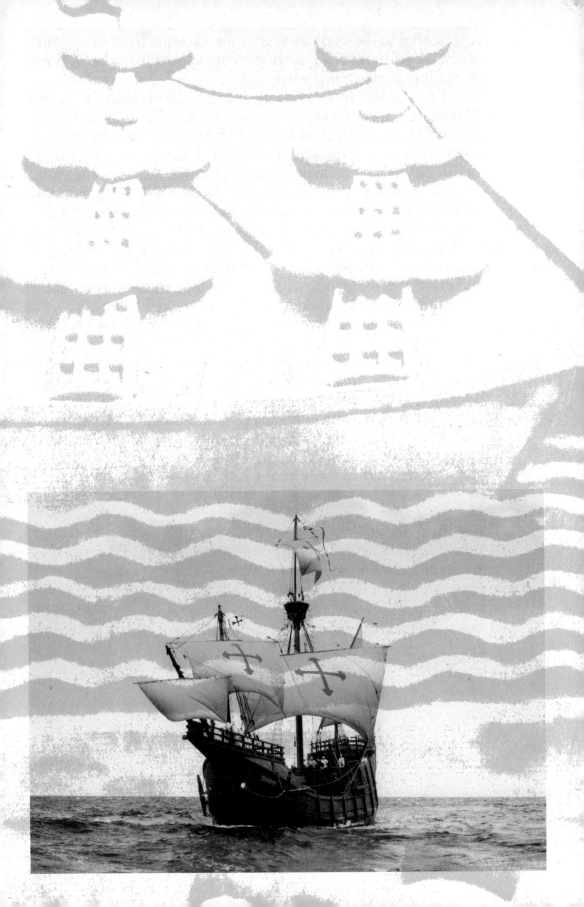

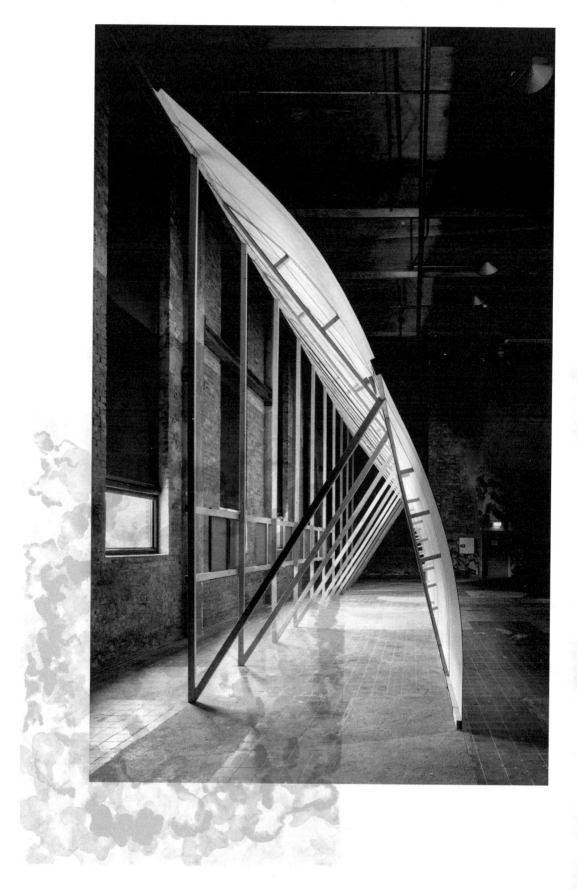

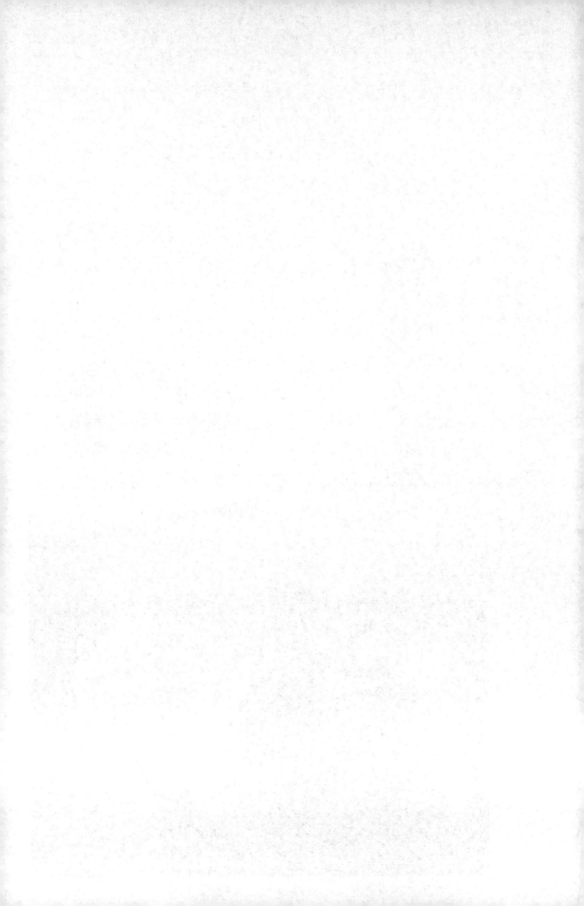

LISA ROSENDAHL

THE BIENNIAL FORM AND THE NARRATION OF HISTORY

THINKING THROUGH THE GHOST SHIP AND THE SEA CHANGE

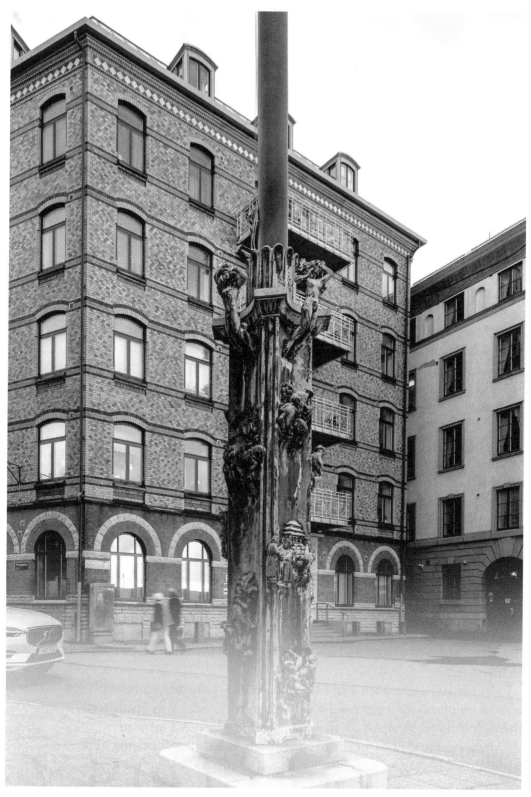

View of Franska Tomten in Gothenburg, including flagpole with sculptural reliefs by Arvid Bryth commissioned by the shipping company Rederi AB Transatlantic in the 1940s.

LISA ROSENDAHL

Introduction

Exhibitions are powerful tools for staging historical narratives. The canonical site for this undertaking has traditionally been the historical museum, from its strictly linear chronological configuration of the late nineteenth century to more recent examples of critical museology. Since the 1960s, however, the practice of historiography through exhibition-making has undergone a re-conceptualization within artistic and curatorial practice. Over the last two decades, the contemporary art field has gravitated towards re-formulating hegemonic narratives of the past to the point of this tendency being theorized as a "historiographical turn."[1] Contemporary art biennials and other large-scale periodic exhibitions have provided important platforms for artists and curators to experiment with historical narration in ways distinctly different from the historical museum, often placing an emphasis on context-specificity and the relationship between suppressed histories of the past and the political present.

This essay reflects on the 2021 biennial exhibition *The Ghost Ship and the Sea Change* as a way of exploring how the biennial form—characterized here as situated and polyvocal—can contribute to the diversification of historical narration through public exhibitions.

History?

Modern Western history, writes Michel de Certeau, essentially begins with differentiating the past from the present.[2] He locates this foundational ontological rift in the fifteenth century, when Europeans first set foot on the continents they would eventually call the Americas. Through this encounter, the perception of the world was split into two: geographically between the "old" and the "new" world and temporally between past and present. Tellingly, it was in the fifteenth century that the separation between the meaning of the words "story" and "history" also occurred in the English language; whereas these terms had previously been used interchangeably, from the fifteenth century onwards story was used to describe imagined events and history to account for real events situated in the past.[3]

In the late eighteenth and early nineteenth centuries—a time of intense colonial expansion—history's claim to "truth" was reinforced through its establishment as an academic discipline. A Eurocentric discourse, the discipline of history was used as a tool for gaining and maintaining power; in Europe, as part of the process of establishing

nation-states, as well as in the conquered territories elsewhere. In the nineteenth-century museum, historical master narratives were staged by using a chronological approach, illustrating a progressive accumulation of time, knowledge, objects, and power. Artifacts representing different historical eras and degrees of civilization were fixed within the tomb-like environment of the museum, which, as Michel Foucault has written, constituted a "place of all times that [was] itself outside of time and inaccessible to its ravages."[4] Although the concept of the historical museum has undergone a number of revisions since, and the discipline of history is now widely recognized as a practice of crafting narratives as much as assembling facts,[5] the foundational separation between past and present, as between story and history, are largely maintained within Western public discourse.

Within the frame of the contemporary art biennial these distinctions are frequently blurred. In discussing the specific mode of addressing history that biennials and other large-scale periodic art exhibitions such as documenta engage with, Nina Möntmann describes a "plunging out of chronology into a multiplicity of temporalities [that] enable[s] us to re-read history not as given sequence of completed entities, but as a complex net of open-ended threads and polychronic narratives, which can still be diverted in different directions."[6] Usually dispersed across several venues and public spaces in a city, and including artists from different cultural and geographical backgrounds, the contemporary art biennial appears non-linear and polyvocal—a far different way of organizing narratives than the constructed coherence of the historical museum.[7] By situating artworks in direct relationship to both historical sites and the flux of contemporary life, the biennial's narrative form seems very much the opposite of the immobile, timeless museum, customarily placed at a distance from the real events it claims to represent and whose conservative model of exhibition-making still holds an outsized place in our contemporary socio-cultural imaginary.

Although the contemporary art biennial's global outlook could be compared to the ambition of nineteenth and twentieth century museums and world fair exhibitions to "make the whole world available"[8]—and indeed the first art biennial, in Venice, whose history goes back to 1895, still maintains such ambitions—it does not order its diverse content under one totalizing frame, at least not spatially. And even though the logic of the biennial still hinges, like the archaeological and ethnographic museum, on the representation of otherness—the otherness of art, the otherness of art from elsewhere, the otherness of alternative histories, the otherness of

subjects not usually represented in public space, and so on—this otherness is not framed as subordinate to the hegemonic gaze, but rather as a potential form of resistance to it.

As with the museum, the biennial is a product of its historical circumstances. If the nineteenth-century museum was constructed as a confirmation of imperialism's processes, Enlightenment rationality, and nation-building, the contemporary art biennial can be seen as an expression of post-Cold War global society, enmeshed within neoliberal capital and the concept of a never-ending "post-historical" contemporaneity. Proliferating across the world over the last thirty years, the art biennial has been instrumental in the globalization of contemporary art while also becoming a tool for city-branding and the accumulation of cultural capital in an increasingly competitive economy of attention. Seen in this way, the biennial looks less like an alternative structure and more like a new way of narrating the same expansion of transnational capitalism that the nineteenth-century museum was an earlier example of.[9] Indeed, its dispersed character appears to mirror late capitalism's decentered power mechanisms.

But the biennial "cannot simply be read as an ideological reflex to economic globalization": it is also a site for critically reflecting on this condition.[10] In his seminal text "Mega-Exhibitions and the Antinomies of a Transnational Global Form" (2003–04), Okwui Enwezor proposed biennials had this potential, suggesting that although "mega-exhibitions have adopted the notion of the global from the perspective of imperial and colonial modes of differentiation and homogenization,"[11] biennials, particularly those located "in the periphery" (those taking place outside Western Europe and North America, in cities such as Havana, São Paulo, and Johannesburg) suggest the "possibility of a paradigm shift in which we as spectators are able to encounter many experimental cultures, without wholly possessing them,"[12] an approach he had already developed in the second Johannesburg Biennale (entitled *Trade Routes: History and Geography*, 1997) and in documenta 11 (2002). Far from being a celebration of the arrival of global culture, the biennial was recast here as a critical exploration of the global connections foundational to its own coming into being.

When attempting to read it through the question of how historical narratives are made public, the biennial form does seem to provide a different framework than that of the museum. The curatorial practice of assembling and juxtaposing a variety of perspectives, and temporarily situating them in the middle of society, is one such example. Together

with the invited artists, various forms of telling are produced that, unlike the historical museum, are not required to submit wholly to established facts validated by academic discourse but can approach the past from other angles, generating alternative ways of seeing.

Perhaps such practices should not be called "history" at all but rather be understood as part of ancient and ongoing forms of narration that existed long before the idea of history as a science was formulated in the nineteenth century. In her essay "Novel and History, Plot and Plantation" (1971), Sylvia Wynter proposes that the literary novel could be seen as a site of resistance to the master narratives of history, comparing this genre to the small plots of land allocated to enslaved laborers by Caribbean plantation owners to cultivate their own food, pointing out that it was from these small parcels of earth that the uprisings against the plantation system were eventually launched. Although these garden plots were originally intended to maximize the plantation's profits, they also offered the enslaved the possibility to cultivate traditions and values associated with their homelands. If the plantation was the superstructure of civilization, writes Wynter, the garden plot gave space to the roots of culture: whereas the myth of history was used by the plantation owners to safeguard their power, the plot opened up another space for narrating past events, expressed in song and ritual as well as the growing of traditional crops. The literary novel, argues Wynter, performs a similar function, offering a way to critique the very historical process and market society that brought it into being.

Visual art practice could be similarly considered as a space of resistance, enabling other ways of narrating the world to be cultivated, and in terms of making such forms of telling public, the biennial can function as a polyvocal counter-model to the master narrative of the historical museum. In creating spaces across a city for languages and modes of narrating the past that transcend the discipline of history to grow, the "historical turn" of biennials should perhaps be understood as the expression of a two-fold desire to reformulate hegemonic narratives of the past and to delink from the neoliberal framing of art practice as a symbolic bearer of the "new" and "contemporary" in a never-ending present. Enacted in this way, the biennial format becomes not simply a mirror of globalization, but a potential agent for different kinds of translocal and transversal narrations, addressing the global connections it engages with through re-reading the ways histories are continued as and in our present.

Vue de la ville Gustavia dans l'isle St Barthélemy (View of the City Gustavia on the Island of Saint Barthélemy),
Louis Belanger, ca. 1790–1805.

THE BIENNIAL FORM AND THE NARRATION OF HISTORY—
THINKING THROUGH THE GHOST SHIP AND THE SEA CHANGE

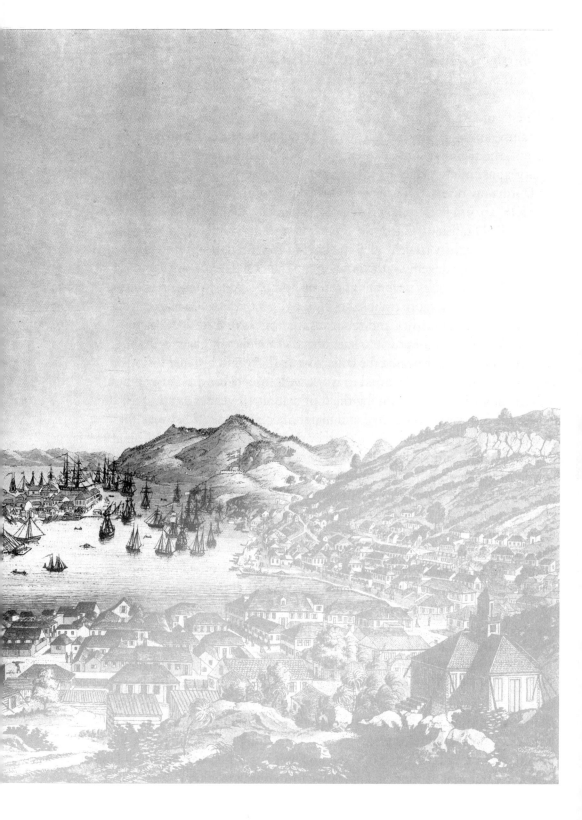

Curatorially, the eleventh edition of the Göteborg International Biennial for Contemporary Art (GIBCA) in 2021 was envisioned as a counter-narrative to a concurrent event, that of the 400-year anniversary celebration of the city of Gothenburg's founding. Starting from the environmental, anti-racist, and anti-patriarchal struggles defining our contemporary moment, the biennial sought to explore how different ways of narrating the city's past might affect its future.

During my research for the previous edition of the biennial (*Part of the Labyrinth*, 2019) I had come across a plot of land located in the city's historical harbor called Franska Tomten (the French Plot) that had played a key part in an eighteenth century trade deal involving France, Sweden and the Caribbean island of Saint Barthélemy.[13] Deviating from the popular narrative and self-image of Gothenburg as a vibrant maritime hub of trade and industry,[14] this piece of land offers a more troubled perspective on the city and its connection to Swedish colonial history and the transatlantic slave trade. Although Franska Tomten is well-known to specialized academics, it has not, despite its central location, permeated the collective memory and broader historical consciousness of the city. I started to work with the site for the 2019 edition of the biennial, including it among the four exhibition venues as a way to address the historical, conceptual and material entanglements between these sites, as well as between the city and other parts of the world. The biennial's first on-site interventions included the commission *Walking with Shadows* by Eric Magassa and the presentation of Ayesha Hameed's soundwork *A Transatlantic Periodic Table*. The enquiry into the history of the site and its contemporary consequences continued throughout 2020 with a series of public lectures and seminars, including the project *Possible Monuments?* and a new artistic commission by Ibrahim Mahama. For the 2021 edition of the biennial, I decided to reverse the dramaturgy of the previous edition: instead of weaving a narrative across four separate venues to show how their histories are connected, I made Franska Tomten the starting point of my curatorial enquiry, letting the questions emerging from that specific plot of land shape the other parts of the project.

This decision to structure *The Ghost Ship and the Sea Change* from the perspective of Franska Tomten gave rise to a number of questions: In what way could using the material, historical, and symbolic layers of Franska Tomten as a narrative starting point alter our way of thinking about the 400-year history of the city? What could this piece of land make visible that many public institutions and history books do not? And how might starting with a plot of land affect the curatorial method and narrative form of the biennial?

Today Saint Barthélemy is known as a luxury tourist destination.

Franska Tomten: The French Plot

Franska Tomten received its name in 1784 when King Gustav III exchanged the plot of land for the Caribbean island of Saint Barthélemy, granting the French trading rights in Gothenburg in exchange for the island, thus giving Sweden a foothold in the Caribbean.[15] This apparently symmetrical exchange hides a set of deeply asymmetrical relations. Until 1847, Sweden's economic activities connected to Saint Barthélemy were predominantly concerned with the transatlantic slave trade. Enslaved persons were traded via the island on Swedish ships, as well as by other nations, who used the harbor as a free port. In 1878, some decades after the slave trade had been abolished and Sweden was no longer able to profit from the island, it was sold back to France.

Today Saint Barthélemy is a French overseas territory whose economy centers around luxury tourism. The island's capital is still named Gustavia after the Swedish king. But in Gothenburg there is nothing commemorating the shared history of the two places, nor any official commemoration of the victims of the slave trade. This absence extends to the way Sweden's colonial involvements are commonly left out of narratives concerning the modern welfare state's origins. The economic gains from colonial trade, however, are most definitely part of contemporary Sweden. Like

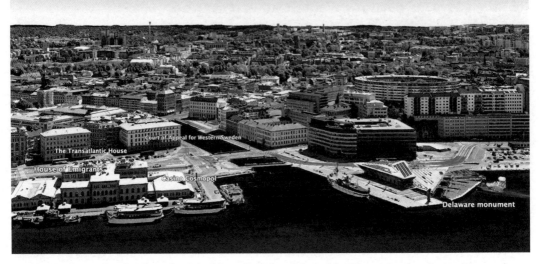

Franska Tomten as plot: the Transatlantic building, the Court of Appeal for Western Sweden, Casino Cosmopol, the House of Emigrants, and the sea. Maps data, Google, 2021.

many other European countries, Sweden profited immensely by taking advantage of the triangular trade. Sweden's export of iron is a case in point. During the seventeenth and eighteenth centuries, Sweden was the biggest iron producer in the world. Swedish iron was used by other colonial powers, notably Great Britain and the Netherlands, as "voyage-iron," as well as in the production of war ships, weaponry, shackles, and chains.[16] Although mined and processed in other parts of the country, most of this iron was shipped out of Gothenburg Harbor, a history commemorated at the centrally located Järntorget (the Iron Square) with its fountain, *The Five Continents*.[17]

The export and expertise connected to the production of iron in the seventeenth and eighteenth centuries laid the foundations for Swedish industrial society and attendant welfare state as we know it today—a state that is still one of the world's most prolific iron and steel producers, exporting more weapons per capita than any other nation in the world.[18] But beyond the specific details of Sweden's involvement in the triangular trade and the role this history has played in contemporary Sweden's development, the point to recognize is that the colonial project fueled the growth of global capitalism as a whole, and is therefore integral to understanding the society we live in today.

While the Franska Tomten of 2021 can best be described as an anonymous piece of asphalt-covered urban ground, upon closer inspection it still tells us something about how events of the past 400 years have carried over into our own times. Transatlantic building, the former headquarters of the shipping company Rederi AB Transatlantic, still stands on the site.[19] A stone's throw away is the palatial headquarters of another shipping magnate, Broström, which today houses the Court of Appeal for Western Sweden (Hovrätten för Västra Sverige). Across the street you find the old harbor goods warehouse and customs house, shared by Casino Cosmopol and the Emigranternas Hus museum (the House of Emigrants).[20] And behind that building lies the sea, the biotope and infrastructure that historically served as the medium for all of these relations. These entities bear witness to a sequence of events spanning several centuries and continents. Seen together, they form a fragmented map of the interrelated flow of goods, capital, bodies, and ideology that have defined the last 500 years. The writing of law is historically bound up with the regulation of international trade: the mobility of goods and capital globally are connected to flows of migration, and the slave labor system of the past has produced entrenched structural inequalities, such as institutionalized racism. Yet, nothing at Franska Tomten publicly acknowledges any aspect of this history.

What we do find there, however, is a number of artworks commissioned by the Swedish transatlantic trading companies who operated from the same site in the twentieth century. These sculptural reliefs, many of which are based on racist and sexist stereotypes, visually express the colonial lineage and violent mindset of the trading companies, if not society of the time. The fact that they remain today, uncommented on, says something about Sweden's tendency to ignore its long history and contemporary problems of structural racism. As these artworks appear to us in 2021, placed in between the Transatlantic building and the Court of Appeal, they also remind us of the role played by trade and international trade law in institutionalizing racism at a global level—the term "white" for example, first appeared in colonial law in the late 1600s—in order to preserve inequality and secure profits.[21]

When I encountered this historically rich yet anonymous site during my curatorial research, it was clear it needed a public re-reading. As the only explicit traces of the site's transatlantic past are artworks, it seemed logical to address its history and contemporary consequences by asking contemporary artists to respond to it.

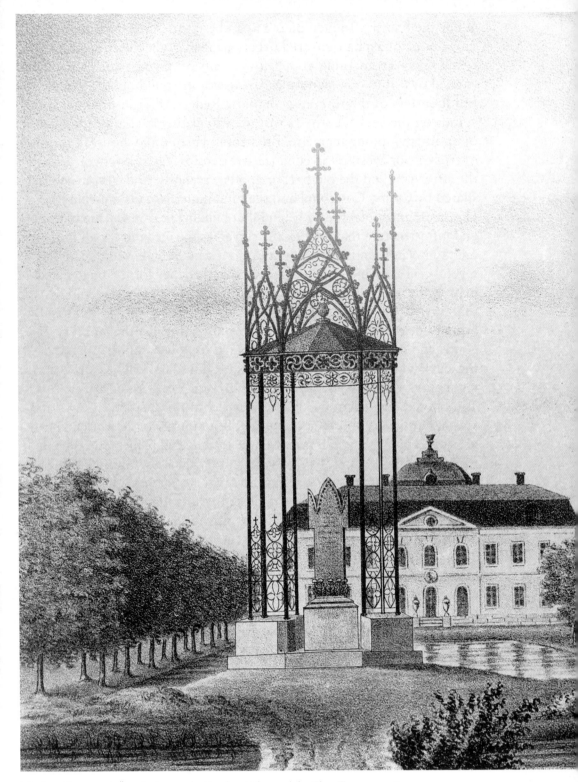

The Iron Monument, Österby ironworks, Sweden. Lithograph by Claes Tamm, ca. 1840.

The Plot

When starting to approach the site curatorially, the first thing that struck me was the double meaning of the English word "plot." Poised between the idea of a "site" and the idea of a "narrative," a plot refers both to a sequence of events and designates a physical space. If a "theme" is an overriding message, a "plot" is how that message plays out over time through actions and events. What might working curatorially with Franska Tomten as a "plot" rather than a "theme" entail? For me, the word "plot" offered a possibility to think about my curatorial practice in terms of "speaking from" rather than "speaking about." The curatorial narrative of the biennial was not constructed to "be about" Franska Tomten but rather to *depart from* there. This is an important distinction for several reasons, not least because the act of projecting a narrative *onto* a plot of land, no matter how much of a counter-history one intends to relate, is a form of telling that in itself carries echoes of colonial and imperial strategy.[22] By attempting instead to trace a narrative outward from Franska Tomten, starting from what is already there and following that plot to where it meets other voices and stories, my hope was that the histories connected to the site could be narrated in a more complex

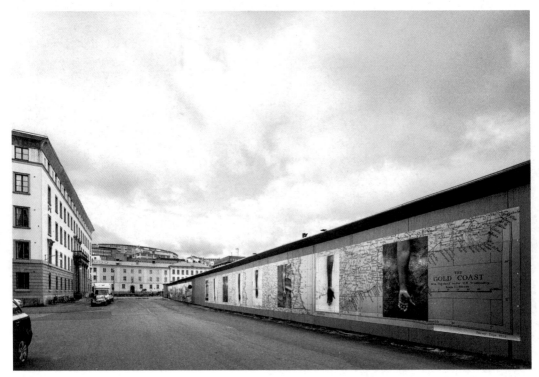

Installation by Ibrahim Mahama at Franska Tomten, facing the Transatlantic building and the Court of Appeal for Western Sweden, GIBCA 2021.

THE BIENNIAL FORM AND THE NARRATION OF HISTORY—
THINKING THROUGH THE GHOST SHIP AND THE SEA CHANGE

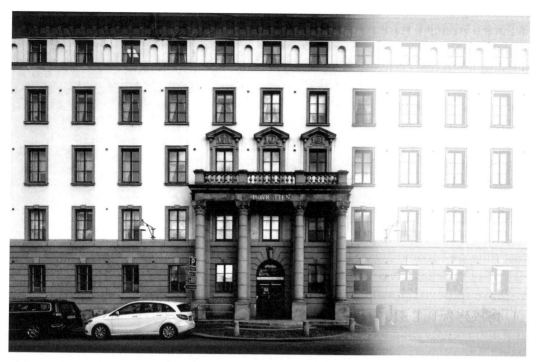

The Court of Appeal for Western Sweden, housed in the former headquarters of Broströms shipping company.

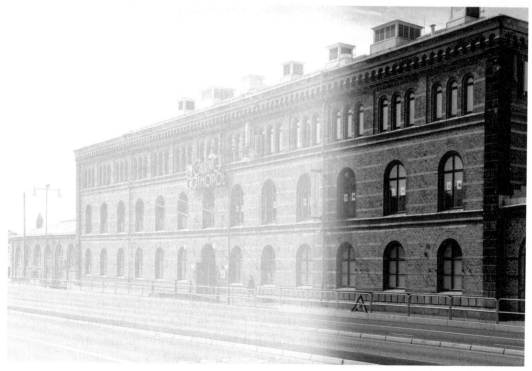

The former harbor storage and Customs House, occupied by Casino Cosmopol and the museum the House of Emigrants.

manner, through a multiplicity of voices and contexts rather than a singular authorial discourse or master narrative. These voices would not add up to one coherent story, history or discursive argument. In contradistinction to conventional Western modes of history writing and storytelling, the narrative of the biennial would not be linear, progressive, or conclusive, but multilayered, multivocal, and multi-sited.

In my effort to understand the lineage of the term "plot" and what potential it could have for curatorial methodology, Benedict Singleton's essay, "The Long Con," where he writes about the origins and uses of the word (2015), was extremely useful.[23] A characteristic of plot, Singleton says, is that it reveals a gap between how the world was believed to be and how it actually is. When reading a thriller or a suspense novel, the first time we become aware of the underlying plot is usually when we, or one of the characters in the story, begin to suspect that the narrative we have followed thus far in fact is hiding another layer of meaning. A plot, writes Singleton, makes itself known in the distance, between the real and the represented, in that it "indicates that our knowledge of the world is incomplete," creating a desire in us to find out more.[24] At Franska Tomten, this hidden layer of meaning is represented by the absence of the island of Saint Barthélemy—historically connected to the site but nowhere to be seen. By installing contemporary artworks that address colonial histories at Franska Tomten, the biennial brought the city's transatlantic connections back into view, but from different perspectives than those of the shipping companies. Elsewhere in the biennial, the relationship between the seen and the unseen was used metaphorically to draw attention to many other similar relationships between hegemonic and suppressed histories connected to the city.

Another aspect of "plot," Singleton notes, is that the practice of "plotting" straddles both past, present, and future: for example, the way a detective uses forensics to determine the sequence of events behind a crime committed in the past in order to prevent other crimes from occurring in the future. The title of the biennial, *The Ghost Ship and the Sea Change*, reflects a similar intention to simultaneously look backwards and forwards, using artworks to both honor ghosts from the past and to move beyond them, acknowledging historical violence while also contributing to processes of repair.[25]

The biennial's turn towards history should not be understood as a fascination for what once was but rather as a way to imagine what might happen next—all the while remembering that "history" and "future" are both highly contested terms. Christina Sharpe, for example, questions

the use of the term "history" when speaking of the slave trade: how is it possible to think of the transatlantic slave trade as being in the past when its consequences still act upon our present?[26] Decolonial thinkers such as Walter Mignolo have pointed out that the discipline of history and the separation it imposes between "past," "present," and "future" is itself a colonial tool, one designed to reinforce the Western capitalist narrative of progress. Standing at Franska Tomten for the first time, facing the sculptural reliefs commissioned by the transatlantic shipping companies, I had been struck by how the buildings and sculptures on site so clearly show that the past is not sealed off from the present but continues on in our midst; they are evidence of relations across time and space, telling us in the most concrete way imaginable that exploitative actions *elsewhen* and *elsewhere* have lasting effects in the here and now.

But the connections these traces of an otherwise absent history make us see are offset by the equally striking presence of the many gaps on site. The spaces between the buildings became for me metaphorical of how the economic and historical linkages between them have been rendered invisible, a concrete image of the stories that are presently absent from the predominating historiography of the city. The reason these links are not publicly visible is partly due to the fact they were forged using labor, land, and materials located elsewhere and deliberately kept hidden from the northern European consumer-citizen. It is also because these links are left out of how the story of the Swedish welfare state and the city of Gothenburg itself is commonly told. We know about the global success of Volvo, but not about the colonial violence connected to the capital and infrastructure that made Volvo possible. In other words, at Franska Tomten today we can see that Casino Cosmopol and the House of Emigrants share the building of the harbor's former goods storage and customs house, but nowhere is the link between historical global trade, speculative capital, and contemporary migration clearly spelled out.

In her essay "Venus in Two Acts," Saidiya Hartman writes that the irreparable violence of the slave trade lies precisely in the gaps left by all the stories we cannot know and never will. She also discusses how, when narrating the time of slavery in and as our present, we must avoid "filling in the gaps and providing closure."[27] Only by leaving these gaps open are we reminded of what is not and never will be there. But a gap is not only a lack or a wound: it is also a space for action and additional meaning production, as every practitioner of montage knows. In the biennial, it is in the gaps—in between the artworks, the buildings, the exhibition sites, and the visitors—that other stories and ways of seeing can emerge.

The zones of potential meaning provided by these gaps are unstable and porous: they change depending on who enters them and how. Here lost connections can be made visible and temporary speculative links can be drawn without closing off the story to further interpretation.

When creating counter-histories, writes Hartman, one cannot rely solely on facts—it is essential to also engage in critical fabulation. The reason for this is that facts invariably belong to power; it is power that decides what will count as fact, which facts will be made publicly available, and which added to history. Fiction, on the other hand, belongs to the realm of possibility. Through fiction it is possible to speculate about what could have happened as well as what might. Counter-histories, then, can only be produced at the "intersection between the fictive and the historical."[28] *The Ghost Ship and the Sea Change* was placed precisely at this intersection. Starting from what was visible at Franska Tomten— historical evidence, material facts—the biennial invited different voices to continue the narration from multiple perspectives. Rather than plotting a continuous line between the fragments, the biennial added more pieces, insisting they were all part of the same plot.

Ursula K. Le Guin writes about open-ended forms of narration in her 1988 essay, "The Carrier Bag Theory of Fiction," using the analogy of a bag that holds things of importance in no particular order. Thinking of a story or, indeed, an exhibition in that way leaves it open and unending, without fixed outcomes and heroes, offering the possibility of several viewpoints and modes of narration. Furthermore, it suspends the linear logic of "past" as opposed to "present," allowing for protagonists both dead and alive, human and non-human, to continually shift position. And contrary to popular belief, speculative storytelling is not just for science-fiction writers like Le Guin, or artists and curators. It is also an essential tool within scientific disciplines such as archaeology. In my work with GIBCA 2021, archaeology was an important methodological reference. The concept of "multi-sited archaeology," for example, has been helpful in exploring the history of Gothenburg by looking at the city's global connections as exemplified by Franska Tomten. Coined in the 1990s, the term multi-sited archaeology was developed in response to an increasingly globalized world in order to describe how to deal archaeologically with transnational economies, cross-cultural flows, and diasporic movements that cannot be adequately understood through single-site research.[29] According to this approach, a place only becomes legible by looking at other places. Examining Franska Tomten from a multi-sited archaeology perspective entails tracing the "dislocated sets

of relations"[30] that have made themselves felt in that small plot of land but can never be understood from looking at that site alone. Some of the artworks exhibited by the biennial explicitly provided such links. Others told stories that, while not explicitly connected to Gothenburg, enabled an understanding of the global conditions foundational to the development of this type of northern hemisphere port city.

Archaeology also provided the starting point for the biennial's exhibition architecture. As Scandinavia's biggest port for hundreds of years, the history of Gothenburg is also a history of ships. One of the more well-known examples is the East India trader *Götheborg*, that sank outside the city in 1745 upon its return from China. Found by marine archaeologists in 1984, the shipwreck instantly became famous, eventually leading to an expensive replica being built and sailed along the same East Asian trading routes as the original ship to draw attention to the history of Gothenburg and promote Swedish business abroad. (When not at sea, the ship is moored in Gothenburg Harbor, where it functions as a tourist attraction.)

Not so well known, however, is another ship found by the same marine archaeologists—the West India trader *Havmanden*—which sank in 1683 while carrying Danish convicts and colonial administrators on their way to Saint Thomas, Denmark's colony in the West Indies. From the Caribbean the ship was set to continue to the Gold Coast to purchase 300 slaves. However, early in the voyage its crew mutinied and diverted course, only to be caught in a storm and forced to abandon ship close to the island of Risö outside Gothenburg. Just as the Scandinavian involvement in the triangular trade remains largely suppressed in narrations of Nordic welfare states' formation, this ship was neither publicly paraded, nor replicated. On the contrary, after being found in 1999 it was wrapped under protective sheeting and pushed even deeper out of sight.[31] Together with the artists, the biennial set out to dig—albeit discursively—until this ship came back into view. Exhibition architects Kooperative für Darstellungspolitik were commissioned to stage a metaphorical replica of this Scandinavian ghost ship, still buried in the sands outside Gothenburg— a gesture mirroring the city's own attempt to connect its past to its future through the East India trader *Götheborg*. But the two endeavors were separated by one important difference: in the biennial's replicated ship, the fragments were never joined to make a whole. On the contrary, there was no attempt to close the gaps or join the dots into a comprehensible form. Presented in fragments, just like the actual ship's ruin, the exhibition architecture represented the incoherent and unknowable past that

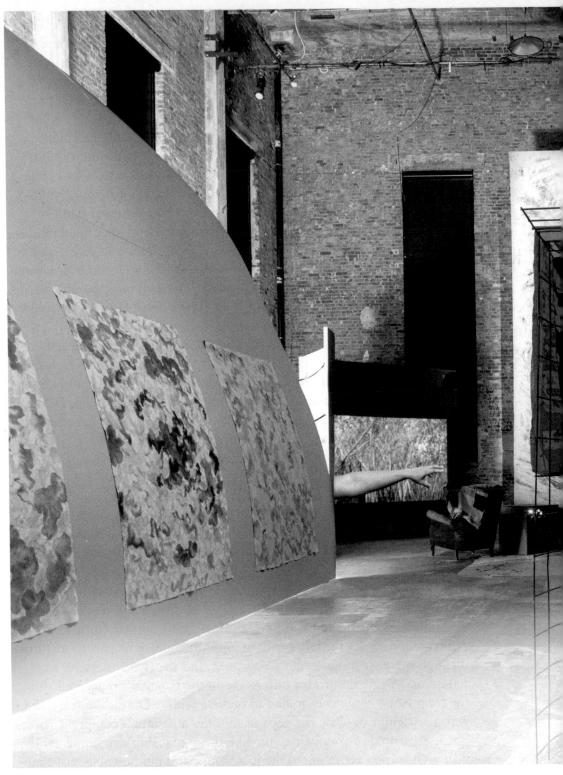

Installation view from Röda Sten Konsthall, the 11th Göteborg International Biennial for Contemporary Art, *The Ghost Ship and the Sea Change*, September 2021.

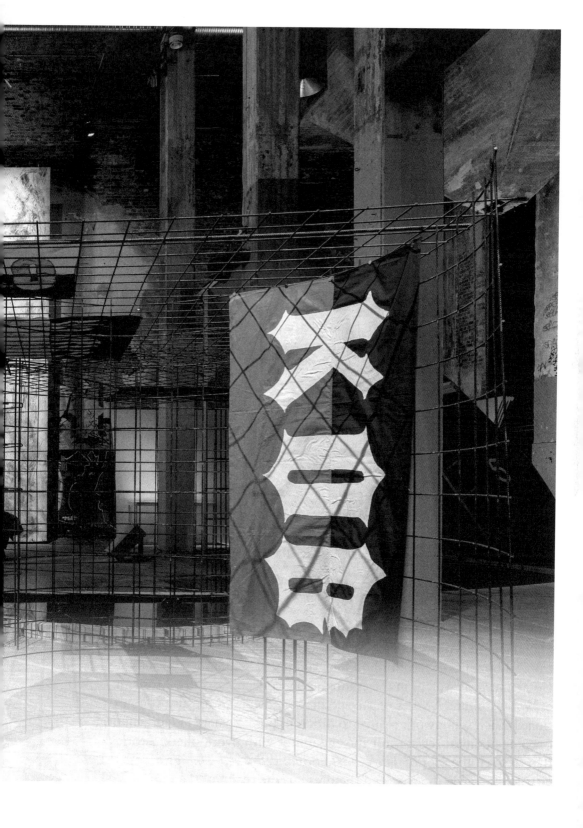

LISA ROVENDAHL

nevertheless frames our present. The walls produced by the ship—none of which were straight—were uneasy ones; their purpose was not to create the perfect conditions for the display of artworks, but to participate in the telling of a difficult story.

In line with its title, the biennial exhibition changed during the duration of the project. The first part, which opened in June 2021 to coincide with the 400-year anniversary of the city's founding, was centered on the fragmented ship-structure built at Röda Sten Konsthall. Here the project unfolded in stages, with artworks being added, moved or altered over the months between June and November. In the process, the exhibition architecture disintegrated further. Whereas the inaugural display was spare and linearly ordered—with stretches of empty wall space in between the artworks signaling lost links and missing voices—the exhibition gradually became more complex over time, with the historical materials and sections of the architecture being moved aside or re-positioned to accommodate additional artworks. This movement was mirrored in the exhibition's content, which was initially focused on the history of the colonial project as traceable in contemporary society—for example in precarious labor conditions, unjust juridical structures and polluted natural environments—but gradually grew to include more transformative propositions. Like a gathering storm, the installation evolved into something more dense and disorderly, encompassing multiple layers of meaning.

In the project's second phase, the narrative expanded from Röda Sten Konsthall to include more exhibition sites. Two new commissions were added at Franska Tomten: Salad Hilowle's sculpture *Untitled (En resa från förr)*, which takes one of the historical wooden reliefs by Arvid Bryth (1905–1997) located inside the Transatlantic building as its starting point, and M. NourbeSe Philip's poem *Zong!* (originally published as a book in 2008), which was installed on-site as a public text work. In addition to the bespoke art galleries of Göteborgs Konsthall and Konsthallen Blå Stället, works were shown at the Palm House (a nineteenth-century replica of London's Crystal Palace housing a tropical botanical collection) on the grounds of the Garden Society of Gothenburg, as well as in the ethnographic collections of the Museum of World Culture. A series of site-specific soundworks were also commissioned. Each soundwork related to different public places in Gothenburg, opening an aural register for the encounter with overlooked histories that weaved the plot of *The Ghost Ship and the Sea Change* across the city—in between the past and the present, the real and the represented.

As undertaken in *The Ghost Ship and the Sea Change* exhibition (as well as in this accompanying book), exploring the potential of the contemporary art biennial as a site of historical narration was not intended to diminish critical, self-reflexive work being done within historical and archaeological museums or their constitutive disciplines. It is also not a suggestion that art biennials replace historical institutions. It is, however, an attempt to articulate what biennials can contribute to historical consciousness by creating public sites for insisting on—and experimenting with—the co-presence of different temporalities and ways of knowing.

Perhaps it is a form of epistemological disobedience to attempt to dissolve the boundaries between the past and the present, as between story and history.[32] An art exhibition is in some ways an inversion of a historical museum display. Rather than being under pressure to adhere to the official narrative of what verified facts tell us about what *has been*, art and curatorial practice allow for the critical possibility of also imagining what *should* have been, *could* have been, or *might still* be. The polyvocal and dispersed biennial form can spread a multifaceted story across a whole city, allowing for encounters with a particular issue from many different perspectives and in many different contexts. This form thus offers up the possibility of showing how a problem, a question, or a historical process can permeate an entire society and is not confined to a single location or perspective. And whereas museological narration makes explicit connections between objects, ideas, and geographies for pedagogical reasons, the curatorial narrative of an art exhibition tends to operate implicitly, in the background, as an undercurrent that suggests certain perspectives while leaving them open for questioning and contestation. This open-endedness is emphasized by the tensions that sometimes manifest between the curatorial narration and the individual artworks, as between the artworks and the different exhibition sites. In this form of telling, the gaps and empty spaces are just as important as the works and sites themselves. They serve as physical reminders of everything we do not and cannot know, of how the story of history is always incomplete—making space for additional voices to enter with their own perspectives and knowledges, reformulating the narrative once again.

A version of this text was first published in the online research journal *PARSE*, Issue 13.1 (Spring 2021).

1. See, for example: Dieter Roelstraete, "The Way of the Shovel: On the Archaeological Imaginary in Art," *e-flux journal* No. 04, March 2009, https://www.e-flux.com/journal/04/68582/the-way-of-the-shovel-on-the-archeological-imaginary-in-art/ (accessed Nov. 14, 2020).

2. Michel Certeau, *The Writing of History* (New York: Columbia University Press, 1988 [1975]), 2.

3. Raymond Williams, *Keywords: A Vocabulary of Culture and Society*, revised edition (New York: Oxford University Press, 1983 [1976]), 146.

4. Michel Foucault, quoted by Tony Bennett in *The Birth of the Museum* (New York: Routledge, 1995), 1.

5. See, for example: Hayden White, "The Burden of History," *History & Theory* Vol. 5, No. 2 (1966): 111–134.

6. Nina Möntmann, "Plunging into the World: On the Potential of Periodic Exhibitions to Reconfigure the Contemporary Moment," *OnCurating*, Issue 33 (2017): 13.

7. Not all contemporary art biennials use this dispersed form. The São Paulo and Gwangju biennials, to name two high-profile examples, are more or less single-site projects. Although it is beyond the scope of this essay to consider the difference between single- and multi-site biennial models, it is worth noting that even though a unifying architectural frame may evoke the totalizing apparatus of the historical museum, the different temporalities and diversity of subject-positions usually included in these biennials do not.

8. Tony Bennett, "The Exhibitionary Complex," *New Formations*, No. 4 (Spring 1988): 79.

9. Peter Osborne, "Existential Urgency: Contemporaneity, Biennials and Social Form," *The Nordic Journal of Aesthetics*, Issues 49–50 (March 2016): 180.

10. Oliver Marchart, "The Globalization of Art and the 'Biennials of Resistance': A History of the Biennials from the Periphery," *OnCurating*, Issue 46 (June 2020): 22.

11. Okwui Enwezor, "Mega-Exhibitions and the Antinomies of a Transnational Global Form," *Manifesta Journal* No. 2 (Winter 2003–Spring 2004): 118.

12. Ibid., 115.

13. The site was mentioned in a display at the Museum of Gothenburg (Göteborgs stadsmuseum).

14. See for example: Gothenburg's official webpage for the 400-year jubilee, www.goteborg2021.com (accessed Sept. 25, 2021).

15. Today, the neighbourhood between Skeppsbron, Kronhusgatan, Smedjegatan and Postgatan is still registered in the city records as Franska Tomten, although the name does not appear on any signage in the area. It is somewhat unclear, however, what the precise boundaries of the historical site were. According to Björn Siesjö, the Gothenburg city architect, Franska Tomten corresponds to the present-day address Packhusplatsen 4. He also related that different historical maps show different demarcations, and that structures dating from the years when the French concession was active no longer exist. Additionally, the area has been rebuilt several times over the years, while the actual harbor front has moved further away due to land reclamation projects. In the essay "Franska tomten och den svenska jakten på kolonier" (published in the anthology *Göteborg utforskat: Studier av en stad i förändring*, Glänta, 2010, pp. 175–182) Klas Rönnbäck writes that the earliest known map where the site is named (1802), places it on the corner of Packhusplatsen and Norra Hamngatan where the Court of Appeal for Western Sweden is located today.

16. "Voyage iron" was a transatlantic slave trade currency consisting of forged metal bars, used along the West African coast. It had a profound impact on the economic geography of West Africa. See, for example: Chris Evans and Göran Rydén, "'Voyage Iron': A Transatlantic Currency, its European Origins, and West African impact," *Past & Present* Vol. 239, No. 1 (May 2018): 41–70.

17. *The Five Continents* (1927) by Tore Strindberg represents each continent with a naked female figure, modeled according to ethnic stereotypes.

18. The past and present of Swedish iron mining, as well as Swedish industrial modernity as a whole, has been the subject of two of my most recent curatorial projects prior to GIBCA: *Extracts from a Future History* (various sites across Luleå, produced by Public Art Agency Sweden in 2017) and *The Society Machine: The Industrial Age from the Perspective of Art* (Malmö Konstmuseum, 2016–17). My research into the translocal traces of Swedish iron mining was also what prompted me initially to dig deeper into the country's colonial relations.

19. Rederi AB Transatlantic was not founded until 1904 and thus played no part in the transatlantic slave trade. The company was active until 1994, transporting goods and passengers between Sweden and America, South Africa, and Australia.

20. The House of Emigrants moved out of these premises in March 2021.

21. Robin DiAngelo, *White Fragility* (London: Allen Lane, 2019), 17. For further discussion about how the ideology of the inequality of different races was created to justify the exploitation of labor and resources, see: Ta-Nehisi Coates, *Between the World and Me* (New York: Spiegel & Grau, 2015).

22. The decision to let the biennial narrative depart from Franska Tomten also led to a process of self-questioning. What did it mean for me, as a white Swedish curator, to concentrate the biennial on colonial relations? How does my identity affect the narration of this ongoing history? As discussed above, thinking of my curatorial narration as an act of "speaking from" Franska Tomten rather than "about" it offered a possibility to be clear about my own situatedness and starting point, proposing the history of a particular site as a point of departure rather than an overarching theme, leaving it open to the artists where to take the story from there. The message I hope the biennial communicated is that it is necessary for all of humanity to take an anti-racist stance in everything we do, no matter our individual ethnicity. And as the history (and present) of colonialism is a global problem, it needs to be critically addressed from every perspective— not least European ones.

23. Benedict Singleton, "The Long Con," in *When Site Lost the Plot*, ed. Robin Mackay (Falmouth: Urbanomic, 2015), 105–120.

24. Ibid., 111.

25. Apart from alluding to titles of fables and nursery rhymes, such as *The Tortoise and the Hare* or *The Lion and the Unicorn*, the biennial's title is also a play on the 1989 historical exhibition *Lejonet och Kronan. Stormaktstidens Göteborg* (roughly translatable as "The Lion and the Crown. Göteborg during the Swedish Empire") which was named after Gothenburg's two seventeenth century military fortifications Skansen Lejonet (the Lion sconce) and Skansen Kronan (the Crown sconce) and involved all of the city's historical museums. The exhibition focused on the first hundred years of the city's history (1621–1721).

26. Christina Sharpe, *In the Wake: On Blackness and Being* (Durham: Duke University Press, 2016).

27. Saidiya Hartman, "Venus in Two Acts," *Small Axe: Caribbean Journal of Criticism* Vol. 12, No. 2 (June 2008): 12.

28. Ibid., 11.

29. Christopher Witmore, "(Dis)continuous Domains: A Case of 'Multi-Sited Archaeology' in the Peloponnesus, Greece," in *Of Rocks and Water: Towards An Archaeology of Place*, ed. Ömür Harmanşah (Oxford: Oxbow Books, 2014), 213–241.

30. Ibid., 214.

31. There is nothing in the documentation of the ship to indicate this was done for any reason other than conservation. The archaeological excavation of the ship is detailed in *Havmanden–ett danskt 1600-tals-fartyg*, Bohusläns museum, Rapport 2003:29, 2004.

32. Walter Mignolo describes decolonial thinking as epistemological disobedience through delinking from European models of knowledge as represented by the university, the museum, and the church. In "Thoughts on Curatorial Practices in the Decolonial Turn," Ivan Muñiz-Reed discusses how curatorial practice and authorship is part of the colonial matrix of oppressive hierarchies of knowledge constructed from Western imperial categories, pointing out that when operating "through European-generated categories, they construct a 'Eurocentric critique of Eurocentrism'... Decolonial thought on the other hand, is not constructed from or in opposition to European grand narratives, but rather from the philosophical, artistic and theoretical contributions that originate from the Global South" (*OnCurating*, Issue 35, December 2017, https://www.on-curating.org/issue-35-reader/thoughts-on-curatorial-practices-in-the-decolonial-turn.html#.YWgP83mxXEY [accessed June 22, 2021]).
 Although I strongly support decolonial thinking and practice, I don't refer to my own work in those terms as my epistemological and professional background—however critical I might be of it—is unavoidably European. Several of the artists in GIBCA 2019–2021 practice from decolonial perspectives, however. In light of this, I hope that my effort to enact curatorial agency by being part of a conversation rather than creating a totalizing frame offers the possibility of engendering a complex reading of the position of the project and its treatment of colonial history as an entanglement of *both and* rather than modeled on modernity's false dualism of *either or*.

EXHIBITION

ARCHITECTURE

AS

CONCEPTUAL

GHOST

INTERVIEW WITH
KOOPERATIVE FÜR
DARSTELLUNGSPOLITIK

Lisa Rosendahl (LR):
What were your thoughts when we first
invited you to make the exhibition archi-
tecture for the 2021 GIBCA biennial
venue Röda Sten Konsthall as a replica
of the seventeenth century ship
Havmanden?

Kooperative für Darstellungspolitik (KfD):

To be honest, we were not convinced
in the beginning. As we have doubts
about a primarily symbolic or meta-
phoric understanding of architecture,
to produce a replica sounded like a
strange idea. But the story of the
Havmanden ship says a lot about
historiography—the stories that are
told—and even more about the blind
spots. On the occasion of the 400th
anniversary of the city of Gothenburg,
this story enables a discussion of the
dark sides of the city's past; its involve-
ment in the slave trade and exploitation
of colonial territories. Many of the
artists who you invited to the biennial
deal with similar questions about criti-
cal historiography and counter-history.
Therefore, it made a great deal of sense
to take this story as a starting point for
the exhibition architecture, although we
tried hard to avoid making an exact
replica of the ship.

*LR: Can you say something about
your research and process leading up
to the final architecture?*

KfD: Our first meetings circled
around the question of how the ship
could be made present in the exhibi-

tion space as a conceptual ghost. In the
beginning, there was also the idea that
the ship could appear in the different
exhibition venues in Gothenburg that
together make up the biennial—a ship
fragmented not only in a single space
but throughout the city. We talked about
how realistic the ship should be, what
images or associations it could evoke.
You brought in the image of the archae-
ological site; initially we were thinking
more of a construction site, a shipyard
or dry dock. In both cases, the ship only
exists in fragments, either not fully as-
sembled or broken up after sinking.

*LR: The reason for contacting you
was that I was interested in exploring
how the exhibition architecture could
become an explicit part of the biennial's
story-telling. I was curious about the
potential in the relationship between the
physical frame of the project and the
curatorial frame. I guess I thought about
it as something in-between scenography
and architecture. What are your thoughts
about those relationships?*

KfD: We have experimented in previous
projects with display structures that are
somehow autonomous from the displayed
artworks, becoming metaphoric objects
in themselves that coexist with the art-
works. The exhibition architecture for
Röda Sten Konsthall is a continuation of
this experiment. Nevertheless, we found
it interesting to consider the ship as not
only a metaphor but a real space defined
by its curved hull, its scale and size, its
surface, its position in the exhibition
space. The curved geometry of the ship,

even if it is only present in fragments, can evoke very basic questions that are connected to your curatorial questions. Am I inside the ship or outside? How does my body relate to the history of the ship? Or, as you put it in the introduction text: "How does the past continue to frame the present?"

LR: One important realization you brought to the project was that in order for the architecture to be part of telling a difficult story, the walls had to be a problem rather than a solution. The resulting exhibition architecture has no straight walls. Rather than providing perfect background conditions for the display of the artworks, it added more questions and perspectives.

KfD: Our proposal for the exhibition space presented quite a few challenges for displaying the artworks. All the surfaces provided for display are curved, there is no straight wall in the whole space. There were many questions from the side of the artists, ranging from aesthetic ones (whether the display overshadows the artworks) to technical ones (whether projections can be focused on curved surfaces). It was rewarding to see how initial doubts could be resolved through discussion: all the artists agreed to show their works in very specific installations. It all worked out in the end, thanks also to the great installation team. But indeed, the intention was to complicate the display of artworks. Since we collectively

decided to bring in a complicated and painful story of a sunken ship, it was clear that this needed to produce problems and questions. The curved walls is one of them, the fragmented associations another.

LR: As the biennial exhibition deals with change, I wanted this to be expressed in how the project physically unfolded between June and November and for the architecture at Röda Sten Konsthall to be part of that. You spent a lot of time together with me working on various solutions for that to be possible. What was your experience of conceiving of an architecture that should undergo transformation? Have you worked like this before?

KfD: The changing of spaces is something that we are familiar with from the design of festival spaces—for example, the three iterations of the Berlin Documentary Forum, a film festival at Haus der Kulturen der Welt, that we worked on. For the three editions we had to design stage and audience settings for a variety of different events held in the same space, ranging from film screenings of different scales, to round table discussions, to more open formats and specific performances. For Röda Sten Konsthall, the changes were quite simple. Additional artworks were added over time in three phases, with the exhibition becoming gradually denser. The concept was that the three large ship parts constructed for the initial phase would be

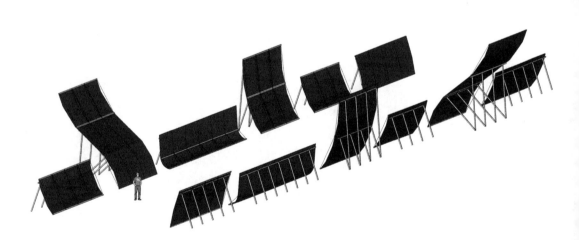

Preparatory drawings by Kooperative für Darstellungspolitik, for the GIBCA 2021 exhibition architecture at Röda Sten Konsthall, 2020.

deconstructed into smaller fragments and spread in an arbitrary way throughout the exhibition space. The initial setup resembled a shipyard, the last phase could be read as an archaeological site. Our design in this case was not a concrete spatial setting but more a device for a process that you, the installation team, and the participating artists could use for a transformation of the display principle.

LR: What are your thoughts about the role and narrative potential of exhibition architecture when it comes to projects dealing with historical consciousness? Maybe you have examples of other biennials, exhibitions, or museums that you feel would be interesting to mention here.

KfD: From our Berlin perspective, this issue is not as emancipatory as it could be. Look at the reconstructed castle (the Humboldt Forum) in Berlin, that deploys a very powerful and uncritical historical narration through spatial settings and (exhibition) architecture. Here, a monstrous spatial construct recalls a past empire while housing the ethnographic collections of the city's museums, which have their origins in this same imperial and colonial past. No critical approach is possible here. This is hard to digest. But the critical debates surrounding this project from all sides show, at the same time, how important and relevant it is for contemporary society to negotiate and reflect upon historic narrations ... to read them as powerful constructions and not as something given or true.

GRAPHIC

DESIGN

AND

HISTORY-MAKING

INTERVIEW
WITH OSKAR LAURIN

Lisa Rosendahl (LR):
You did the graphic design for the overall identity of the 11th edition of GIBCA as well as for the accompanying book, where this interview is published. The book explores the potential of contemporary art biennials as sites of historical narration; graphic design and exhibition architecture are both important aspects of how the core ideas of a biennial are expressed and communicated. How do you see the role of graphic design in this context? Do you think of it as a narrative tool?

Oskar Laurin (OL):
Absolutely. Especially with regards to group exhibitions and biennials, the visual language used to frame them often become the visitors' first real meeting with the exhibition. I think the narrative role of graphic design for biennials is to make a complex event visible in a coherent way, and hopefully make people feel like something interesting is happening. As a designer, I am interested in helping communicate a theme introduced by someone else—in this case your curatorial vision for the biennial. So, in a way the visual output consists of your ideas filtered through my voice as a designer.

Then there is the role of design in documentation and history-making. As someone interested in art history who works with graphic design, it's impossible not to think of how historic and not-so-historic exhibitions take place in the world of books, printed ephemera, and, more recently, digital channels. In these cases, the relationship between the designed object and the subject of the exhibition become intrinsically entwined.

LR: Your own research leading up to the graphic identity of the biennial and, later, the design of this book included quite a bit of historical material and references. Could you let us in on some of the backstory to your design decisions?

OL: In conceptualizing the visual identity of the biennial, I wanted to bridge different times in history and make a place for visual languages that would otherwise never meet to combine. In the case of the final design, we have a combination of decorated swirly contracts written by hand in the seventeenth century, and a geometric machined typeface that draws inspiration from the industrial optimism of the 1920s. Together these forms make for an aesthetic that is unexpected and hard to place.

The book is something quite different. The design of the book is the result of extensive dialogue with both you, Lisa, and the team at GIBCA. It has been a very interesting undertaking. Design-wise, it is inspired by themes of layering and the idea that time moves in several directions. I especially recall being shown the original document outlining the exchange of Saint Barthélemy for Franska Tomten in

Research image for GIBCA 2021's visual identity: detail from *Spieghel der Schryfkonste…(Mirror of the Art of Writing)*, 1605, Jan van de Velde I.

GRAPHIC DESIGN AND HISTORY-MAKING

1785, whose paper is so thin that the pages look like palimpsests, with writing going in two different directions on top of each other. This and other ideas about the layering of history influenced everything from the sequencing of the book, choices for typographic solutions, paper, etc. So, with this book I feel that we have knowingly entered a process that is slow and bespoke, and for me this is very much in line with the theme of the biennial. Today the making of a book is often characterized by standardization, efficient processes, and defaults. To reverse the rods and spell the charm backwards, as they say, we've adopted ways of working that are time consuming, reflective, and curious. *What happens if we order the texts like this? Or this?* We've spent a lot of time searching for possibilities in the gaps of what is known. Hopefully, the book will be better for it!

LR: One of my ambitions with the biennial was to give voice to parts of Swedish history that have often been underplayed in official narratives. Bringing out these perspectives through the biennial was a way not only to discuss them publicly and show how they relate to our own time but also to explore how contemporary art can offer different ways to negotiate the relationship between past and present than those used in historical museums and history books. This includes how to think about time and narrative as non-linear,

possible to navigate in many different ways. This consideration also affected our discussions about the structure and look of this book. Could you explain some of the design ideas relating to that discussion?

OL: This is a complex book, with a polyvocal host of voices coming from different fields, professions, and places that are, variously, theoretical, artistic, serious, and playful. On top of that, the book tells the story of two separate editions of the biennial that are already complex in themselves. So, it made sense for us to explore this complexity, as well as different ways to use the narrative possibilities of the book. I remember you, Lisa, sending me an email just to make clear that you did *not* want to make a conventional book. What we ended up with is a book that is non-linear and divided into several parts: a collection of essays, a visual time journey through the two biennials (and what happened in-between), an index of all exhibited works, and visual representations of some of the soundworks. It's a book that is neither consistent nor linear, made up of many parts and fragments that together make up an open-ended narrative.

CUAUHTÉMOC MEDINA

DRILLING TIME: HISTORY TUNNELS IN THE BIENNIAL SYSTEM

In 2011, Beatrice "Bice" Curiger, one of the founding editors of *Parkett* magazine, decided to challenge artworld conventions by pulling one of the strangest stunts in the history of recent Venice Biennales. Unashamed of the possible accusation that she was reinforcing Eurocentric cultural prejudices, or criticism that the exhibition had practically excluded artists from the periphery,[1] Curiger placed three works by the great sixteenth century Venetian painter Jacopo Robusti (a.k.a. Tintoretto) practically in the center of the Italian Pavilion in the Giardini. In one of the central galleries of the exhibition, framed rather obscenely by air conditioning pipes, hung Tintoretto's *Last Supper* (1591–1594), from the church of Saint Giorgio Maggiore, next to two more of his paintings from the collection of the Gallerie dell'Accademia—*Creation of the Animals* (1550–1553) and *The Removal of the Body of Saint Mark* (1562–1566). The rather arbitrary effect the hanging produced on visitors to the rooms—at one of the most influential events in contemporary art—did not go unnoticed. Tintoretto (along with Christian Marclay's video *The Clock* [2010]) practically stole and at the same time saved Curiger's show, who claimed her intention had been to "question conventions, conventions of the art world, conventions of the contemporary art public, conventions of the old-master public."[2] The question that lingered in visitors' minds was not if Tintoretto's work overshadowed most of the works included in the Biennale, but what did his presence in the show make of our assumptions about the function of biennial exhibitions. As *Guardian* art critic Jonathan Jones wrote at the time:

> Tintoretto was a genuinely pious man, in the age of the Counter-Reformation when Italy abounded in new religious energy. His art is a rejection of the sensual fullness of Titian. Paradoxically, this reactionary art now looks "modern" because it does indeed break the rules of the Renaissance. … Do artists today need telling to break rules? Surely Tintoretto is more likely to look, in the context of the Biennale, like a fiery prophet of artistic crisis.[3]

1. "The artists checklist, slimmer than in previous years, shows an insolent and offensive contempt of everything we recently used to refer to as the periphery." Javier Hontoria, "Pólvora mojada en Venecia," *El Cultural*, June 19, 2011, https://elcultural.com/Polvora-mojada-en-Venecia (accessed June 20, 2021).
2. "Michelle Kuo talks with Curator Bice Curiger about the Upcoming 54th Venice Biennale," *Artforum*, May 2011, https://www.artforum.com/print/201105/michelle-kuo-talks-with-curator-bice-curiger-about-the-upcoming-54th-venice-biennale-28059 (accessed June 20, 2021).
3. Jonathan Jones, "What light can Tintoretto shed on modern art at the Venice Biennale?" *The Guardian*, May 9, 2011, https://www.theguardian.com/artanddesign/jonathanjonesblog/2011/may/09/tintoretto-venice-biennale (accessed June 10, 2021).

The arrival of Tintoretto at the Venice Biennale not only created a bridge between the event and its surroundings—making the art of great masters conveniently available to a crowd that, frequently, does not have time to visit Venice's many churches while trying to consume as much contemporary art as possible—it was also a manifestation, perhaps the most striking one, of a significant trend, that of trying to infuse old blood into the veins of contemporary cultural temporality.

The primary role of introducing history into biennial exhibitions consists of the infection the arrival of an alien past brings, and the introduction of real alterity into a system predicated on a dubious brand of uniqueness. Thanks to the arrival of artworks and artifacts from past ages, biennials seem to aspire to restore density and depth to an artworld that appears diluted by overexposure. Sometimes, as happened with the inclusion of Tintoretto, it is hard to relate to the claim to critical interruption they allegedly offer. More often, they end up looking like ill at ease foreign houseguests at an inhospitable mansion.

Instead, one could point to the many cases where, in fact, a biennial is able to disrupt the accumulation of historical meaning in a place, producing a true short circuit of meanings, unsettling not only our experience of the temporality of a place but the content of the past encapsulated in a specific locale as well. *Germania*, Hans Haacke's installation at the German Pavilion of the 1993 Venice Biennale, excavated the obliterated memory of the classical architecture of this pavilion, resuscitating the image of Hitler's 1934 visit to the Biennale. The way Haacke alluded to the ruins of Germany's past—breaking the gallery floor and recuperating the sinister Latin inscription originally featured in its Nazi-era architecture—was particularly poignant, as this was the first pavilion presented after the reunification of the country under the hegemony of the almighty Deutsche Mark, added by Haacke as a decoration above the main doorway entering into the pavilion and singled out from its surroundings by a spotlight. As Benjamin Buchloh has argued, the work's strength comes in great part from the "seemingly impossible convergence of a literal and a metaphorical axis" it offers: "the reemergence of the German nation state appeared here as a field of shards and discontinuities, suspended between its unacknowledged Fascist past and its problematic and illegitimate claims for the reconstruction of a conventional model of national identity."[4]

4. Benjamin H.D. Buchloh, "Hans Haacke: The Entwinement of Myth and Enlightenment," in *Hans Haacke: Obra Social*, ed. Benjamin H.D. Buchloh and Walter Grasskamp (Barcelona: Fundació Antoni Tàpies, 1995), 57–58.

Biennials are keen to interpellate viewers and citizens by using devices that renew interest in historical symbols and memory places, rescuing them from the banality of their normalization within everyday life. Paradoxically, public monuments, as is well known, tend to be invisible to a city's inhabitants despite their colossal immortality, rendered in bronze, iron, or marble. Their political function depends on remaining relatively innocuous on our streets and in our parks, ready to be activated as objects of power by all kinds of ideologies. Artists like Tatsurou Bashi use biennials to provoke conditions of visibility for such historical markers and idols, simultaneously deriding their seriousness and making visible their menacing aesthetic. At the 2002 Liverpool Biennial, he famously squatted the Queen Victoria Monument at Derby Square by building a fully functional deluxe hotel room, *Villa Victoria,* that could be rented to guests, who slept, partied, and had sex in sight of the queen's threatening presence. No matter how humorous or tragic they are, such works disturb the many scholarly and ceremonial techniques by which the present wrongly assumes that it keeps images and narratives of the past under control. Especially in the twenty-first century, biennials have functioned as sites where the ghosts of the past are brought to life, to entertain, disrupt, intrigue, and alert the usually-distracted tourists to our festivals of culture to their presence.

The Sense of Enquiry

Arguably, staging the arrival of the past in order to shake expectations of what we understand as "contemporary" does not really suffice when discussing the significance of history and historicity for current biennials. This sort of archeological intrusion, similar to the way geological eras can break out of the sediments of time when they collide and mix with other strata, lacks a specific quality—that of the pursuit of enquiry which Herodotus of Halicarnassus ciphered by naming his nine books "the results of his enquiry" on the origins and development of "the hostilities between Greeks and non-Greeks."[5] For Herodotus, the term ἱστορία, rendered in Latin as *historia,* was not intended to be defined as a narrative of "the past." It was related more closely to the cognitive task he had inaugurated. As the OED defines it, enquiry is a process of rationally "learning *or* knowing by enquiry [or] an account of one's inquiries."[6] It is this "sense of enquiry,"[7] the understanding of history as a gathering of information,

5. Herodotus, *The Histories*, trans. Robin Waterfield (Oxford: Oxford University Press, 1998), 3.
6. *The Compact Oxford English Dictionary: The Complete Text Reproduced Micrographically, Second Edition* (Oxford: Oxford University Press, 2002), 771.
7. Raymond Williams, *Keywords. A Vocabulary of Culture and Society* (London: Flamingo, 1993), 146.

CUAUHTEMOC MEDINA

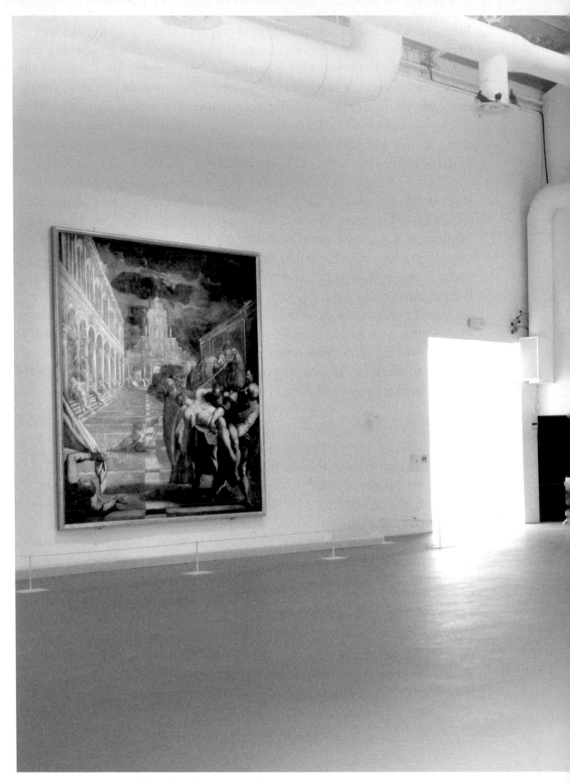

Paintings by Tintoretto installed at the 54th Venice Biennale in 2011.

DRILLING TIME:
HISTORY TUNNELS IN THE BIENNIAL SYSTEM

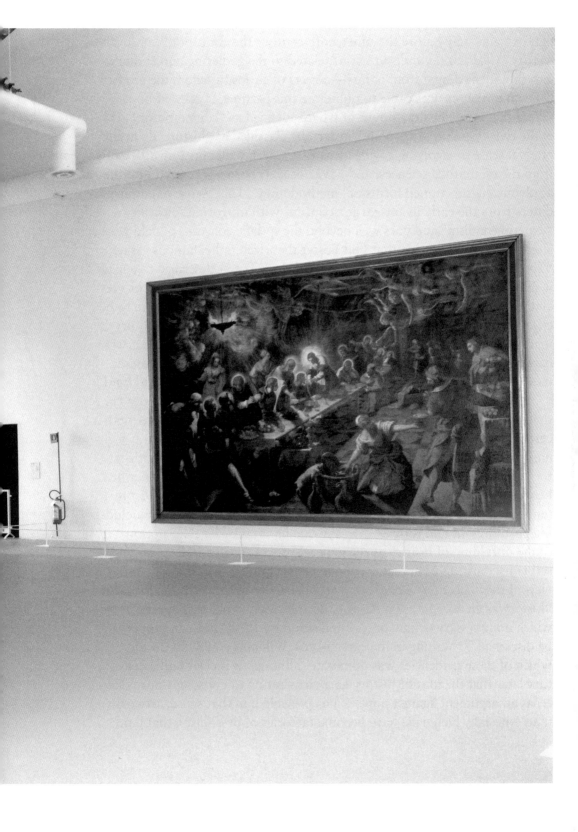

that explains why before the nineteenth century the concept of "natural history" (*historia naturalis* in Latin) related to the gathering and enquiry into specimens drawn from nature—objects of curiosity, before the modern division of the sciences came to obliterate this pastime. It goes without saying that a significant amount of what is defined as "contemporary art" in the twenty-first century could, in fact, be classified as "historical" in this original sense of involving a wide array of researches that operate differently from the established sciences, and have not (yet) been normalized into the academically sanctioned forms of "methodology." This "sense of enquiry" differs from the early avant-garde's concern with mirroring scientific "experimentalism" and goes well beyond the specific concerns of field work, alterity, and self-othering that Hal Foster theorized in his famous essay, "The Artist as Ethnographer."[8] The general drive Foster described to engage in all kinds of investigations of the social, or explore the genealogy of sites and practices, relates to the way that contemporary artists seem again to be engaged in restoring the general spirit of individually concocted enquiry that somehow the historian understood as inherent in a practice that was based, more than in method, on a general sense of curiosity. In that sense, most artworks populating biennials today are historical in spirit and kind.

Nonetheless, a relation to the passing of societies, events, and ideas in time remains inscribed in the modern concepts of "history," together with a certain tension between notions of history-as-process and history-as-a-narrative of contingent events. Raymond Williams has pointed out that the German language had the advantage of making a verbal distinction between the two: "*Historie* refers mainly to the past, while *Geschichte* (and the associated *Geschichtsphilosophie*) can refer to a process including past, present and future."[9] On the one hand, the Hegelian notion of the unfolding of history as the general process of the realization and self-consciousness of humanity, aligned conceptually with the Marxist view of the dialectic as a battle of historical, materialist forces; on the other, "history as an account, or a series of accounts, of actual past events, in which no necessary design, or ... implication for the future, can properly be discerned."[10] Writing in the early 1970s, Williams could not decide which of these tendencies was dominant, although it is clear half a century later that the idea of history as a "frustration of conscious purposes ... as an argument against hope"[11] has prevailed. In that sense, artworks (and especially biennials) have become factories of pessimism, that tend

8. Hal Foster, *The Return of the Real* (Cambridge, MA: The MIT Press, 1997), 171–203.
9. Williams, *Keywords*, 147.
10. Ibid.
11. Ibid.

to immerse us in the condition of history as an accidental (although sometimes entertaining or peculiar) chain of unforeseeable if not tragic events. Rather than being the fulfilment of the dreams of humanity, they tend to illustrate the continuous triumph of the irony of events and the contingency of cultural development. Western historical consciousness slides from Friedrich Schlegel's proud dictum that viewed the historian as "a prophet looking backwards"[12] to Walter Benjamin's "angel of history," who (where we perceive a chain of events) in looking backwards at the past sees "one single catastrophe which keeps piling wreckage upon wreckage and hurls it in front of his feet."[13]

In fact, one of the main considerations visible in historical research projects undertaken as biennial commissions is the production of anti-monuments—artifacts or interventions whose purpose is to disrupt our image of the past, to outline its arbitrariness, absurdity, strangeness, and, frequently, establish a relationship with the history of violence and barbarism. Antoni Muntadas' 2002 intervention in the *Arte Cidade* festival in São Paulo, Brazil, is particularly poignant in this regard: he installed a number of official looking bronze plaques throughout the city that commemorate failed public works and urban disasters perpetrated by Brazilian authorities, such as the long delayed work on the Fura-Fila transportation system. Muntadas described his work both as a remark on the medium of the plaque as "elements that are aimed to celebrate and remember an event or important historical situation," where what he termed, with Swiftean irony, his "modest interventions" commemorated the "urban-political and economic decisions that fundamentally determined the current situation of despondency, destruction, transformation, and loss of identity" burdening several locations of the city.[14]

The Biennial as Historical Machine

More often than one would expect, biennial curators speak as if they are undercover agents hoping to put an end to the evil empire of biennialization. They claim biennials induce a particularly mistaken malaise that tends to produce a counterfeit brand of art ("biennial art"), curated in haste and tending towards a superficial form of consumption by harried

12. Friedrich Schlegel, "Fragment 80 of the Athenaeum," in Friedrich Schlegel, *Fragmentos seguido de Sobre la incomprensibilidad*, annotation and trans. Pere Pajerols (Barcelona: Marbot Ediciones, 2009), 74.
13. Walter Benjamin, "On the Concept of History," in *Selected Writings*, ed. Michael W. Jennings (Cambridge and London: Harvard University Press, 2003), 392.
14. Antoni Muntadas in collaboration with Paula Santoro, "On Translation: Comemoraçoes urbanas," in *Muntadas en Latinoamérica*, ed. Paulina Varas Alarcón (Manizales, CO: Universidad de Caldas, 2009), 141.

cultural tourists alienated from the sense of depth and calm once considered a necessary precondition for properly experiencing art.[15] It is a contradiction that such disparaging arguments are put forward by the very same curators busy with producing biennial events. Beyond that, such arguments tend to overlook the importance that the multiplication of biennials has had in transforming the geographical range and narrative plurality of contemporary culture since 1984, the year the Havana Biennial was incepted, as well as the specific potential biennial exhibitions possess as sites of curatorial and intellectual experimentation.

One particularly interesting aspect of this transformation is the notion that due to their size, their educational value, and (sometimes) the impossibility of subjecting biennials to a single linear argument, they tend to operate, as José Roca once argued, as "a kind of temporary Museum [that] can perform the function of familiarizing the audience of a certain place with the images and discussions of contemporary art."[16] Such a role has been particularly prominent in places like Brazil, where audiences and artists are educated over the long term by the São Paulo Biennial, the country's most important artistic institution. Roca, however, is clear in foregrounding the substantial difference that exists between museums and biennials in terms of their pedagogical value, given the enormous resourcefulness biennials have displayed in terms of challenging our epistemological conventions:

> Based on Art History's orthodoxy, the Museum aspires to truth. A biennial is not grounded on a mountain of facts— it is sheer speculation. Let us not aspire to Truth, only to beautiful half-truths, or to lies that resemble alibis: believable, useful and adorned with a veil of suspicion.[17]

Certainly, biennial exhibitions can be extremely powerful experimental historical machines, that (ab)use the unique power of museums to materialize and spatialize historical narratives, creating instead *dérives* for negotiating the distance between epochs, geographies, and styles. Biennials become all the more seductive in rendering history as a physical experience. "The Enlightenment institution of the museum,"

15. For an example of this kind of complaint, please see the opinions compiled by Jane Morris in: "Is the biennial model busted," *The Art Newspaper*, June 12, 2018. https://www.theartnewspaper.com/feature/is-the-biennial-model-busted (accessed June 9, 2021).
16. José Roca, "Ceci N'est Pas Une Biennale," in *SITAC IX. Teoría y Práctica de la Catastrophe/Theory and Practice of Catastrophe*, ed. Eduardo Abaroa (Mexico City: Patronato de Arte Contemporáneo, 2013), 401–402
17. Ibid.

as Donald Preziosi describes it, "established an historically-inflected or funeous[18] space-time. It thereby served as an epistemological technology: defining, formatting, modelling and 're-presenting' many forms of social behavior by means of their products or relics."[19] In a similar vein, biennial exhibitions can induce a counterfactual alternative to hegemonic narratives, and, in doing so, operate like models of historical fiction, suggesting alternative accounts of modernism's relationship to more distant pasts.

In discussing the strategic use of the exhibition platform as a tool for infiltrating our predominant historical consciousness with alternate narratives, two experiences come to mind. In 2012, I was appointed curator of Manifesta 9, slated to take place in Genk, a town at the center of Limburg, formerly a coal mining district in Belgium. The energy of memory present within the surviving miners and their communities, along with the ambivalence of the local population and elites towards their historical heritage, prompted me to propose a three-part project centered around exploring alternative possibilities for engaging culturally with history. By reducing the contemporary art section of Manifesta to a few dozen artists, the curatorial team was able to create two other sections that explored the modern industrial world's historical roots and economic and ecological basis in the exploitation of fossil fuel resources. The most challenging section, curated together with historian Dawn Ades, consisted in installing a proper museum gallery in the midst of Genk's ruinous former Waterschei colliery. Here we presented the history of European culture and art of the last three centuries, conceived as a product of the coal age. The gallery included sections exploring such issues as the relationship between nineteenth century Impressionism and the aesthetics of air pollution, the types of human bodies produced by mining and coal use, and a display that forged connections between paintings of the carboniferous age and other forms of fossil art-making, including the way the coal industry provided source material for the identification of species via paleontology. These topics set the conceptual stage for the section about how the coal industry's dismantling became a central referent in the "epics of redundancy"—the social and political clashes provoked by the deindustrialization of Europe in the late-twentieth century —through artworks by Jeremy Deller and Igor Grubić, and the poetry of Tony Harrison. In fact, the overall intention of Manifesta 9 was to address

18. Term derived from "Funes the Memorious," Borges' short story about a man that remembers everything he experienced.
19. Donald Preziosi, "Avoiding Museocannibalism," in *XXIV Bienal de São Paulo. Volume 1: Núcleo Históroco: Antropofagia e Histórias de Canibalismos* (São Paulo: Fundaçao Bienal de São Paulo, 1998), 57.

Magdalena Jitrik, *Revolutionary Life*, 2012, installation view Manifesta 9 in Genk, 2012.

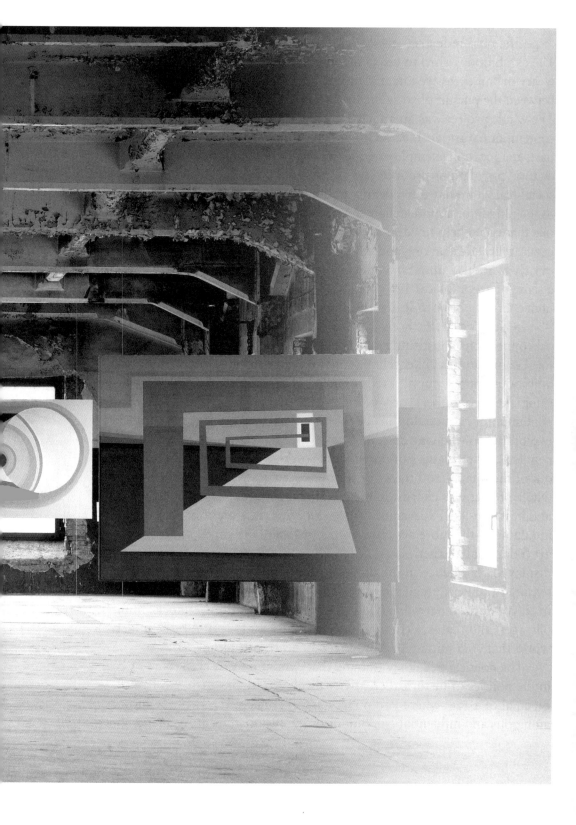

a specific post-industrial, neoliberal malaise: the "fear of nostalgia." The exhibition wished to dispel the frequent distrust of history in a culture weary of "an excessive interaction with memory ... [to] intervene in the gap between the pursuit of social memory and the desire of modernization."[20] The whole project was an attempt to mobilize the power and prestige of the contemporary art world in a Gramscian turn towards the significance of the past, at a location exemplifying the challenges of accommodating the multi-cultural populations produced by industrialization in a new landscape of social fears dominated by identity politics. Our intention was to contribute to the pursuit of a more enlightened and complex contemporary culture, one that could help to "deal with the loss of orientation that the process of geographical decentering and cultural dematerialization have brought to our civilization, without intending in vain to reintroduce identities based on a sense of geographical and social fixity rather than in terms of an informed understanding of historical and social processes."[21]

In Genk's case, the hope was to transmit a deeper sense of the histori-cal connections constitutive of the local experience to art audiences and local communities alike, relating this to the goal of providing a more ambitious context for all kinds of cultural practices—aspiring to some-thing like a cognitive synergy. The intellectual and affective demands of contemporary art could thus be mobilized as part of a wider and deeper exploration of the way culture is developed in relation to the historical conflicts and challenges of the modern world, developing poetical material out of the images and traces of social experience. One key element of the whole project was its trust in the social and cultural agency of exhibitions and museum-like experiences as sites of critical formation. Rather than indulging in the more accepted forms of socially engaged contemporary art (relational aesthetics and community interventions), Manifesta 9 displayed confidence in the disposition of audiences to explore the texture of objects pregnant with history. History was not presented as a fixed, authorized narrative but as a series of excavations, tunnels, funnels, passages, and seams, akin in their complexity and wealth to the under-world that coal mining had produced beneath our feet.

The political pedagogy framing that exhibition was even more radical in the politics of historical creativity displayed by the 24th São Paulo Biennial of 1998, where Paulo Herkenhoff conceived one of the most ambitious and influential exhibitions of the twentieth century. Herkenhoff

20. Cuauhtémoc Medina, "Exhibitions 'Are Material Forces,' Too," in *Manifesta 9: The Deep of the Modern. A Subcyclopaedia* (Milan: Foundation Manifesta–Silvana Editoriale, 2012), 25.
21. Cuauhtémoc Medina, "News from the Graveyard: On the Biennial as a Migratory Centre," in *Manifesta 9: The Deep of the Modern. A Subcyclopaedia* (Milan: Foundation Manifesta–Silvana Editoriale, 2012), 201.

launched an overall challenge to the content and form of the dominant narratives of art history and modernity, based on one of the most important tracts of the Brazilian avant-garde: the 1928 "Manifesto Antropófago" (Anthropophagic Manifesto) by poet and polemicist Oswald de Andrade. Andrade's radical defense of cultural appropriation was a defiant rejection of all pretensions to cultural purity and originality—instead he embraced contamination and exchange. So inspired, Herkenhoff conceived of the biennial as a gigantic operation of historical subversion that would subvert the linear narrative of Western history in favor of a compilation of "histories of cultural cannibalism around the world, and through modernity, in a venue that also discarded walls and divisions as means of administering circulation, hierarchy and narrative order."[22] Invoking Andrade's definition of cultural practice as an incorporation of the culturally and socially alien ("I am only interested in what is not mine"), Herkenhoff invited the world to have a productive, free, creative, devouring relationship with history and culture, bringing together paintings of quartered corpses from Géricault to Pedro Américo, contraposing Van Gogh, Armando Reverón, and Francis Bacon, and rethinking the tradition of the monochrome as the consequence of a form of color cannibalism ("White devours all colors," he claimed[23]). He did this to challenge both the colonial dichotomies of north/south, Old World/ New World, as well as the temporal conventions of modernity. As Lisette Lagnado wrote in 2015:

At the 24th Bienal, the display of museum artifacts itself became a cannibalistic device, eliminating notions of evolution and influence typical of the natural sciences without dispensing with historicizing narratives. On the contrary, the curator assumed such narratives as the exhibition's horizon by writing about 'histories,' 'stories' and 'cannibalisms' in the plural … Herkenhoff proposed a theory of art articulated along three axes—interrogative, dialogic and erotic—while referring to the exhibition as an inventive and poetic interpretation of art, and finding its avowal in the following line from Andrade's 'Manifesto': 'The spirit refuses to conceive the spirit without body.'[24]

22. Paulo Herkenhoff, "General Introduction," in XXIV Bienal de São Paulo. Volume 1: Núcleo Históroco: Antropofagia e Histórias de Canibalismos (São Paulo: Fundação Bienal de São Paulo, 1998), 35–47.
23. Ibid., 200.
24. Lisette Lagnado, "Antropophagy as Cultural Strategy: The 24th Bienal de São Paulo, Exhibition Histories Vol. 4" in Lisette Lagnado and other authors, Cultural Anthropophagy: The 24th Bienal de São Paulo 1998 (London: Afterall Books, 2015), 16.

Certainly, in its purported universalism the omnivorous program of the antropophagic biennial mimics the endless appetite of imperial domination. Rather than hoping to offer a project of decolonization, the 24th São Paulo Biennial offered up a distorted mirror to refract back the utopian project of the universalist museum and the endless digestions of the colonial museum model. Such a strategy, based more on a logic of excess than a pursuit of ethical judgment stemming from an ideology of critique, is key to the logic of the Brazilian avant-garde and the way it challenged the centrality of Western culture. It suggested that for post-colonial cultures, as in Latin America, there is a potential in mobilizing the colonial inheritance against the grain, in pursuit of complexity and empowerment rather than aiming for an unmediated figure of justice. In any case, it would be rather difficult to disentangle the modern-day genre of biennial mega-exhibitions from its colonial roots in nineteenth century world fairs, or the other means early capitalism employed to manufacture forms of global representation. By commenting and stra-tegically mimicking the gargantuan cultural appetite biennials evince in their project to create contemporary forms of world representation, the 24th São Paulo Biennial has provided a lasting point of reference for the unconscious values that biennials still express, even when contempo-rary curators and artists hope to have transcended their original form and intention.

In any case, notwithstanding the powers of imagination that are integral to it, history has always been both art and science, based on negotiating with material evidence, as well as the experience the past leaves as an imprint on our own bodies. Inasmuch as they are material experiences, biennials are thus particularly well suited to staging material moments of historical consciousness, provided we understand that they are not mere accumulations of prestige and sites of symbolic exchange, but spaces where the future of our politics and epistemologies (and, as a consequence, *the future of history*) is also at stake. The fact that exhibitions have—in a different way than books or films—a material basis (involving the experience of artifacts, signs, and places—not only negotiation with words, facts, and images), they are bound to lend a corporeality to our experience of history, one that goes beyond the im-materiality of discourses and its ideological import. This fact in itself— that is, the way biennials deploy any number of critical games to treat history as both raw material and physical experience—ensures that contemporary art and biennials will remain key to the experience and understanding of history in the times to come.

BIENNIALS AS

COLLECTIVE PRACTICE

AND ASYNCHRONOUS

HISTORIO-GRAPHIES

INTERVIEW WITH
NATASHA GINWALA

Lisa Rosendahl (LR):
You have curated and co-curated a number of biennials in different parts of the world: *The Museum of Rhythm* section of the Taipei Biennial (chief curator Anselm Franke [2012]); the 8th Berlin Biennale (curated by Juan Gaitán with Tarek Atoui, Catalina Lozano, Mariana Munguía, Olaf Nicolai, and yourself [2014]); *Polyphonic Worlds: Justice as Medium*, the 8th Contour Biennale in Mechelen (as chief curator [2017]); and, most recently, the 13th Gwangju Biennale, *Minds Rising, Spirits Tuning* (co-directed with Defne Ayas [2021]). In several of these biennials you exhibited historical material alongside contemporary art. Can you say something about why you decided to do that and what you think including historical objects and documents can contribute to the biennial context and format?

Natasha Ginwala (NG):
These have been attempts to interrogate and utilize biennials as instruments, marking an affective cartography and carrying an archival impulse in order to assemble collective historiographies. Put another way: they are efforts to make visible grains of knowing and being that have been denied, buried, or erased. In this way, biennial-making can be a way of instantiating acts of renewal as well as interruption.

Often artistic gestures and historical documents carry a deep correlation. The curatorial mode can act as an artificial force of separation; it can also navigate diagonally through connective thresholds, observing commonality and lived experience.

At Contour Biennale 8 (*Polyphonic Worlds: Justice as Medium*) we conceived of a space called "Evidence Room," which included both archival documents and artistic works that function as an annotated taxonomy of historical encounter, recorded testimony, and a way of interrogating what had previously been discarded as "impermissible evidence." This section interrelates a legal history trajectory—starting with late medieval Mechelen to the proceedings of the International Criminal Court in Den Hague (by Judy Radul)—and from the globality of colonial enterprise (through Cooking Sections' project *The Empire Remains Shop*) to schemes of imperial punishment, made visible by including nineteenth-century sketches outlining forms of punishment and torture in the Congo Free State. This section also featured *J'ai huit ans* (I Am Eight Years Old, 1961), a rare film chronicling the Algerian War of Independence through the recorded experiences of child refugees in Tunisia, realized by the Maurice Audin Committee, a collective consisting of Jann Le Masson and Olga Poliakoff, together with militant filmmaker René Vautier (the film was later credited by the new Algerian government as being "prepared by Frantz Fanon and R. Vautier").

I've recently been thinking a lot about Saidiya Hartman's assertion in *Intimate History, Radical Narrative*: "I have embraced the document, which isn't to suggest any fidelity to the truth or

authority of the document, but simply that I have tried to figure out what I might do with official documents, given the limits, the lies, the omissions, the fabrications." I am interested in how the document becomes the basis for propositional articulations in the ellipsis and ruptures they suggest, as well as the agency they provide to liberated and/or oppressed protagonists, enabling them to recount what the dominant codes utilized in historiography are too frightened to acknowledge.

LR: At the Taipei Biennial 2012, Modern Monsters / Death and Life of Fiction, you used the trope of the historical museum to create an exhibition within an exhibition. Why did you decide to use the idea of the historical museum as a framing device and what did it bring to the curatorial narrative?

NG: First off, it is important to mention that the invitation to envision the museum as a speculative device within the context of a biennial was initiated for Taipei by Anselm Franke. In his words, this biennial "addresses the relationship between historiography and the imaginary. Fiction occupies the blind spot of historiographic and documentary work, as it speaks of the fundamental underside of modernity, its dialectics and paradoxes, as well as the systemic terror that lurks behind modernity's emancipatory promises." Thus, alongside *The Museum of Rhythm* was Chihiro Minato's *The Gourd Museum*, *The Museum of Ante-Memorials* by Eric Baudelaire, and others. Each model was particular in its approach to dismantling the hegemonic epistemologies of modernity by building upon artistic fictions, oral records, elements of material culture, and the logic of vernacular narrative.

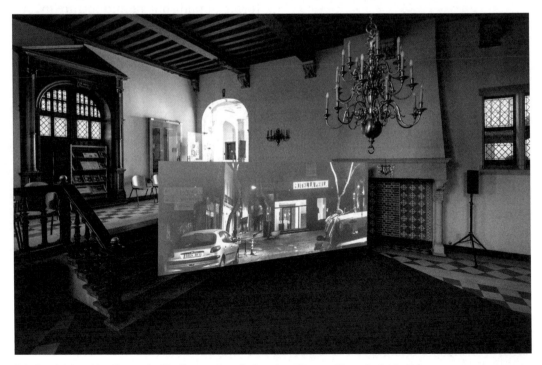

Eric Baudelaire, *Also Known As Jihadi*, 2017, installation view Contour Biennale 8, Mechelen, 2017.

The Museum of Rhythm (2012–ongoing) charted an inclusive, vibratory terrain upon which to challenge structural divisions between organic and mechanistic labor, esoteric vs. rational principles of rhythm, standardized regimes of time-keeping, the politics of the voice, and forensic listening. It illustrated the ways in which rhythm is fundamentally "contagious" and communal, while attempting to put into action Henri Lefebvre's exercises in "rhythmanalysis."[1]

LR: As one of its principle venues, the Berlin Biennale on which you collaborated used an existing historical museum, the Museen Dahlem—Staatliche Museen zu Berlin, which housed an ethnological museum and a museum for Asian art. Can you say something about that process and what the encounter between the museums' permanent collections and the temporary biennial generated in terms of historical narration?

NG: The 8th Berlin Biennale took shape across vectors of the city in a process of transformation, and was partly located, as you mention, at the museum complex in Dahlem that has since relocated to the newly-built Humboldt Forum—a contentious site in many respects. The work I did there over two years, at the invitation of Juan A. Gaitán, has had a lasting impact on my practice, and relationship to Berlin's cultural and political ecologies.

When starting to spend time within the museum, exploring what kinds of images, objects, and stories it had devoted itself to thus far, I realized increasingly that

biographies were missing, along with the idea of the biographical as a knowledge form—the writing of life.

So, I started to research nineteenth century figures—expedition makers, travelers, and administrators—who, through colonial exploits and mercantile expansion from different parts of the world, brought "scientific knowledge" back to Europe. At the same time I was looking at what the museum chose to categorize and display, as well as what remained in storage. That navigation brought me to several other organizations, such as Berlin's technological and natural history museums, the Tropenmuseum in Amsterdam, various cartographic archives, and the Staatsbibliothek zu Berlin, with its amazing collection of rare books. I brought material from all these institutions into the museum in Dahlem as a mode of re-organization, to challenge a hetero-patriarchal imperial narrative composed of multiple erasures. That in itself was an active form, not only of educating but also changing the hierarchy of objects already present for many years at Museen Dahlem within quite stable systems of display.

The project, *Double Lives*, focused on how there were critical incisions being made by certain figures within what is deemed "the Enlightenment" process. I was interested in looking at individuals crossing the lines between art and science, and at that specific moment in history when science was not yet a profession. These figures worked in two ways simultaneously: administratively and imaginatively—bringing us

1. Henri Lefebvre, *Rhythmanalysis: Space, Time and Everyday Life* (London and New York: Continuum, 2004).

a lot of material that was later coded and manufactured as rational information. The time before a division between art and science was clearly established also takes us to the very early history of photographic image-making, and to a particular visual apparatus of the nineteenth century: the stereoscope. This animated mode of viewing "the world as image" allowed for a notional proximity to far-flung geographies; but with the growing desire for knowledge, the systemic violence of Empire remained voracious, too. I was interested particularly in looking at certain moments of Berlin's history using these ambivalent figures and their double consciousness. In the end, the staging of *Double Lives* unfolded like a museological display. But when you looked inside the vitrines, things started to jump out at you that seemed slightly odd; you saw things that didn't belong, that were out of place.

LR: Most recently, at the 13th Gwangju Biennale, that relationship was reversed: you brought objects from The Museum of Shamanism into the biennial venue. Did this create another type of relationship between historical artifact and artwork?

NG: In Gwangju, Defne Ayas and I—in close collaboration with our exhibition team—initiated research visits to The Museum of Shamanism located on the outskirts of Seoul, as well as to the Gahoe Minhwa Museum, an apartment museum in the center of Seoul that focuses on folk painting and popular visual traditions. While engaging with these immense private collections, we were accompanied by artists—both literally and figuratively—resulting in presentations that contextualized their holdings in terms of the broader meaning of their role within Korea today. The artists came up with intriguing

Emin Pasha, Episode 1: Early Life and Ambivalence; Episode 2: The Ornithologists as Governor, exhibition view *Double Lives,* Berlin Biennale 8, 2014.

questions in terms of how these artifacts and relics reflect and challenge histories of militarization, family law, economic liberalization, and generational trauma. Thus, there was a conversational element that was ongoing throughout the process that informed how we brought selections from these collections into the biennial.

We were also invested in engaging not only with aspects of symbolism, or the "pure form" of shamanism, but also its social role: for example, ceremonial practices connected to mourning and renewal, or modes of healing connected to the mountain-river systems of the region. In terms of the exhibition experience, we also had long discussions with Diogo Passarinho, our exhibition architect, around the expanded temporality and communitarian horizon of rituals in Buddhism, Taoism, and animistic belief systems. The nature of intelligence embodied in these ritual-forms and our decision to read them as "techne"—not in a primitive sense but rather as lasting formations of body-mind oriented technology entwined with sovereign models of life and "cosmopolitics" (to reference Yuk Hui)—has been at the core of *Minds Rising, Spirits Tuning*.

LR: Due to the pandemic, I only saw your edition of the Gwangju Biennale from afar, through a digital walk-through. It looked absolutely incredible; a visual feast, bringing together very strong artistic practices from many parts of the world that entangled indigenous life-worlds with new technologies. Biennials have at times been accused of being protagonists in a hypercapitalist regime of visual abundance and representational difference. Your project obviously had very different intentions and concerns, but how did you and Defne navigate such claims curatorially while working on such a global scale?

NG: How might the nuances and operations of "representational difference" bear an agential imperative, keeping intact the traces of communally anchored subjective affinities? Often we remain preoccupied with the external identifiers of the biennial rather than its narrative substance. At the level of methodology, our intention right from the beginning was to scale down and re-orient the Gwangju Biennale model in terms of production attitudes and (anti-)museological display styles rather than simply cater to ingrained expectations of the Asian art economy. *Minds Rising, Spirits Tuning* affirmed continuity between artistic and editorial processes as thought cycles. Artistic practices converged from across the world—from Sápmi, Haiti, Mongolia, Chile, to Aotearoa—to mark indigenous records of world-making, inclusive and rebellious styles of leadership, and anti-systemic forms of kinship. As I mentioned earlier, we were also examining the range of indigenous expression extant across the Korean peninsula, especially given the fact that ethnic purity has been constructed in South Korea as a singular narrative with nationalistic and patriarchal connotations.

LR: Based on your own experience of curating biennials, but also as someone

who has visited many biennials in various parts of the world, what potential do you see in the biennial form—however changeable it might be—as a narrative structure capable of contributing to the production of historical culture and consciousness?

NG: There is a tension in the fact that while biennials are meant to renew fields of sociality—where hospitality operates as an active substance in the global reception of contemporary cultural production—for those involved, biennial contracts already entail a limited engagement with a place and the administrative entity that persists from one edition to the next. In effect, one is playing the role of both host and guest. The question remains how to make this paradoxical position useful, while also responding to collective memory (or a lack thereof). How might biennials address the anxiety and sense of vulnerability induced when audiences encounter provocative leitmotifs and readings of a volatile present?

Biennials—at least over the past decade—involve collective labor by default. Thus, it is most often the case that it is collectivity and polyphonic consciousness which is effectively registered. Moving away from centralizing tendencies toward disparate forms of processual artistic engagement—expanding spatial practices and experiences of locatedness—are ways of sourcing "an otherwise," to use Ariella Aïsha Azoulay's phrase, excavating different potential histories.

LR: Is there a particular biennial that you would like to mention that made an impression on you in the way it related to the representation of history?

NG: To respond differently, I've been reflecting recently on biennials that have been composed and accomplished during the pandemic's uneven timeline. And in this, especially how history and historical becoming have been figurated; a project manifested in endeavors such as *The Stomach and the Port*, the Liverpool Biennial curated by Manuela Moscoso, who emphasized the porosity of history, the deep time of fermentation, and ingestion as an organic pathway into ways of remembering and more-than-human kinship. Raqs Media Collective's Yokohama Triennale 2020, *Afterglow*, charted encounters in "re-apprehending the world" in lines of desire and contagion, radical acts of cleaning, the unbounded time of care-work and toxicity, and what Svetlana Boym calls "the luminosity of friendship." Most recently, the approach of Sonsbeek20→24: *Force Times Distance* addresses the gradients of labor through sonic experience and sensorial environments, using slow transmissions and notations of commemoration so that the unfolding of past injustices can reverberate in the here and now.

What does the body endure when mandatory hotel quarantine is also your jetlagged office capsule? An entirely different but related aspect of this question, that we are just now reckoning with, is what it means to experience biennials as manifestations encountered exclusively through virtual circuits, media profiles, and algorithmically filtered feeds.

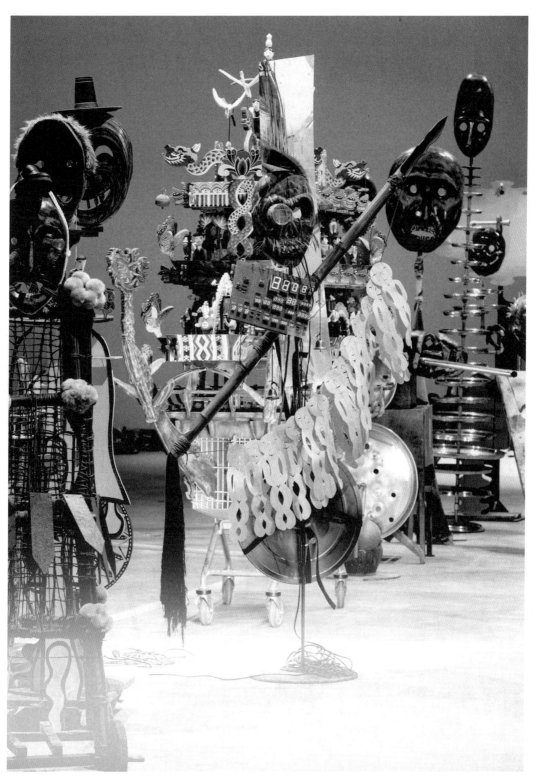

Sangdon Kim, *March*, 2021, exhibition view 13th Gwangju Biennale, 2021.

HOW TO BUILD A LAGOON WITH JUST A BOTTLE OF WINE?

INTERVIEW WITH
OYINDAMOLA FAKEYE &
TOSIN OSHINOWO

Lisa Rosendahl (LR):
The two of you curated the second
Lagos Biennial together with Antawan
I. Byrd, which opened in 2019 with the
title How to Build a Lagoon with Just
a Bottle of Wine? To begin with, can
you say something about the title?

Oyindamola Fakeye (OF):
The title was inspired by lines from
Nigerian writer Akeem Lasisi's poem
"A Song For Lagos." It evokes the wa-
terways on which Lagos was founded
and metaphorically calls up the outsized
ambitions and herculean challenges
of urban transformation. Much of the
work in the exhibition addressed the
history and urban character of Lagos
from the perspective of artists who
either live in the city or have spent
time here for residencies or research
projects, and those who could see the
correlation between a city like Lagos
and the themes they were exploring in
their work.

Tosin Oshinowo (TO):
In recent decades, Lagos has expanded
exponentially through large-scale land
reclamation initiatives, industrial and
luxury development projects, new
transportation infrastructures, and
sprawling housing settlements. This
steady growth has transformed and
amplified the city's distinctive history
as a cosmopolitan hub, an incubator of
cultural and technological innovation.
Yet, such rapid change continues to
raise immense challenges, similar to
those facing cities across the globe,
related to the impact of urbanization

on conceptions of identity and citizen-
ship, affordable housing, the sustain-
ability of natural resources, and socio-
economic equality.

LR: The main venue of the biennial was
Independence House, a 25-story disused
office building erected in the 1960s
by the British government as a symbol
of its support for Nigerian independence.
Today, after having passed through a
series of owners this example of high
modernist architecture is derelict. How
did the history and present state of
that building provide a context for the
biennial?

TO: The venue was chosen by the
curatorial team specifically for the
2019 biennial, it had never been used
before as an art venue.

OF: In a way, the building was an
artwork in and of itself.

TO: We wanted a venue in old Lagos,
situated in the heart of the city. Lagos is
expanding very rapidly—there are new
parts of the city shooting up every day—
and they don't have the same character as
the old center. The historical center also
happens to be quite cultural, a lot of art-
ists are living there—you have Freedom
Park down the road, many creative
design practices, and so on. The building
is also close to the marina, where British
colonizers first arrived in 1861 (Lagos
was the first place the British set up as a
colony in what would become Nigeria).
So, there is a lot happening within a one-
kilometer radius of Independence House.

The history of the building was also important to us. Independence House was commissioned and gifted to Nigeria by the British government in 1959 to commemorate Nigeria's impending independence from colonial rule in 1960. At the time of its completion in 1963, the building was among the tallest in Nigeria, and so came to symbolize the country's modernity and sovereign ambitions. Throughout its history, it housed corporations and government offices. After the coup in 1985, it was used by the Babangida military government (1985–1993) and became the headquarters of the Ministry of Defense. It was partially destroyed in a fire in 1993. Since then it has largely been abandoned.

The original building was beautifully designed. It is a modernist office building using tropical architecture principles, like cross ventilation and shaded fenestration. After it burned, it was completely stripped out. When we first came to visit, there were people squatting it. It is also frequently used as a location for music videos—it has an amazing 360 degree view over the whole city. It is still a federal government asset, but no one has decided what to do with it.

LR: What did the building mean to you, encountering it in its contemporary state?

TO: In the city of Lagos, everything this building stands for is connected to the expectation of independence, to the idea of so much promise. If you think about the forward-looking optimism of the time of independence as expressed

Exterior view of Independence House, Lagos.

in the original architecture, and you look at what we have achieved, we fell short of those expectations. It is this irony that makes it so powerful. And that is why, for me, it was a very fitting location. The question for us was how to repurpose the space from a failed monument of independence to a contemporary symbol of success.

OF: When we came into the space with the title *How to Build a Lagoon with Just a Bottle of Wine?*, we thought about the building as a metaphor for Lagos (a lagoon). We asked ourselves: Can we reimagine this city? Can we build the biennial where we are now? Our collective answer was "Yes!"

TO: The irony was that nobody knew where Independence House was! It's a 25-story building, but because it is not functioning, people don't see it. And people forget to look up.

OF: The building was hiding in plain sight.

LR: Things that we decide *not* to look at are often connected to suppressed histories or to suppressing certain aspects of the present.

TO: Exactly. And that's the point. I wanted people to realize the importance of where we are and why we are not where we should be. It is very easy to be a hamster in a wheel, to go to work every day and not think much about it. What else should influence the decisions we make every day? Progress does not only mean hyperinflation and building, building, building. Maybe we need to pause and reconsider our purpose, as a city and as individuals. People drive past this building every day and nobody remembers it's there.

OF: Once people entered the building, they could also see the city from a new perspective. Standing in the space, looking out over Lagos, it makes you feel hopeful: you actually feel optimistic. I felt that I could sense the optimism dating from when the building was built. There were loads of young kids running around the building during the biennial and we would let them go up just to see the city from a different perspective. That was very rewarding to see, it is why I do what I do.

LR: How did you work architecturally with the building to prepare it for the biennial exhibition? Looking at the documentation, it seems you have done some very careful renovations and insertions of new walls and colors while still keeping the derelict state of the building visible.

OF: When we entered the building there was a lot of graffiti. And this was a curatorial discussion that went back and forth, because I really didn't want to lose the graffiti. In most cities graffiti is illegal but it's still everywhere. In Lagos, however, it's very rare to see graffiti.

Because we wanted to honor the needs of our artists, we decided that if an artist really needed a blank wall to

work with we would paint that wall, but if we felt it would not take away from the work, we would leave the space as it was. And in all the liminal spaces, the stairs and hallways, the graffiti was left as is, as part of an ode to what was there and to the space itself.

LR: There were also some existing artworks in the building that had been commissioned around the time it was first built. Did they play a role in the biennial?

OF: We noticed the building had some pre-existing artworks, and upon further investigation discovered these were original artworks by pioneering Nigerian artists. On the side of the building there are bas-relief sculptures by Felix Idubor (1928–1991) and the first-ever mosaic to have been designed by Yusuf Grillo (1934–2021) traced the now empty elevator shafts.

We decided to use the opportunity to showcase the mosaic work by creating a social and performance space for conversation and live events, drawing visitors to a different section of the building they might not have seen had they gone directly in to the exhibition via the side entrance. We also started or ended guided tours in front of the work to honor the masters who couldn't have anticipated that their work would feature in a contemporary art biennial in 2019.

LR: The biennial included work by 44 contemporary artists, from Nigeria as well as other parts of the world. How did the biennial artists respond to the building?

OF: One artist that responded directly to the building was Ndidi Dike. As we mentioned, Independence House was originally an office building and was taken over by the military during the coup. After it had been set ablaze, there were still all these confidential government files stored there. The original files could not be touched— the government asked us to block off the area where they were kept. But Ndidi bought other cardboard files and old documents from second hand bookshops around Lagos, some of which were from the early 1980s. She created a scaled-down urban landscape with these files and documents. The work was called *A History of a City in a Box*, and it addressed power dynamics created by access to information.

TO: A thing that came about quite unexpectedly—through the artists that responded to the open call that was made before we even had the building in mind—was the shared history between the United Kingdom and Nigeria, which also resonates with the history of Independence House. There were certain nuances of the building that were connected to this theme, and many of the artists could situate themselves within that context. One example was Tolu Coker and Ade Coker, UK-based Nigerian diaspora artists who together produced a video as a visual research into their family history, but also as a wider investigation into

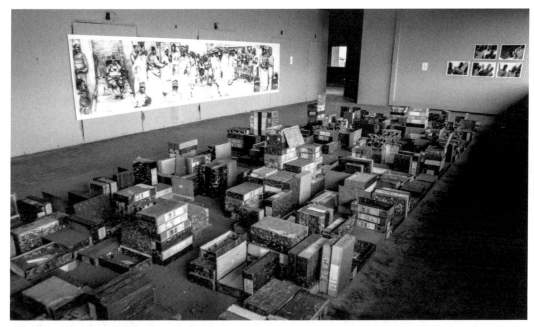

Installation view from the 2019 Lagos Biennial: Ndidi Dike, *A History of a City in a Box*; Uthman Wahaab, *Back with Me Again*; Ezemezue Nneka, *The Vendors (Lagos)*. All works 2019.

"cultural confusion" and the balance between "the land of your father being your own land" and "the land you now reside in being your own." Diasporic identity swings between the cultural and the environmental role within the issue of belonging.

OF: That is actually something I can relate to personally, as I grew up in the UK and moved to Nigeria at the age of 25. I still feel very British, but also very Nigerian. I guess Independence House has its own duality, having been built by the British as a gift to Nigeria—representing political independence yet still remaining a static structure.

LR: You have talked elsewhere about Lagos featuring in the biennial both as a case-study and a vehicle for addressing similar concerns in different parts of the world?

OF: Because Lagos is in Africa, you might think that the biennial would only be concerned with issues pertaining to this continent, but there are many different nations on other continents going through similar things. We are dealing with climate change, for instance. Global warming. As we wanted it to be an international biennial, we needed it to be able to reflect some of these shared global challenges.

TO: I am very interested as an architect in urbanism, history, and city occupation, so my choice of artists reflected that. For example, Karl Ohiri's work focused on how disabled people navigate Lagos. They move around on re-appropriated skateboards; by placing a camera on

them, the artist could capture footage from the vantage of how the disabled commuter experiences the city. What became clear in this work is that Lagos' urban evolution has not accommodated them, but through appropriation and resilience they have made it work for them. So, I am very mindful of this project because urbanism has to be inclusive.

LR: Do you think the 2019 edition of the biennial offered a different way to understand Lagos and the relationship extant in the city between the past and present? I am thinking here about your context-specific choice of venue and the historical significance of Independence House, in combination with the work of the local, international, and diaspora artists exhibited there. Did you feel that the form of the biennial could contribute something different to historical consciousness than, say, the narratives put forward by existing historical institutions or in the mass media?

OF: I believe that the 2019 biennial took place at a *kairos* moment, an important time in the history of contemporary art. Many things came together to make the event a reality and the convergence of the various artists, collectors, curators, and events delivered a shot to the heart of the various stakeholders. I heard it and I sensed it; something had changed. The lid had been taken off, the glass ceiling broken. We told the art world that contemporary art had a home in the Global South, in Nigeria, and more specifically in Lagos. In terms of history and in terms of remembrance, I have no doubt that the 2019 biennial left a lasting impact on the city and on the lives of the people whose paths crossed the experience, having long left the exhibition but somehow still wondering "How to Build a Lagoon with Just a Bottle of Wine."

BIENNIALS OF RESISTANCE AND CARE

INTERVIEW WITH JOANNA WARSZA

Lisa Rosendahl (LR):
You have worked on several biennials and large-scale periodic exhibitions over the last few years. I'm interested in your view on how these projects engaged with historical narration in different ways. *Forget Fear*, the 7th Berlin Biennale (2012, where you were an associate curator to Artur Żmijewski), was not framed curatorially as a project dealing with the past. Rather, the focus was on the contemporary political moment and the possibility of social transformation. But several of the works dealt with history, evoking certain layers of the past that had shaped the present. For example, the work *Peace Wall* (2012) by Nadja Prlja. Can you say something about that project, and more generally about how you saw the role of historical consciousness within that edition of the Berlin Biennale?

Joanna Warsza (JW):
At the 7th Berlin Biennale where I "served" as an associate curator, we were mostly preoccupied with what was, at the time, the NOW: the emergence of the Occupy Movements and the Arab Spring, the role of artists in those events, and the relationship between art and activism. Our curatorial methodology was to "follow the news," not the artworld calendar of fairs or mega-exhibitions. We would open the newspapers and go to places of turmoil and political resistance to support/look and discuss the role of artists there, their engagement as citizens, and the place of artistic/political imagination. It was clear that if as a doctor you find yourself at Tahrir square, you will immediately contribute if your help is needed. But what if you are an artist? How will you employ your tools? Does it matter and how? How can activism and art empower, rather than disempower, each other? With those questions in mind, we traveled, interviewing the artists amidst the uprisings, be it in Tunisia, New York, Cairo, Bogota, or Amsterdam. 2011 was an eventful year, and our common research experience was pretty incredible and perhaps the strongest part of this biennial. The texts resulting from those conversations are to be found in the *Forget Fear* reader.

On the other hand, one of our central threads was indeed the politics of memory, memorial culture, and the concept of shared history, especially between Poland and Germany. We realized a number of projects dealing with the gaps, omissions, and counter-narrations, with monuments and state art, but also—something unsurprising considering Żmijewski's practice—the violence of representation and the Eastern European obsession with history, without the will to examine it critically. This last point led to the invitation of a Polish re-enactment group to "restage" the 1945 Battle of Berlin, which is a sort of popular and dangerous historical entertainment in the streets of small Polish towns. But in Germany nobody understood why we did this. History is not something that could be performed here, and especially not WWII. Żmijewski very stubbornly insisted that it should happen, despite huge resistance, also in the team.

For me, personally, one of the most memorable projects was a call initiated by Roma activist and curator Timea Junghaus to complete an unfinished memorial to Roma and Sinti victims of the Holocaust, back then an open wound in the middle of Berlin. The partially completed memorial site was then sitting abandoned between the Reichstag and Brandenburger Tor, with all the invisibility and under-representation of Roma and Sinti palpable in the dereliction of this uncompleted endeavor. And the call, next to many other actions by activists, was actually heard. It contributed to building up a momentum, resulting in the memorial eventually coming to fruition the following year!

Nada Prlja's *Peace Wall* that you asked about was also a very charged endeavor. The Macedonian artist erected a wall in the middle of Friedrichstrasse—a backbone of the city—almost without consulting the authorities and overnight, just like the one in 1961. Prlja's project was intended to delineate a mental and tangible divide locatable in the very recent history of East and West Berlin, and in Germany as well; to deal with a memory that was perhaps too fresh, too close to be remembered and unpacked. Now looking back at the project, and also Żmijewski's wish not to employ any mediation connected with it, I have a feeling that enough time has to pass for certain issues to come to light. The wall did provoke discussion, but more about the gentrification and commercialization of the adjacent public space rather than about

what is in the air now, ten years later: namely the question if reunification was a fair and symmetrical process or, rather, an annexation of sorts?

Perhaps my biggest learning experience from that edition of the Berlin Biennale and my work with Żmijewski (who is first and foremost a radical artist) is that as an artist dealing with the politics of memory you can be shocking, you can be violent or provocative, but you can't be that as a curator. You have the responsibilities of sublimation, transformation, or shaping narration. Curating can be everything—a smell, a walk, an exhibition—but it cannot be stripped from your relationship with others and the responsibility around it, which was often the case in our biennial. So, I do believe art is a powerful agent in memory culture and can operate on historical consciousness, but only when treated with care, fragility, integrity, and kindness.

LR: You have used the term "context-responsive" when talking about your curatorial practice. What role has situatedness and context-specificity played in projects like the public program you curated for Manifesta 10 in St. Petersburg (2014), Public Art Munich (2016–18) and, more recently, the Autostrada Biennale in Kosovo (2021)?

JW: You have used, Lisa, in describing your curation of the Gothenburg biennial, the notion of "speaking from." Situated, context-responsive art is an art that speaks *from* rather than *about*. The

term situatedness is, of course, based on Donna Haraway's notion of "situated knowledges," which claims that the perception of any situation is always a matter of an embodied, located subject as well as a geographical, political, ideological perspective that is constantly restructured by circumstance. Yes, it is one of the overused terms of our times, and yet it's only now that we start to understand its implications—also in art. It is only now that many curators ask how they can give place to art based on migrant-situated knowledge, women-situated knowledge, queer-situated knowledge, and other forms of engaged experience. However, I don't think we should fall into an essentialist dogmatism. It is important to borrow and "border," as Achille Mbembe says, each other's stories, stand for each other, and be neighbors. And curation as a midwife activity is concerned with amplifying, sublimating, exteriorizing, counter-narrating, negotiating, dialoguing, but also having the intuition for timing, space, and form… bridging the divide between where you speak from and other positions; which bridges you build and how.

During preparations for Manifesta 10 in St. Petersburg back in 2014, where I was the head of the public program across the city, the annexation of Crimea took place. The main question that fell upon us was: do we engage or do we disengage?; where do we stand? We decided to continue, but not to continue undisturbed: to take this political situation into account, speaking from an Eastern European perspective. It is a lens very much informed by historical relations with Russia as a colonizing force, but also as a zone of cultural influence. The strategy of responsiveness to the political events being the only way to go shaped the incredible projects of Deimantas Narkevičius, with his choir of Cossacks singing "Sad Songs of War," with Slavs and Tatars problematizing Soviet Orientalism, with a powerful film by Kristina Norman overlapping the Maidan square in Kiev with Palace Square in St. Petersburg, and many others. You can say it was only art, but it was so powerful as a form of life and orientation in those messy times. The works stood as a soft, complex, metaphorical, poetic, and political form of engagement, creating spaces for discontent and intellectual disobedience. We could either leave OR engage with the context full-on from a situated perspective. I still believe we made the right choice.

At Public Art Munich 2018 (in a city full of self-satisfaction), the guiding questions were the notion of performative democracy (after Elżbieta Matynia), the mechanisms leading to ideological changes, the questions of publicness and politics, as well as art lived in minutes rather than square meters. The pivotal moments in the history of Munich—from the funding of the Soviet Bavarian Republic, through the optimism of the Olympic games in 1972, to the welcoming of refugees at the train station in 2015—became the material for artists to work on the balance between short-lived performative occurrences and their long-lasting consequences.

Summing up many experiences from various public art projects, I have a feeling that as a curator you are always negotiating your relationship between being a guest and a host. First you need to listen, to behave, to respect, then you start to hear and see incredible stories, and—in the optimistic scenario —are then allowed to interfere in the spheres of the host, the house, the neighborhood, the plurality of worlds.

LR: You often work with artists in public space, installing works or staging performances and actions in buildings and sites of historical significance. At the Autostrada Biennale, which you co-curated with Övül Ö. Durmuşoğlu under the title What If a Journey…, you for example worked with the Palace of Youth and Sports, and the National Library of Kosovo. What is it that interests you about the meeting between the material and architectural traces of the past and contemporary art works? How do they affect each other?

JW: One of the starting metaphors for our collaboration with Övül Ö. Durmuşoğlu in Kosovo was an image of a half-built house. You see so many of them in a country where the diaspora is bigger than the number of local inhabitants. The houses are constructed over many years, and very often left unfinished. We saw those half-built edifices not necessarily as signs of failure but as an invitation for a necessary reciprocity, a critical search for incompleteness, tangible architectonic places where intimacy

and infrastructure meet. And so the whole exhibition went in the direction of making a narration about ruptures, unfinished plans, erased histories, sudden arrivals and delayed departures, and a relationship between how we build infrastructure and the infrastructure that builds us. It was also, finally, a take on a phrase of Fred Moten and Stefano Harney, the title of their last book together, *All Incomplete*, where the philosophers speak about refusing completion as a strategy for fugitive, queer, and undisciplinary thinking.

The two buildings you are asking about are special carriers of history—the first being a sign of the suppressed Yugoslav past, and the second a metabolic organism meant to grow forever, a beautiful cultural negotiation between the endless cubes of the Orthodox tradition and the domes of Ottoman hammams. Buildings are like open archives: you can relate and grow into them and with them. It is true that for many years, especially in the post-Soviet and post-communist context, I was drawn to the theme of entropy and questions about how the present grows on the ruins of a failed socialist past. But today I am more interested in an intersectional experience of architecture and the public sphere. How do you experience such a place as a woman, as a Roma, as a child— basically as everyone who is not a cis man. Art is a powerful language to mediate such vulnerable lived experiences in a poetic and political way.

LR: For the 7th edition of GIBCA in 2013 (co-curated alongside Katerina Gregos, Claire Tancons, and Ragnar Kjartansson & Andjeas Ejiksson), you worked with the artist Núria Güell. Her project from Sweden was re-visited again this year in Kosovo as part of *What If a Journey...* . Did the meaning and understanding of the work change as it moved from the context of Gothenburg in 2013 to Kosovo in 2021?

JW: In 2013, Núria Güell staged a hide-and-seek game in the harbor of Gothenburg with an asylum seeker from Kosovo, a former policewoman named "Maria" who was then in the process of applying, for the third time, for permission to stay in Sweden. A contract was issued by the Gothenburg biennial in Swedish and Albanian—the mother tongue of Maria and Edi Muka (back then GIBCA's artistic director). The employment contract with GIBCA was made in consultation with activists and was helpful in enabling her to procure a residence permit. In the hide-and-seek game staged during the exhibition, Maria was always the one hiding, while visitors were always the ones searching. The invitation to play was meant to open up an in-depth dialogue about migration policy, political asylum, integration, and displacement, turning the game into a conversation piece.

When we started to work in Kosovo, the memory of that project came back to me,

Núria Güell, *Too Much Melanin*, 2013, 7th Göteborg International Biennial for Contemporary Art, 2013.

since Kosovo is the other end of its road, being the native country of Maria—in reality Lumnije Gërguri Stojkaj. Güell and Gërguri Stojkaj met again in Kosovo and took a short vacation in Prizren, walking, visiting, and talking after a space of eight years. Questions arose: What is the relationship between an artist and their collaborator? How to see and work with unequal relations in collaborative projects, especially around migration issues? What are some ethical ways of addressing power asymmetries in art? How does Gërguri Stojkaj see art as part of her journey to Sweden, where she now works as a prison guard? On their vacation, captured in a new film by Güell, instead of hide-and-seek both women talked about homeland, exile, ethnicity, war, cultural identity, and how one's life gets shaped as a stranger everywhere. And so many more asymmetries came to light between 2013 and 2021. In some sense, Gërguri Stojkaj's revisiting her past in her native country enabled us to complete the narration, making the project more complex but also revealing the blindspots that existed from the beginning—how artists need to deal with migration histories and their consequences, and how art and activism can symbiotically coexist.

LR: The curatorial text for *What If a Journey...* mentions collective memory and art as a form of recovery. This suggests to me a belief in art's ability to activate different relationships to historical processes than possible with academic historiography. Would you agree?

JW: Of course, art is a language telling other tales of our times. A language that recontextualizes, suspends, and reverses what one takes for granted. For years Kader Attia has been using the term "repair" for his overall practice. We have used the term of recovery, be it in post-war Kosovo or in *Die Balkone,* an exhibition staged in windows and balconies throughout Berlin's Prenzlauerberg district, which Övül and I inaugurated at the beginning of the Covid-19 pandemic. When the whole artworld was going digital and so many of us felt lost, we proposed an artistic analogue experience, sending signals to each other in real space. This exhibition made clear that art may not save lives, but it can nurture them with a grain of meaning, situate us ontologically, and help us recover, survive, and create communities. Since then, as a curatorial duo, we have continued *Die Balkone* as a cyclical event, maintaining our co-curation around these guiding questions: How can public art become a form of social semaphore? How can it evoke, play with, and confront what is hidden, suppressed, or untold? In which way can it be a form of recovery?

LR: I'm curious to hear your thoughts about the medium of the biennial as a narrative tool: for example, regarding its temporary and often dispersed form.

JW: I love your metaphor using Ursula K. Le Guin's collecting bag that holds many things in no particular order. We desperately need more exhibition

narrations that are not dry, concept-driven curatorial statements, and I guess you are one of those paving the way. My first serious experimentation with narration was, in fact, at GIBCA in 2013. The idea was to build an exhibition as a piece of Nordic noir, a show delegated to literature against the backdrop of so-called Scandinavian consensus culture (it's almost as if Scandinavians need fictional horror as a way of living politics, which are otherwise too calm). Anyway, I managed to persuade one of Sweden's top-selling authors, Åke Edwardson, to translate the exhibition into a short crime story. Put in words, the pieces of many artists—including Forensic Architecture, Mapa Teatro, Tania Bruguera, Marion von Osten, Maja Hammarén, Sunshine Socialist Cinema, and others—were gathered together in a completely different way than a curator would do it. And, of course, they reached a much larger audience by being printed in the daily newspaper *Göteborgs-Posten* and penned by Edwardson. One of the starting points for this exercise was also Adorno's quote: "Every piece of art is an un-committed crime." But there is another layer of narration that art can bring to light, carried by objects—something I learned from the artist Janek Simon. Take, for example, an iPhone. Think of the raw materials it contains and the itinerary these made from the Global South to the Global North; think of their travel to China, think of other substances needed that are contained in this machine. And then think about the fact that many of these electronic devices, once disused, end up in the huge markets of Africa. So, how could an object—be it an art object or an everyday item—open up the narration about its own provenance, circulation, labor, asymmetries, consumption, and disfunction? It is all there, but one need to look closer, and art provides a lens.

LR: The idea of the contemporary art biennial has a particular history and comes with certain expectations. The first art biennials were related to the idea of world expositions and an imperial desire to represent the whole world within one framework. In the 1990s, the format became associated with the arrival of neoliberal global culture. Is that something you have reflected about while working with the biennial format?

JW: There are approximately 300 biennials in the world. One could, theoretically, attend an opening every week. But there are biennials and biennials. Examples from the second category are more worth looking at, and are called by political scientist Oliver Marchart "biennials of resistance." Throughout the last 40 years of the proliferation of perennial platforms, the "biennials of resistance" were created mostly in the Global South—such as the early Havana Biennial, Johannesburg after the end of apartheid, or in Gwangju after the democratic uprising in South Korea. Some of them aimed to de-Westernize the art canon, create another cartography, shake-up

legitimized institutional art, decentralize the Global North, take risks, and create counter-hegemonic models—including, of course, the politics of history. So, yes, many biennials are part of the neoliberal agenda, but many are not, or at least do a little more than that—educating, teaching critical thinking—and we need to cultivate those. For biennial makers such as you and I, it is important to defend the format against its takeover by the market-oriented ideology in a versatile, delinked, decentered, political, and poetic manner.

LR: What would you wish for the future development of biennials? How might the form be developed to reflect the needs and desires of our current moment?

JW: I would generally wish from art that it does what it preaches. When it says "decolonization," "horizontality," "forms of care," that it means it. Recently, I also realized one more thing. In our days, the problematic ontology of museums is the thing you cannot not address when you are working there. We are entering an era where museums are a problem, a ballast, machines that need rethinking, and rightfully so. But if you want to engage in some other topics, the biennial is a good exit plan for other tales.

Núria Güell and Lumnije Gërguri Stojkaj, *My Vacations with Lume*, 2021, 3rd Autostrada Biennale, Kosovo, 2021.

Hi.
It's me.
(Pause)
Do you hear?
(Pause)
Do you know me?
(Pause)
Maybe it'll come later. Regardless, I'm already here.
(Pause)
I'm here now.
(Pause)
They didn't ask me if I wanted to come here.
They just said we were headed to yet another city by the ocean.

With a lot of little houses. And quite a few big ones.
With sugar in them.
Sugar and flags.
(Pause)
You weren't here then.
Do you remember?
(Pause)
I could've needed you.
But I'm glad you're here now.
Grateful is an overstatement.
But relieved.
Anyway.
(Pause)

I came here in 1939.
I came here in 1878.
I came here in 1986.
They said I'd be safe here.
But they lied.
(Pause)

We met at the corner of Södra Hamngatan and Stora Badhusgatan.
We met at the corner of Kungsgatan and Surbrunnsgatan.
We looked down when we passed Magasinsgatan.
We looked up at the monument without end.
(Pause)
1939 we met exactly here.
Here below the Eriksberg crane.
We looked around.
We looked out across the ocean.
We looked around.
We looked out across the ocean.
There below the Eriksberg crane.
You took my hand and tried to say a few comforting words.
(Pause)
You knew that they (whispers) the Swedes wouldn't let me stay here.
We were sent away.
And sent on.
1989
1939

Now we're all here. Again.
We are here again.

Salem Yohannes

My name is Salem and I'm born and raised in Angered. Am a Gothenburger through and through and right now I'm standing at Kungsportsplatsen looking up at Avenyn and thinking of the spring of 2018. I had a side job as a salesperson in a shop pretty far up on Avenyn…a clothing store, it's not there anymore but it was Tommy Hilfiger. And I worked every other weekend and was… We weren't… We were maybe four, five employees there of whom I was, back then, the only one who wasn't white and, in this case, also Black. And it was during a time when the Nordic Resistance Movement pretty regularly kind of just walked around and…didn't exactly march, but there were three or four of them with flags and whatever else it was they'd carry around. And I remember a time when I sort of saw the flag in the distance, but from inside the store, and immediately felt, like, "Whoa, now it's so close that I can see and feel their presence while I'm at work but also physically very close." So I guess I was staring a bit too long and it's like…they're on the other side of the street, but… And then I see how one of them turns around and looks over…across the street to where I'm looking in the window. Then a little bit later that day they switched sides and came over to the side where my store was, so at one point I turn to my colleague and say, "It's unpleasant that they're standing right outside the store and I don't know if you noticed but I made eye contact with one of them a bunch of times and I think this is really hard." Whereupon my colleague, who is…well, white majority Swedish, says, "Oh, yes, this is so unpleasant and I'm so afraid and, like, I don't want to be in here working if they're going to be standing right outside." Eeehhh…And of course I totally sympathize with her in this case, while at the same time I'm also provoked and irritated that…the eye contact was primarily with me and I interpreted it as a sign, and I reply and say, "Yeah, it sucks…but if shit goes down I'm the one they're after, not you."

I know that I told my parents and they were like, "No, but it…no, but they won't…don't worry, it was just, like, a coincidence that they were there then… Like, don't worry." And then I explained that they were there several times, or several weekends, and THEN I know my parents immediately were, like, "But, like, we don't think you should work there, you can find some other side job, it's just not worth it" … Because then suddenly they understood that it was something bigger and that it might also be dangerous.

Eeehhh…Like, I would never want to play down who I am and my entire identity in any way, but it's still another vulnerability in that every cell of my body is political. My Blackness can't be hidden that way, and maybe that's why I can't pass the way I sometimes would need to. And that's probably what my parents mean where they're like…never mind that job, we'll figure something else out. And that was probably when I realized, whoa, that's where we're at now. That now my parents are starting to understand that, "not even in our day, when we first got to Sweden, was it this bad". Now we fear for our children and I can't protect my daughter when she's, you know, selling jeans on a Saturday afternoon. Something that, like, should be considered so basic, you know.

Excerpts from the script for *Brunbältet**—a soundwork by
HAMN (Nasim Aghili & Malin Holgersson), presented as part of
The Ghost Ship and the Sea Change, the eleventh edition of
Göteborg International Biennial for Contemporary Art, in 2021.

* This expression literally translates as "The Brown Belt" and refers to an area along the West Coast of
Sweden where Nazi- and neo-Nazi ideology has been present since the beginning of the twentieth century.

ARIELLA AÏSHA AZOULAY

EXCERPTS FROM

POTENTIAL HISTORY:

UNLEARNING IMPERIALISM

Installation view from the exhibition *The Natural History of Rape*, 2016, Pembroke Hall, Brown University, curated by Ariella Aisha Azoulay.

Not the Past, but the Commons

One of the challenges of this chapter is to question the identification of the archive with the past and the archive's declared role as the past's guardian. The archive lends the past a palpability that makes probing it all the more difficult. How can we question what is reaffirmed through the dates on the documents, the type of paper, the ink, their order, the signs of aging, the crumbling paper in the researcher's hands, the smell of old glue, the carts of boxes and files, the way they are indexed? Because it can be touched, it feels true; but this is part of the archive's ontology.

And if there was no past? And if the past was the invention of the imperial archive? And if the keepers at its gate are guarding something else? That none of these questions are pertinent to the study of the archive testifies to how very difficult it is to study its ontology. Imperial agents' annihilation of political species and modes of life, and the confinement of their acts of deportation and incarceration to a delineated space called "the past," were all necessary in order for the imperial enterprise to materialize as a condition of political life. The archive makes the condition palpable. It is a graveyard of political life that insists that time is a linear temporality: again, an imperial tautology.

Though we know very little about how many species of political forma-
tion had to be annihilated when the archival regime was substituted for
them, we must assume their existence in order to perceive imperialism as
reversible. Regardless of the proper or general names such species had
or were given later, or the names that were erased with the annihilated
species, before the half-millennia of imperialism people shared worlds
under singular forms of organization, rule, nomenclature, ceremony,
objects, and temporal and spatial configuration. The body politic of
which they were a part gave shape to the political regimes under which
they lived. Studying the history of imperial destruction from what is in
the documents preserved in archives aids in keeping the destruction of
diverse and incompatible political formations and forms repressed and
unnoticed. What do we know, for example, about the political formations
of the destroyed communities in the Indies described by Bartolomé de
Las Casas beyond the detailed cruelty of the Spanish against them, and
the characteristics given to them by their conquerors ("the least able to
withstand hard labor," "those who possess the fewest temporal goods,"
"never ambitious," "never covetous")?[1] After all, the 10 or 12 million
people who were slaughtered had their own different patterns of political
behavior, regularity, and formation. Curiously, these complex political
species did not pique interest as competing political modalities that could
be explored. These other formations are assumed to be either nonexistent
or necessarily obsolete to "modern politics."

Rather than reading the little that is present in the archive about those
"extinct" political species—often buried in records of the creation of the
new, in documents of what was once and is no longer—only as proof of
their destruction, potential history reads records of destruction as proof
of persistence and the right to survive.

This identification of the archive with the past dooms what is in it to a set
of abstract and neutral laws, regulations, and practices, and thereby outlaws
all other sets of laws, regulations, or practices that were in use. Whoever
resisted being properly archivable along a linear time line, and under
established categories, became a violator of the already accomplished past
and, thus, the present. The violence involved in the imposition of imperial
power is rendered past and, hence, nonnegotiable. If there is any sense
in working with the common definition of the archive as a composite of
"putting away" and "sheltering," it is not as a predicate of how the archive
works by itself but rather of how the imperial gesture is performed.

1. Bartolomé de Las Casas, *An Account, Much Abbreviated, of the Destruction of the Indies—
 With Related Texts* (Indianapolis: Hackett, 2003), 5.

Historians, as experts of the past, came later, and were grounded in the institution only after archival practices had distributed political roles and wealth. They were interpellated to account for political life as it was already mediated through the regime of the archive. Unsurprisingly, for a long time historians were unable to integrate "people's history" into their narratives, and in order to do so they had to break with what their profession helped to fortify—the imperial phenomenal field. History as a profession was based on reading outrageous accounts of human trafficking or fatal enslavement as chronicles of past times, and on shaping national and imperial narratives in dialogue with their predecessors in such a way that the same nomenclature of disavowal was used time and time again, thus continuing to abet the reproduction of that nomenclature. When historians, for example, choose to question the professional expectation that they work hard at unearthing what by definition the archive's mission is made to conceal, and when they prefer to privilege sources other than those classified in archives, they are reminded that their choices are wrong and that such choices affect the credibility of their research: for example, "that Du Bois did not work the archives would constitute one of the gravest criticisms by professional historians of *Black Reconstruction*."[2] Paradoxically, this internal disciplinary discourse is considered an assumption even in historical accounts that seek to write about what has been ignored.

In a recent account of the opening of British archival records on slavery, for example, David Olusoga compares the explosive potential of this collection of documents to the effect created today by documents from WikiLeaks:

> The T71 files consist of 1,631 volumes of leather-bound ledgers and neatly tied bundles of letters that have lain in the archives for 180 years, for the most part unexamined. They are the records and the correspondence of the Slave Compensation Commission.[3]

The core of the scandal cannot be in these unrevealed documents. Nothing in these documents would be more scandalous than that which is already known about the enslavement of Africans. It is only within the closed circuit of citizens for whom the "past" is *in* the archive that

2. David Levering Lewis, "Introduction," in *Black Reconstruction in America 1860–1880* by W. E. B. Du Bois (New York: The Free Press, 1998), x.
3. David Olusoga, "The history of British slave ownership has been buried: now its scale can be revealed," *The Guardian*, July 11, 2015, https://www.theguardian.com/world/2015/jul/12/british-history-slavery-buried-scale-revealed (accessed February 23, 2018).

ARIELLA AÏSHA AZOULAY

documents with details on enslavement can today provoke an unheard-of scandal. Unlearning this paradigmatic interpellation of the archive means stepping back from the inclination to unearth secrets from the archive of catastrophes perpetrated in the open, disengaging from the position of the explorer-historian and instead engaging in a present continuous mode with those considered "past." It means acting on the belief that what they sought to protect is not over.

The Pitfalls of the "Alternative" Approach

The contention that the archive is not about the past but about the commons requires a different genre of narrative than the one known as history. The genre of history interpellates authors to conceive of the relationship between their work and that of their predecessors as evolving along a temporal axis. Whoever is critical toward the imperial archive must provide an alternative history, as if one's predecessors could not be allies in a common struggle. Thus, the archive is preserved as a cohesive institution immune from those who interact with it, necessarily external to it. Personal experiences, emotions, and affects (the use of imagination and inventiveness, and, in general, a critical approach to the archive) are considered part of the flourishing field of alternative and counter-histories; they cannot be assumed to be new.

Arguing that a new anthology of essays on the archive challenges "the *tired* assumption that an archive is simply an immutable, neutral, and ahistorical place in which historical records are preserved": its editors have to adhere to the order of disciplinary genealogies and forget the rage that archives provoked among those who resisted the dissection of their world into archives.[4] This raises a cluster of questions: What are these new approaches countering, exactly? In what sense are they new? Why do their authors assume that others before them, those who entered archives or were left outside of them, did not feel rage or envy, distress or pleasure, in their interaction with the archive? What leads scholars to so often believe that prior to their discoveries people viewed the archive as a serene institution, consistent and coherent, and that they are the first to deconstruct it? And if, on the other hand, one already knows that the archive has never been a serene and equitable site for preserving documents and storing them away, why is one seduced into beginning the archive's alternative history by projecting onto it an integrity and coherency that it never had in order to criticize and deconstruct

4. I picked up this quotation randomly to illustrate a recurrent discursive practice and omitted the editors' names.

it in the contemporary moment? What prevents critical scholars from acknowledging former challenges to the hegemonic forces working in and with the archive, and from continuing the transgressive work begun by their predecessors? What is it that continues to provoke this drive for an alternative account as if for the first time, that leads scholars to associate the archive with a certain homogeneity? Is it the archive or its idea? Is it our predecessors' actions and accounts that provoke and justify the engagement with alternative history or is it our contemporaries, who perpetuate oppressive options and maintain the archival cohesiveness that justifies it? And why does alternative history adopt a structure of temporal progress that invalidates precedents and predecessors rather than adopting a structure of ongoing and continuous struggle between competing incompatible principles?

Nonimperial Grammar, Not Alternative Histories

The discovery *for the first time* of the violence of the archive, its manipulations, silences, and absences, is predicated on the denial of the presence of others in the archive. It is as if, regardless of what one already knows about the history and functioning of the archive and similar institutions, as well as people's experience with them, scholars are trapped in the grips of the power of its abstract idea. They are interpellated to look at it through a lens that positions them outside of its configuration and enables them, through its study, to emerge with a new alternative critical history, which breeds the modest joy of revelation and a kind of temporary liberation from the imperial condition.

Alternative history is usually conceived of in terms of binaries, and these are often projected onto a temporal axis in a way that renders the alternative narrative more progressive than those made earlier and more relevant to the contemporary moment. It also renders those who struggle against the archive as victims to be salvaged from the archive rather than allies in a common struggle. It may be that only now, after a few decades of writing explicitly critical and alternative histories, can the unpremeditated aspects of this approach to time and the role historians inadvertently played in reifying the imperial imagination be grasped and studied.

Imperial archives, as such histories seek to show, were not born as solid, coherent, and functioning institutions devoted to the neutral preservation

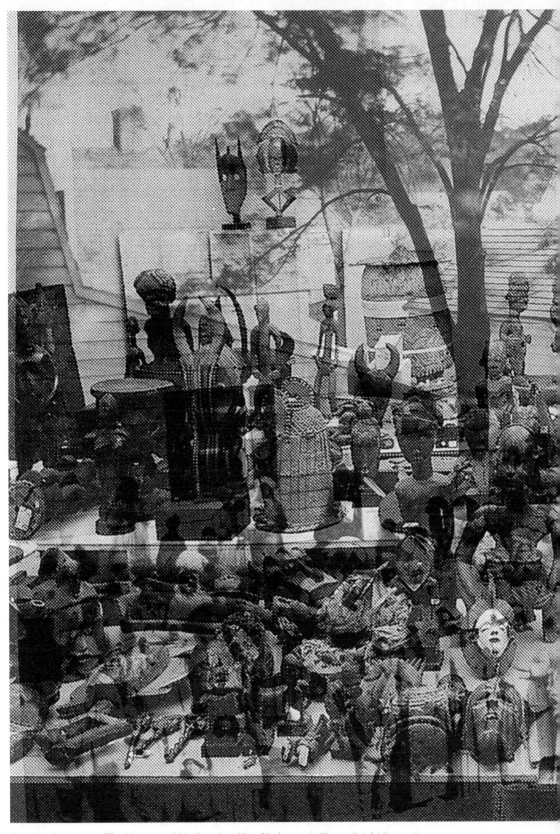

Dismissed exposure: The Museum of Modern Art, New York, 1936 (Photo: Soichi Sunami), and "Large group of slaves (?) standing in front of buildings on Smith's Plantation, Beaufort, South Carolina" Library of Congress (Photo: Timothy O'Sullivan). Image: Ariella Aïsha Azoulay.

of *the past*. Even today their realities always exceed their coherent representations in alternative histories. Those of us who write about archives today are in one way or another imperial citizens by birth, native speakers of imperial dialects that we had to unlearn if we wanted to speak in nonimperial grammars. Nonimperial grammar, shared with others, is essential for such dialects not to be heard as scattered cries in an alienated world but as truth claims about stolen shared worlds. Given that opportunities to speak nonimperial dialects with others, in public spaces, are limited—confined to protest sites and strikes—it is not surprising that when scholars find themselves alone at their separate desks they tend to relate more to successive histories written by single authors, constantly improving their predecessors' narratives.

Rather than writing alternative histories to what disciplinary predecessors wrote and have "not gone far enough in addressing," a potential history of the archive is an attempt to undo imperial disciplinary grammar, foregrounding its incompatibility with nonimperial grammars. Nonimperial grammar cannot be invented: it can only be practiced through unlearning the imperial one. Even if nonimperial dialects of dis/engaging with/from archives are not victorious, they are enduring dialects, not inventions by individuals who could go "far enough." Their grammar is founded on the assumption that the imperial archive cannot be described from an external or *a posteriori* position so long as who we are—citizens or undocumented —is defined and regulated by the archive.

Even in the nineteenth century, when archives were associated with positivistic science, they were approached and perceived this way only within very limited circles. Indigenous peoples, chartists, freedmen and freedwomen, slaves, communards, anarchists, activists, and many social actors and writers in the nineteenth century were engaged in diverse archiving practices and didn't recognize the archive's claim to objectivity or the power of positivist history. Objectivity did not play a significant role in the different battlefields in which they were engaged. For these different actors, the archive was not about writing history, and therefore was not about the past. They founded journals, composed educational agendas, wrote manifestos, fabricated papers, reclaimed their lands, published stories and histories, initiated social projects, became activists and revolutionaries, and sought other modes of inscriptions and representation. There is a justification for mentioning such different actors together, because they share one trait: none recognized the authority of

the imperial archives, either by opposing them or avoiding them. Listen to Audra Simpson: "How, then," she asks,

> do those who are targeted for elimination, those who have had their land stolen from them, their bodies and their cultures worked on to be made into something else articulate their politics? How can one articulate political projects if one has been offered a half-life of civilization in exchange for land? These people have preexisting political traditions to draw from—so how do they, then, do things? They refuse to consent to the apparatuses of the state.[5]

And the way her scholarship refrains from archiving their politics: "In time with that, I refused then, and still do now, to tell the internal story of their struggle. But I consent to telling the story of their constraint."[6] These different modes of engagement with the archive—opposition, avoidance, disengagement—undermined many of the positivistic assumptions about the archive that recur in alternative histories. Having read numerous alternative histories and written some such histories myself (in fact, *Potential History: Unlearning Imperialism* started as a series of studies of alternative history of sovereignty, revolution, human rights, and Israel–Palestine), I'm concerned here with a twofold question. On the one hand, why is the archive's claim to objectivity or neutrality, even though it cannot be sustained, quoted time and time again in alternative histories in order to be refuted time and time again? On the other hand, why are different modalities of engagement with the archive kept apart from the archive, as if its essence is immune to them?

Not Predecessors but Rather Present Actors

Archives, both those I am using or refuse to use and those I have created, have played a pivotal role in enabling alternative histories, but also in realizing that something is wrong with the paradigm of alternative history. The problem is that it proposes some things as "hidden histories" in need of discovery, but in fact these aren't hidden things or histories but rather open secrets known far beyond the archive and the grammar invented as a guardian of its orderly usage. I have noticed that often,

5. Audra Simpson, "Consent's Revenge," *Cultural Anthropology* 31, No. 3 (2016): 328. Or aesthetic sovereignty: "the ways that kaona [hidden meaning] requires Hawaiians to connect with our kupuna [the plural form of "ancestors"] and with each other, as an affirmation of our aesthetic sovereignty." Brandy Nālani McDougall, "Putting Feathers on Our Words: Kaona as a Decolonial Aesthetic Practice in Hawaiian Literature," *Decolonization: Indigeneity, Education and Society* 3, No. 1 (2014): 1. (I include the definitions because not to do so renders the footnote quite opaque.)
6. Simpson, "Consent's Revenge," 328.

soon after formulating what seemed to me a new, alternative, or critical perspective, I could use it to find precedents for this perspective. If a certain written story is an alternative to imperial premises, it cannot be new: it is always already known, and it is only its authors that had to unlearn its imperial version in order to utter it properly—that is, from the point of view of those who never accepted its imperial version as truth. If we accept, as Tuck and Yang write in their critique of decolonization as metaphor, that "settler perspectives and worldviews get to count as knowledge and research" and that "these perspectives—repackaged as data and findings—are activated in order to rationalize and maintain unfair social structures," the task at hand cannot be to forever write alternative histories to settler worldviews.

The idea of archive as ur-form of the past also has an impact on the way imperial catastrophes are narrated. Common tropes like "bad days" or "dark times"—always implying previous or future better times as well as narratives of deterioration and decline—are often repeated with respect to historical spectacles of violence, cruel regulations, and unjust laws. These can be refuted only if we equip ourselves with counter assumptions that unseat the archive from its position as the ultimate depository of accurate information about the commons. That genocides, expulsions, dispossessions, and enslavements were practiced since the beginning of the invention of the New World is not (and was never) a secret. When the archive is assumed as the major site whence knowledge can be reconstructed and confirmed, other modes of inscription are neglected. When it comes to imperial catastrophes, the function of the archive is to render all other sources of knowledge superfluous and irrelevant so that the paper it stores will stay mute, too. Thus historians can read without reading the traces of crimes written in innumerable papers, until they find the ultimate document in which a clear intention to commit a mass crime is written down. Similarly, histories of the imperial enterprise can continue to be written and disseminated with very little, if any, account of the organized crime it perpetrates, because the neutral political lexicon enables and promotes crime-free narratives. This lexicon conditions scholars to react in surprise and stupefaction when the same recurrent crimes are encountered today. This astonished response is more an indication of solid assumptions created by the archive through its attendant professions and orchestrated ignorance, denials, and imperviousness, and less an indication of the real degree of atrocity in the scale of crimes committed by imperial enterprise.

Neither the atrocious measures nor the resistance to atrocities—nor the aspiration to promote other options—are new. Our approach to the archive cannot be guided by the imperial desire to unearth unknown "hidden" moments. It should, rather, be driven by the conviction that other political species were and continue to be real options in our present. We should not seek to discover but to join with others. Unlearning the past guarded by the archive and recognizing the archive as the institution through which the imperial condition is maintained is necessary in order to be able to come together as allies with those who have been relegated to the past. When we insist on being with others across the triple imperial divide of time, space, and the body politic, the division between past and present ceases to be a neutral axiomatic and the unexpected is no longer such. We should not forget that this imperial temporality is neither neutral nor natural and, hence, should not accept and present alternative history as a fresh, new perspective on the past. These two pairs of oppositions— past/present and hegemonic/alternative—and their conflation in the genre of alternative histories are the products of an imperial logic, which led us to believe that those before us were somehow blind to its machinery of power, which we can see because we are endowed with the virtue of being critical, a virtue we have been granted because we are modern—always more modern than others. For a nonimperial "we" to be pronounced, a shared commitment to confront and substitute imperial premises is needed, and this has little to do with whether the historian was active now, a decade, or two centuries ago.

Our predecessors—be they scholars or those whose existence can be recovered through scholarship—are not less astute than us regarding the archive. When we encounter them in the archive we should remind our-selves that they were and continue to be political actors, and that their actions were not exceptional or unique. Rather, their actions are variations of a nonimperial position that should help us interpret our right to the archive—not in terms of access to classified documents but in terms of a different form of engagement with those others. Our joint efforts, across time, should be the sign that the imperial condition is reversible. Knowing the long-lasting evil perpetrated by imperialism, we should suspect that if we find ourselves "discovering" its violence for the first time it means that we are already caught in one of its numerous traps. We have allies in the archive, even if they are often defeated in their mission. Rather than confirming their relegation to the realm of history, we should engage with their deeds as political partners and not as objects of research.

Alternatives are not to be sought along this past–present axis, and they are not to be written as history that *a priori* frames our findings in the past. For alternatives to imperialism to exist, unlearning what is assumed to be a structural distance between actors—in time, space, and the body politic—is a distance in relation to which we are enticed, encouraged, impelled, and interpellated to introduce ourselves; it is a distance that transforms others from political actors into subjects or objects of alternative histories, and deprives them and us of the common ground of a shared tradition. Powerful as the imperial enterprise is, and even though its procedures brutalize the conditions under which people can engage with each other and the world, as long as people live they cannot be completely subsumed by the imperial condition.

This text is comprised of excerpts from the book *Potential History: Unlearning Imperialism* by Ariella Aïsha Azoulay, published by Verso (2019).

The video *Un-documented: Unlearning Imperial Plunder* (2019) by Ariella Aïsha Azoulay was shown as part of *The Ghost Ship and the Sea Change*, the eleventh edition of Göteborg International Biennial for Contemporary Art, in 2021.

LENA SAWYER & NANA OSEI-KOFI

"LISTENING" WITH GOTHENBURG'S IRON WELL:

ENGAGING THE IMPERIAL ARCHIVE THROUGH BLACK FEMINIST METHODOLOGIES AND ARTS-BASED RESEARCH

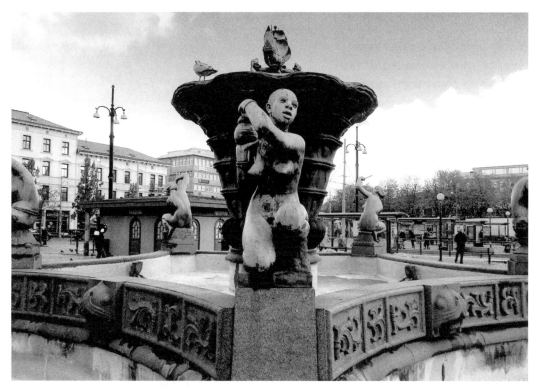

Africa, detail of the fountain *The Five Continents*, Tore Strindberg, 1927.

Nana Osei-Kofi:

*The sound of water, the sound of
the movement of iron, from mine,
to scales, to ship, to sea, to iron.
The sound of the whip on the backs
of those who carried the iron, the
sound of water as it flows through
the fountain. In tension with the
silence of water, in the vessel YOU
carry. Water, the source of life.
YOU, the carrier.*

Lena Sawyer:

*Your open mouth, your gaze far away.
Back turned against the water, so
alive, frozen, looking out into space.
The future. What are you trying to
say? You speak to us.*

Lena:

*A message, of your life, how you got
here, of your humanity, of those
before and those who came after and
who are waiting to be? An edit that
Tore Strindberg had not imagined or
hoped for.*

Lena and Nana:

Let us begin at the beginning. Let us begin at the end.

Lena:

I was born in 1968 in Princeton, New Jersey, my mother having left
Sweden on one of the last "America boats" from the Gothenburg port.
There, working as an au pair in New Jersey, she and my father met in a taxi
in Harlem, so the story goes. He was part of the small, close-knit African
American community of Princeton, NJ, and had just returned from service
in the army. I grew up in the US, did fieldwork in Sweden for my anthropol-
ogy dissertation in the 1990s, and moved to Sweden (more) permanently
twenty years ago—about the same time, Nana, you moved to the US. I
wonder if our paths crossed? I moved to Gothenburg recently and often
pass by the statue that is the subject of this piece, as it is a few minutes from
my workplace at the Department of Social Work, University of Gothenburg.
Seeing it has always done something to me—the naked women's bodies—
but in particular the representation of an African woman is where I have
often found myself drawn to stand, look closer and sometimes touch; her
crouching body alone and often cold (she is made of bronze), her gaze
staring out into space and her mouth slightly open. The encounter has
always felt heavy, and when I looked into published work about the statue
I was confounded by the silence (in terms of how little critical writing,
as well as talk, there is about the statue), and it became clear to me that
this is yet another fragment, evidence of the Swedish colonial archive and
silence on Swedish coloniality. At the same time vibrating with affect. A
reminder, a fragment, of loss and the ruptures of diasporic life. Like a few
other potent archival fragments I have gathered into my own little archive
during my time in Sweden. I have used images of the statue in my teaching
as a way to create alternative knowledges and to create awareness about
the public archive and cultural memory. I ask students to see the archival
fragments I share as ghosts of colonialism, asking them: *What do they say
to you? Do you hear their whisper? What stories do they tell you?*

Nana:

Born in Gothenburg in 1969 to a Swedish mother and a Ghanaian father, in 1988 I was selected to participate in a year-long travel experience with the US-founded international educational organization Up With People, an event that was covered by several of Gothenburg's newspapers during the early part of 1989. One of these articles detailing my then forthcoming experience, published in *Arbetet*, included a very large photograph of me at Järntorget (The Iron Square), standing in Järntorgsbrunnen (The Iron Square Well) next to one of five bronze figures of nude women representing the continents of the world (it is emptied of water during the winter months). Specifically, I was positioned next to the figure representing Africa, with my right arm embracing her shoulders. Today, I can only speculate about the representational intentions of the photographer and/or the journalist who interviewed me. Was it meant to symbolize my connection to the African continent, my upcoming travel experience as a form of "conquest" or journeying outside Sweden as an extension of the worldliness of the city of Gothenburg? I will probably never know.

Growing up, for me Järntorget was about the Swedish labor movement with which I, along with my family, so strongly identified. My most salient place-based memory of Järntorget is standing in a long line at ABF (*Arbetarnas Bildningsförbund*—Workers' Educational Association) in 1986 to sign a book of condolences following the murder of Swedish prime minister Olof Palme. As a young adult, I do not remember the photo shoot or having any specific thoughts about the statue. It was just a part of my everyday life; coloniality hidden in plain sight. And it would take several years, decades in fact, living outside Sweden for Järntorgsbrunnen to take on a new meaning for me.

In the same way that much of qualitative inquiry asks that we defamiliarize ourselves with the familiar, to see things anew and to question that which we have thought of as natural, assumed, and unquestioned, years after standing in the fountain to have my picture taken I would come to see it as if it were for the first time. Seeing it through the eyes of whom I had become and what I now knew of the world, of history, of empire, of racialization and racisms, of capitalism, of tropes of gender and nation, and of public memory.

Today it has become impossible for me to pass the fountain without experiencing frustration at the ways in which most, if not all, who pass by

fail to actually "see" it. Whether it is rushing to catch a tram or a bus, or sitting on the edge of the fountain eating ice cream in the summer, or gathering for a demonstration, there is an absence of impact or significance—in the same way I experienced this public archive, one of the city's most well-known statues, in my youth.

An Edit

A naked African woman in bronze crouches, frozen in space at Järntorget, a heavily frequented public space in Gothenburg, Sweden. She is part of Tore Strindberg's (1882–1968) 1927 statue *De Fem Världsdelarna* (The Five Continents), or as it is typically referred to today, Järntorgsbrunnen. She is positioned as one of five naked women who occupy the outer circle of the fountain, all of whom are either seated or crouching, looking outward into space, with their backs to each other. These women, representing the world's continents, were sculpted to mark the port city of Gothenburg as a central actor in the global export of iron ore. Järntorgsbrunnen is a marker of imperial memory and the European colonial archive (Wekker 2016). At the same time, over one hundred years later, the statue is a part our cityscape. Moving through this space, we heard the statue whisper, as she asked us to engage the colonial archive and the ways in which our own past, present, and future intertwine in and with this public archive. And in hearing this whisper, listening carefully, we chose to respond.

The focus of this piece, first published in the Open Space section of the *Feminist Review*, is to reflect on our process of seeking a way to understand this archival entity/public space and question its meaning/significance in the present/past, as well as in our own lives. From 2018 to 2019, we collaboratively engaged in the project of creating affectively based knowledges about this space and statue, which we saw as a trace, a vestige archive of slavery (Hartman 2006; Cvetkovich 2012).

In our arts-based research piece, which we performed at Denor, a decolonial conference in October 2018, and at G19, a gender studies conference in October 2019 (both in Gothenburg), we aimed to engage the colonial archive through decolonial and Black feminist methodologies. Through this project we sought to offer a contribution to the long legacy of counter-narratives and shadow archiving—to add to the ongoing edits that have been made and are being made to public archives as a way of contesting the dominance they invoke. Importantly, we envision

ourselves as joining a community of counter archivists who are part of critical debates and knowledge-making around the colonial public archive. Recent examples of this include the Rhodes Must Fall movement in South Africa, La Vaughn Belle and Jeannette Ehlers' *I Am Queen Mary* (2018) statue in Copenhagen, as well as activism around confederate statues in the United States.

In our case, methodological approaches have been central to understanding and creating decolonial meanings about the statue. Indeed, over time our listening led us to refusal; the African woman's body not sitting but crouching, her little toe hanging in space as a sign of potential. Frozen, but not captured, ready to leap up and forward through space and possibly time. It was a listening that meant engaging our imaginations and maintaining narrative restraint (Hartman 2008)—a refusal of the impulse to write in this archive with only the history of anti-black dehumanization. Or, as Saidiya Hartman (ibid., 7) so beautifully argues, "If it is no longer sufficient to expose the scandal, then how might it be possible to generate a different set of descriptions from this archive?" In this way, this project was a way to speak with and through the statue and the long history of edits being made in relation to public archives. Finally, it was also to encourage you to "listen," and to create alternative visions and stories of our shared public space and ultimately also our future.

Lena:

As we started this work, I was deeply inspired by Tina Campt's (2012, 2017) work on listening because it suggested a way to do research from an embodied place that is anchored both in the material and political realities of anti-blackness and black living. This is a perspective that theorizes the continuity of slavery rather than as a break from the past with the present, where slavery's dehumanization continues to shape our lives as black peoples (Hartman 2008; Sharpe 2016; Habel 2018).

Campt's concept of "listening" is in this context a love letter of sorts, written to us, researchers of and in the African diaspora, an offering of an incredibly beautiful and powerful methodology of refusal that lies in the tradition of Black feminism. She offers a decolonial feminist methodology, what she calls "a grammar," for engaging and challenging traditional social science methods and ways of knowing, which have prioritized the ocular and contributed to the objectification of black life and living. Instead, she asks us to notice how we encounter these

colonial archives and what they say, speak, and whisper through our engagement with them. This is a methodology that is futuristic, imaginative, and imperative; an envisioning of the future we want to see, and live in, in the now (Campt 2017, 17) through our recognition of the historically dismissed archives of black life. Listening necessarily destabilizes linear traditional ways of knowing and their dichotomies, where quiet does not mean silence, and where images, events, and Black life are re-engaged and importantly repositioned.

Such methodological inspirations invited us to also understand our process as an affective assemblage that necessarily included ourselves and each other as also shaped by and negotiating the legacy of slavery in our lives. At the time of our collaboration, the 2018 Swedish parliamentary election was an affective backdrop to our work, and the nationalist and racist Swedish Democratic Party (SD) held a rally near the statue that we attended in counter protest. During our arts-based performance, I wore my grandmother's wool sweater as a way to bring her with me into the room and to give testimony to her shaping of my own life and that of my father (Sawyer 2008). Nana, you brought the pouring of libations into our performance, the life sound and scene of us both pouring water, together with moving images of the ocean projected onto screens behind us.

We intuitively began filming moving images of the water—the sea in the Gothenburg archipelago and the shores of Cape Coast, Ghana. As Christina Sharpe (2016) discusses, water is an archive: of slavery's violence, the intermixing of death with material. Sharpe's powerful images of "the wake" as the movement of water left after ships pass as an archive of the ongoing dehumanization and social death of black people guided us in our engagement with water. Like Campt's call for the urgency of a methodology of "listening," we also heard in Sharpe's (ibid., 13) "wake work" the call for methodological disobedience and, in particular, that Black scholars *become undisciplined.*

Nana:
For me, I strongly identified our process with previous experiences I have had with arts-based research, and what I have come to think of as a set of refusals. I have written elsewhere (Osei-Kofi 2013) about the freedom and joy I experienced in coming to understand that there are spaces, albeit small, within the academy where multiple ways of coming

120

"LISTENING" WITH GOTHENBURG'S IRON WELL:
ENGAGING THE IMPERIAL ARCHIVE THROUGH
BLACK FEMINIST METHODOLOGIES AND ARTS-BASED RESEARCH

to know—outside of the narrow confines of research described as either quantitative or qualitative—can come to life. Work that refuses hegemonic notions of the only way of coming to know as a linear, objective, and disengaged process. I see our project as a form of *a/r/tography* (Springgay, Irwin and Kind 2005), which engages with art, research, and teaching through the notions of theoria (knowing), praxis (doing) and poesis (making) (Irwin 2004), and which takes up the late Mary Hanley's (2011) notion of arts-based research as counter-narrative.

As noted earlier, our work was never simply about a single representation of the Swedish colonial archive but, rather, part of a larger conversation that is ongoing in many parts of the world today concerning the ways in which public artworks such as Järntorgsbrunnen illustrate how power determines the history we choose to remember in public spaces (Foner 2017). That is to say, we take up Hanley's notion of both meaning-making and commitment to social change.

As we made meaning through a process that refused methodological conventions, we walked together, experiencing Järntorgsbrunnen in silence. We wrote together, sharing our texts with each other, and then wrote some more. We listened repeatedly to the sound of water as we sought meaning. Yet another refusal—a refusal of contemporary demands by the academy for "speedy scholarship" (Hartman and Darab 2012, 53).

We turned, I would argue, towards the notion of slow scholarship, through a process where we honored the role of contemplation and time for/in creation. Finally, I want to suggest that our collaboration— and shared multimodal knowledge construction across different ways of knowing—represents a refusal of the constructed borders, hierarchies, and mainstream assumptions of disciplines, and the notion of discipline itself; discipline as regulating. While we both read Campt's *Listening to Images* (2017) as a way of preparing for our joint work, and approached the project from our shared commitment to Black feminist and decolonial thought, I was struck by the ways in which our separate and overlapping reading practices brought us together in ways that revealed parallel ways of understanding—a process that speaks to the silenced nature of the academy and how different academic languages and epistemologies discipline and easily foster rifts and separations rather than challenging the logic of mastery (Singh 2017). Addressing anti-colonial work, specifically in *Unthinking Mastery*, Julietta Singh (ibid., 2, 6–7) describes her

work as "a summons to postcolonial studies and its interlocutors to attend to the persistence of mastery at the foundations of the field," going on to argue that no matter how it is applied, the logic of mastery is "bound to relations founded on and through domination." And I want to think that, in some small way, our work as a whole pushed against this insidious logic of mastery.

Acknowledgements
We would like to dedicate this work to Mazahr Makatemele, the first Black woman in Sweden whose name we know, as well as to the Black and brown women in Swedish academia whose work speaks truth to power.

A version of this text was first published in *Feminist Review*, Issue 125 (2020), published by SAGE Publications.

References

Belle, La Vaughn and Jeannette Ehlers. *I Am Queen Mary*. Public sculpture. Copenhagen, 2018.

Campt, Tina M. *Image Matters: Archive, Photography, and the African Diaspora in Europe*. Durham and London: Duke University Press, 2012.

Campt, Tina M. *Listening to Images*. Durham and London: Duke University Press, 2017.

Cvetkovich, Ann. "Depression is ordinary: Public feelings and Saidiya Hartman's Lose your mother." *Feminist Theory* 13, No. 2 (2012.): 131–146.

Foner, Eric. "Confederate Statues and 'Our' History." *New York Times*, August 20, 2017. https://www.nytimes.com/2017/08/20/opinion/confederate-statues-american-history.html (accessed August 16, 2019).

Habel, Ylva. "Little Pink: White fragility and Black social death." In *The Power of Vulnerability: Mobilising Affect in Feminist, Queer and Anti-Racist Media Cultures*, edited by Anu Koivunen, Katerina Kyrölä and Ingrid Ryberg, 71–94. Manchester: Open University Press, 2018.

Hanley, Mary. "Resisting Sankofa: Art-Based Educational Research as Counternarrative." *Journal of Curriculum and Pedagogy* 8, No. 1 (2011): 4–13.

Hartman, Saidiya. *Lose your Mother: A Journey Along the Atlantic Slave Route*. New York: Farrar, Straus and A Giroux, 2006.

Hartman, Saidiya. "Venus in Two Acts." *Small Axe* 12, No. 2 (2008): 1–14.

Hartman, Yvonne and Sandy Darab. "A Call for Slow Scholarship: A Case Study on the Intensification of Academic Life and Its Implications for Pedagogy." *The Review of Education, Pedagogy and Cultural Studies* 34, Nos. 1, 2 (2012): 49–60.

Irwin, Rita L. *A/r/tography: A Metonymic Métissage*. Vancouver: Pacific Educational Press, 2004.

Osei-Kofi, Nana. "The Emancipatory Potential of Arts-Based Research for Social Justice." *Equity & Excellence in Education* 46, No. 1 (2013): 135–149.

Sawyer, Lena. "Grama, Einstein and me." *SLUT*, 2, No. 1 (2008): 8–17.

Sharpe, Christina. *In the Wake: On Blackness and Being*. Durham and London: Duke University Press, 2016.

Singh, Julietta. *Unthinking Mastery: Dehumanism and Decolonial Entanglements*. Durham and London: Duke University Press, 2018.

Springgay, Stephanie, Rita Irwin and Sylvia Kind. "A/r/tography as living inquiry through art and text." *Qualitative Inquiry* 11, No. 6 (2005): 897–912.

Wekker, Gloria. *White Innocence: Paradoxes of Colonialism and Race*. Durham and London: Duke University Press, 2016.

JONAS (J) MAGNUSSON
&
CECILIA GRÖNBERG

A SEDIMENTAL
JOURNEY,

REVALOR, OR,
LOCALITY,
IT'S OK TO BE, OR,
HISTORICAL
MATERIALIST

For one must, to survive as an unassimilated socialist in this infinitely assimilative culture, put oneself in a school of awkwardness. One must make one's sensibility all knobbly—all knees and elbows of susceptibility and refusal—if one is not to be pressed through the grid into the universal mishmash of the received assumptions of the intellectual culture.
(E.P. Thompson, *Socialist Register*, 1973)

An epistemological shift is necessary in order to recover the idea that there are alternatives … such diversity translates into what I designate as an ecology of knowledges, that is, the recognition of the copresence of different ways of knowing and the need to study the affinities, divergences, complementarities, and contradictions among them.
(B. de Sousa Santos, *The End of the Cognitive Empire*, 2018)

Our journey will be (…) in thickness rather than extent. (…) we have changed course, moving from horizon line to thickness, from global to local. (…) because the ground is infinite in its stratification, the curving of the surroundings is infinite in its movement. Could the Earth be discovered again, otherwise, by adopting a centripetal thought, and no longer a centrifugal one?
(F. Aït-Touati, A. Arènes, A. Grégoire, *Terra Forma*, 2019)

Walter Benjamin, in his notes "On the Concept of History" (1940), talked about historical method as a "philological method," implying the reading also of "what was never written"; a reading of the world including material and local complexities that are not immediately recognizable as texts or images, perhaps, that don't belong to an already identified genre or discipline, nor have a given value.

Almost a century later, such a non-affirmative project, counter to the status quo of culture, can seem even more against the grain, but maybe not less vital. What does it imply, then, to try to reinvent an attention to "localities," to "local knowledge," to "minor" or "local literatures," to "visual history" and histories outside History?

Despite all the work on locality that has been done in the *Annales* school, in "microhistory" and "marginal history," etc., it would probably be rather safe to say that "local history," with all its textured materialities, still hasn't completely managed, or been allowed to free itself from the old prejudiced suspicions of being "parochial" and "antiquarian." For a very long time, among professional historians there was a strongly held

view that local studies were relevant only insofar as they provided examples in support of a preconceived national agenda. General history, real history, proper history was "national history," while "local history" was something to be dismissed. Since the Second World War, this perspective has often been challenged, and sometimes even turned on its head, but the pejorative overtones have tended to stick, as if "local history" was still somehow merely an amateur and, by implication, valueless collection of data, not a proper production of knowledge (see the analyses in John Beckett's *Writing Local History*, 2017, and in Carol Kammen's *On Doing Local History*, 2014). Despite Marc Bloch's assertion in 1913 that "local history alone makes the study of more general problems possible." Despite H.P.R. Finberg's claim in 1962 that "local history is not only a challenge to the most trained master of historical techniques; it is also … the last refuge of the non-specialist." Despite the publication, in 1963, of E.P. Thompson's *The Making of the English Working Class*, a "history from below" that nevertheless created somewhat of a seismic shock through the (British) history profession, and which subsequently rubbed off on to local history. (Thompson refused to accept the argument that history was about the 'successful'; instead, he set out to rescue "the poor stockinger, the Luddite cropper, the 'obsolete' hand-loom weaver, the 'utopian' artisan … from the enormous condescension of posterity.")

From the perspective of professionals, what makes local history problematic in a negative sense often seems to be its multi-disciplinary character, but especially its connection to *place*. From the perspective of art and alternative historiographies, however, this is what can render it problematic in a productive way—when "local knowledge" ("… the shapes of knowledge are always ineluctably local, indivisible from their instruments and their encasements," Clifford Geertz) is afforded the power to question our epistemological preconceptions and hierarchies.

Gilles Deleuze highlighted the "plastic force" in Nietzsche, a plastic principle capable of transforming itself together with what it determines (*Nietzsche et la philosophie*, 1962); which would amount to a new relation between the universal and the singular—a relation where the universal can be productively 'deformed' under the impulse of a local object. But it is Aby Warburg, as read by Georges Didi-Huberman, who in the most serious way would have practiced such a "superior empiricism," starting from the epistemological decision to "transform the historical intelligibility of images under the pressure—the imprint—from every fruitful singularity"

(*L'Image survivante*, 2002). This is why knowledge in Warburg would be a *plastic knowledge* par excellence, acting through memories and intertwined metamorphoses, while the art historian's library as such, with its incredible quantity of manuscripts, index cards, and documents, would constitute a *plastic material* capable of absorbing every contingency, every unthought and unthinkable object of art history—and of transforming itself starting from these contingencies, without ever being fixed in a finished result, a synthesis, or a definitive knowledge.

Such epistemological plasticity might be productive to put in dialogue with what Lytle Shaw has called "lowercase theory"—that is, a theory "capable of learning from, transforming itself in relation to, its objects of inquiry," implicating that "theory's interlocutors in the arts must be granted the authority to do more than passively instantiate. Beyond disagreeing or failing to illustrate, they must be granted the power to produce theory themselves … pushing back at times, offering qualifications, and even generating modes of thought completely outside the existing corpus of theoretical concepts" ("lowercase theory and the site-specific turn," 2017).

Sketching new logics and scales of contextualization to articulate an alternative to both the "bottom-up expressivism" of most regionalism and the "top-down political templates" of most Marxist geography, Shaw's "lowercase theory" is based on a site-specific thinking where the fit between object and site is embraced as problematic and non-isomorphic, and where normative historicism is checked by paying attention to site not merely at the empirical but also at the discursive or disciplinary scale. This is what Shaw names "fieldwork."

"Proposals designed to transform disciplinary fields," Shaw writes in *Fieldworks* (2013), "work their magic best when staged in literal fields— when they seem to emerge from contact with specific places and cultures, 'grounded' in the singular context of which they offer an … explanation." Shaw argues that the turn to *place*, and later *site*, allowed postwar poets and artists in North America to develop a poetics of fieldwork that also enabled them "to rethink their relations to neighboring disciplines— historiography and ethnography above all—and to critique and recode those fields." However quaint a paradigm *place* can be, "its promise of concreteness, grounding and contact has enabled fantastic effects—just not exactly those intended or claimed." And as poets and artists became experimental historiographers and ethnographers of place, "they also necessarily engaged the authority of those disciplinary fields traditionally used to frame, contextualize, and historicize these literal spaces."

Following spread: Jonas (J) Magnusson & Cecilia Grönberg, *Billingen* (edit spring 2022).

C. Billingen. Klippformation vid Ramlaklef.

FALKÖPING, SKARA, SKÖVDE
KOMMUNER
SYDBILLINGEN

MAJ 1975

Billingen. Jättegrottan

ANTECKNINGAR
OM
WESTGÖTA-BERGENS BILDNING.

MED
PHILOSOPHISKA FACULTETENS TILLSTÅND
UNDER INSEENDE
AF
Mag. **L. P. WALMSTEDT**
PROFESSOR I CHEMIE, K. N. O.

FÖR PHILOS. GRADEN
FÖRFATTADE OCH UTGIFNE
AF
Grefve **ADOLF L. HAMILTON**
AF VESTG. LANDSK.

UPSALA
LEFFLER OCH SEBELL.
1845.

Hågkomster och
teckninge

Från Westergötlands

af

Fredrik Berggren.

Ulricehamn.
B. M. Kjellerstedtens Förlag.
Pris 1 kr.

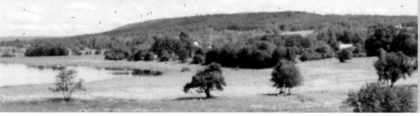

Billingen

LAGERFÖLJDEN I BILLINGEN

U Urberg
1 Sandsten
2 Alunskiffer
2a Uranskiffer (259–325 g/t)
3 Kalksten (ceratopyge och planilis
4 Skiffer och kalksten
5 Ortocerkalksten
6 Chasmopskalksten
7–9 Skiffer
D Diabas

...arta över Nordbillingendiabasens nordspets visande strömeroderad topografi.

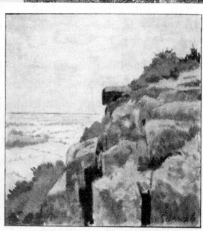

Miljörisk-
område

Hugo Swensson

UTBÖLING
i
VÄSTERGÖTLAND

Wahlström&Widstrand

ALUNSKIFFER

SECTION OF THE BILLINGE MOUNTAIN

SIND PM 1978:2

Utredning från statens industriverk · Stockholm 1978

Ranstads-
verket

Place is layered, or stratified, in highly entangled ways. And if we are searching to find more material, localized modes of working-with (historical) matter, in long-term, non-extractivist engagements with place and site, then we could also benefit from being more attentive to the agency of "strata" in an ecology of practices and disciplinary frames including "geology," "archaeology," "history," "art," "literature," and "philosophy."

Knut Ebeling, investigating connections between archaeology, history, philosophy, media, and aesthetics, has called "wild archaeology" an archaeological project outside classical archaeology and focusing on experimenting with more material reflections on temporalities, making it possible to conceive of different simultaneous strata of time capable of permeating and informing one another: "Archaeology shows where history tells. It shows gaps, discontinuities and what has been rejected, as well as the instances where the rapid and linear history of chronology is lagging behind. Archaeology is slower than the science of history. It counts with larger time spaces, which it only can understand literally: as fields, strata or blocks of time" (*Wilde Archäologien* 1, 2012).
An instance of such "wild archaeology" is the one that Benjamin sketches in his text "Excavation and Memory" from 1932: "Above all, [one] must not be afraid to return again and again to the same matter; to scatter it as one scatters earth, to turn it over as one turns over soil. For the 'matter itself' is no more than the *strata* which yield their long-sought secrets only to the most meticulous investigation … a good archaeological report not only informs us about the strata from which its findings originate, but also gives an account of the strata which first had to be broken through."

It is the concept of stratification that gives earth a concrete historical direction. And this is also, according to Marx, how social classes and social structures, economies, and systems are formed—like strata of earth carry other strata of earth; that is, not only one after another, but where the present constantly relates to a historical condition. The strata or layers are of course not always discrete—they often interact and give rise to cross-scale entanglements—but they do nevertheless display stages of transformation, which invites the possibility to talk about stratigraphy also in connection with layered matters and processes along time axes far less extreme than geological deep time.
Lucy Lippard, for instance, in *Overlay* (1983) showed how "overlay" can be understood in several ways: "It is temporal—human time on geological time; contemporary notions of novelty and obsolescence on

prehistoric notions of natural growth and cycles. The imposition of human habitation on the landscape is overlay; ... Christianity is overlaid on 'paganism,' urban on rural, stasis on motion. Artists working today from models of the distant past are consciously or unconsciously overlaying their knowledge of modern science and history on primal forms that remain mysterious to us despite this knowledge." While Bertrand Westphal, more recently, has advocated a "stratigraphic vision" for literature studies, a "geocritical," complex and multi-temporal approach to place, with reference to Deleuze and Guattari's examination of "layers" in Henri Lefebvre's work as "strata," where each stratum is organized as a function of another stratum, which serves as "a support (the *substratum*)"; implying that "one of its sides is always facing another stratum (the *interstratum*), but it also turns toward, not another stratum, but an 'elsewhere' (the *metastratum*). ... the strata maintain dynamic relations between them, transforming them into so many 'intermediate states' whose variability is limited only by the threshold of identity or degree of the system's tolerance with respect to the deviation" (*Geocriticism*, 2015).

Marx may have underestimated the importance of symbolic or cultural reproduction processes. This, however, does not imply that a sharp understanding of historical materialism by necessity is acquired at the expense of the *perception* of history, a heightened graphicness, as Benjamin demonstrates when revalorizing the 'trash of history,' the world of devalued or unnoticed material objects, by "carrying over the principle of montage into history" (*Arcades Project*); that is, when assembling large-scale constructions out of the smallest and most precisely cut components, and thereby also sketching a still challenging conception of alternative temporality or historical time.
Stressing the epistemological force of the relation between images and knowledge, and addressing images in the broadest sense ("all pictures and formats across categories such as fine art, popular or folk art, and non-art"), Daniela Bleichmar and Vanessa R. Schwartz have emphasized images as historical actors and agents that make history: "Ultimately, we believe that the format of images, and thus the context of their circulation and the material conditions of their production and display, shape genre and narrative capacity" ("Visual History: The Past in Pictures," 2019). Whether we look at images or texts, however, montage, conceived as a transversal cultural technique, would remain, according to Didi-Huberman, a question of how to respect, to the greatest possible extent, the material singularity of a document, and then to render this a readability in a

Following spread: Jonas (J) Magnusson & Cecilia Grönberg, *Kinnekulle* (edit spring 2022).

KINNEKULLE

HILL of KINNEKULLE.

I. Bewiset.
Af Kinnekulla.

Rinnekulle är en mitt uti Wester-Göt alla sidor rund/ fall i förstone litet/ sedan och mer/ tils then löp optöre. Ligger wid af then stora Swens Wennern/ opkastad lifasom til ett thes ment. På nedra kanten finnes Hus/ och hela Sochnar; på öfwersta spetzen Moras och Skog. Är i liuslighet och fru het som ett litet Eden: Fruchtbar Trän m i likenelse af wild Skog: Wälnötträn i dar; och alt hwad ther planteras/ hielpe och marcken op med härligare ymnighet är dra stellen. På then ene sidan ifrån högst

A 3

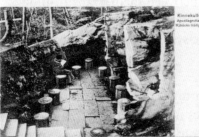

Kinnekulle
Apostlagrottan
Råbäcks hradgård

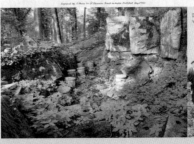

Den 100-åriga 14-stammade granen vid Finnebacken på Kinnekulle.

Gust. Lindberg

Jill Kinnekulle

Pris: 50 öre.

Lagerserien i Västgötabergen.

Diabas.

Silur	9 b.	Retiolitesskiffer
	9 a.	Rastritesskiffer
	8.	Dalmanitesskiffer och -kalk (= Brachiopodskiffer)
Ordovicium	7.	Trinuclusskiffer
	6.	Chasmopskalk
	5. Ortocerkalk	c. Lituitkalk
		b. Vaginatumkalk
		a. Limbatakalk
	4.	Undre didymograptusskiffer (= Phyllograptusskiffer) (ersättes sträckvis av Planilimbatakalk)
	3.	Ceratopygekalk och Planilimbatakalk
Kambrium	2. Alunskiffer	(c. Dictyonemaskiffer)
		b. Olenidskiffer
		a.* Paradoxidesskiffer
	1. Sandsten	b. Lingulidsandsten
		a.* Mickwitziasandsten

Panorama from Kinnekulle, 325 m. above the level of the sea. Panorama från Belvederen å Kinnekulle, 325 m. öfver hafvet. Aussicht vom Kinnekulle.

Utsikt frå Kinnekulle

BLOMMAN
PÅ
KINNEKULLE

NOVELL
AF
G. N. M—a.

Tredje Upplagan,
Författaren besörjd och öfversedd.

*En blomma öfver alla blommor
dock menniskan, när oskuld strålar
ur hennes öga, fröjd och skönhet
igt blommar uppå hennes kinder.*
VITALIS.

STOCKHOLM.
a Bokhandlaren W. Lundequist.

LERSKIFFER

DIABAS

TRAPP, diabas

Marka Klef, Kinnekulle.

montage which at the same time separates and pieces together, linking the document to other documents in order to display possibilities, potential affinities and differences; in a montage, that is, where the singularity of the document and the specific attention to which it has been subjected may be considered in a constellation that could open up a wider field of theoretical, historical, and political reflections. In order to reach new layers of knowledge one has to return indefatigably to the materiality of images and words. One has to know what one sees, but one must also be able to see what one knows in order to make this knowledge sharper, more acute, more embodied.

*

For our work at GIBCA 2021, called *reading | locality (mountains, prints) [strata from an expanded book; billingen, kinnekulle (2001–2021)]*, we have traversed the mountains of Billingen and Kinnekulle by foot as much as worked through 'mountains' of representations and descriptions of them in geological, topographical, geographical, historical, botanical, ethnographical, folkloristic, literary, artistic, touristic, etc. 'strata.' These Westrogothian *table mountains*, born from the sea, formed by different layers of sediments during Cambrian, Ordovician and Silurian, appear like geological monuments, or islands in the otherwise rather flat landscape, sculptured by the inland ice. The diagram of their singular stratigraphy—bedrock, sandstone, alum shale, limestone, slate, and diabase—has loosely informed our attempts to approach as many layers as possible of their cultural and natural histories.
Michel Foucault, in *The Order of Things* (1966), also addressed the historically charged issue of the "Book of Nature": "The great metaphor of the book that opens, that one pores over and reads in order to know nature, is merely the reverse and visible side of another transference, and a much deeper one, which forces language to reside in the world, among the plants, the herbs, the stones, and the animals." In *reading | locality (mountains, prints)*... we are playing with the idea of a worldly 'book of natureculture.' The installation consists of a 9 × 3,6 m 'spread,' four 'book films' and two 'publication tables,' offering a composite and layered geography of shifting temporalities of reading and looking; a montage where the editorial enunciation circulates between different media, materialities, and scales—zooming in and out of pages and spreads, texts and images, book covers and photographs, matter and morphologies, diagrams and constellations highlighting fields of affinities and tensions, analogies and differences.

While the sometimes parklike mountain of Kinnekulle, called "the flowering mountain," is densely culturally layered, described and praised in an almost innumerable number of texts and images, the much vaster and 'wilder' mountain of Billingen, covered by wetlands and forests (being at the same time the site of vast nature reserves and diverse outdoor recreational activities, *and* an intense forest exploitation and mining), has attracted considerably less attention from writers and artists—which does not exclude utterly complex historical overlays, as exemplified by the history of the Ranstad uranium mine, including the Swedish nuclear program, industrial history, the protest movements of the 70s, attempts to restore the area, and continued environmental effects.

Between 2001 and 2021, we have 'excavated' the multiple temporalities of these topographies by fieldworking, walking, photographing, assembling and editing collections and archives of all possible prints—from booklets by local communities and societies, to scientific offprints (sometimes also offering valuable instances of an involuntary, or 'grey' literature); from local history magazines, to yearbooks and novels; from maps and graphic sheets, to paintings and postcards.* Here, we have emphasized publishing ecologies by observing the personal or institutional contexts of circulation. And we are inviting an attentive and layered looking by presenting images in assemblages where they echo and augment one another to produce non-linear or non-narrative constellations that may enable new kinds of knowledge, as reproductions have the power to offer not just the same but also more of the not-same. In short, we have been engaging with the materiality of actual locations while calling attention to the forms of mediation—as it is, to quote Lytle Shaw again, not just objects and sites that provide former events but also the sedimentary history of descriptions and analyses, the discourses that have framed and contextualized these sites.

* Since 2017, this work has been run as the artistic research project *The expanded book: stratigraphy, locality, materiality,* funded by the Swedish Research Council.

The installation *reading | locality (mountains, prints) [strata from an expanded book; billingen, kinnekulle, (2001–2021)]* by Jonas (J) Magnusson & Cecilia Grönberg was shown as part of *The Ghost Ship and the Sea Change,* the eleventh edition of Göteborg International Biennial for Contemporary Art, in 2021.

MICHAEL

BARRETT

GOTHENBURG'S

BLACK

ATLANTIC

SHADOWS

Band leader, impresario, and dance teacher Van Prince (left) with unidentified man and a shadow. Gothenburg, 1960s. Photographed by Clarence Goodwin Barrett.

MICHAEL BARRETT

In Eric Magassa's installation *Walking with Shadows* at Franska Tomten, the past and the elsewhere make their presence felt in what used to be the maritime heart of Gothenburg.[1] Viewing the artwork together with the artist in September 2019, I experienced a surge of repressed memories related to my late father, who once lived nearby. It was as though these recollections—my father's voice, the sounds and smells of his decrepit apartment in the Haga neighborhood—had been lodged deep in my consciousness and were now responding to visual cues in the art. Emblazoned across a construction hoarding near this historic location, Magassa's patchwork of bright colors, archival photographs, and reworked reproductions of classical African art continues a strand of work that challenges simplistic notions of place, belonging, and identity.[2] Among these fragments brought into public view from the shadows of memory are images of Gustavia, the capital of Saint Barthélemy, and photographs of notable Black Swedes.

A key trope in antiracist writing and art is the shadow, one example being the digital shadow of a Vodou devotee dancing through the halls of the Marienborg estate in Danish artist Jeannette Ehlers' video work *Black Magic at the White House*, where the devotee paints ritual symbols on the wooden floors, evoking Legba, deity of the crossroads separating the land of the living and the land of the dead. Significantly, Marienborg was the residence of Caribbean plantation owner Peter de Windt from 1750 to 1753, and is now the official residence of the country's prime minister.[3] By staging her work at such a historically loaded location, Ehlers opens a portal between contemporary Denmark, its historical Caribbean territories, and the country's role in slavery and the transatlantic slave trade. The digitally manipulated shadow—simultaneously representing addition and erasure—highlights how Black subjects have been deliberately removed from Danish mainstream historiography. In their contribution to this book, the feminist anthropologists Lena Sawyer and Nana Osei-Kofi set out to add to a "shadow archive" of Gothenburg through "listening with" the Järntorgsbrunnen (an iconic fountain located at Gothenburg's central city square, Järntorget ["The Iron Square"], known as *The Five Continents*, its artistic name, and colloquially as "The Iron Well").[4] More specifically, their point of departure is one of the fountain's elements, a bronze figure of an African woman. What the authors hear by superimposing their own diasporic biographies onto this representation of blackness is the recurrent failure of Swedish public culture to acknowledge colonialism—past or present—and also the futuristic potential that lies in engaging with alternative

GOTHENBURG'S BLACK
ATLANTIC SHADOWS

histories of migration and affect. I have drawn in the following upon my personal biography to listen, like Sawyer and Osei-Kofi, to the signs and shadows hiding in plain sight within the city's architectural memory; shadows that indelibly implicate us, the living, in the exchanges, dependencies, and horrors of an Atlantic world that is not behind us.

My father Clarence Goodwin Barrett (1916–1988) led a truly transatlantic life. His family history traces a complex web of underwater threads stretching between Jamaica, Nigeria, Sierra Leone, England, Scotland, Cuba, The Bahamas, Panama, Canada, the United States, and Gothenburg. One of the "Windrush Generation," he left his native Jamaica in the early 1950s, a British subject headed for the opportunities promised by the colonial metropole. Ten years later, Clarence traversed the North Sea to land at Majnabbehamnen in Gothenburg, a journey that brought him at last to the European periphery.

Josephine Minto (1894–1971), my father's mother, came from proud but poor circumstances in northern Jamaica. She was a young, unmarried domestic servant when she gave birth to my father. Born into slavery at Maggotty Estate in Hanover Parish, Jamaica, Josephine's grandfather, John Minto (1824–1900) was manumitted by his white father while still a child. His three sons, George Finlayson, John Jarvis, and William Shakespeare Minto, would, as their formidable names suggest, become prominent elders of the Zion settlement, one of the earliest communities for freed slaves established in northern Jamaica.[5]

My father's paternal grandfather, on the other hand, hailed from the brutal colonial conquest that made social movements such as Zion—designed to restore justice, dignity, and independent livelihood to the formerly enslaved —necessary in the first place. Edward George Barrett (1822–1907) was the last in a male line of enslavers and exploiters, purveyors of sugar and coffee to an insatiable European market. Born in Coventry, he ended his days in Saint Ann, Jamaica, custodian of the dwindling estates of an entrenched transatlantic family. For 300 years, from the time their ancestor Hersey Barrett first disembarked in Jamaica in 1655, the male members of the extended family commuted between these two islands.

Clarence arrived in Gothenburg at a time when Sweden was known for international solidarity and sexual liberation. Indeed, his immediate reason for immigrating to Sweden was the birth of my sister Lotta by his first

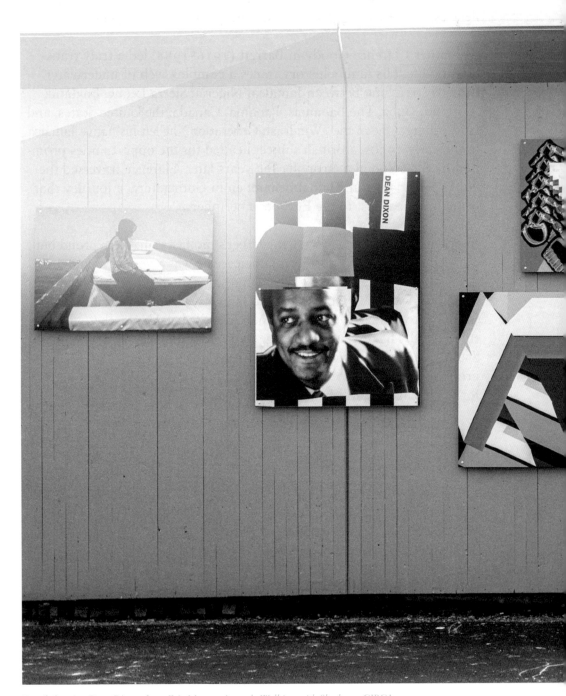

Detail showing Dean Dixon, from Eric Magassa's work *Walking with Shadows*, GIBCA 2019.

Swedish partner, followed by six more children—and additional partners—in the following decade. He found in Sweden a temporary space of freedom, alongside quite a few fellow members of the Black diaspora.

We could excuse Clarence for thinking he had escaped his lower middle-class origins, the uncertain economy of Jamaica—conditioned by the colonial center to its role as a provider of sugar, coffee, bananas, and bauxite—and the closed mindset of late-imperial Britain. Trained in the United Kingdom as a textile cutter, he first worked at the Asken factory in the Gamlestaden district of Gothenburg, during the dying days of the once mighty textile industry. One of Asken's factory buildings itself has a fascinating Atlantic history. It hails back to 1729, the only surviving structure of the Sahlgren Sugar Mill (Sahlgrenska sockerbruket, a multi-building complex) that churned out loaves of refined sugar for the Swedish market, processed from molasses produced by enslaved workers in the Caribbean. But the building's entanglement with slavery does not end there: a hundred years later, the same building was part of a complex that housed Gamlestaden Cotton Mill, where machines spun threads from cotton grown by enslaved laborers in the southern United States.[6]

We will never know whether or not my father's workstation was in the same building, or if he was even aware of these connections. He could not fail, however, to see the cruel irony of his next place of employment. When the Asken textile factory laid off workers in the late 1960s in the face of dwindling profits, Clarence took the only work available to him—hiring on as a dockworker unloading cargo from giant ships docked at the "Banana Pier" of Gothenburg Free Port. Until retiring in 1981, he bitterly made these sweet bananas from the Americas his livelihood. Clarence had moved from one end of colonial modernity to the other.

Arguably, the impossibility of escaping a past of colonialism and slavery is a hallmark of being Black today. American scholar Christina Sharpe calls it "a past that is not past," an "ongoing rupture."[7]

Clarence was joined at the pier by other migrants, including people of African descent, who formed a diasporic community of convenience. They were largely unwanted and out of place in Europe, and took to living as shadows. According to official Swedish historiography, they barely existed:[8] my father's incessant photographic documentation of friends and acquaintances tells a different story.

In looking back at my father Clarence, his life seems to recede into the shadows, joining the other Black people who were never given a letter in the written history of Gothenburg. These men and women broke off from the larger shadow body of the Black Atlantic, becoming stranded on Sweden's cold and rainy shores. The notion of a "Black Atlantic," a term coined by Paul Gilroy in 1993, captures the hybrid cultural, social, and political space that connects people of African descent in the modern era.[9] Undeniably, the intellectual production this space enabled has had a profound influence on European culture over the course of the twentieth century—from music to art to politics—but in the popular record is often overlooked, rendering our view of the European past poorer and more one-dimensional. As both Ehlers and Magassa seem to contend through their art, we cannot make sense of Europe's complex multi-cultural demography without considering the shadows of the Black Atlantic.[10] For instance: returning to Eric Magassa's installation, one photograph in *Walking with Shadows* shows a mildly smiling man peering at us from among the archival fragments which illustrate the time-space continuum of the contemporary Afropean. This is the African American conductor Dean Dixon (1915–1976), who served as artistic director of the Gothenburg Philharmonic Orchestra from 1953 to 1960. His workplace at the Konserthuset was only a short walk from Franska Tomten. During his time in Gothenburg, Dixon was enthusiastically lauded as a humanist innovator, modernizing the classical repertoire and introducing concerts for children and young people. He went on to have a successful career in Europe and the United States.[11] Nevertheless, when he left Gothenburg for Germany it was partly due to the racism he encountered in Sweden.[12]

The American novelist and playwright James Baldwin also made a short, ill-fated trip to Gothenburg. On October 6, 1965 (a Wednesday), Baldwin entered Folkteatern, addressing a janitor. Since the janitor spoke no English, as a news article would later report, after a brief, confused altercation, the visitor left the venue and then the city. Baldwin was there for the opening night of his play *Blues for Mister Charlie,* at the invitation of Folkteatern's director.[13] Leaving the theater and continuing along Järntorget, Baldwin may well have thought about the existential alien-ation of those living in the shadows of the Black Atlantic. Perhaps as he passed *The Five Continents,* which stands just outside the theater, he reflected on the figure of the kneeling African woman cast in bronze, who holds a water jug balanced on her shoulder.

MICHAEL BARRETT

Like other public memorials to the Atlantic world in Europe, the fountain celebrates and naturalizes the colonial division of labor and status. The black laboring body merges with the commodity it carries, just as my father hauls bananas in a mental image I cannot shake.

Not referred to in Strindberg's fountain but nevertheless omnipresent in the city are the celebrated names of the influential Gothenburg families Sahlgren and Röhss. Strangely disconnected from the material legacy of the Atlantic world, they are known for their philanthropy and as benefactors to the cultural life of the city. In fact, they were also investing in and profiting from imported goods manufactured by enslaved laborers in the Americas.[14] This aspect of Gothenburg history is patently uncomfortable; attending to it is like sitting on nails. Until quite recently, Swedish popular history has preferred to incorporate more comfortable stories about its past.[15]

We could listen to the growing number of writers who claim that European colonialism—the capture and exploitation of territory and natural resources, and the subjugation and enslavement of others—was integral to the forging of European modernity, its modes of production, consumption, value, and social hierarchy.[16] French Réunionese feminist scholar Françoise Vergès has powerfully articulated this idea:

Europe must remember slavery for many reasons. One being that the slave trade and slavery were a matrix of modernity. Of what Europe is so proud of. And the idea and invention of humanism, of "Man." And the division between who belongs to humanity—who is fully human, and who is not. And Africans were in the category of not totally human—subhuman—and they could be then captured and deported.

(...)

So, we cannot think of [Europe], even today, without thinking of how Europe was invented and on [what] Europe was built. It was also the wealth that Europeans took from slave trade and slavery.

(...)

GOTHENBURG'S BLACK
ATLANTIC SHADOWS

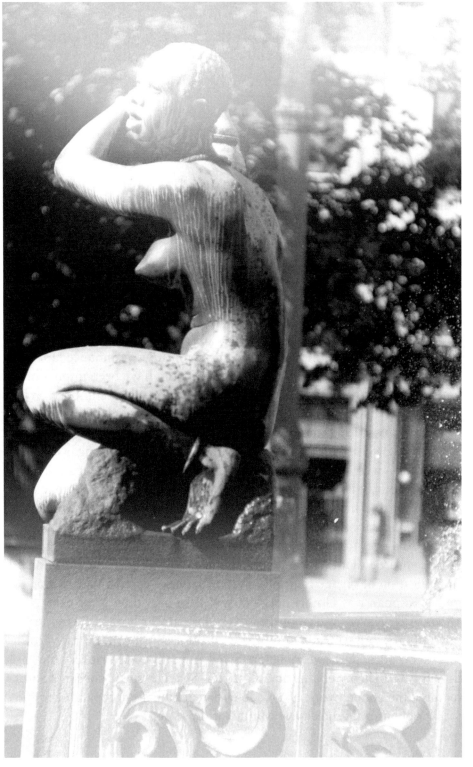

Africa, detail of *The Five Continents*, Tore Strindberg, 1927. Photographed by Clarence Goodwin Barrett, 1971.

MICHAEL BARRETT

Our way of separating production from consumption. I will consume coffee and sugar, and I will not pay attention to where, and how, and by whom it has been produced, as today, I will consume. So, even ethical consumption is still consumption from another place. It does not attack the international divisions [of] inequality between what we call North and South.[17]

This separation of production and consumption, Vergès insists, deeply influences our understanding of the world, both past and present. The neutrality of our historical vocabulary—"trade," "production," "commodity," "industry"—hides that which would cause us to question its singularly positive connotations. Take, for example, the early sugar "industry" in Gothenburg. The aforementioned Sahlgren Sugar Mill—a building my father may or may not have worked in while employed as a textile cutter at the Asken textile factory—was the leading producer of sugar in Sweden and one of the largest in Europe, until its dominance faded in the early nineteenth century. This industry would have been impossible without a cheap and steady supply of sugar cane molasses imported from plantations in the Caribbean, where some of the most violent and brutally exploitative labor regimes in human history were practiced. Death rates among the enslaved on Jamaica—one of the largest of the sugar cultivating islands—were staggering, with rape, torture, and various forms of corporal punishment being everyday occurrences.[18] Over the course of the eighteenth century, 575,000 captured Africans were needed for the enslaved population on the island to increase by a scant 250,000 people: disease, malnutrition, overwork, and the slavers' brutal punishment regime ensured that the death rate always exceeded births in the colony.[19] An indication of sugar's centrality to the European economy: the sugar mill at Klippan was Gothenburg's largest employer during the early 1800s. After slavery was abolished in the British Caribbean, the century saw imports shift to Cuba and Brazil, where it continued unabated for several decades. In the years before Sweden finally ended slavery on its Saint Barthélemy colony, in 1847, total Swedish sugar consumption required the annual work of 15,000 enslaved adults—comparable to the total population of the city of Malmö at the time.[20]

GOTHENBURG'S BLACK
ATLANTIC SHADOWS

Goods leaving Gothenburg Harbor were just as embedded in the Black Atlantic world as those arriving. The foundational Swedish iron industry has now lost its innocence, after its deep ties with the West African trade in human beings were exposed. It is estimated that Swedish iron constituted up to 18 percent of the European goods traded for kidnapped Africans in West Africa in the 1700s.[21] During a period of abundant herring fishing (1760–1808), half of the processed fish leaving Sweden's west coast ports would have ended up as food for the enslaved in the Caribbean.[22] As a temporal reminder of the importance of this nutrient-rich fish to local growth, the name of present-day Postgatan, which terminates at Franska Tomten, was once Sillgatan: iron and herring in exchange for sugar, cotton, and bananas were the seemingly innocent commodities of the transatlantic trade through which Gothenburg became embedded in today's exploitative global economic system.

Through their artworks and arts-based research, Magassa, Ehlers, and Osei-Kofi and Sawyer urge us to be more attentive to our built environment; to perceive what has been removed out of sight; to coax subjects and memories out from its shadows. To draw out, listen, and learn from the shadows is a way of actively being-in-the-world. It is a way of admitting that past events have made us as social beings, while simultaneously highlighting possible ways of acting on the world for the future.[23]

1. *Walking with Shadows* by Eric Magassa was commissioned by GIBCA in 2019 and installed at Franska Tomten for *Part of the Labyrinth*. It was made in collaboration with Trafikverket/ The Swedish Transport Administration. Franska Tomten ("the French Plot") was the spatial manifestation of a deal allowing French trading rights in Gothenburg, granted by Sweden in 1784 in exchange for sovereignty over the Caribbean island of Saint Barthélemy.

2. Michael Bachmann, "Not out of context: Eric Magassa's 'The Lost' Series," *Notes: Letters to Photography*, No. 4 (2018): 4–15.

3. Jeannette Ehlers, *Black Magic at the White House* (single channel video, 26:33), 2009.

4. Tore Strindberg's *The Five Continents* (1927) is a fountain incorporating five bronze figures representing the continents. Lena Sawyer and Nana Osei-Kofi, "'Listening' with Gothenburg's Iron Well: Engaging the Imperial Archive through Black Feminist Methodologies and Arts-Based Research," *Feminist Review 125*, No. 1 (2020): 54–61. The methodology of listening draws on Tina M. Campt, *Listening to Images* (Durham: Duke University Press, 2017).

5. Jean Besson, *Martha Brae's Two Histories: European Expansion and Caribbean Culture-Building in Jamaica* (Chapel Hill: University of North Carolina Press, 2002).

6. Victoria Ask and Johanna Roos, *Gamlestadens fabriker: Kulturmiljöbeskrivning – Planeringsunderlag* (Gothenburg: Antiquum, 2011).

7. Christina Sharpe, *In the Wake: On Blackness and Being* (Durham: Duke University Press. 2016), 13.

8. A growing body of work is beginning to redress this silence. See: Ryan Thomas Skinner, "Walking, Talking, Remembering: An Afro-Swedish Critique of Being-in-the-World," *African and Black Diaspora: An International Journal*, 12:1 (2019): 1–19. DOI: 10.1080/17528631.2018.1467747; Monica Miller, "Figuring Blackness in a Place without Race: Sweden, Recently," *ELH* 84, No. 2 (2017): 377–397; Nana Osei-Kofi, Adela C. Licona and Karma Chávez, "From Afro-Sweden with Defiance: The Clenched Fist as Coalitional Gesture?," *New Political Science* 40, No. 1 (2018): 137–150. DOI: 10.1080/07393148.2017.1418576; Lena Sawyer and Ylva Habel, "Refracting African and Black diaspora through the Nordic region," *African and Black Diaspora: An International Journal* 7, No. 1 (2014): 1–6. DOI: 10.1080/17528631.2013.861235; Michael McEachrane, ed. *Afro-Nordic Landscapes: Equality and Race in Northern Europe* (New York and London: Routledge, 2014).

9. Paul Gilroy, *Black Atlantic: Modernity and Double Consciousness* (New York and London: Verso Books, 1993). Gilroy insists on the fluidity and creativity of the Black diaspora identity, one shaped by the migration experience and a self-awareness responsive to the anti-black nationalism(s) it has encountered. As a perspective for understanding global history, and in drawing on writers and artists of the African diaspora, Gilroy's work is helpful in countering myopic and nationalist historiography. Making sense of Sweden's place in the Atlantic world (the territories and people that over the course of history have become entangled through trade, migration, and cultural exchange across the Atlantic Ocean) through the prism of the "the Black Atlantic," can thus serve as a corrective to what Lill-Ann Körber has characterized as "the White Atlantic," a nationalistic and nostalgic historical narrative that elides uncomfortable topics, suppressing the subjectivities of the colonized. Körber's work provides documentation of this tendency, referencing texts on the Swedish connection to the Caribbean island of Saint Barthélemy that foreground white beaches, quaint Swedish street names, and smiling creoles whose "fond memories" of the Swedish administration scarcely mention the whip wielding Swedish enslavers, or the local version of the Code Noir, laws devised to uphold the institution of slavery and resource extraction. Lill-Ann Körber, "The White Atlantic? Representing Scandinavian Colonialism." Paper presented at The Sea is History: Discourses on the Poetics of Relation, Oslo, 23 May, 2019. See also: Lill-Ann Körber, "Sweden and St. Barthélemy: Exceptionalisms, whiteness, and the disappearance of slavery from colonial history," *Scandinavian Studies* 91 (1-2): 74–97.

10. Writer/photographer Johny Pitts makes a similar point compellingly in an account of his travels across a European continent "populated by Egyptian nomads, Sudanese restaurateurs, Swedish Muslims, Black French militants …Yes, all this was part of Europe, too, and these were areas that needed to be understood and fully embraced if Europe wanted to enjoy fully functional societies." Johny Pitts, *Afropean: Notes from Black Europe* (London: Allen Lane, 2019), 8. Recent contributions to the history of Black people in Europe include Olivette Otele, *African Europeans: An Untold History* (London: Hurst, 2020) and David Olusoga, *Black and British: A Forgotten History* (London: Macmillan, 2016).

11. Homepage of Göteborgssymfonikerna. https://www.gso.se/goteborgs-symfoniker/dirigenter/ (accessed May 14, 2021).

12. "I have lately noticed blatant racial prejudice in the Nordic countries. In some hotels, I was denied a room until the manager was made aware of who I was." No author listed, "Dean Dixon vägrades servering i första klass" (Dean Dixon Refused Service in First Class), *Aftonbladet*, April 7, 1960 (author's translation).

13. No author listed, "Baldwin kom och kom inte" (Baldwin Came and Did Not Come), *Göteborgs Handels- Och Sjöfartstidning*, October 8, 1965 (author's translation).

14. The Sahlgren and Röhss families have a prominent place in the physical landscape of the city of Gothenburg, as attested to by the conspicuous presence of their name on streets, buildings, and institutions. For instance, the main hospital is named after Nicolaus Sahlgren (1701–1776), a long-term director of both the Swedish West India and East India companies and founder of the Salhgren Sugar Mill. The Röhsska Museum of Design and Craft was founded with donations from the Rhöss family, who were wealthy merchants heavily involved in importing coffee and cotton from the slave colonies.

15. Historical writing on Swedish entanglements with the Atlantic world and colonialism has been relatively limited, often emphasizing—without considering their wider impact on society—how Swedish colonial interests were insignificant and comparatively benign. A corrective to this is: Ylva Habel, "Challenging Swedish Exceptionalism? Teaching While Black," in *Education in the Black Diaspora*, eds. Kassie Freeman and Ethan Johnson (New York and London: Routledge, 2012), 99–122. More recently, a growing number of scholars are attempting to enrich our understanding of Sweden's role in the transatlantic slave trade, colonialism, and global political economy. See for example: Holger Weiss, *Slavhandel och slaveri under svensk flagg: koloniala drömmar och verklighet i Afrika och Karibien 1770–1847* (Stockholm: Atlantis, 2016); Holger Weiss, ed., *Ports of Globalisation, Places of Creolisation: Nordic Possessions in the Atlantic World during the Era of the Slave Trade* (Leiden: Brill, 2015); Magdalena Naum and Jonas M. Nordin, eds., *Scandinavian Colonialism and the Rise of Modernity: Small Time Agents in a Global Arena* (New York, Heidelberg, Dordrecht and London: Springer, 2013); Leos Müller, Göran Rydén and Holger Weiss, eds., *Global Historia från Periferin: Norden 1600–1850* (Lund: Studentlitteratur, 2010).

16. Aníbal Quijano, "Coloniality and Modernity/Rationality," *Cultural Studies*, Vol. 21, No. 2–3 (2007): 168–178.

17. Françoise Vergès interviewed by the author, Museum of Ethnography, Stockholm, October 2019.

18. Frank Wesley Pitman, "The Treatment of the British West Indian Slaves in Law and Custom," *The Journal of Negro History* 11, No. 4 (1926): 610–628; Stella Dadzie, *A Kick in the Belly: Women, Slavery and Resistance* (New York and London: Verso Books, 2020). Almost half—or just over six million—of the captive Africans that slavers brought to the Americas in the period 1501–1866 disembarked in the Caribbean, according to the authoritative research database Slavevoyages.org, hosted at Rice University. Five and a half million enslaved disembarked in Brazil, while less than half a million disembarked in North America. http://www.slavevoyages.org/estimates/dDKCJI9x (accessed September 26, 2021).

19. Trevor Burnard and Kenneth Morgan, "The Dynamics of the Slave Market and Slave Purchasing Patterns in Jamaica, 1655–1788," *The William and Mary Quarterly* 58, No. 1 (2001): 205–228.

20. Klas Rönnbäck, "Socker och slavplantager i svensk historia," in *Global historia från periferin: Norden 1650–1800*, eds. Leos Müller, Göran Rydén and Holger Weiss (Lund: Studentlitteratur, 2010), 97–115.

21. Göran Rydén, "Från Gammelbo till Calabar," in *Global historia från periferin: Norden 1650–1800*, eds. Leos Müller, Göran Rydén and Holger Weiss (Lund: Studentlitteratur, 2010), 75–96; Chris Evans and Göran Rydén, "'Voyage Iron': An Atlantic Slave Trade Currency, its European Origins, and West African Impact," *Past & Present* 239, No. 1 (2018): 41–70.

22. "Arfvidsson & Söner," *Svensson Nyheter*, 2012. http://blog.zaramis.se/2012/04/24/arfvidsson-soner/ (accessed May 30, 2021); Victoria Ask, ed., *Gamlestadens fabriker* (Stockholm: Antiquum, 2003), 26.

23. Tessa Morris-Suzuki, *The Past Within Us: Media, Memory, History* (New York and London: Verso Books, 2005).

MARINA REYES FRANCO

SOFÍA GALLISÁ MURIENTE

&

ON THE COMPLEXITIES OF CARIBBEAN SOLIDARITY

The initial invitation to contribute a text to this publication involved a possible travelogue or mixture of images and text—a curatorial and artistic response to contemporary Saint Barthélemy, preferably based on a visit to the island. Although we live in Puerto Rico, less than an hour by plane from Saint Barthélemy, travel restrictions during the pandemic, as well as the limited budget to travel to a place most people know only as a luxury destination, made this trip impossible. This impossibility mirrored the issues the GIBCA team has encountered in not being able to travel to or ship artworks from the region. Therefore, our participation in these pages must suffice—telling instead of showing—though it's clear to us how insufficient this effort will be. How could we, as an artist and curator from one of the many nations that make up the Caribbean, speak with certainty about a Caribbean we don't know? What would we imagine Saint Barthélemy to be, having never traveled there? Would we not merely reproduce the touristic narratives so entrenched in the Caribbean, and in the West's historic construction and understanding of us since the time of colonization? Saint Barthélemy continues to be unknown to both of us, so our counter-proposal was to write about some of the Caribbean people that we know who have tried to grasp the region's enormity.

We are writing this text from Puerto Rico, an archipelago of islands that were colonized by Spain in 1493 and now remain a colony of the United States since the Spanish-American War of 1898. While connections abound between islands that were formerly colonized by the same empire, as an island controlled by US law, a set of social, political, and economic circumstances preclude us from sharing the same experiences as even the closest of our island neighbors. The realities of contemporary sea travel between Caribbean islands oscillate between extremes: some people travel by raft or motor-powered makeshift wooden boats such as *yolas* on their way to what they hope will be a better life; others do so by yacht, island hopping and sports fishing. Geopolitical divisions and visa requirements add another layer of privilege and exclusion. If traveling by plane, a Miami stopover is very likely, but only if you possess a US visa. Although the Caribbean was populated by navigators, ancestors who traversed the Caribbean Sea, the Gulf of Mexico, and the Atlantic Ocean to inhabit thousands of islands—today this freedom of movement is nearly impossible for the average islander. In the Puerto Rican archipelago, only Gilligan Island, an uninhabited key popular with beachgoers, can be accessed by public ferry; every other island has been privatized. On Culebra and Vieques, two island municipalities that are part of Puerto Rico, a functioning ferry service

scarcely exists, even though residents must visit the main island for medical services, education, and other basic necessities.

The Caribbean is an imagined community claimed by people isolated from each other—by history, language, capital, geography, and national borders—yet yearning for connection. This text narrates four different attempts to breach the distance between islands, driven by art, solidarity, and shared struggles. The failure of these gestures reveals a larger impossibility. The Caribbean is never one thing, never fully encompassed; it seems to exist immeasurably. In the words of Édouard Glissant, one of the most lucid Caribbean thinkers of recent decades:

> The Whole-World, which is totalizing, is not (for us) total. ... And I call Poetics of Relation this possibility of the imagination that leads us to conceive of the elusive 'worldness' of such a Chaos-World, at the same time as it allows us to pick up some detail from it, and in particular to sing the praises of our place, unfathomable and irreversible. Imagination is not a dream, or the emptiness of an illusion.[1]

What follows is a succession of tales of Caribbean navigation that rhyme with each other: though scattered throughout the archipelago, their protagonists relate poetically and chaotically. Our intention is not to analyze them or draw from them any definite conclusions, but to inscribe them within a greater social history of art, complicating the myths that persist about our region in faraway lands.

Silvano Lora

Silvano Lora (b. Santo Domingo, 1931–2003) was a multifaceted artist who developed an ever-expanding socially engaged practice as a painter, sculptor, muralist, printmaker, stage and costume designer, poet, filmmaker, performer, and cultural organizer. He was and remains an essential artist in both modern and contemporary Dominican art history, who placed social struggle at the center of his political and artistic endeavors. His contributions as an artist, revolutionary, and founder of the Bienal Marginal, have yet to be fully recognized and studied.

1. Édouard Glissant, *Treatise on the Whole World*, trans. Celia Britton (Liverpool: Liverpool University Press, 2020 [1997]), 12.

By the early 1990s, Lora had become engaged in social and artistic actions in the Santa Bárbara neighborhood of Santo Domingo, where he staged the first Bienal Marginal in 1992, conceived in opposition to planned festivities celebrating the 500-year anniversary of the arrival of Christopher Columbus in the Americas. The city's grandiloquent commemoration of Caribbean colonization included a welcoming celebration for replicas of Columbus' caravels and the inauguration of the Columbus Lighthouse, a mausoleum/museum built between 1986 and 1992. Funded by several Latin American countries, the project cost US$ 70 million. The building projected a cross-shaped light skywards at a time when power outages were common in Santo Domingo.

Construction of the Columbus Lighthouse was only possible due to mass evictions in the surrounding area of Santo Domingo Este. Other quincentennial-related renovations in the capital's Zona Colonial (Colonial Zone) also put residents of the Santa Bárbara neighborhood in special danger of being evicted. By staging the Bienal, as well as through his own artistic actions, Lora protested against the celebration of the so-called "Discovery of America." But these were also a direct response to the terrible living conditions in what was once the site of a quarry mined to build one of the first cities in the Americas. According to Lora's collaborator Óscar Grullón, with whom he co-organized the Bienal Marginal, the Santa Bárbara neighborhood, located behind the sixteenth century Spanish fortified palace Alcázar de Colón, was the first slum in America, where they had locked up the enslaved before they were sold at La Plaza.[2]

Recounting Lora's actions, particularly the events of 1992, entails a belief in the merits of myth-making. There are difficulties in writing about the much-retold story of how he crossed the Ozama River in a canoe to interrupt the celebrations of the quincentenary of the "Discovery of the New World."[3] Depending on which account you read, he rowed towards the replicas of Columbus' ships in a "symbolic and funny protest,"[4] shot arrows at where the Columbus Lighthouse inauguration was being held, or threw paint darts at the Spanish training ship *Juan Sebastián Elcano* while wearing a loincloth. Some write that he did this

2. Rosanna Cruz Betances, "Santa Bárbara: Arte Marginado," *Listín Diario*, August 10, 2013. http://www.listindiario.com/ventana/2013/08/10/287763/santa-barbara-arte-marginado (accessed June 14, 2021).
3. Documentation of the protest/performance action *Crossing the Ozama River in Remembrance of the 500 Years of Indigenous Resistance in the America* (1992) was shown at Röda Sten Konsthall as part of GIBCA 2021, courtesy the artist's daughter, Quisqueya Lora, and the Taller Público Silvano Lora, Santo Domingo.
4. José del Castillo Pichardo, "El Vuelo De Silvano," *Diario Libre*, August 24, 2013. http://www.diariolibre.com/opinion/lecturas/el-vuelo-de-silvano-KCDL399276 (accessed June 6, 2021).

"practically alone," while at least one account describes his actions as taking place with the help of a local craftsman, sometimes referred to as Pachito or Pachiro, and within the larger context of street theater happenings and concerts denouncing the celebrations.[5] To complicate matters further: Lora carried out two performative events in a canoe during the same year and these are sometimes confused. One was his interruption of the reception of the replicas of Columbus' caravels on the Ozama River; the second was *La ruta de Hatuey* (Hatuey's Route), a multi-pronged artistic project that included a journey from the Dominican Republic to Cuba.

Extant documentation of Lora's intervention on the Ozama shows him, together with a companion, rowing in a canoe towards the Spanish conquistador ship replicas, bearing an offering for the descendant of Christopher Columbus who had traveled to Santo Domingo for the event. Intercepted by Dominican Navy officials, the motorboat's wake capsized Lora's canoe, causing a potentially dangerous situation, since, oddly enough, he did not know how to swim. Once back on land, wet and annoyed, he gave an interview to the surrounding press:

> We think that it is not a celebration but a commemoration of an event that could have been happier, and that, unfortunately, was called colonization, was called conquest. We think that the Spanish people, the peoples of Europe, the peoples of the world, can find a better way of coexistence and throw the forms of colonization and oppression into the dustbin of history.[6]

Later that year, Lora embarked on the aforementioned *La ruta de Hatuey* project aboard *Hatuey II*, a 31-foot dugout canoe made from a single sandbox tree. Consisting of a journey in July 1992[7] from the town of Sánchez in the Dominican Republic to Baracoa, Cuba, both project

5. Amaury Rodríguez, "Silvano Lora: His Legacy Lives On," CUNY *Dominican Studies Institute Library*, September 17, 2013. http://www.cunydsi.typepad.com/dominican_library/2013/09/silvano-lora-his-legacy-lives-on.html (accessed June 6, 2021).

6. "Silvano Lora y Su Arte Irreverente," cited in an unnamed article from *Periódico Hoy*, January 1, 1992. http://www.silvanolora.org/portfolio/silvano-lora-y-su-arte-irreverente/ (accessed May 14, 2021).

7. Although there are conflicting published accounts, we have confirmed that *La ruta de Hatuey* occurred in July, 1992. Performar. Espacio de convergencia. Encuentro internacional de performance y arte acción (Performar. Space of convergence. International meeting of performance and action art). Santo Domingo: Centro Cultural de España, 2009, and: "Silvano Lora y Su Arte Irreverente," http://www.silvanolora.org/portfolio/silvano-lora-y-su-arte-irreverente/ (accessed May 15, 2021).

Silvano Lora vs the Caravel. Illustration by Fernando Norat, 2021.

and canoe reference the *cacique* (chief) who in 1511 rowed from Ayití (Hispaniola) to Cuba in order to alert his fellow Taíno tribespeople of the approaching Spanish threat. Hatuey would later lead the first indigenous guerrilla resistance on the island, dying at the stake in 1512. *La ruta de Hatuey* also incorporated several education initiatives, including a reforestation campaign, a course of study about the construction of the canoe and its materials—as well as an exploration of the canoe as an indigenous tool for transport, fishing, and other activities—and the publication of a storybook, written by Lora and illustrated by school children.[8]

Both his Columbus Lighthouse intervention and *La ruta de Hatuey* were influenced by Lora's participation in the 1987 expedition "In Canoe from the Amazon to the Caribbean," organized by the Cuban geographer, speleologist, and archaeologist Dr. Antonio Núñez Jiménez. Fifty Cuban and Latin American researchers and artists participated in the expedition, touring more than twenty countries—from Ecuador to The Bahamas—aboard twelve canoes. Some participants joined the expedition for only a portion of the route—Lora among them, who was part of the crew

8. Performar. Espacio de convergencia. Encuentro internacional de performance y arte acción. Santo Domingo: Centro Cultural de España, 2009.

during their Caribbean journey, embarking from Trinidad and Tobago on August 17, 1987. This expedition united Lora's diplomatic experience as a politically engaged artist affiliated with the Dominican Communist Party with the poetic, symbolic, and performative aspects of this arduous journey across the Caribbean, undertaken at a time when Hispanophilia was running rampant across Latin America. The expedition was undertaken while preparations were already underway across the world to celebrate the quincentenary of Columbus' arrival on the Lucayan island of Guanahani, inaugurating European colonization of the Americas in what is now The Bahamas. The itinerary was meant to emulate the possible route indigenous peoples might have taken in populating the Caribbean, highlighting their contributions and cultural persistence, as well as the genocide colonization unleashed. Significantly, among the canoes used in this expedition was one named *Hatuey*, which was pulled out to sea during a storm while the group was stopped on the island of Nevis, making it necessary for the adventurers to carry on in the remaining canoes.

The group continued on towards The Bahamas, until they were rescued by the Cuban Coast Guard on November 23. The *Hatuey*, however, remained lost at sea for over 40 days, eventually entering US Navy-occupied territory off the Puerto Rican island of Vieques. Thus, despite the US State Department's refusal to grant visas to the expedition's Cuban crew members, making a planned stop in Puerto Rico impossible, poetically the *Hatuey* arrived in Vieques on its own. A local fisherman, thinking the flipped-over canoe was a dying whale, rowed closer to investigate and, with the help of his colleagues, dragged the canoe to shore. Eventually, *Hatuey* was sent to the Dominican Republic to rejoin the expedition, and several months later Lora joined a partial crew that was restarting the trip from there aboard the canoe, finally landing in The Bahamas in June of 1988.[9]

Lora's actions in 1992, from his interruption of the ceremonies on the Ozama River to staging the Bienal Marginal to undertaking the *La ruta de Hatuey* project, were an homage to the marginalized Caribbean peoples who had been erased from history. He is part of an ongoing tradition among artists and activists in the region who redo the journeys of admired predecessors—those who have engaged in pro-independence or anti-colonial struggles across the region.

9. All dates and details of the trip are from: Ángel Graña González, *Memorias y Viajes* (Havana: Fundación Antonio Núñez Jiménez De La Naturaleza y El Hombre, 2008).

The epic tales of Alberto De Jesús Mercado, an electrician and environmental activist better known as Tito Kayak (b. Jayuya, 1958), would be better told as a superhero comic book. They are always recounted as a sequence of increasingly heroic stories, like waves getting successively larger. Mercado, who was once a US Coast Guard marine, has been protesting with his kayak since 1994. Sometimes he also climbs construction cranes, buildings, or antennas as a protest against everything from plutonium shipments, to the US military presence in the Caribbean, to the privatization of beaches, to Israeli abuses against the Palestinian people.[10] In 2014, he achieved international notoriety by climbing up to the Statue of Liberty's crown to denounce the US Navy presence on Vieques, earning him a year in prison. The last wave of protests in the decades-long struggle against the US military presence in Puerto Rico had been rekindled by him in 1999, when he kayaked into waters controlled by the Navy, planting a flag on a tank used for target practice and then refusing to leave. His actions are always swift and brave; his body's endurance is his weapon. Though he has never identified himself as an artist, one look at him in action (in person or on YouTube) is enough to understand why he belongs in an art publication. Yet, one ambitious goal has eluded him—to paddle from Venezuela to Cuba in his single-person kayak.

Tito has traversed many parts of the Caribbean during the past 15 years, island hopping throughout the Antilles. His reasons are many: to advocate for the freedom of independence leader and former political prisoner Oscar López Rivera; to denounce militarization in the region; to promote unity amongst Caribbean people. "We seek Caribbean brotherhood," he proclaimed in a video, upon landing in Vieques during a trip between Saint Croix and the Dominican Republic in 2006, speaking in undefined-yet-determined plurals.

The so-called "Expedición Filiberto Ojeda-Silvano Lora" was a nod towards two other freedom fighters not unfamiliar with expressing themselves beyond the trenches of political action. Besides commanding an underground guerrilla group known as Los Macheteros (until assassinated by the FBI in 2005), Ojeda was also an accomplished trumpet player; Lora's prolific artistic and political endeavors have previously been described. The most challenging part of this journey was the Mona

10. In 2010, the Puerto Rican Senate approved what was popularly known as the Tito Kayak Law, making the obstruction of a construction a felony. It was later rescinded.

SOFÍA GALLISÁ MURIENTE &
MARINA REYES FRANCO

Passage between Puerto Rico's western coast and the eastern coast of the Dominican Republic. Although only 121 kilometers separate Punta Cana from Rincón, this stretch of sea possesses treacherous currents and shark-infested waters that have claimed the lives of thousands of migrants trying to reach Puerto Rico. After several attempts, Tito successfully crossed in the opposite direction—from Puerto Rico to the Dominican Republic—and was immediately detained for trespassing on a private beach.

A second, more arduous, journey would come in 2012, when Tito attempted to kayak 2,600 kilometers from the Venezuelan port of Macuro to Puerto Rico during hurricane season. Aside from continuing to advocate for the freedom of Oscar López Rivera (whose sentence would finally be commuted by Barack Obama during his final days in office), this expedition was also undertaken as a homage to the Arawak people, who had traveled a similar route—from South America through the arch of the Antilles—centuries before the arrival of Columbus. Salvador Tió, one of Tito's spokespeople, explained that the mission "sought to overcome the distancing provoked by the historical reality of each island and of the region."[11] For a people whose past was purposefully obliterated as part of a long-term project of colonial domination and erasure, little evidence has been preserved and often public education efforts rely on myth and manipulation. Historical memory and historically significant sites have survived thanks to continued use, interventions, and the informal conservation efforts of people who connect with their meaning. Tito sailed the same waters and faced the same currents as our ancestors, participating in the continuation of a scattered history. For this expedition he used a wooden kayak (*piragua*) named *Cetáceo* (Cetacean), built in Venezuela. By this time, Tito's revolutionary fervor had won him comrades throughout the world and his organization Amigos del MAR (Friends of the SEA) had taken on a more radical tone, claiming that the word MAR stood for Movimiento Ambiental Revolucionario (Revolutionary Environmental Movement). Accordingly, he began the trip escorted by two Venezuelan navy vessels. He couldn't disembark in Trinidad and Tobago due to his previous arrest there for protesting, so he stopped at a Saudi-Venezuelan oil rig in the open sea, then continued rowing with an inflamed wrist for nearly 95 nautical miles until reaching Carriacou, south of Grenada. Tito kayaked alone through the smaller Grenadines heading towards Saint Vincent—with broken oars fixed with tape and without a radio—but shipwrecked on the Grenadine isle of Bequia before reaching his

11. Juan Cermeño, "Travesía a remo por la libertad y la paz," ciudadces.info, May 17, 2012, http://www.cstytdc.blogspot.com/2012/05/travesia-admirable-por-la-libertad-de.html (accessed May 15, 2021).

intended destination.[12] Strangers came to his rescue, helping him to fix *Cetáceo* while he waited for a new vessel.

Days later, Tito paddled past Saint Lucia and Martinique—avoiding currents and under the haze produced by the volcano La Soufriere—arriving in Dominica, where he was hosted by the Kalinago community. He spent the night in the Caribbean's largest indigenous enclave, and an advance team met him there, providing little Puerto Rican flags for him to hand out. The blue triangle matched the blue of the skies that was reflected on the waters he navigated. Everywhere he landed, he was greeted by local activists and supporters who offered him platforms to speak about his experience. This "pilgrimage through the Caribbean," as he called it, continued through the islands of Guadeloupe, Montserrat, Saint Kitts, Nevis, Saint Barthélemy, and Saint Martin; islands close enough to each other that he could embark from one while in view of the next, orienting himself solely by sight. Yet, his voyage would come to a halt upon landing on Saint Martin, for reasons that included bad weather, a broken kayak, health issues, and the delicate condition of his ailing father. From Saint Martin, Tito flew to Orlando, Florida, to be with his father on his deathbed.

The expedition was resumed some weeks later, on August 31, 2012, when Tito returned to Saint Martin to recover his kayak in order to head north towards Anguilla. Later he would speak of feeling his father with him as he battled the open sea, rowing for 30 hours straight during a second shipwreck that occurred between Anguilla and the island of Virgin Gorda. Tito claimed he never felt alone at sea but "in harmony with the universe," even when he was not in sight of land. He was kayaking with his ancestors, in his native waters; his father providing solace, just as he had once flown a kite with water bottles attached to help Tito stay hydrated while protesting on the eaves of a government building. He wasn't a foreigner crossing international waters, he was a Caribbean man sailing Caribbean seas.

Tito's shipwreck resulted in a brief hospital stay on Tortola to treat his exhaustion, hypothermia, and dehydration, yet he remained undeterred. On September 16, 2012, at last he landed at Vieques, the easternmost island of Puerto Rico—the island he had defended for so many years—to be greeted by the warm embrace of a handful of friends and admirers.

12. In the context of this text, we are using "shipwreck" as a translation for the Spanish word "naufragio." In English Creole usage and in Spanish, "shipwreck" can mean that the vessel was lost at sea and badly damaged but was nevertheless fixed and able to continue its journey.

Tito Kayak in Martinique. Illustration by Fernando Norat, 2021

La Flexible

On November 3, 2003, a crew of six boarded a small *yola* christened *La Flexible* in the municipality of Rincón, Puerto Rico, en route to the fifth Bienal del Caribe at the Museo de Arte Moderno in Santo Domingo. *La Flexible* and its crew—made up of artists Raimond Chaves, Carolina Caycedo, Jesús "Bubu" Negrón, and Chemi Rosado Seijo, collaborator Olga Casellas, and Carlos Casellas, who served as captain—was escorted by a second, larger boat. The group had been assembled by curator Michy Marxuach, who had been invited by museum director Sara Hermann to participate as part of the biennial's Puerto Rican delegation.[13] As it made its way from Rincón to Punta Cana, *La Flexible* was aided across the Mona Passage by the current, arriving in approximately four hours on a beautiful, unusually clear day. During the voyage, the group was filmed hanging out, swimming in the strait, and listening to reggae and reggaetón, while Negrón drew scenes with an indelible Sharpie marker on plastic sheets, his solution for making the drawings waterproof.

13. Michy Marxuach is the founder of M+M Proyectos, an artistic residency program and platform for conceptual art based in San Juan. She has developed a vast network of international collaborators through biennial events like *PR'00* (PARÉNTESIS EN LA "CIUDAD") and *PR'02* (En Ruta), which created considerable excitement about the Puerto Rican art scene. The Puerto Rican delegation included: Bubu Negrón, Tony Cruz, Beatriz Santiago, Edmeé Feijo and Chemi Rosado. Caycedo, a Colombian who at the time lived in Puerto Rico, and Chaves, were both invited to the biennial by Colombian curator María Inés Rodríguez.

This *yola* had its own mysterious yet not surprising origin story: it had been found on the northwestern coast of Puerto Rico, possibly abandoned after a group of undocumented migrants had completed their journey. Fueled by economic despair, thousands of Dominicans have made the journey to Puerto Rico, particularly during the first half of the 1990s. As a project, *La Flexible* was initiated by Chemi Rosado Seijo based on the question of what would happen if this journey was reversed.[14]

This question not only harkens back to Pre-Columbian migration and the inter-island connections that existed in early Caribbean societies, but evokes a more recent past, when Puerto Ricans were the migrants, drawn to the Dominican Republic by its buoyant sugar industry.[15] During the late nineteenth and early twentieth centuries (roughly from 1890 to 1920), thousands of workers from Puerto Rico became day laborers and foremen on Dominican plantations. Starting in the 1960s, however, political turmoil in the Dominican Republic and the United States' Cold War policies prompted a reversal of the flow of migration. During the intervening years, Puerto Rico had access to New Deal funds, participated in the war economy during WWII and was later economically propped up by tax incentives for corporations that propelled an expansion of the middle class, serving as an example of "good" US intervention in Latin America. Meanwhile, the Dominican Republic endured the rule of longtime dictator Rafael Trujillo, an American-supported autocrat who governed from 1930 until his assassination in 1961. This was followed by the brief presidency of Juan Bosch, who was quickly ousted in 1963, a military junta, a civil war and, finally, a US invasion in 1965 that was meant to stabilize the country by installing a president favorable to US interests. Between 1966 and 2002—the year before *La Flexible*'s voyage—118,999 Dominicans legally immigrated to Puerto Rico; countless others attempted the treacherous journey in overcrowded, makeshift boats—many dying en route—only to be captured by US immigration authorities. Chemi's proposed trip "in reverse" now seems like a premonition. By 2006, Puerto Rico would be plunged into a still ongoing economic depression, turning the seemingly buoyant economy of the early 2000s into a mere mirage, an indication that we had been living on borrowed time and cash.

14. Michelle Marxuach, "Archivo Informal," *Bienal Caribe—Archivo Informal*, http://www.cargocollective.com/archivoinformal/Bienal-Caribe (accessed June 14, 2021).
15. Jorge Duany, "La migración dominicana hacia Puerto Rico: una perspectiva transnacional" (Dominican migration to Puerto Rico: A Transnational Perspective) in *Globalización y localidad: Espacios, actores, movilidades e identidades*, eds. Margarita Iguiniz Estrada and Pascal Labazée (Marseille: IRD Editions, 2007), 397–428, http://www.books.openedition.org/irdeditions/26945 (accessed June 14, 2021).

Once *La Flexible* arrived in Punta Cana, everybody was processed through immigration and the trip continued to Santo Domingo, where the artists unloaded the boat, hauling it to the exhibition hall of the Museo de Arte Moderno. The video of the journey was shown alongside a selection of Negrón's Sharpie drawings. The boat, which had been refurbished and equipped for the trip, had also been painted with stenciled phrases, such as "CON EL AGUA HASTA EL CUELLO" (with water up to our necks) or "ni de aquí ni de allá" (neither from here nor there). The latter slogan seems fitting for a boat with a name like *La Flexible*, especially as its voyage dislocated the site of the artwork from the biennial to the middle of the sea. There is a desire expressed in this project to turn this "geographically discontinuous region"[16] into one united by water and boats.

Once installed, however, the project caused a controversy in the Dominican press, who took offense at the use of the *yola*, pointing to the discrepancy between the conditions under which Dominican migrants travel to Puerto Rico and the rather more joyful experience of *La Flexible*'s crew, as captured on video. While the artists had thought of *La Flexible* "as an attempt to playfully negate boundaries represented by nationhood, citizenship and empire,"[17] some Dominicans seemed to consider the action as defamatory or ridiculing the plight of migrants who regularly risk their lives traveling by boat, without escorts, GPS, or, crucially, a US passport. Although the empathy *La Flexible* sought to express was partially rejected, it was undertaken in a genuine attempt to connect with an imagined Caribbean.

A Puerto Rican Flotilla

In September 2017, during a historic hurricane season for the Caribbean, Hurricane Irma tore through the US and British Virgin Islands, causing only minor damage in the eastern part of Puerto Rico. Puerto Ricans quickly mobilized relief efforts to support "our Antillean neighbors" (or, more often, "people from the little islands," as many expressed it on social media and in the press). Governor Ricardo Rosselló, who would be kicked out of office two years later following massive public protests, looked more statesmanlike than usual, wearing his official governor

16. Jaime Cerón Silva, "La 5a bienal que mira hacia el caribe," *ArtNexus*, No. 98, http://www.ceronresumido.com/La-5a-bienal-que-mira-hacia-el-caribe. (accessed June 14, 2021).
17. Anna Schneider, "'El Flexible': Tensions in the Caribbean Sea," *Springerin*, Issue 03 (2009), http://www.springerin.at/en/2009/3/el-flexible (accessed June 10, 2021).

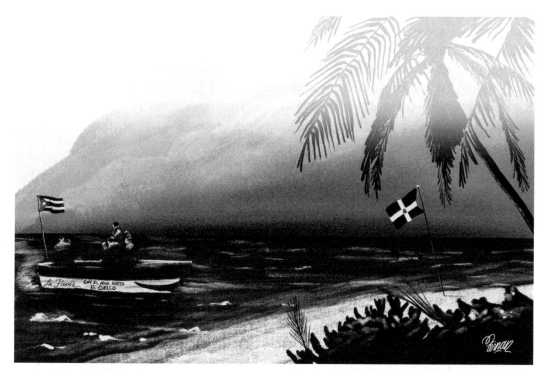

La Flexible Arriving in the Dominican Republic. Illustration by Fernando Norat, 2021.

windbreaker and hugging evacuees in front of cameras as they landed at the airport. The sudden outpouring of solidarity from a people who felt they had narrowly avoided catastrophe now seems distant and ironic considering that only two weeks later Hurricane Maria would devastate Puerto Rico, and we would be the ones receiving shipments of flashlights and used clothes.

What stands out in retrospect was the fact that so many of the donation drop-off sites were located in marinas, boat dealerships, and yacht clubs. In the days after Irma, the self-organized relief efforts—delivering supplies to places like Tortola and Jost Van Dyke, picking up stranded survivors, and documenting the wreckage by posting videos on social media—were often led by wealthy Puerto Rican boat owners, accustomed to traveling to the US and British Virgin Islands for weekend fishing tournaments and vacations. While their generous efforts are certainly commendable—hundreds of volunteers packed shipping containers full of supplies and evacuated people in need, among other things—the heroism would be short-lived and revelatory of the visitor economy of the region. Less than a week after the hurricane, the US Coast Guard would

start issuing warnings regarding dangers faced by the spontaneous flotilla, who kept showing up like curious neighbors carrying bottled water and canned food, and then ended up needing help, thus diverting local resources. The press circulated the cautionary tale of a Puerto Rican couple who took off on their own carrying emergency supplies to Saint Thomas and were held up at gunpoint by a smaller boat, then left stranded in a *yola*. Some even spoke of modern-day pirates and an imminent civil war as desperate islanders struggled to survive food and water shortages, while the Dutch, French, British, and American imperial powers struggled to respond and retain control.

Looking Out to See

The overwhelming majority of Puerto Ricans who have visited the Antilles have done so on cruise ships, on a tight holiday schedule that limits the possibilities of any real exchange with locals. So, who gets to imagine these as neighboring islands? Who has real access to the dream of Antillean brotherhood in Puerto Rico today? The British and American Virgin Islands have ferries that connect them and trade agreements that foster exchange. For Puerto Ricans, it remains cheaper to fly to New York than to Tortola, though they both remain a part of our imagined neighborhood. For others, used to fearlessly tearing through the waters on luxury boats, the trip can be done in a couple of hours if you have the right motor.[18] Ours is a fractured, controlled-access neighborhood.

Nevertheless, our regional consciousness and desire to be connected persists. We chose to write about these four instances of Caribbean solidarity, because in retelling them we are amplifying that possibility, manifesting our desire for interconnectedness. When you come from a small place, there's a lot at risk from being forgotten. Art can offer other strategies for remembering, and the freedom to rewrite. We know our islands are surrounded by other islands, with people and stories similar to ours; so, we write as they sailed. We seek each other out and imagine each other's islands, even if often the only way we can visualize them is by looking out at the sea at night to find lights in the distance.

We look out, even if we can't see anything at all.

18. "One week-long event held in July in the British islands attracts such a large contingent of visiting boats that locals joke about hosting the Puerto Rican Navy." Luis, Ferré-Sadurní, "Spared Irma's Worst, Puerto Ricans Sail to Virgin Islanders' Aid," *The New York Times*, September 11, 2017, www.nytimes.com/2017/09/10/us/puerto-rico-virgin-islands.html (accessed May 14, 2021).

REBECKA KATZ THOR

VULNERABLE MEMORIES: MONUMENTS AND GRIEVABILITY

Daniela Ortiz, *In the Celebration of Our Struggles Is Their Collapse* (detail from proposal), 2020.

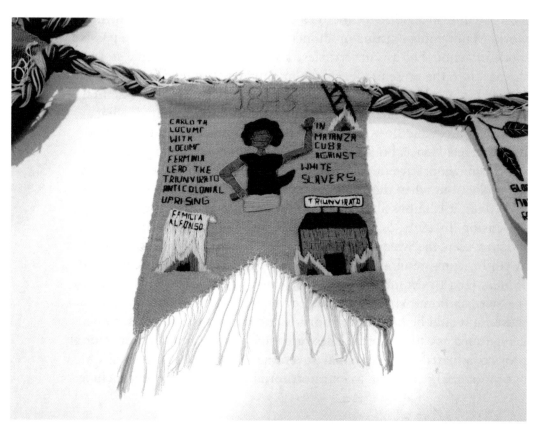

Daniela Ortiz, *In the Celebration of Our Struggles Is Their Collapse* (detail from work), 2021.

How are historical events made visible in the contemporary? Can monuments be used to care for and acknowledge wounds from the past instead of trying to heal and conceal them? Sweden's colonial history is seldom brought forth in public discourse, neither the colonization of Sapmí in the twelfth century nor colonial endeavors in the West Indies in the eighteenth century. In the summer of 2020, millions of people demonstrated in support of the Black Lives Matter movement as a direct response to American police brutality and structural racism. One of the protests' key issues was how history is represented and what view on historical events is upheld within the public realm. Demands to remove statues celebrating violent colonial histories in both Europe and the United States was a direct result of such structures of visibility in invisibility that pervade the public realm. In Sweden the discussion momentarily surfaced, but soon vanished again. The statues still stand.

A prominent feature of most monuments is that they contribute to the historical narrative of and about a society. Erecting a monument can be thought of as a society's way of saying: We, as representatives of the state/region/city, acknowledge what happened, and wish this acknowledgement to be visible for future generations. Thus, erecting a monument is a way of writing history, turning passive memory and processes of memorialization into an action—a care for, a concrete doing, as well as a form of work. Maintaining existing monuments might appear as a more passive mode of action, but it is nevertheless a way to further a specific story of the past into the present. Hence, the monument's context, its motif, time of creation and placement, as well as the viewer's gaze are all essential, since they all are facets of the way remembrance is negotiated, what is remembered, and how remembrance is put into practice in a shared public space. Hence, both presentation and encounter take place there.

Commemorative projects result from a wide range of commissioning bodies, but when they are the outcome of high-ranking political initiatives, it is impossible to ignore their national historiographic dimension. In 2014, on the tenth anniversary of the tsunami in the Indian Ocean, the Swedish government decided to erect a memorial for its Swedish victims, resulting in a public work by Lea Porsager, *Gravitational Ripples* (2018). On International Holocaust Remembrance Day in 2019 the Swedish Prime Minister Stefan Löfven announced that a Swedish museum would be built in memory of the Holocaust's victims, to be inaugurated as early as 2022. These are merely two examples of memorial projects initiated by the national government: both are expressions of a form of grief pertaining to extraterritorial events; they do not include

a scrutinization of Swedish national history. What they accomplish, whether they make visible and acknowledge or cover up and conclude, is not a given. The salient fact is this: these projects were chosen and implemented by the state, which is crucial to how they subsequently should be read. Further, the proposal for a Holocaust Museum was made by a survivor and adopted by the government. Similar processes are often seen at the local or regional level. What may appear at first glance as a technicality has great significance, since the formation of commemorative projects also involves a negotiation about which lives are considered grievable and which wounds are worth tending to.

In 2019, the Göteborg International Biennial for Contemporary Art (GIBCA) launched a three-year project centered around the idea of building a monument to the victims of Swedish colonialism at Franska Tomten, adjacent to Gothenburg Harbor. GIBCA invited artists, curators, and researchers to reflect on the past and present implications of the site and to propose interventions in the form of artworks. The biennial's work on Franska Tomten also included installing artworks on site, as well as a series of events that approached the theme of Swedish colonial history from different angles. For the 2021 edition of the biennial, which coincided with the celebration of Gothenburg's 400th anniversary, GIBCA's engagement with the site went beyond the concrete issue of a monument, taking Franska Tomten as a starting point for a critical approach to Sweden's colonial history that permeated the whole biennial. Elsewhere in this publication curator Lisa Rosendahl describes how this history is reflected in the present buildings and activities—the former headquarters of a transatlantic shipping company, a court, a casino, a museum of migration, the port and the sea—and how they illuminate the link between the past and present, along with how the City of Gothenburg is interlinked with other parts of the world.

The gesture of taking Franska Tomten as GIBCA's narrative point of departure opens up an understanding of the colonial project that is not bounded by the period when Franska Tomten was actually a French possession, lending itself to a view of colonialism as a continuum that began much earlier and has not yet ended. This continuum is evidenced by the traces of colonial motifs present on site, such as the reliefs on the facades that refer to the global scale of the shipping industry, or the bronze flagpole studded with a sculpted hippopotamus, a monkey, and four people in loincloths—two of whom carry a third in a sedan chair while one balances a parcel on his head—all of whom are surrounded

Proposal for Franska Tomten by Fatima Moallim. Detail from *Legera (Alloy)*, 2020.
Stainless steel sculptures at human scale. Rendering by Nils-Erik Fransson.

by tropical flora. These visual traces of the colonial project illustrate a line running from the colonial world's conceptual underpinnings, through the period where merchant shipping was a principle engine of Sweden's economic growth, and into contemporary capitalism.

Every monument can be seen as governed by at least three temporalities: the time it represents, the time when it was created, and the time in which it is read. If interpreted through such a three-part lens, the key to understanding simultaneously resides in the instability of such temporal structuring—hence, who sees, what is visible for whom, and when it is seen. The three temporalities of the monument do not comprise a definite past, present, and future. They speak more to a movement through several points in the then, the now, and the uncertain future, reflecting the tension that exists between the monument itself, the agency of the work, and how it is read. Therefore, monuments need to be understood in context: who commissioned the monument and when, what is its shape and form, and how are these formal aspects discussed concurrent with and in relation to how they are perceived today.

Franska Tomten is not so much a place where something actually took place, but rather an integral part of the larger negotiation that enabled Swedish colonialism in the West Indies. Yet, traces of Gothenburg's past as a trade and shipping hub are manifest at the site and, hence, possess a built-in element of colonial exploitation. Sites where historic crimes and events took place could be regarded as a type of monument in themselves, and their perceived authenticity is a key component in many commemorative practices. The crime addressed by a possible monument erected at Franska Tomten took place somewhere else, yet the Swedish colonial project concerns the whole nation. In a sense, such a monument could be placed anywhere in the country. The artistic interventions by GIBCA at Franska Tomten could be compared to the development of a monument to the victims of French colonization placed in central Paris, or the monument in Berlin Mitte dedicated to murdered European Jewry. The interesting aspect of these monuments is that they were built by the perpetrators themselves, as a form of remembrance and implicit atonement. To place a monument at Franska Tomten could constitute an atonement of this sort, as well as a sort of remote site-specific connection to that which is being remembered.

Another example of a monument that addresses the question of site-specificity versus placement, is the ongoing campaign in the Netherlands for a monument commemorating the genocide in Srebrenica, based on

the notion that the event is part of Dutch history (that the Dutch are complicit in its occurrence).[1] This would be a monument that is not built at the scene of the crime, but, rather, in a place where the memory of the crime, to some extent, is absent—in concrete terms, there is neither a site nor any other physical traces of the genocide in the Netherlands, nor does the massacre possess an active memory amongst the Dutch population.[2] Site-specific or site-less remembrance can also be seen in relation to the purpose of commemoration itself, as a way of making a place for grieving or making visible. Yet, many monuments are both, since how they are perceived is largely dependent on the viewer's connection to whatever is being commemorated.

The Swedish King Gustav III (1746–92) had long wanted a colony and this desire motivated his granting France a concession in Gothenburg in exchange for a West Indian island. However, Saint Barthélemy proved unsuitable for agriculture. The solution was to set up a free port, where ships from various nations could trade, which in practice meant that the Swedish colony was a transit point for the American slave trade (from which the Swedish King received a 25 percent profit).[3] Yet, the colonial endeavor proved to be unsuccessful in the long run—both in terms of reaping a direct profit and as a launching pad for an expansive colonial policy—and Sweden sold Saint Barthélemy back to France in 1878. The 1784 agreement granted the rights to Franska Tomten "in perpetuity," but France had already ceased to use its concession by the early 1800s.[4] While it may appear remarkable that Sweden's colonial past has been effaced in its general national history, it is in line with a self-image that also denies Sweden's colonial presence in Sápmi and insists on its lack of complicity in the devastation of World War II on account of its political neutrality (despite the many historians who have proved otherwise).

To acknowledge a history of violence through the creation of a public memorial or monument might also shed light on a societal wound and the means of care that a society can offer through confirmation, processing, and making visible. In that sense, embarking on a remembrance

1. See: Erna Rijsdijk, "'Forever Connected': State Narratives and the Dutch Memory of Srebrenica," in *Narratives of Justice In and Out of the Courtroom: Former Yugoslavia and Beyond*, eds. Dubravka Zarkov and Marlies Glasius (New York: Springer Publishing, 2014), 131–146; and also: Marjolein Koster, "The Netherlands Looks Again at its Controversial Role in Srebrenica," *BalkanInsight*, July 10, 2020, https://balkaninsight.com/2020/07/10/the-netherlands-looks-aga-in-at-its-controversial-role-in-srebrenica/ (accessed September 10, 2021).
2. The UN force dispatched to Srebrenica was Dutch and has been criticized for failing to prevent the genocide.
3. Klas Rönnbäck, "Franska tomten och den svenska jakten på kolonier," in *Göteborg utforskat*, eds. Helena Holgersson, Catharina Thörn, Håkan Thörn and Mattias Wahlström (Gothenburg: Glänta, 2010), 179.
4. Ibid., 181.

REBECKA KATZ THOR

Proposal for Saint Barthélemy by Fatima Moallim. Detail from *Legera (Alloy)*, 2020. Stainless steel sculptures at human scale. Rendering by Nils-Erik Fransson.

process also demonstrates commitment to the past and present lives that could be described as vulnerable—e.g., subjected to hate, threats, and physical or structural violence and racism. The colonization of Sápmi is a tangible example of how vulnerability is constituted and maintained to this day. The Sámi population has been granted national minority status and a degree of autonomy, and specific laws have been introduced to protect the reindeer population, among other things, yet the colonial project is maintained in that Sápmi is still divided between Sweden, Norway, and Finland.

However, it is not only a matter of making amends or healing; vulnerability should not be understood as passive victimhood but as an unstable but not necessarily powerless position. A central question is how the majority population should be held accountable and take responsibility for society's most vulnerable. This question is intrinsically linked to a philosophical discussion about ethical responsibility and answerability; the imperative to *answer* and the requirement to explain and take responsibility for actions that need to take place on a societal level. For what are monuments if not a kind of answer? An answer,

VULNERABLE MEMORIES:
MONUMENTS AND GRIEVABILITY

however, that can be simultaneously both reactive and proactive, both a response and an embodiment of the will to create anew, depending on who asks and who answers. This is where the circumstances of who initiates, commissions, and implements monuments and memorials become vital—who wants to remember, why, and how?

A society's failure to admit a historic crime does not indicate there is no awareness of the crime itself, nor does the choice to not remember mean that others are not suffering. Hence, a public monument always runs the risk of being an empty gesture or chimera, maintaining a stable "we" who regard and evaluate historic crimes, or only reluctantly present historic events and narratives that are rarely understood, seen, or valued.

The intention to bring forward wounded or vulnerable lives is thus intrinsically connected to issues of remembrance, public space, and cultural heritage. On the societal level, legislation is one way of addressing these wounds, of offering care and taking responsibility. The recent reformulation of the Swedish law on cultural heritage states that cultural heritage should be "interpreted in an open sense: in a general meaning, cultural heritage can be understood as those traces and expressions of the past that are ascribed a value and are employed in the present."[5] The law's main emphasis is that cultural heritage issues are an ongoing process, a matter of interpretation and reinterpretation—an evaluation subject to re-evaluation. What this implicitly highlights is the importance of remaining perceptive in processes of historicization and in evaluations of the present, along with the importance of listening and learning outside one's own framework of understanding.

A case in point: Jonas Dahlberg's unrealized monument, *Memory Wound,* was intended to commemorate the victims of the far-right massacre on Utøya, in Norway in 2011. The proposal caused strong reactions and the project was eventually cancelled. The point of departure for an intense debate on the means of commemoration, and, above all, who needs to be confronted with this memory, was triggered by the design itself—a wound in the island. Dahlberg's proposal involved physically taking a slice out of the island, thus creating a gap separating two land masses from each other—a material and metaphorical wound that would convey a form of symbolic violence, in that it could never heal and the island would never be whole again. Therein, perhaps, lies

5. Section 5.2, "Kulturarvet är föränderligt och öppet" (Cultural heritage is changing and open), paragraph six of Regeringens proposition 2016/17:116 Kulturarvspolitik (Government proposal 2016/17:116 Cultural heritage), 58. The original Swedish reads: "Det förflutnas spår i samtiden förstås i öppen bemärkelse: i allmän mening kan kulturarv förstås som spår och uttryck från det förflutna som tillskrivs värde och används i samtiden." https://www.regeringen.se/4933fd/contentassets/127b80d33b084194a415d72b85721874/1617116o0web.pd (accessed June 25, 2021)

REBECKA KATZ THOR

one reason for the immense opposition to the work among those who live in the area, but also its artistic strength. We simply have to live with some wounds. There are traumas that endure within us, and the massacre of children and young adults on Utøya is one of these. The main question is how we care for them.

Notions of vulnerability and grievability are interlinked when they relate to commemoration and memory practices. Judith Butler's discussion of what lives are considered grievable in a given society is based on the same premises of acknowledgement, responsibility, and answerability I have articulated above. In her understanding, how ethics and norms regulate societal responsiveness is connected to political values and actions, ethical responsibility and affect. In 2009, she asked a question that still calls for an answer: "Why is it that governments so often seek to regulate and control who will be publicly grievable and who will not?"[6] This is a question that every society, and its citizens, should ask unceasingly.

In Malmö, there is currently a project underway to create an anti-racist monument. It began as an initiative to erect a memorial for the victims of the racist serial shooter Peter Mangs. Initiated by antiracist activists and relatives of the victims, it is now being realized in collaboration with the municipality of Malmö. This is a clear example of how an event initially characterized by society's unwillingness to see what was going on—it took years before the police detected a pattern in the shootings and even longer before Mangs' racist motives were acknowledged—is renegotiated and, hopefully, represented as a monument. It is a means of claiming that the vulnerable lives lost or wounded by racist violence are indeed grievable and *should* be grieved by society at large.

In a recent interview, Judith Butler criticized the expression "Don't waste any time mourning – Organize!" The trade union activist and singer Joe Hill wrote this in a letter shortly before his execution in 1915, and it has since become a slogan for the labor movement. Despite the potential strength of this expression, Butler points out that it is also deceptive, since it implies that mourning is private and passive, and, consequently, the opposite of acting and organizing. To her, Black Lives Matter is an example of another kind of mourning. Hence, one of the things that makes this movement so strong is that its keystone is a collective manifestation of grief that involves both public mourning *and* organizing. This acknowledgement of grief is the very basis for demanding change—the acknowledgement that Black lives matter, that the lives of George Floyd, Breonna Taylor, Trayvon Martin, and so many others are, in Butler's own terminology, liveable and grievable.

6. Judith Butler, *Frames of War: When is Life Grievable?* (New York: Verso, 2009), 38–39.

As part of GIBCA 2019, the artist Eric Magassa was invited to create a work relating to Franska Tomten. The location of the work was a wooden construction hoarding near Franska Tomten, from which Magassa focused our eyes on the place and reflected on its invisible history. The hoarding was painted with bright pink and blue triangular fields, on which the artist mounted a combination of abstract images, processed photographs, representations of artifacts (of the kind found in ethnographic museums), a map, a book cover, and more. The background colors can be seen as a disruption in themselves, a form of resistance against a given order in terms of a city's color scheme (or rather, the absence of bright colors in urban space). In a conversation held prior to the writing of this text, the artist described the different layers and sediments of images in the work as a walk with the city's shadows and the history of the city and its inhabitants. This history lives within us, shaping our actions and under-standing of the world.[7] Magassa's work enacts this embodied history by illustrating it and transferring it from obscurity to the public domain. The inanimate objects, artifacts, and images stand as symbols for these shadow-like histories, present within the city dwellers. It is a double exposure that uncovers and covers, relates to and opposes. There is no distinct past and present, just a multitude of colors, objects, representa-tions and narratives that should be regarded individually and together.

The following year, artist Ibrahim Mahama was invited to create an installation on the same hoarding. He contributed a work consisting of a series of colonial-era maps of his native Ghana. Superimposed on the maps are photographs of the lower arms of precarious workers, tattooed with their name, place and date of birth. These workers have left their rural homes to seek labor opportunities in larger cities such as Accra, and the tattoos are intended to ensure identification in the case of injury or death resulting from the harsh working conditions they frequently must endure. Due to the lack of official proof of identification, an alter-native system has been put into practice, where the bodily conditions of labor, its precarious conditions and vulnerability, make such tattoos manifestly necessary.

Neither Mahama's installation nor the work by Magassa that preceded it is a monument per se, but nevertheless both highlight and process possible layers that should be included in one. That is, the nego-tiation between past, present, and future, between what is hidden and what is visible in the public domain and the necessity of a polyphony that both forms a chorus and resonates in solitary voices. Both works could be a point of departure for a future monument.

7. James Baldwin wrote in the mid-1960s about how history lives in our bodies: "The White Man's Guilt," *Collected Essays* (New York: The Library of America, 1998), 72.

Geography of Haunted Places (detail), 2020. Proposal by Runo Lagomarsino.

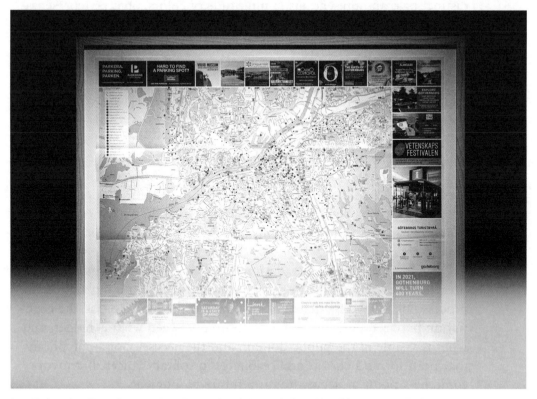

Installation view: Runo Lagomarsino, *Geography of Haunted Places* (detail from proposal), GIBCA 2021.

VULNERABLE MEMORIES:
MONUMENTS AND GRIEVABILITY

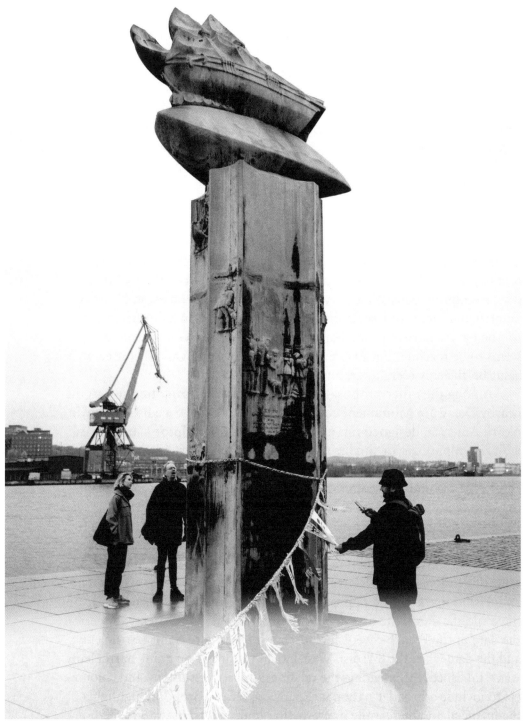

Documentation of *In the Celebration of Our Struggles Is Their Collapse* by Daniela Ortiz. Action by the Delaware Monument in Gothenburg, November 2021.

As another project within the framework of GIBCA's three-year engagement exploring possibilities for a monument at Franska Tomten, the biennial held a seminar in November 2020, in collaboration with Public Art Agency Sweden, where seven artists presented speculative draft proposals for possible monuments commemorating the ignominy of Swedish colonialism in the Caribbean.[8] Runo Lagomarsino's proposal expanded beyond Franska Tomten and, like several other proposals, highlighted the geographical—or, in this case cartographical—relationship between Saint Barthélemy and Gothenburg. He outlined the contours of Saint Barthélemy with tiny dots on a map of Gothenburg, and these markings on the city map would also become manifest using iron rods placed throughout the city, making the superimposed maps both invisible and visible, since a bird's-eye perspective of Gothenburg would be required to actually, visibly, link the iron rods to the contours of Saint Barthélemy. Thus, the symbolism of interwoven histories and a form of absent presence are expressed in a way that would permeate the entire city. Fatima Moallim's proposal entailed an even more concrete dialogue between the two places, with a sculpture consisting of two alloyed elongated bodies on Franska Tomten and three volumes using the same technique on Saint Barthélemy. All the figures have elongated arms, but of the two in Gothenburg one seems to be reaching out to catch the other as it falls, while the three on Saint Barthélemy seem to gesture with heavy limbs.

Among the other proposals are two works that call attention to the nearby Delaware Monument commemorating the first Swedish colony in North America, designed in 1938 by the Swedish sculptor Carl Milles, a Nazi-sympathizer (a similar monument exists in Fort Christina Park in Wilmington, Delaware). Another proposal, devised by Daniela Ortiz, consists of a garland resembling the ropes used to tear down monuments to Confederate soldiers and other colonial-era figures, bedecked with images from anticolonial fights. Yet another, by Aria Dean, involved a proposal to replace Milles' sculpture with two new ones, and an associated work on Saint Barthélemy. Her sculptural proposal was for three iron plinths of the same dimensions as the Delaware Monument to be constructed, each with an incision marking the point at sunset when sunlight turns to shade on three specific dates: the first departure of settlers from Sweden to America; the date of the French-Swedish transaction relating to Saint Barthélemy; and the date when the Swedish West-Indian Company on Saint Barthélemy was established. By extending the relationship between colony and colonizers to include a broader national expansion, Dean's proposal highlights the financial and mercantile interests that underpin transatlantic relations.

8. All proposals are presented at www.possiblemonuments.se (accessed June 23, 2021).

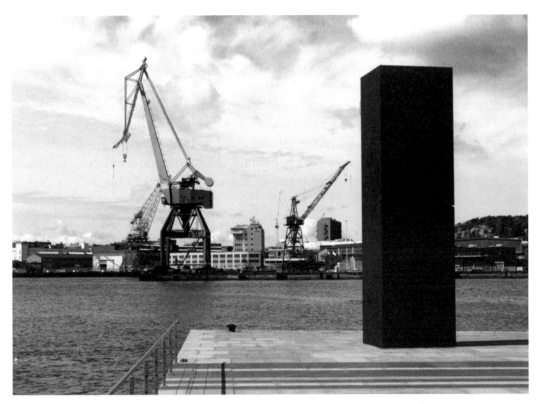

New Monument for Franska Tomten (detail), 2020. Proposal by Aria Dean.

The biennial's efforts were not intended to lead to a monument in the here and now; perhaps not on that site and perhaps not ever. Yet, Magassa and Mahama's installations, and the proposals put forward at the seminar—as well as the biennial's work over a three-year cycle—can be seen as a way of insisting that violent histories resides in us, even if *we* at times resist acknowledging it.

Regardless of the form and expression of a possible future monument, or whether sufficient political will exists to actualize a physical reminder of Sweden's colonial history, the temporality and ideas of the monument-as-re-evaluation must be central. In that way, developing a monument could involve both a form of unlearning and the potential to start over and see in a new way. Marianne Hirsch, whose concept of "vulnerable time" explores links between public cultural heritage and vulnerability, states that "unlike trauma, vulnerability shapes an open-ended temporality—that of the threshold of an alternate, reimagined reality."[9] In view of the idea of taking responsibility, one could consider how vulnerability is a basis on which we can envision future acts of remembrance in terms of permanent public artworks and other sorts of artistic

9. Marianne Hirsch, "Vulnerable Times," in *Vulnerability in Resistance*, eds. Judith Butler, Zeynep Gambetti and Leticia Sabsay (Durham: Duke University Press Books, 2016), 80.

objects and interventions—as a conceptualization of every context to be remembered. Yet, these answers cannot be considered sustainable ethical solutions—they are simply linked to the possibility of a re-evaluated reality, to openness and uncertainty: "vulnerable time." This openness entails that *one* answer does not suffice, but that several different answers are necessary.

The temporal tensions at stake are also a possibility, a courage to remain in what is painful and potentially shameful. Understanding commemorative projects as a form of remaining, a lingering on a painful past, can also create an opening that encompasses the contradictions that are integral to such processes. Hence, the collision between a making visible, an active remembrance, and the possibility of closure, a passive remembering. The active remembrance opens up and can be understood in accordance with both the new definition of cultural heritage and the "vulnerable time" that Hirsch describes. Passive remembering, conversely, involves closure in both real and symbolic terms, in line with the historical customary purpose of monuments. In that sense, monuments have been a way for those who erect them to finish a chapter and move on, having once honored and paid tribute. Active remembrance possesses the opposite purpose: to show the ways in which history looks ahead, indicating how, fundamentally, all processes of remembrance equally concern envisioning the future as much as historical events.

In that light, to linger and affirm a vulnerable time becomes a strategy to neither forget nor to create simplified closure: it is a strategy where the monument opens up rather than consolidates. What this means concretely, and what form such commemorative projects could take, should remain context-specific, but this should not imply abandoning the idea of permanence. A commemorative project can be either transient or permanent without it becoming an instance of passive remembrance. The boundary between temporariness and permanence is destabilized in many commemorative processes—as with much public art, since permanent works have a finite lifespan and temporary works can be exhibited or performed multiple times. To linger, repeating the question of how and what is being commemorated, involves insisting that a monument never permanently define what a society deems memorable. The question requires that it be asked ceaselessly, with the answer reformulated multiple times. Consequently, all monuments need to be evaluated and re-evaluated, regarded as the remains of a specific time and context. It does not mean that they should be removed when history is reinterpreted, but that one must remain humble in the light of a deepened discourse and changing perspectives (which could, of course, entail that monuments be torn down).

Above all, the construction of new monuments should be guided by active remembrance, the intention to address and open up, to continue and also begin anew, rather than cleaving to prior forms of passive remembrance, which allow commemorative projects to remain a gesture that is followed by silent disregard.

This is a translated and revised version of the essay *Minne och monument*, first published in Swedish in *Glänta*, Issue 4.20–1.21, and written with support from the Region Västra Götaland essay fund.

RASHEEDAH PHILLIPS

DISMANTLING THE MASTER('S) CLOCK[WORK] UNIVERSE, PART 1

Where is the master clock? Who watches it and who keeps time? If the master clock stops, does time stop? Most people take their everyday experiences of time as a factual, unalterable facet of reality. There are clocks that chart the hours, minutes, and seconds; calendars that chart the march of days, months, and years; suns, planets, and stars that chart the ages, mapping out cosmic time. More subtle, however, are the ways in which time governs our social interactions, regulates our motions and movements, frames our worldviews, informs our politics, and leaks into our very consciousness. The ways in which we are situated in time are reflected in how we talk about, think about, and conceptualize the world around us. In America and many other places, natural time has been overthrown by Western linear time, where temporal orientation is facilitated by clocks, schedules, cell phones, and digital calendars.

Traditional European spatiotemporal consciousness, around and prior to the fourteenth century, saw time as flow and inevitability. Early recordings of an abstract sense of time as a continuous duration arose during the fourteenth century, while the word "time" itself derives from the word "tide" or "tidiz." Tidiz has etymological roots in the Sanskrit word for "division," "to cut up" or "to flood" (as in "the time of high water"). Within the European Judeo-Christian religious order, work and prayer time were heavily regulated by laws, and because of a belief in biblical apocalyptic visions of the end being near, time had to be tightly regulated. In *Time Wars*, Jeremy Rifkin notes that "Western culture … institutionalized its images of the future by way of religion and politics," making sure that "the future can be made predictable and controlled" (1987, 146, 7).

It is through religion and politics that a linear temporal orientation first came to be discerned, simultaneous with the development of Western culture. The linear Western time consciousness stresses fixed events along a forward-moving timeline, with events seen as irreversible. The linear timeline is embedded within cyclical time: hours, minutes, and seconds repeat in their abstract, numerical form. Events themselves, however, are unique occurrences that will never repeat on a progressive, linear timescale.

Prominent Western religious philosopher Saint Augustine was among the first Western thinkers to view Christian-inspired, linear, irreversible time as an important feature of his philosophy. In *Confessions*, written in Latin around AD 400, Saint Augustine asks, "How can the past and future be, when the past no longer is, and the future is not yet? As for the present, if

it were always present and never moved on to become the past, it would not be time, but eternity" (Pilkington 1876, 302). The structure of time eventually came to be organized discretely and causally into a past, present, and future, with fixed events set against a forward moving timeline—one that would eventually come to a climactic, chaotic end.

The increased building and usage of public clocks, and, eventually, personal watches and timepieces, further inscribed a mechanical temporal order, impacting all aspects of the Western way of life. Eviatar Zerubavel notes in *Time Maps* that "only in the last couple of millennia ... did our un-compromisingly linear view of the past—symbolically captured in the modern relegation of 'time travel' to science fiction—actually come into being" (2003, 24).

This progressive future, one that is unidirectional and does not allow access to the past, was further forged through other significant events in science and technology. The laws of thermodynamics, developed most significantly during the late eighteenth and nineteenth centuries, specifically reinforced the linear notion of time speeding into the future toward a chaotic end, where, as sociologist Barbara Adam notes, "energy was conserved, but cannot be reversed" (Adam, 1990, 61). Other significant temporo-historical events—such as the building of the first long distance railroads and the invention of the telegram—allowed the future to be conquered through a compression of space-time. In *Time & Social Theory*, Adam describes how there was a shift in focus in the late eighteenth and nineteenth centuries "from quantity and timeless laws to change, growth, and evolution [occurring] almost simultaneously in physics, biology, astronomy, philosophy, and the arts" (1990, 61). Many of these milestones intersect with or are simultaneous to signif-icant events of the Maafa (meaning "great tragedy" in Swahili, the word refers to the Transatlantic Slave Trade period, where historians estimate that close to 12 million Africans were captured and brought to the Americas). One could sketch out a timeline of significant events in Black American history—for example, the Civil War (1861–65), the Emancipation Proclamation (1863), or the last voyage of the trans-atlantic slave trade (1887)—and find them overlapping or in close succession to sociohistorical and temporo-historical events; such as the first long-distance railroads (1830), development of the second law of thermodynamics (approximately 1854), and the establishment of the four continental US standard time zones by the railroads (1883).

An accurate measurement of time became crucial to maritime navigation. Although you can measure latitude (north–south) by reading the sun, ship navigators had to guess in order to measure longitude, which often led to grave inaccuracies on long voyages. You essentially needed a clock or timekeeping device in order to measure longitude (east–west). Wikipedia notes:

> Since the Earth rotates at a steady rate of 360° per day, or 15° per hour, there is a direct relationship between time and longitude. If the navigator knew the time at a fixed reference point when some event occurred at the ship's location, the difference between the reference time and the apparent local time would give the ship's position relative to the fixed location. Finding apparent local time is relatively easy. The problem, ultimately, was how to determine the time at a distant reference point while on a ship.

Stephen Kern writes of the relationship between "the future" and imperialism and colonialism, noting how the "annexation of the space of others" and the "outward movement of people and goods" are examples of "spatial expressions of the active appropriation of the future" (2003, 92). If this is true, then the outward movement of people *as* goods—chattel slavery—must be the most potent example of the appropriation of the mode of time known as the future. In her essay "Sights and Sounds of the Passage,"[1] Camae Ayewa explores speculative temporal narratives of enslaved Africans snatched from their homes, forced into ships, and taken across the waters to other lands. The events that took place there comprised the first great Indigenous African Space-Time Splintering, a long wave form of trauma that continues to spread, touching upon the present day. This splintering bears a close temporal relationship to what Kodwo Eshun describes in "Further Considerations on Afrofuturism" as "the founding moment of modernity" (2003, 288).

The inscription of linear space-time came to be discerned in later boundaries to slave ownership.[2] 36°30' north is the parallel of latitude that divided where slavery was allowed or prohibited in America under the Missouri Compromise, the line that separated the United States from the Confederate States. In *Mastered by the Clock: Time, Slavery, and Freedom in the American South*, Mark M. Smith describes the

1. Published in: Rasheedah Phillips and Dominique Matti, eds. *Space-Time Collapse I: From the Congo to the Carolinas* (Philadelphia: The AfroFuturist Affair/House of Future Sciences Books, 2016), 9–13.
2. Although, truly, the notion of ownership over the space-time of millions of human beings cannot be said to contain boundaries, there should be an implied artificiality and arbitrariness.

To conclude the exercis
When you get to 1, you w

Black Quantum Futurism, still from *Time Travel Experiments*, 2017.

t backwards from ten.
lly back in the present.

RASHEEDAH PHILLIPS

process by which white southern slave masters adapted a mechanical clock time and a corresponding linear time construct as the dominant temporal consciousness over that of nature-based timekeeping methods. He notes in detail how this transition impacted the social order and reinforced values of discipline, economic gain, efficiency, and modernity.

In general,[3] in indigenous African space-time cultural traditions time consciousness has been described as having a reverse linearity, in that when events occur, they immediately move backward towards what John Mbiti described as Zamani, or macrotime.[4] In many indigenous African cultures and spiritual traditions, time can be created, is independent of events, is not real until experienced, and is often intimately connected to genealogical, astrological, and ecological cycles. In his article "Time & Culture Among the Bamana/Mandinka and Dogon of Mali," Kassim Koné provides examples of the ways in which "the historical past and genealogies are conceptualized within contexts of space, place, totemic affiliation, and family names," for example, as opposed to "exact chronology, recorded history, dominant figures, royal succession, centralized states, and international relations" like the West (1994, 94–95).

From this time perspective, time is composed of events and days, while months and years are just a graphic or numerical representation of its events. The indigenous heritage of time "often made no sharp distinction between the past, present, and the future (yesterday, today, and tomorrow)" and was generally "uninterested in the minutia of time," according to Omari H. Kokole (1994, 52). In his worksheet "A Comparision of the Western and African Concepts of Time," Bert Hamminga notes "we have to compare the Western linear dead physical timeline (with 'past,' 'future' and a regularly moving 'now') with the African 'living time." Koné points out that "from a Western point of view, African time can be said to be one that is socialized" in contrast to a Western regimentation of time which favors the alienation of other people's space, place, and time

3. It is important to note that temporal-spatial traditions and practices varied widely across cultures, countries, groups, and individuals across indigenous Africa, but that the observations presented in this brief essay are based on extensive research on the space, time, and spiritual traditions of a number of African cultures and groups that yield basic generalizations and assumptions.

4. Many scholars have criticized Mbiti's work for what is considered inaccurate, or in some cases, limited observations. This author agrees with some of those criticisms; particularly, earlier versions of his work that represented indigenous African time traditions as having no concern from the future. However, most agree that he was the first to articulate a detailed theory of time from an African-centered cultural perspective or worldview, and further studies of work on Indigenous African space-time traditions have reaffirmed the value of his work and generalizations. The use of his work in this essay is based on a later edition of *African Religions and Philosophy* that addresses critiques and clarifies the positioning of the future "no-time" as a realm of open possibility, and is not "faced in the same way in Africa as it is in the West" (Koné 2004, 81).

by private individuals" (1994, 83). Events are "situated in time as well as in context" (1994, 95).

As noted above, indigenous African notions of time in many traditions were generally connected to natural events, such as rainfall and the rising and setting of the sun, or saw time as a natural rhythm or pacing, such as the time it takes you to walk from one place to another. Koné points to the example of the Kòmò farming ritual of the Bamana people, who make offerings to religious deities through various farming activities, with the ritual's primary significance lying "in its role in the social construction of time rather than as a ritual that sets in motion the farming season, as seen by the West" (1994, 83). Such an experience of time has features such as "concern for details of the event, regardless of time required; exhaustive consideration of a problem until resolved; and emphasis on present experience rather than the past or future" (Hamminga, date of publication unknown).

Until experienced or actualized, future events are situated in a potential time. Those events do not depend on some specific clock time or calendar date for their manifestation. Instead, time depends on the quality of the event and the person experiencing it. Once the future event is experienced, it instantaneously moves backward into both present and past dimensions. According to theologian and philosopher Dr. John Mbiti, those two dimensions carry the most ontological significance, where "a person experiences time partly in his own individual life, and partly through the society which goes back many generations before his own birth" (1990, 23).

One potent example of the retention of the indigenous African spatio-temporal orientation during slavery is the use of the North Star to point north on the Underground Railroad. Other examples include naming children after their day of birth, or after ancestors.

However, enslaved Africans came to internalize some form of a linear time construct, if only for survival purposes. Modern-day mechanical clock time and its ancillary, linear, temporal rhythms were encoded into the enslaved Black African by means of the whip and other forms of torture and physical violence, and enslaved Africans, through this violent force and torture, came to internalize some form of a linear time construct.

Simultaneously, they were forbidden any access to the future, in much the same way they were denied access to full humanity, both in vision and in practice. In his essay "Time and Revolution in African America," Walter Johnson notes that "one of the many things slaveholders thought they owned was their slaves' time; indeed, to outline the temporal claims that slaveholders made upon their slaves is to draw a multidimensional portrait of slavery itself. Slaveholders … defined the shape of the day." He goes on to note how slave masters controlled enslaved Africans' biographical time, where they "recorded their slaves' birthdays in accounts books that only they could see; they determined at what age their slaves would be started into the fields or set to a trade, when their slaves would be cajoled into reproduction," and otherwise "infused their slaves' lives with their own time … through the daily process of slave discipline" (2004, 153).

Masters further encoded a temporal order by the use of sound; bells, horns, public clocks, chants, songs, speech patterns, and the like were used to regulate slave labor on the plantation. Temporal literacy and ownership of timepieces was also, for the most part, forbidden to enslaved Africans, lest it be used as a tool by which to gain their freedom. Timepieces came to be seen as a symbol of status and progress, as well as becoming symbolic of the conquering of time and space, like the train and the telegram.

Enslaved peoples both obeyed and resisted clock time as if it were an extension of the slave master himself. Both Smith and Johnson detail ways in which "time could be turned back upon its master," by utilizing such passive strategies as "working slowly, delaying conception, shamming sickness, or slipping off" (Johnson 2004, 153), or explicit acts such as mutinies, revolts, escapes, poisonings, magic practices, and other spiritual and religious practices. In *Africa in America*, Michael Mullin notes that:

> In the Caribbean … Christianization, which inspired major resistance, was held up until the slaves themselves judged the traditional and dynamic sources of their rites and knowledge to be ineffectual. In Jamaica, slaves experimented with a variety of cults, including Christianity, as they struggled to find an antidote to the whites' power and magic. Consequently, religion, as contemporaries understood, was a far more important element in resistance to slavery in the Caribbean than it ever was in the South (1995, 62).

The so-called emancipation of enslaved Africans from bondage did not automatically free them of the Master's clock. At the point of emancipation, the Western linear construct of space and time was already encoded into every aspect of the American way of life—social order, economy, transportation, and communication. Time continued to be used as another form of social control against oppressed communities. There was no practical way to totally eschew linear temporal consciousness while remaining in this society. If seeking to integrate into it, or to at least peacefully co-exist (though that ultimately proved to be unsuccessful), compromises had to be made. A split spatiotemporal consciousness, one parallel to Du Boisian double consciousness, was thereby gradually developed in emancipated African people. Black Quantum Futurism sees this event as the second space-time collapse.

Present-Day Spatiotemporal Consciousness or "CP Time"

There is no past, or, rather where does the line between the past and the present draw? Was slavery simply over once declared? At what time did we become free? If time orders actions, when and where was the act of liberation, when did subjugation end? What time was it in the land my people were stolen from? How far away from slavery are we, when slavery as an institution was encoded into the dominant temporal order? In temporalities of pre-slavery, pre- and post-freedom superimposed then collapsed into one/other.

"It's how we remember that which cannot be said." – Ntozake Shange

In *Physics of Blackness*, Michelle M. Wright cautions that "if we use the linear progress narrative to connect the African continent to Middle Passage Blacks today, we run into a logical problem, because our timeline moves through geography chronologically, with enslavement taking place at the beginning, or the past, and the march toward freedom moving through the ages toward the far right end of the line or arrow, which also represents the present" (2014, 57). Black Americans today, bound to and by the linear progress narrative, are the stark embodiment of temporal tensions, a disunity between cultural notions of time, many of us occupying what Jeremy Rifkin calls "temporal ghettos" (1989, 190) as well as physical ones. How we negotiate time and space in relation to the event(s) that forced us upon these shores, the transatlantic slave trade, provides context for the struggles that we continue to endure in

the present. We were told that slavery ended, but if so, *when* remains the crucial question, particularly with the linear temporal-spatial history of the world fully intact but up for question.

That a community bound by particular events in space-time, such as enslavement, would experience overlapping and conflicting temporalities should be of no surprise. Zerubavel rightly points out that "Being social presupposes the ability to experience things that happened to the groups to which we belong long before we even joined them as if they were part of our personal past," and that "such a remarkable existential fusion of one's personal history with that of the communities to which one belongs also helps explain the radiation of pain and suffering carried by American descendants of African slaves as well as the personal sense of shame felt by many young Germans about the atrocities of a regime that ended long before they were born" (2003, 3).

Theoretical physicist Alberto Hernando de Castro uses the laws of physics to study the ways in which communities retain social memories, finding an underlying time-based logic in how communities develop and interact. A community's growth is largely dependent on factors in that community's past. This research is useful in understanding how traumatic and post-traumatic events can connect or disconnect us from our pasts, and the ways in which human behavior, in the aggregate, can influence an entire community or city. It helps us to understand how historical events, such as slavery or war, transform our communities in such a way that it displaces us completely from those events and their sources.[5] The past is still with us, in contact with the present—not cut off along a temporal axis, like the block universe or the master's clock-work universe.

Colored People's Time is often seen and studied as the temporal orientation of presentism in the Black community. Use of presentism's time orientation is class and, by extension, race-based. It has been recently reappropriated by New Age philosophy, yoga, and meditation mantras; however, when a presentism time orientation is applied to Black people, it is often cited negatively, regarded as lacking a sense of future, only concerned with present pleasures and immediate concerns. It has been associated with laziness, indolence, and lateness.

5. This notion has been studied in greater depth in *Space-Time Collapse II: Community Futurisms* (Philadelphia: The AfroFuturist Affair/House of Future Sciences Books, 2020).

These traits are, in turn, used to justify the Black community's disproportionate rates of poverty, joblessness, homelessness, disease, and the like. In studies on the increased presence of heart disease in African Americans, for example, a presentism time orientation is often cited as one causal factor. African Americans with a present-time orientation "may not see the need to take preventative medication or to finish antibiotics when symptoms disappear," or "may delay seeing a physician until symptoms are severe, and begin interfering with their work or life" (Cultural Diversity: ELDER Project, Fairfield University School of Nursing [African American Culture]). Often, their culture-based fear of hospitals and medical institutions—due to decades of illegal medical experimentation on Blacks or the inability to afford sustained medical treatment—go unconsidered.

Less analyzed are the ways in which, contemporarily, this temporal orientation is connected to class oppression, racism, white supremacy, and the legacy of slavery. Slavery was where time was inculcated into our very skin, where the ring of the bell and the tick of the clock regulated our fate—labor, birth and death, taking over the natural rhythms and spirits, spatio-temporal orientation and consciousness. I only speak here of temporal disorientation, but spatial disorientation should also be implied, to the extent that the fabric of the two are co-associated in an Einsteinian universe. CP Time has been both a defense mechanism against Black communal trauma and post-trauma—under the conditions of class warfare and racial oppression—*and* a harkening back to a more natural, ancestral temporal-spatial consciousness and presentism.

Rifkin explains that the consequence of the linear progress narrative being applied to an oppressed people keeps them "confined in a narrow temporal band, unable to anticipate and plan for their own future ... powerless to affect their political fate." For those deprived of access to the future, the future becomes "untrustworthy [and] unpredictable" (1989, 192). They become stuck, only able to plan for the present and a narrowly delimited future time, as the society around them speeds forward in illusory, linear progress. This narrow temporal band is used to penalize people on a daily basis. In the present day, we continue to be punished for not being "on time." For being ten minutes late to an appointment, for example, you could lose your livelihood, children, home, or freedom. Hierarchies of time and lack of access to the future informs intergenerational poverty in the same way that wealth passes

down between generations in traditionally privileged families. Such a narrow temporal band is clearly distinguishable from the sense of presentism, or "living in the moment," that is offered as an option for those tapping into or capitalizing off of so-called New Age techniques appropriated from ancient spiritual practices and spatiotemporal orientations.

Dismantling the Master('s) Clock[work Universe]: Black Quantum Futurism Temporal Dynamics

Now suppose that this high tech substitute of the ancestor worship is self-adaptive. I mean that the rules of this game (which we call natural laws) are not fixed forever but can change defending the participants' creative output. So to say, we are co-creators of this world not just passive actors. Of course such a world view is strongly anti-Copernican, contrary to the last century's scientific mainstream, but I find nothing particularly impossible in it. In such a virtual reality the past is not fixed in every detail, otherwise it would be a foolish waste of computer memory. Backward causality is a natural thing in such a universe: some details of the past are fixed only when we pay our attention to them from the future. – Z. K. Silagadze

How can we control our own time and create healthier cultural time orientations? How can we encode new temporal algorithms? What does it mean to dismantle the master's clock, physically, spiritually, psychologically, cognitively? How do we access and take back control of communal memory? How do we begin to map our return to our futures? There is a necessity to dismantle the master's clock and reinscribe a CP Time, or, perhaps more affirmatively, to construct a new diasporic African spatiotemporal consciousness. There is a necessity to dissolve or dismantle the thermodynamic arrow of time and the arrow of progress. Mechanical time is not absolute time. The present moment is the ether, the absolute frame of reference.

It is unrealistic to expect that we can ever return to the time consciousness of our more distant ancestors, enacting a complete reversal to a pre-transatlantic slave trade spatiotemporal construct. In recognizing that it is not realistic to enact a complete reversal or return to an African spatiotemporal

consciousness, we can instead incorporate particular aspects of these time constructs as they parallel or overlap natural tendencies already encoded into the descendants of formerly enslaved Africans. We seek to reconcile our bifurcated time consciousness by creating or adapting a time consciousness consistent with our experiences as diasporic, displaced Africans, living in communities that have by and large adopted a linear time construct.

There is a meaningful way to embrace the paradox and allow these two opposing temporal modes to coexist, in the way that light coexists both as wave and particle on the quantum level. It's done by crafting a unique time construct that takes account of a Western time mode and our own natural time tendencies, as inscribed in our DNA through biology, ancestry, culture, spirit, and natural rhythms. Such a time construct inevitably requires a new language, a way to speak of the past, present, and future without resorting to time hierarchies.

Black Quantum Futurism (BQF) explores and develops modes and practices of spatiotemporal consciousness beneficial to marginalized peoples' survival in a "high-tech" world currently dominated by oppressive linear time constructs. In crafting new, functional communal temporal dynamics, BQF is developing and enacting a new spatiotemporal con- sciousness. BQF theory, vision, and practice explores the intersections of quantum physics, futurism, and Black/African cultural space-time traditions. Under a BQF intersectional time orientation, the past and future are not cut off from the present—both dimensions have influence over the whole of our lives, who we are, and who we become at any particular point in space-time. Our position from the present creates what that past and future looks like—what it means at every moment. We determine what meanings and what relationships both dimensions of time have to our present moment.

The etymology of the word "future" itself admits this kind of rela- tionship. The word future, by definition, designates a time period or temporal space that is not now, one that is situated ahead (or before) us, distinctive from times that lie behind (or before) the one we are currently situated in. Etymologically, future developed out of the Old French word *futur* in the late fourteenth century. It meant "a time after the present," or "that which is yet to be." *Futur* can be further traced back to the Latin *futurus*, via the stem fu- (to grow or become), which is the future participle of the word *esse*, to be. The Oxford English

Dictionary notes that "both esse, to be, and futur, to become, share 'be' at their root." This may explain why the word "before" can both denote an event that has already passed and is now in the past, or an event that has not yet happened. Unilateral linearity does not lie at the root of the words "before" or "future."

The following principles of temporal dynamics should be coupled with the BQF modes, principles, and practices outlined in *Black Quantum Futurism: Theory and Practice* (2015) and developed further in *Black Quantum Futurism: Space-Time Collapse II: Community Futurisms* (2020):

Retrocurrences: a backwards happening, an event whose influence or effect is not discrete and timebound—it extends in all possible directions and encompasses all possible time modes.

BQF seeks to unravel the processes of how communal memory is seeded, how the collective memory spreads across time and space, reaching backward and forward in time simultaneously to include everything that has and will happen. This dynamic event process, which BQF coined a "retrocurrence," takes on features and characteristics reminiscent of quantum matter, where time is naturally reversible and information can flow in both directions. Retrocurrences provide pathways of opportunity for seeding new schemes of spatiotemporal consciousness.

Entangled Histories: the quantum physics notion of entangled histories was recently developed by nobel laureate Frank Wilczek (and colleagues) and tested experimentally. Entangled histories are "cases in which a single chronology is insufficient to explain the observed changes in the properties of a particle" (1, 2015), meaning the history of a particle may be incomplete without consideration of the existence of multiple, intertwined timelines. The principle essentially states that such multiple timelines must be entangled, demonstrating the "many worlds" quantum mechanics interpretation. With entangled histories, as Wilczek explains, the separate chronologies are intertwined and eventually come back together.

This suggests that timelines aren't "lines" at all, but perhaps strands or something less rigid and more flexible than a line. Entangled timelines invoke layered timescapes, overlapping circles of time. It suggests that one event can have multiple temporal perspectives, operating simultaneously.

For further inquiry: *How might retrocurrences apply to slave-time phenomenon? We (the present) are constantly injecting ourselves into the past. The gaze of history shapes it, crystallizes it, collapses it upon the linear timeline. How do we keep ourselves tethered to the narrative provided to us in history books? When and where do the ancestors speak for themselves? Adopting a similar mode of "potential time," as proposed by ancient African space-time practices, is parallel to Quantum/ Potential energy (meaning no definite space/location). Heisenberg's uncertainty principle implies an open future/open past. Nature is inherently indeterministic. What is the special role of time? Can we use the quantum eraser to erase the past and change the future?*

This is a revised version of a text first published under the same title by The AfroFuturist Affair/House of Future Sciences Books as part of *Space-Time Collapse I: From the Congo to the Carolinas* by Black Quantum Futurism (2016).

The video *Time Travel Experiments* (2017) by Black Quantum Futurism was shown as part of *Part of the Labyrinth*, the tenth edition of Göteborg International Biennial for Contemporary Art, in 2019.

References:

Adam, Barbara. *Time & Social Theory*. Cambridge, Oxford, Boston, and London: Polity Press, 1990.

Anonymous. "Cultural Diversity: ELDER Project Fairfield University School of Nursing (African American Culture)." *https://slidetodoc.com*. https://slidetodoc.com/cultural-diversity-elder-project-fairfield-university-school-of-5/ (accessed May 23, 2015).

Saint Augustine. *The Confessions*, trans. J.G. Pilkington. New York: The Heritage Press, 1876 and 1963.

Cotler, Jordan and Wilczek, Frank. "Entangled Histories," Center for Theoretical Physics, MIT, Origins Project, Arizona State University, Tempe AZ 25287 USA, March 24, 2015. https://www.researchgate.net/publication/272195178_Entangled_History (accessed June 22, 2015).

Dohrn-van Rossum, Gerhard. *History of the Hour: Clocks and Modern Temporal Orders*, trans. Thomas Dunlap. Chicago and London: The University of Chicago Press, 1996.

Eshun, Kodwo. "Further Considerations on Afrofuturism." *CR: The New Centennial Review* 3, No. 2 (2003): 287–302.

Zerubavel, Eviatar. *Time Maps: Collective Memory and the Social Shape of the Past*. Chicago and London: The University of Chicago Press, 2003.

Hamminga, Bert. "A Comparison of the Western and African Concepts of Time." *www.eldrbarry.net*. http://www.eldrbarry.net/ug/afrtime.pdf (accessed June 23, 2015).

Johnson, Walter. "Time and Revolution in African America." In *Rethinking American History in a Global Age*, edited by Thomas Bender, 148–167. Oakland: University of California Press, 2002.

Kern, Stephen. *The Culture of Time & Space (1880–1918)*. Cambridge, MA and London: Harvard University Press, 1983 and 2003.

Kokole, Omari H. "Time, Language, and the Oral Tradition." In *Time in the Black Experience*, edited by Joseph K. Adjaye, 35–54. Santa Barbara: Greenwood Press, 1994.

Koné, Kassim. "Time & Culture among the Bamana/Mandinka and Dogon of Maili." In *Time in the Black Experience*, edited by Joseph K. Adjaye, 79–96. Santa Barbara: Greenwood Press, 1994.

"Longitude." Wikipedia, *Wikimedia Foundation*. https://en.wikipedia.org/wiki/Longitude (accessed August 24, 2015).

Mbiti, John S. *African Religions and Philosophy*. 2nd Edition. Portsmouth, NH: Heinemann Educational Publishers, 1990.

Mullin, Michael. *Africa in America: Slave Acculturation and Resistance in the American South and the British Carribean (1736–1831)*. Champagne, IL: University of Illinois Press, 1995.

Rifkin, Jeremy. *Time Wars: The Primary Conflict in Human History*. New York: Simon & Schuster, 1989.

Silagadze, Z. K. "LHC card games: bringing about retrocausality?" In *Relativity, Gravitation, Cosmology: Foundations*, edited by V.V. Dvoeglazov, 89–100. New York: Nova Science Publishers, 2016.

Wright, Michelle M. *Physics of Blackness: Beyond the Middle Passage Epistemology*. Minneapolis: University of Minnesota Press, 2015.

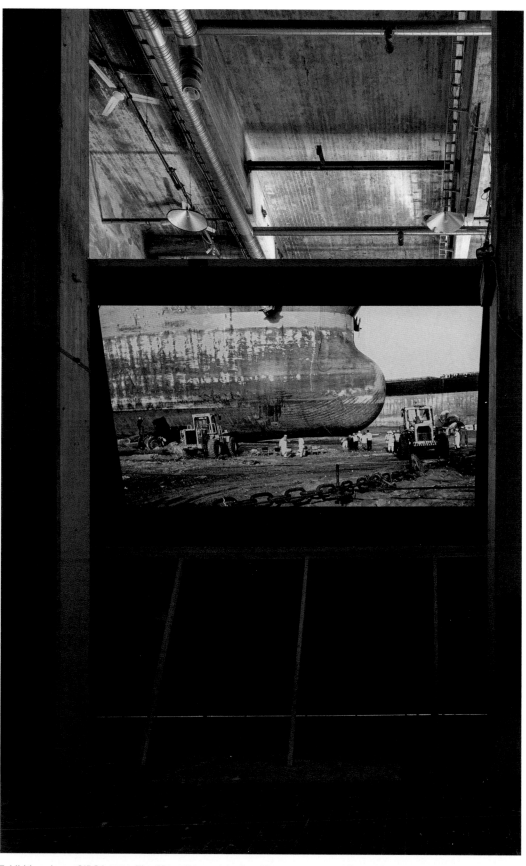

Exhibition views: GIBCA 2021, *The Ghost Ship and the Sea Change* Hira Nabi, text on p. 447 201

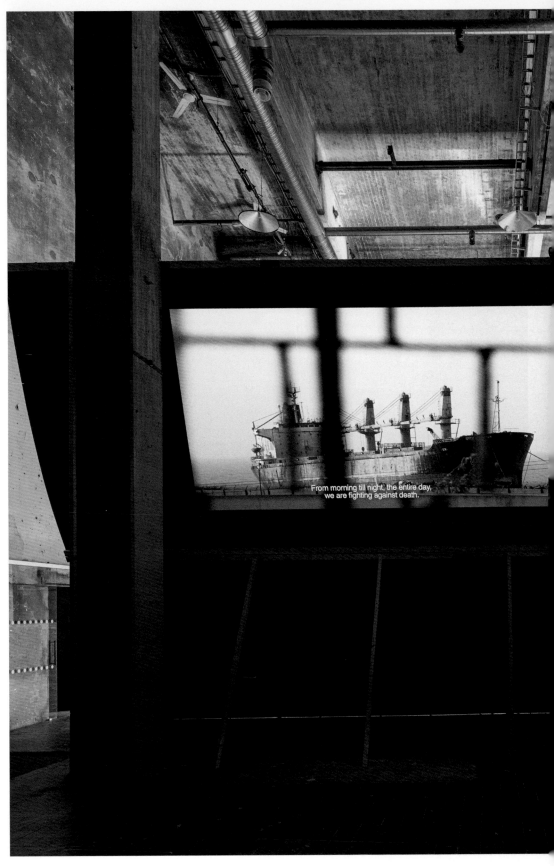

From morning till night, the entire day,
we are fighting against death.

Hira Nabi, text on p. 447

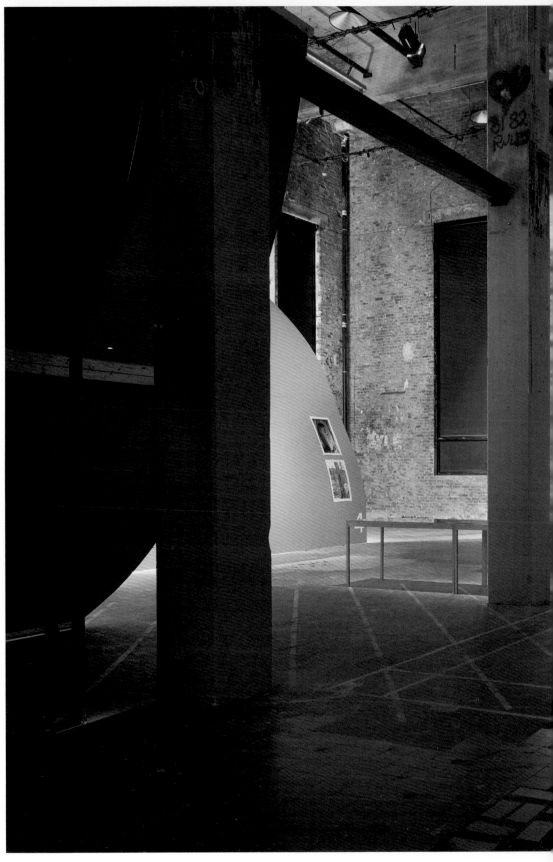

GIBCA 2021, Röda Sten Konsthall Exhibition architecture: Kooperative für Darstellungspolitik, text on pp. 44–48

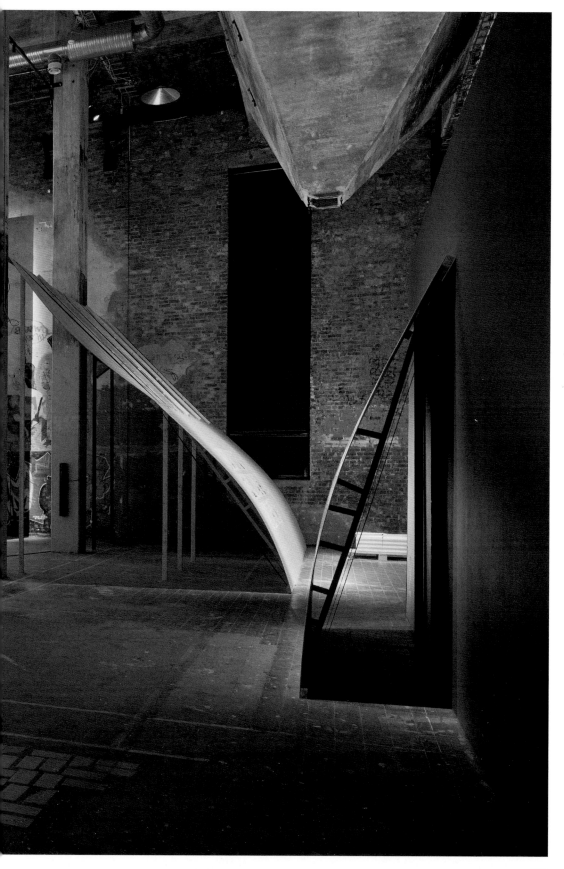

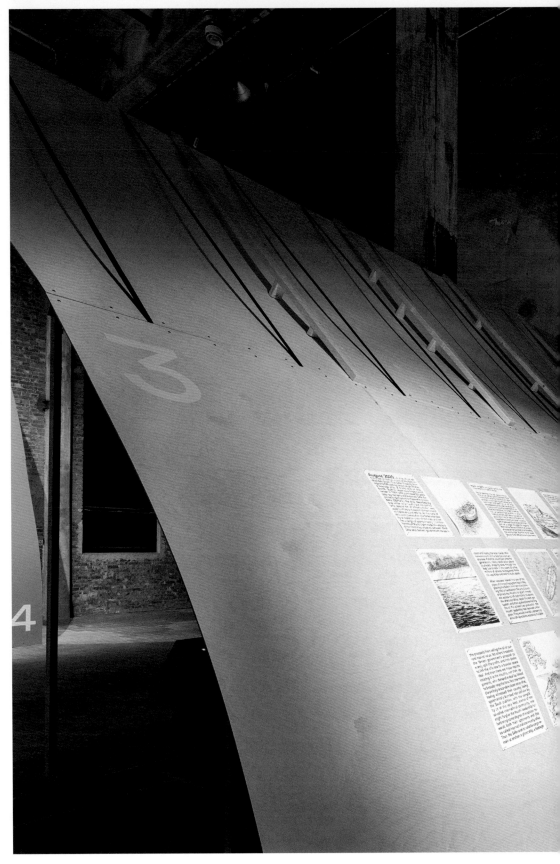

GIBCA 2021, Röda Sten Konsthall

Michael Baers, text on p. 445

coast and nearby Kamaran island, 14 kilometers north of the Safer's current anchorage. Fisheries would be ruined for generations, nearby desalination plants shuttered, shipping lanes through the Red Sea closed. In the event of a fire, millions of already beleaguered Yemenis would be exposed to toxic gases.

After seawater leaked into one of the pipes of the cooling system late in May, placing the Safer in imminent risk of sinking, the United Nations Security Council enjoined the Houthis to grant immediate access to UN technicians to assess the ship's condition, repair the inert gas system, and draw up plans for extracting the oil. For at least two years prior, the Houthi leadership had received similar pleas. They would invariably consent to allow UN specialists access to the Safer

proceeds from selling the oil at current market value. Yet others broadcast the Yemeni government's proposal to evenly split the profits, and their desire to link the oil's sale to a broader peace deal. And then there are those reports insisting it is the Houthis, not their opponents, who demand a deal be linked to broader negotiations. Not one makes the entirely reasonable observation that, having witnessed their country being systematically bombed into oblivion by the Saudi coalition, with the complicity or, at the very least, silence of the international community, one

before abruptly withdrawing permission at the last moment. Reports note Mark Lowcock, Under-Secretary-General for Humanitarian Affairs and Emergency Relief Coordinator, had briefed the Council about the ship 15 times over the previous 15 months, always repeating the same information.

Most news accounts claim the Houthis regard the ship as a cross between a bargaining chip and potential source of revenue. One anonymous European diplomat told the AP late in June that the Houthis like to have the Safer as something to hold against the international community if attacked. Conversely, a report from 2019 in the World Maritime News, as well as reportage from Al Jazeera, say the Houthis have reached out to the UN for assistance in offload-

ing the Safer, noting Saudi Arabia is referenced in this embargo. These same reports mention how Saudi jets twice bombed the Ras Isa Oil Terminal, possibly to discourage attempts to offload the ship's oil, and that it was the Royal Saudi Navy who initially prevented delivery of diesel fuel to the Safer thus disabling its engine, and with it, the inert gas system.

Given the enormity of the threat, how to account for the Safer sitting so long at anchor, rotting in the sun as the TV journalist phrased it. Many news sources report the Houthis demand for $80 million in exchange for the oil being removed (its market price prior to the collapse of world oil prices following the Covid-19 pandemic). Others convey the Houthi's claim to be satisfied with

, a bomb ship or ship-bomb.

...erusing the news accounts, you read the photographs accompanying the articles for indications of the ship's distress. They convey little. Satellite images or photographs taken from a low-flying plane or helicopter, or from the deck of a vessel of similar scale, provide a view of the entire ship, but from such a distance that its condition is not visible. What you see is merely a very large ship afloat upon the sea. Searching for concrete proof of war's devastation, one is brought up short by these photographs, their lack of affect is in inverse proportion to the devastation the Safer may cause. One article even led with a photograph of an entirely different, more dramatically imperiled ship so as to make up for this deficit.

Nonetheless, what you sense when looking at these images is that you are meant to see the danger they—the Yemeni people and residents of adjacent countries, the marine life, the coastal flora and fauna—are in. But it is our danger too, if we could but see it.

Between the present time of composition and October 2020, when this work will first be exhibited, three likely scenarios present themselves: either an agreement will have been reached between the Houthis, the Yemeni government and the UN, allowing the Safer's oil to be unloaded and sold; the ship will have exploded and/or sunk, its contents leaking into the sea and causing untold havoc; or the ship will remain uncertainly and dangerously afloat, the warring parties having been unable to rea...

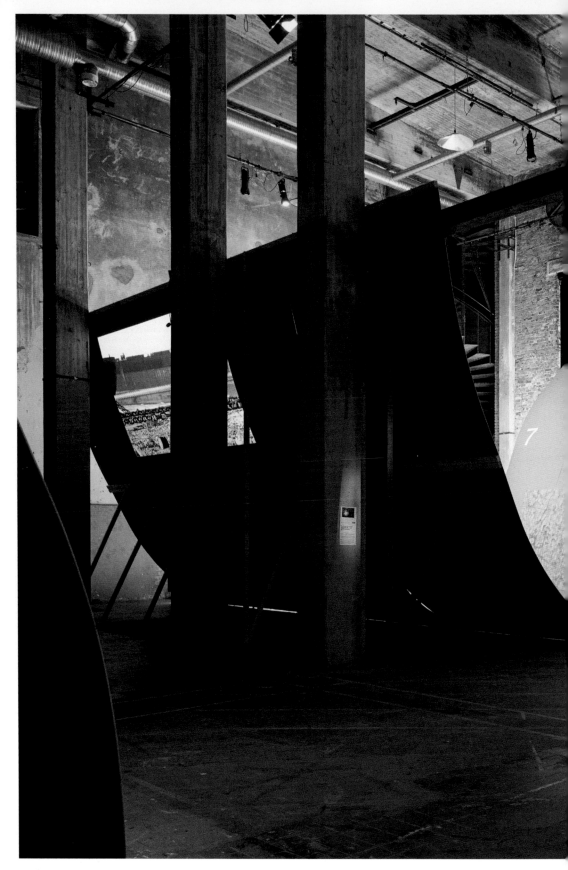

 Hira Nabi, text on p. 447

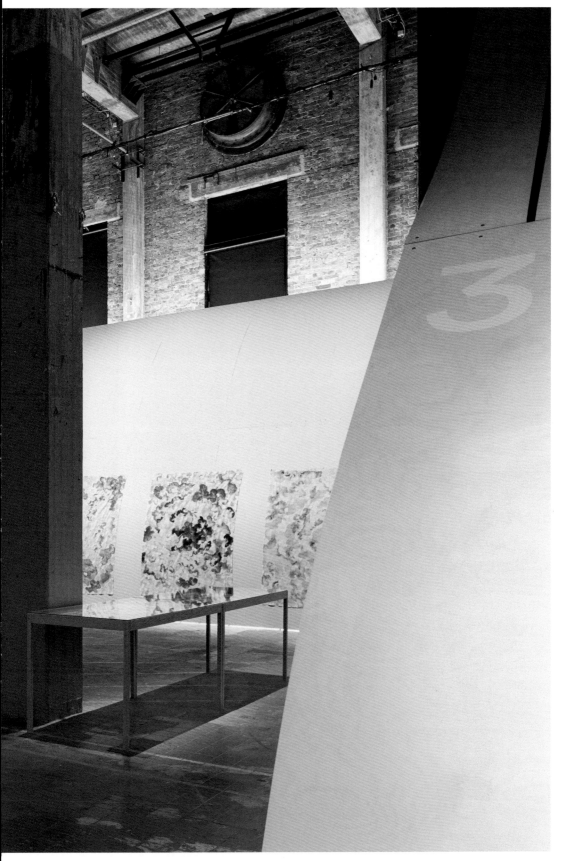

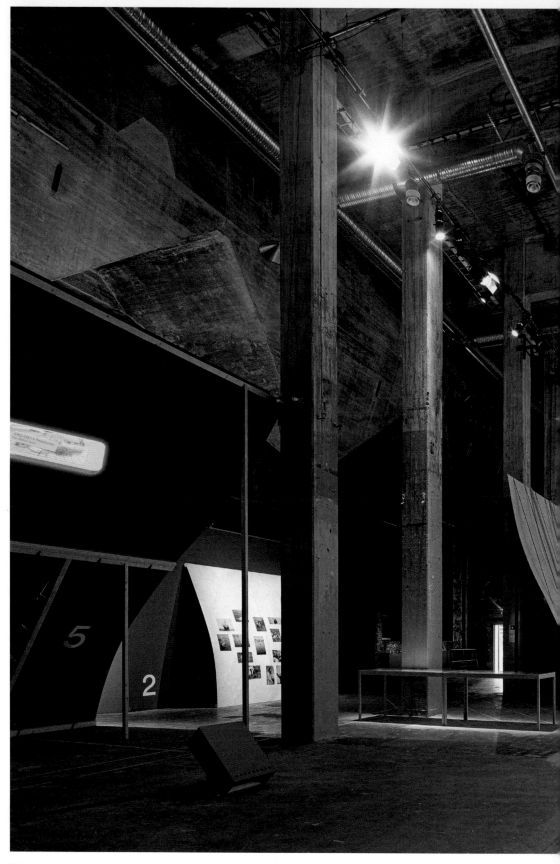

GIBCA 2021, Röda Sten Konsthall Installation view

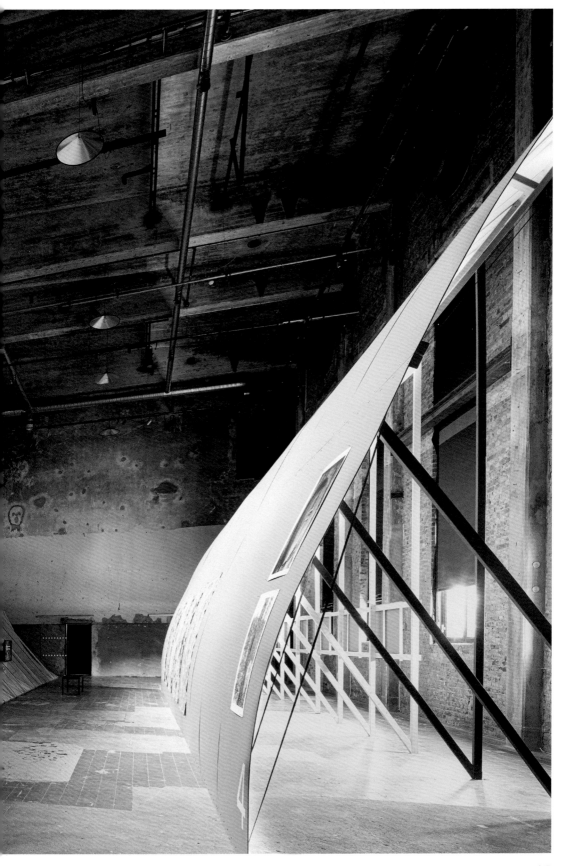

Tabita Rezaire, text on p. 447

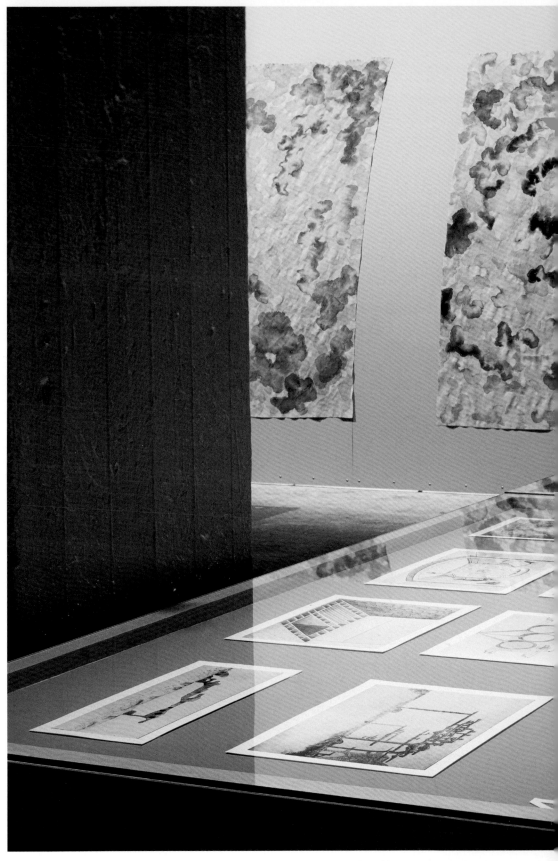

Anna Ling, text on p. 446

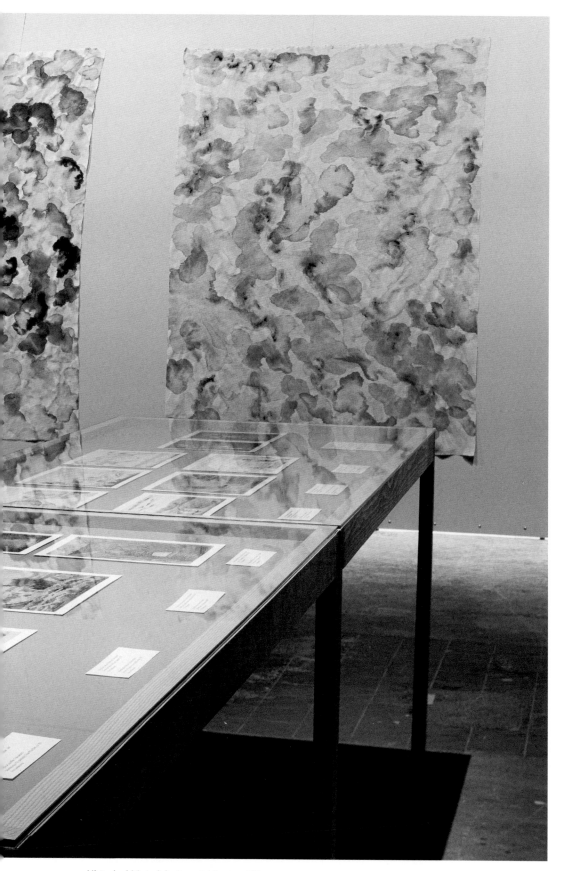

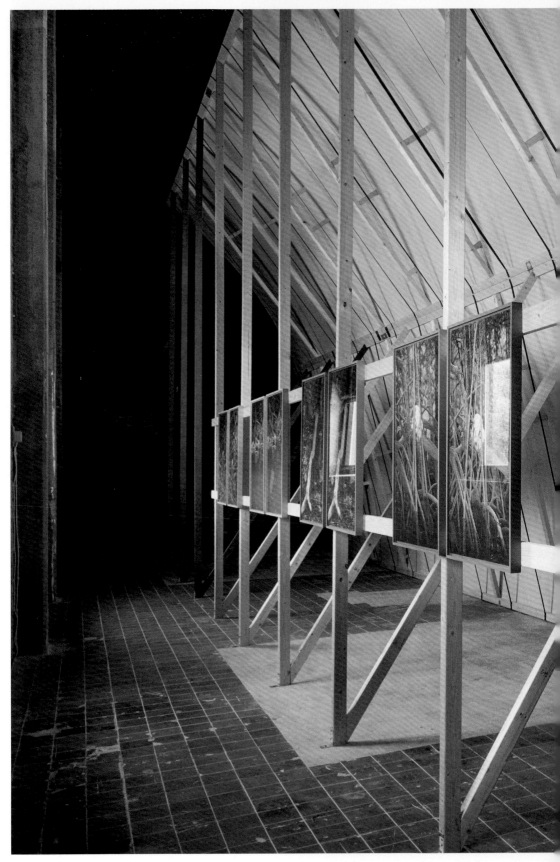

Susanne Kriemann, text on p. 446

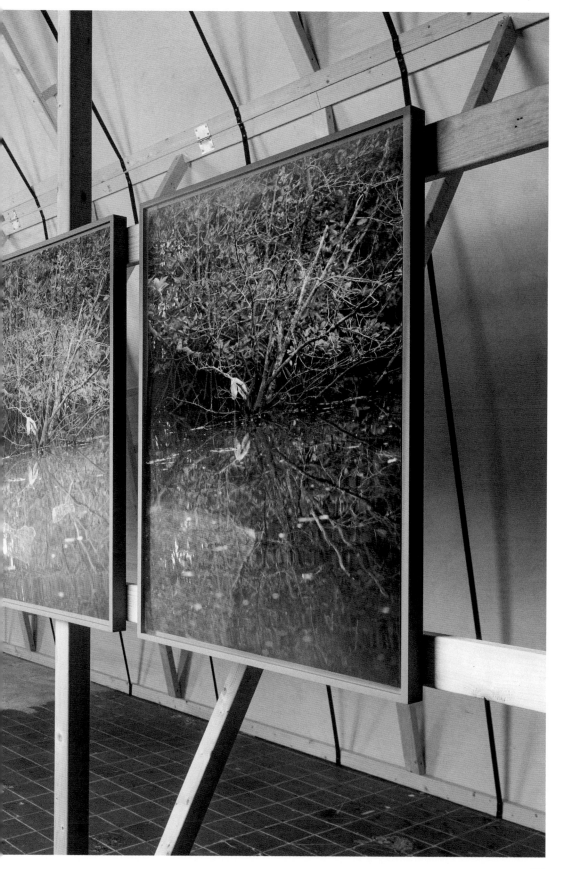

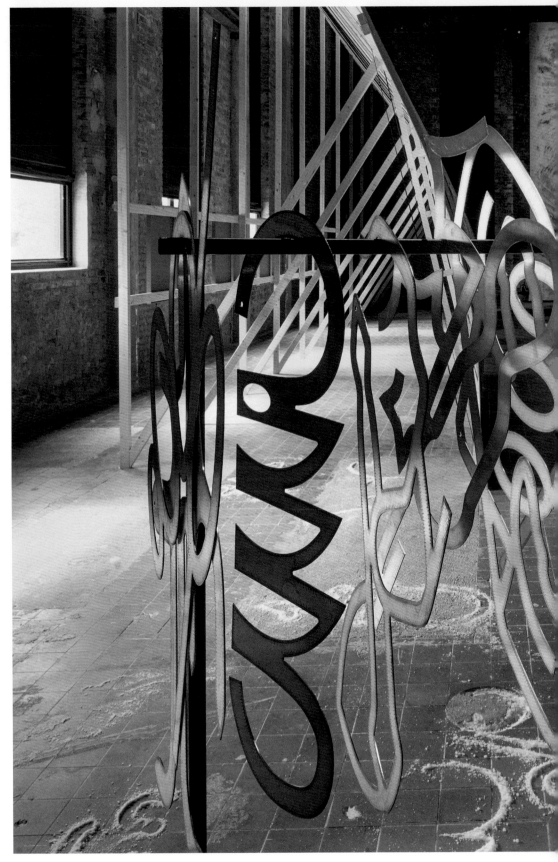

 Damla Kilickiran, text on p. 446

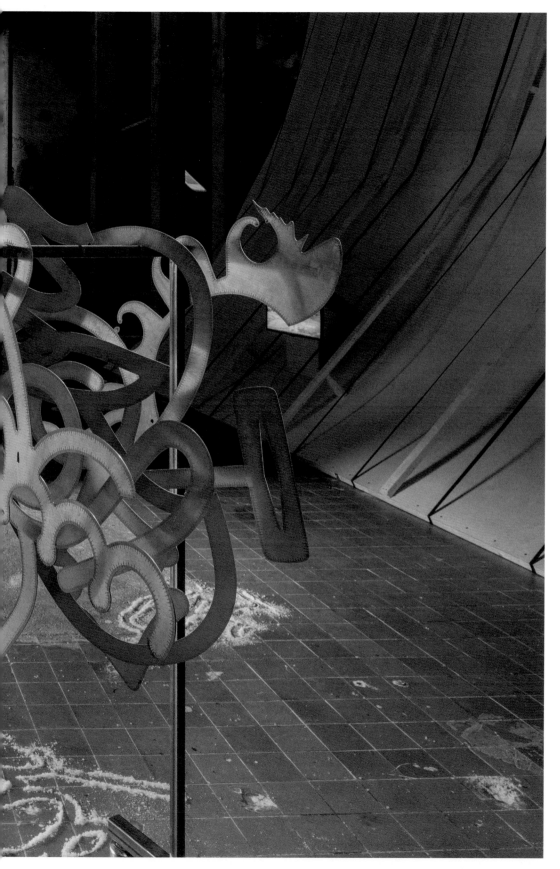

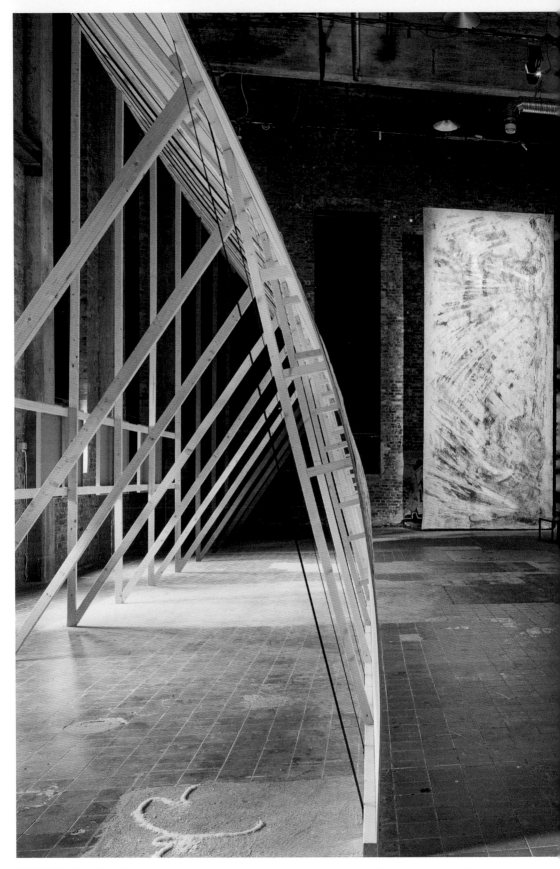

Jessica Warboys, text on p. 447

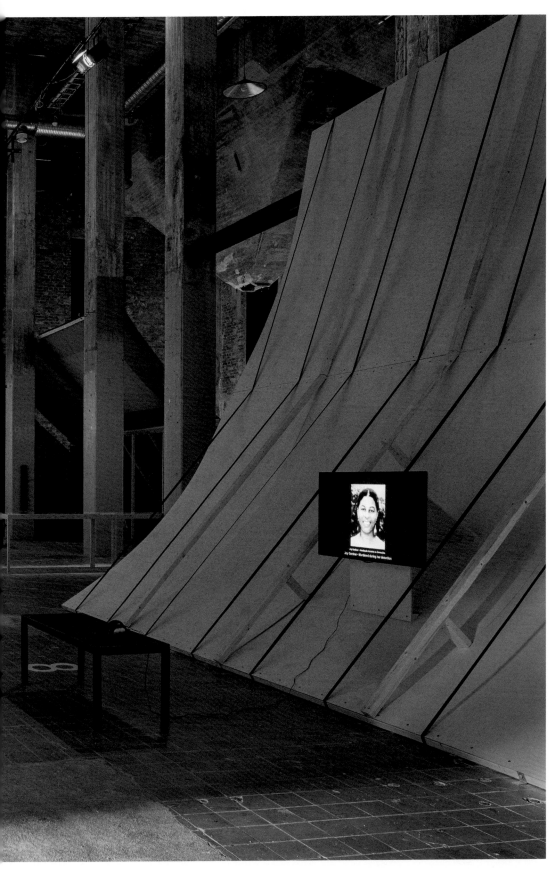

Daniela Ortiz, text on p. 447

2

Silvano Lora, text on p. 447

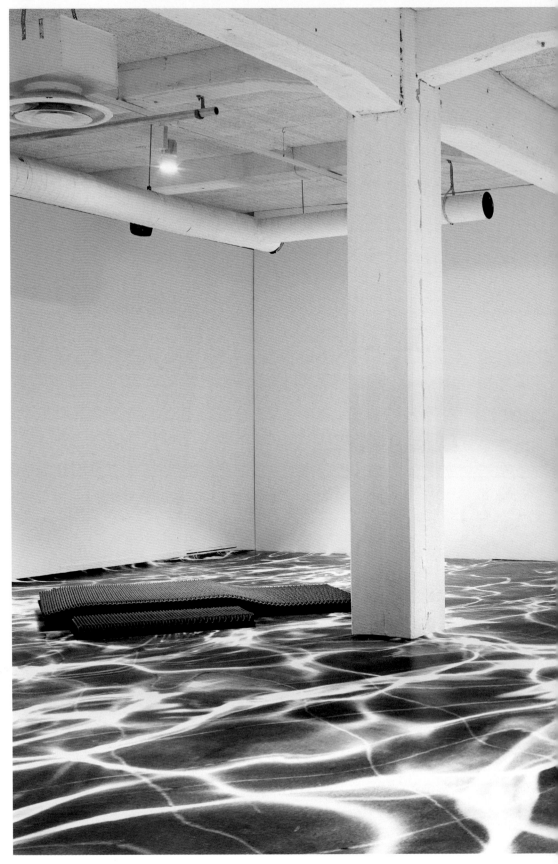

Evan Ifekoya, text on p. 445

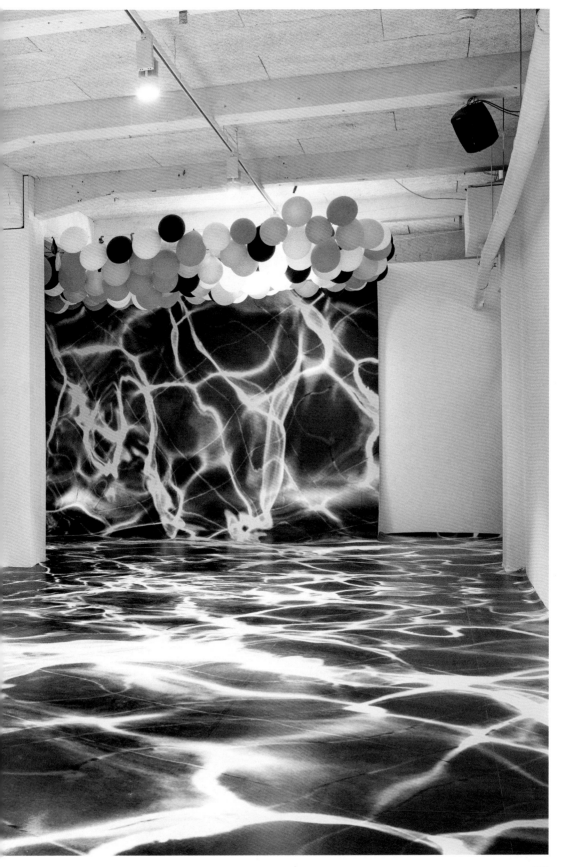

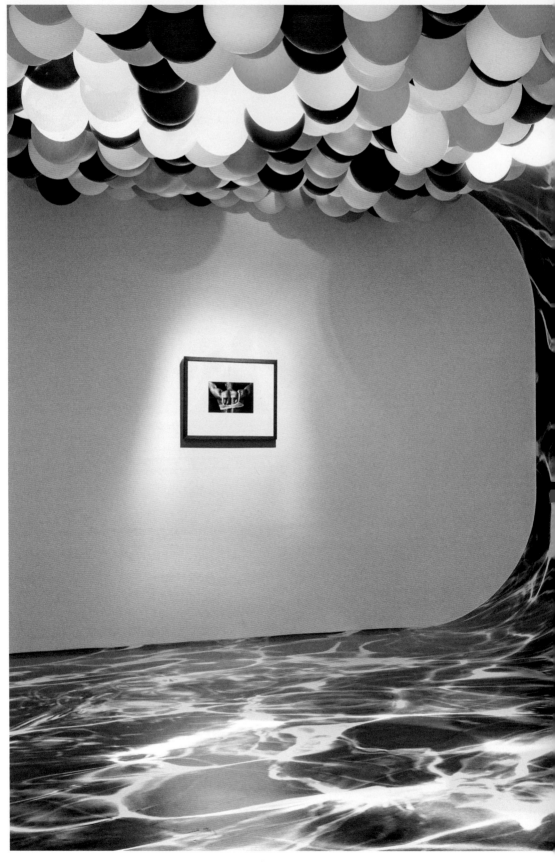

Evan Ifekoya & Ajamu X, text on p. 445

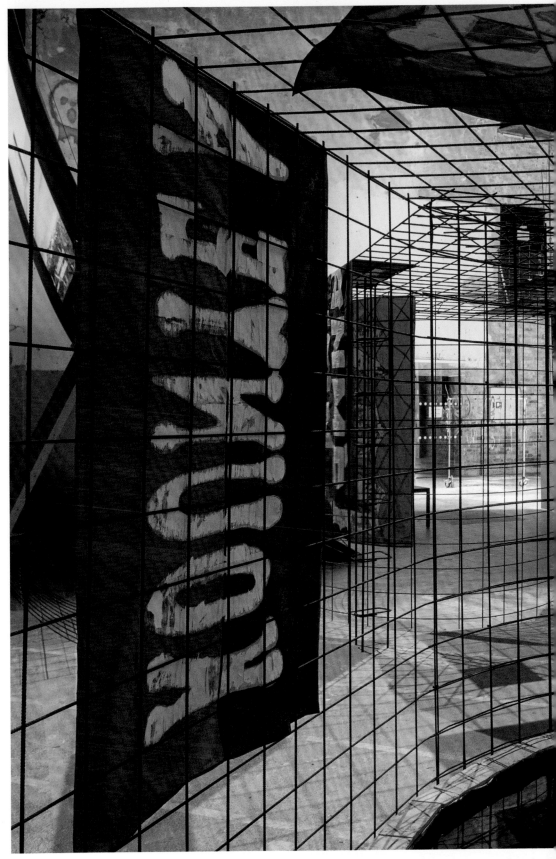

Gaëlle Choisne, text on p. 449

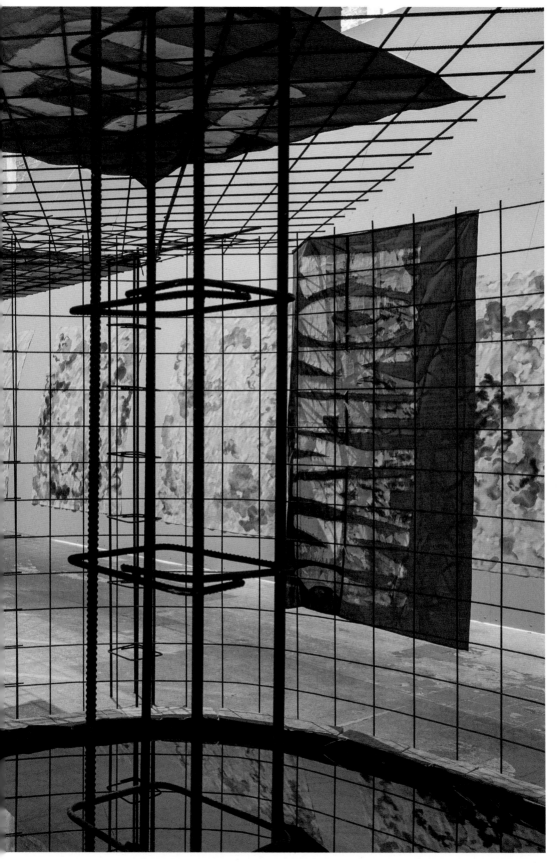

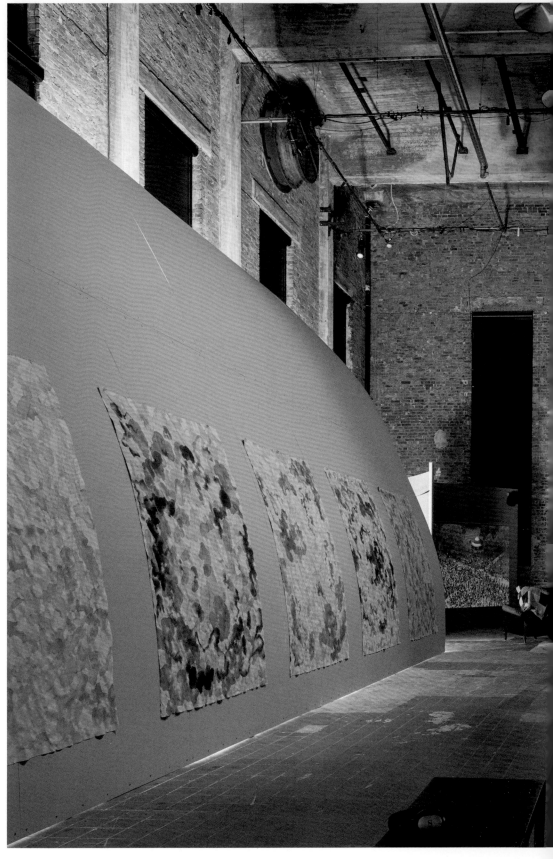

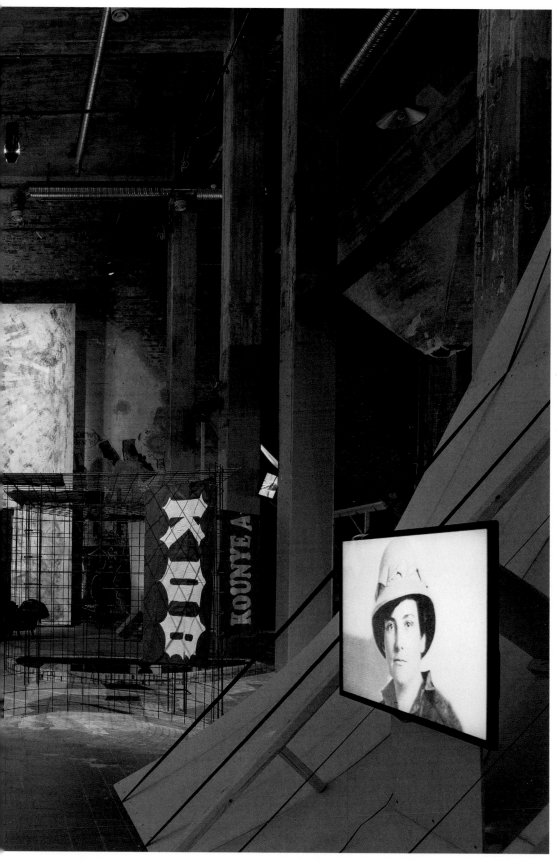

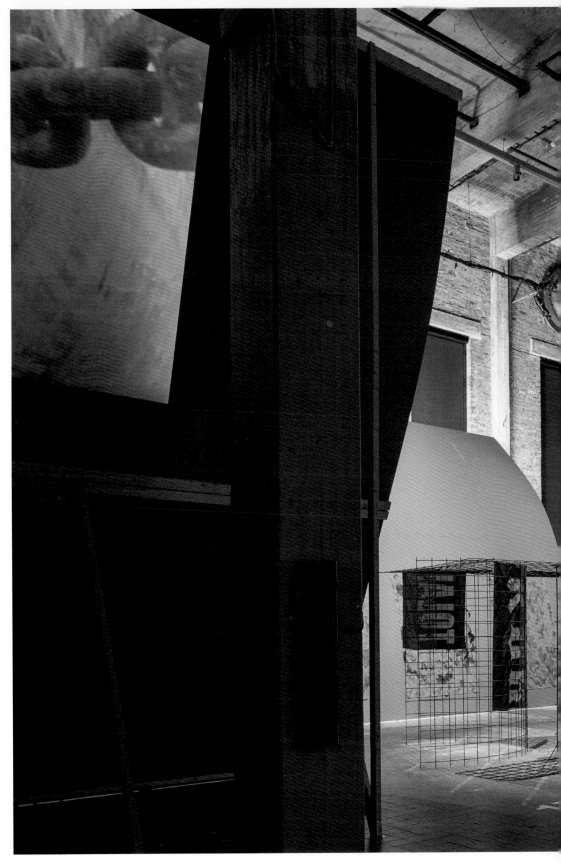

GIBCA 2021, Röda Sten Konsthall Installation view

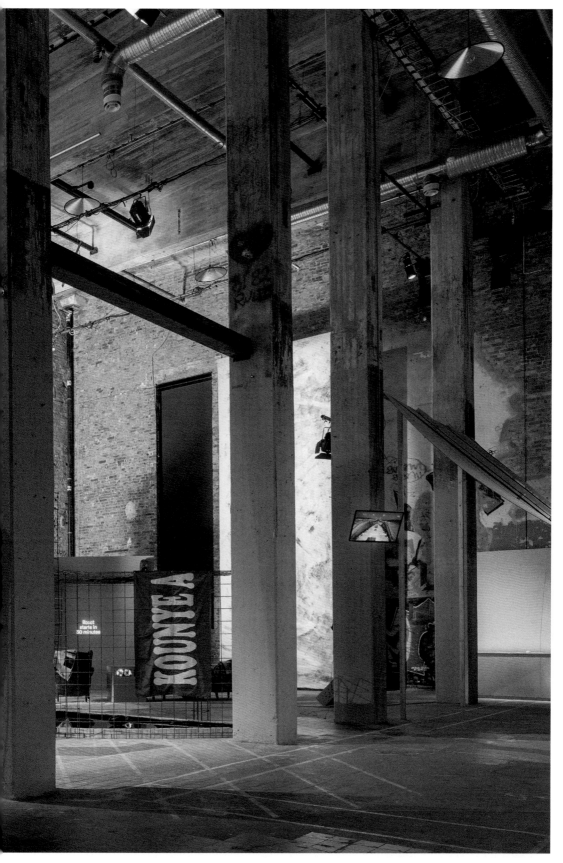

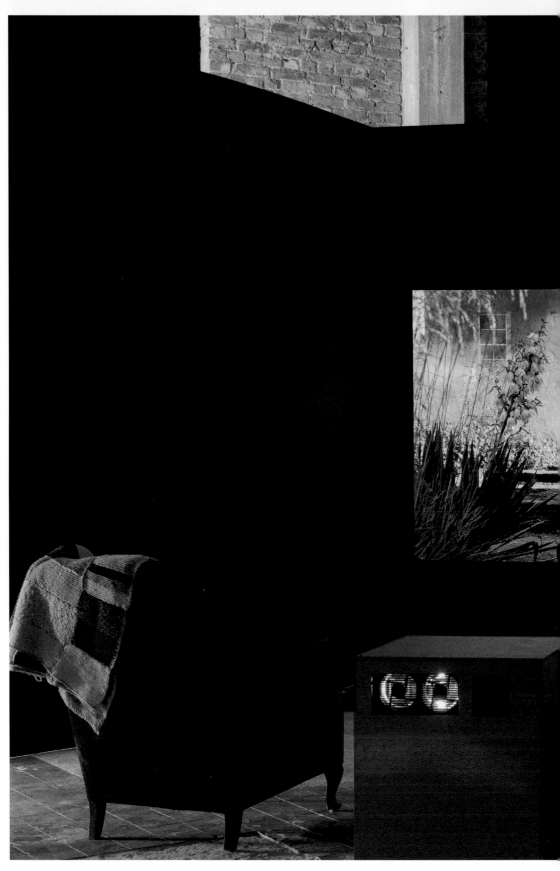

Alberta Whittle, text on p. 450

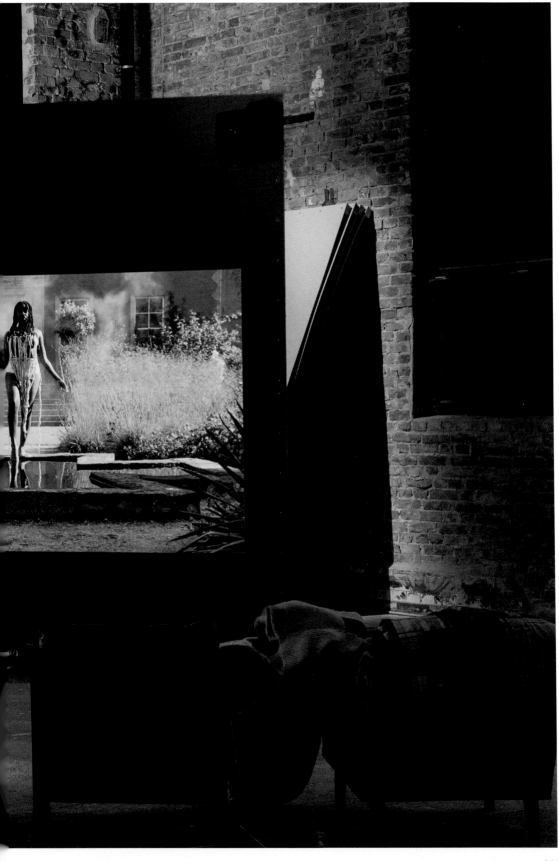

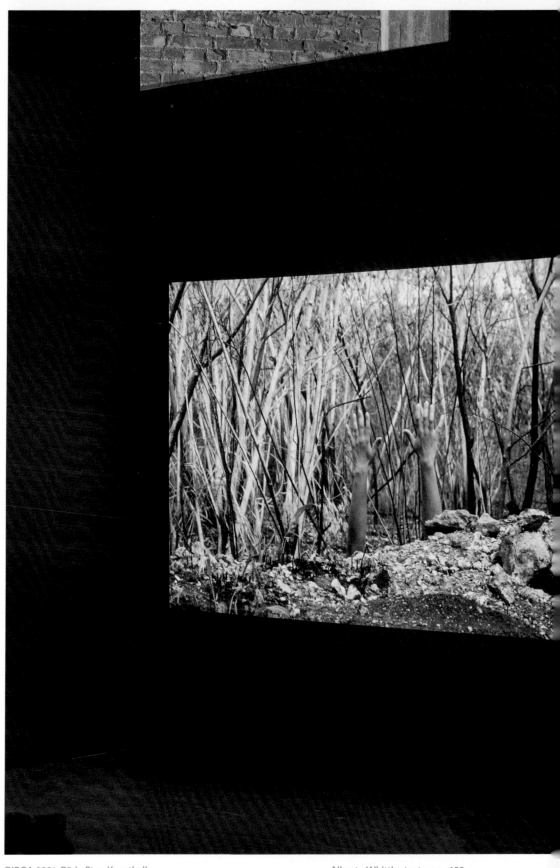

Alberta Whittle, text on p. 450

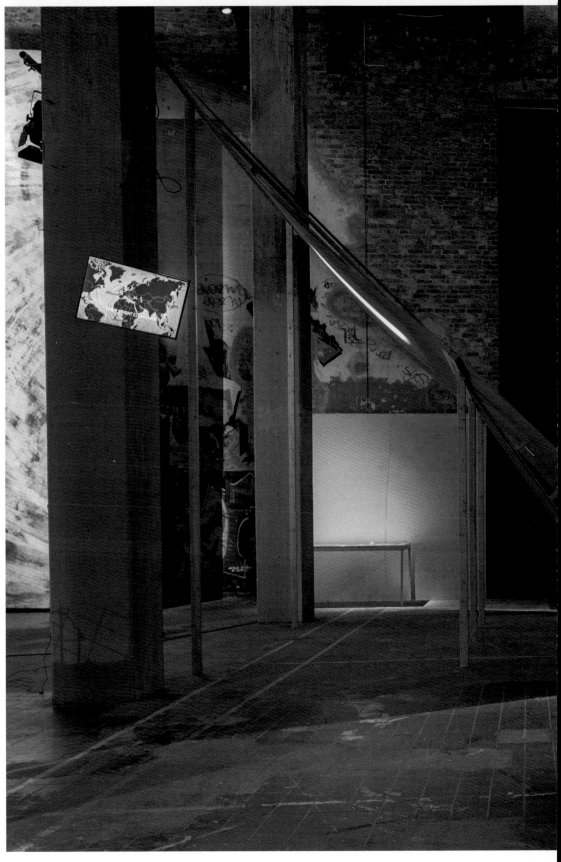

Benjamin Gerdes, text on p. 449

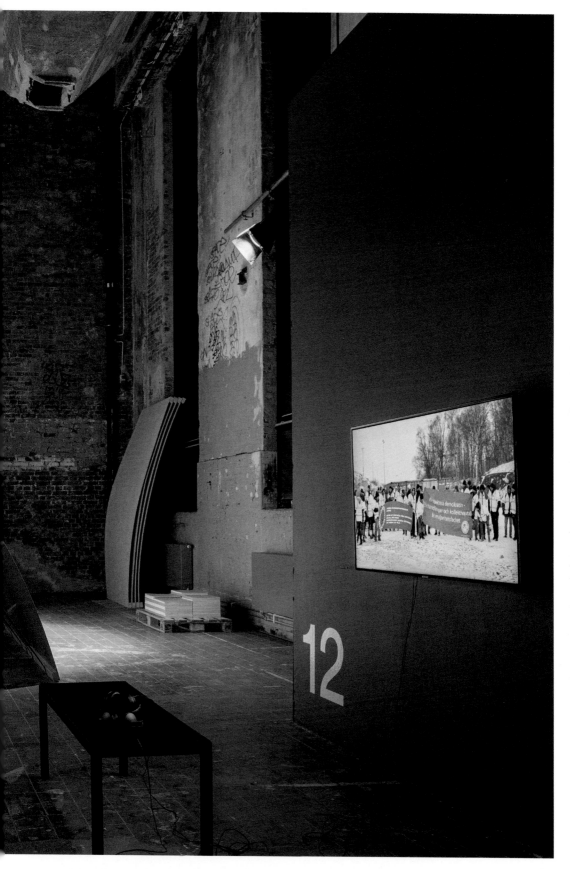

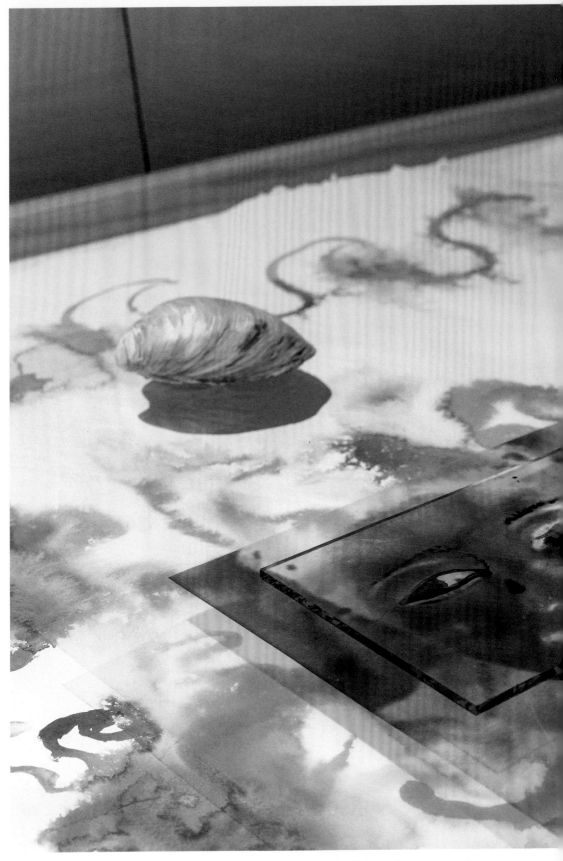

Cecilia Germain, text on p. 450

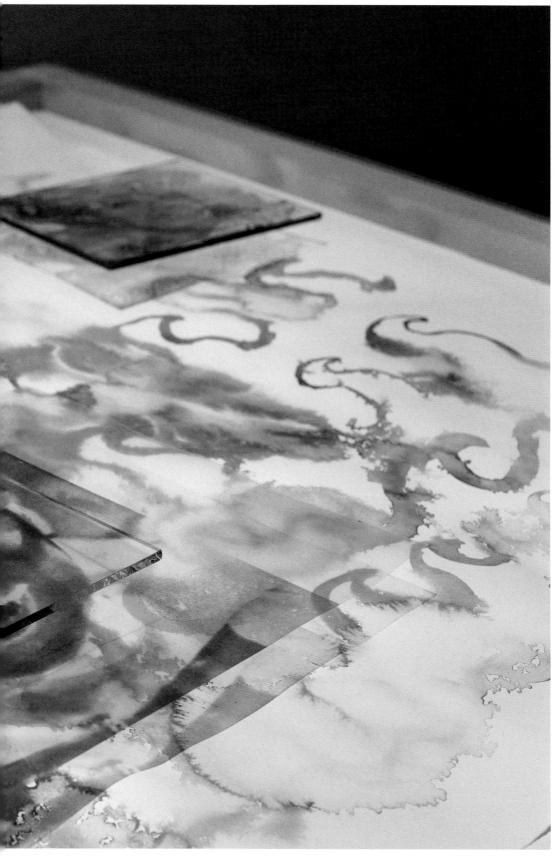

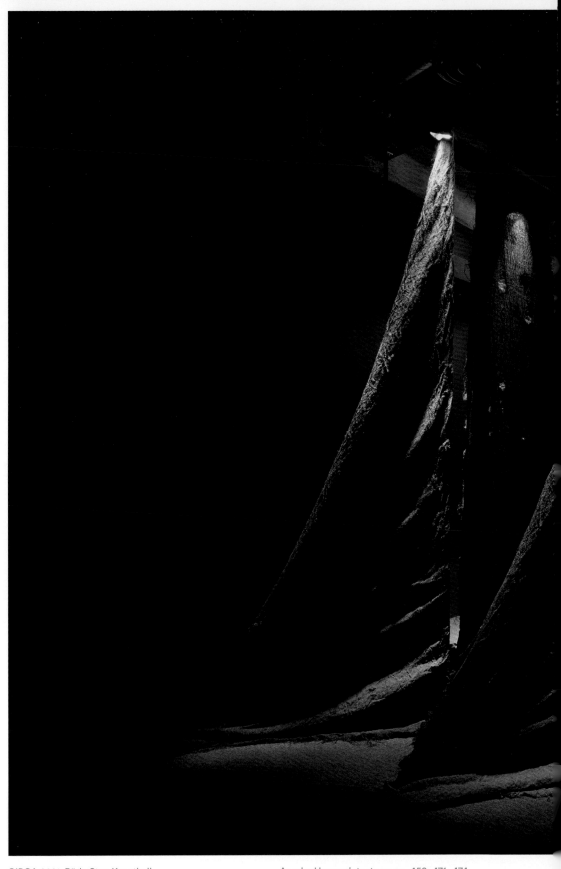

Ayesha Hameed, texts on pp. 450; 471–474

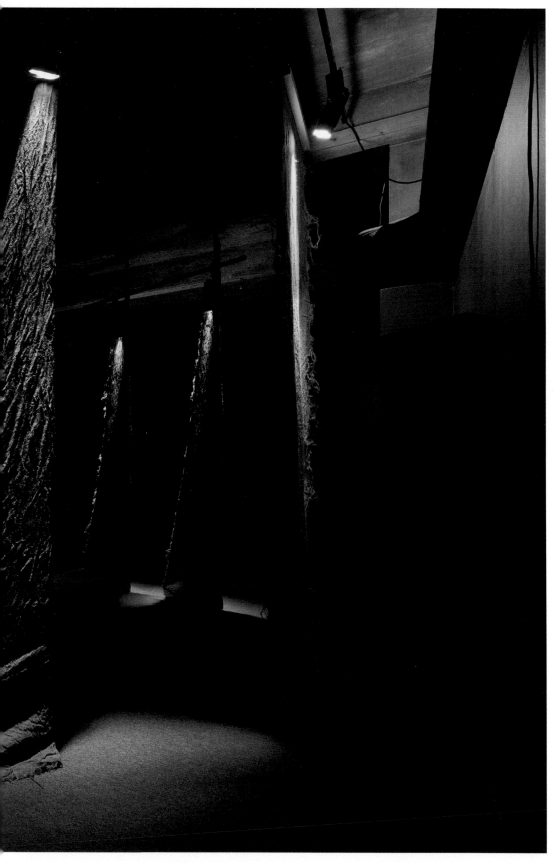

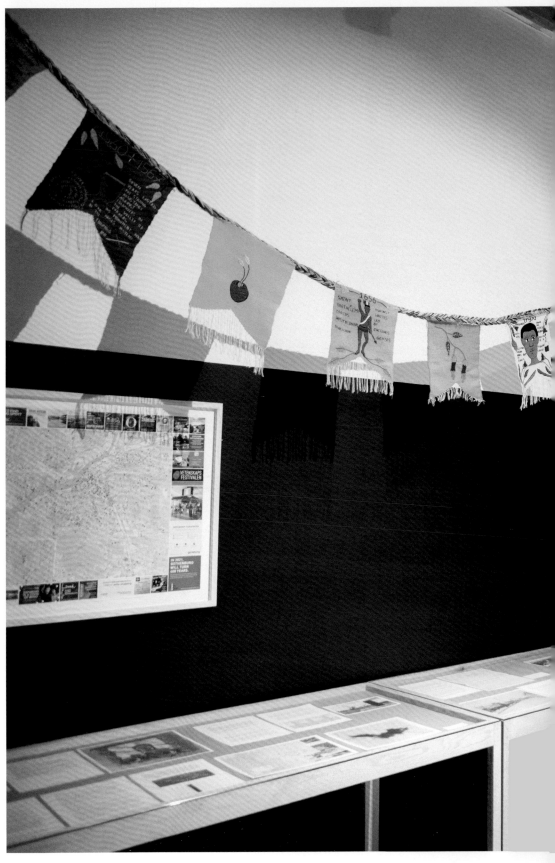

GIBCA 2021, Röda Sten Konsthall *Possible Monuments?*, texts on pp. 166–183; 448

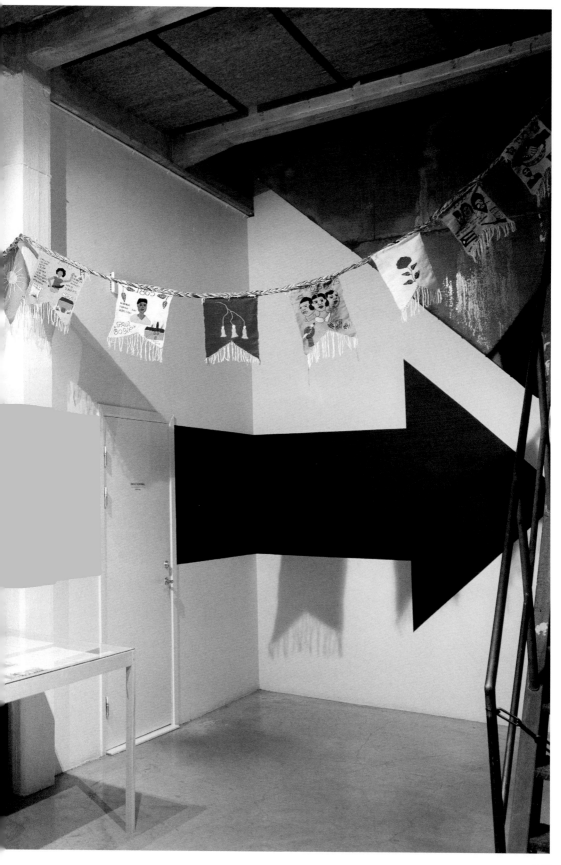

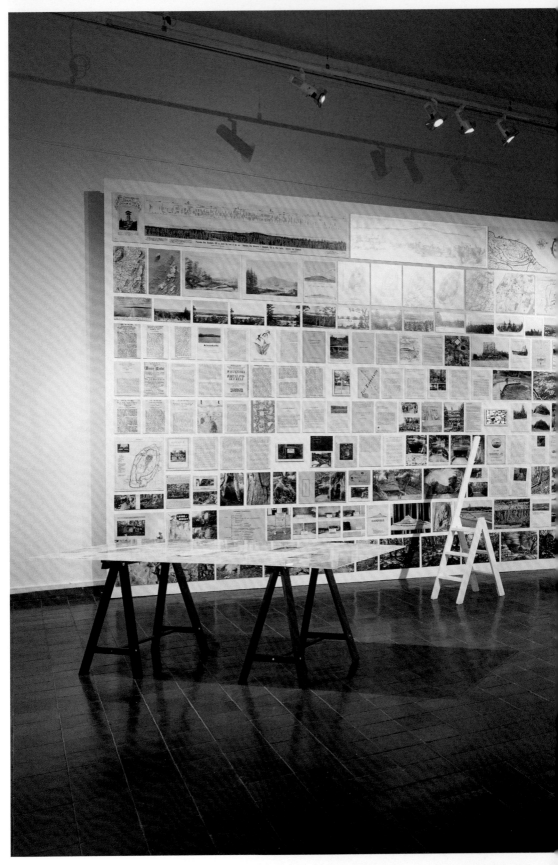

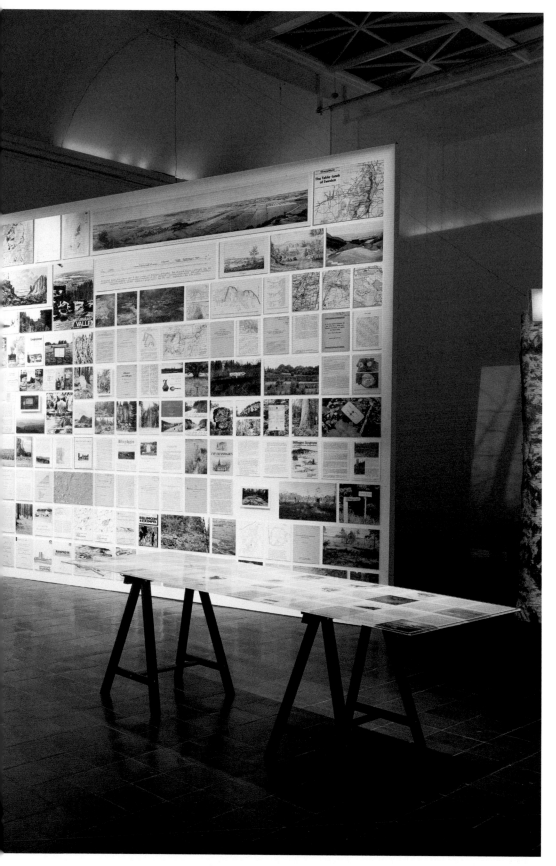

255

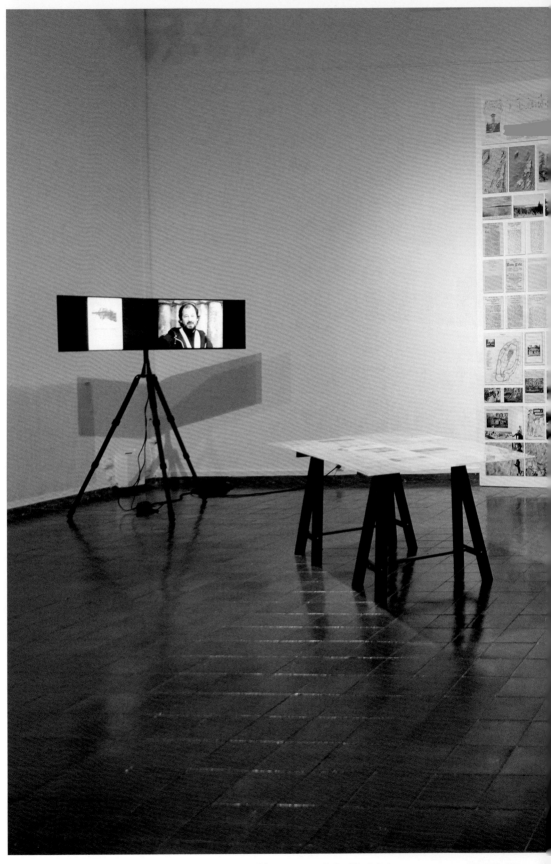

GIBCA 2021, Göteborgs Konsthall　　　Jonas (J) Magnusson & Cecilia Grönberg, texts on pp. 124—135; 458

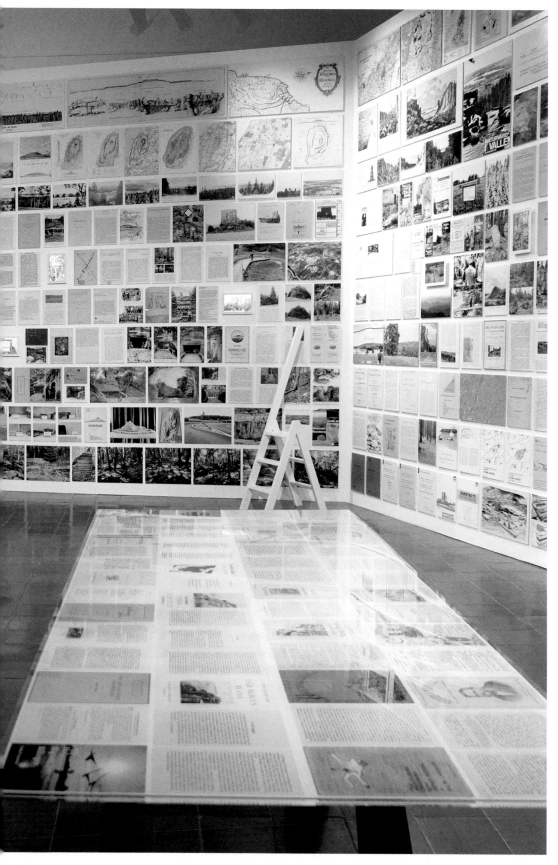

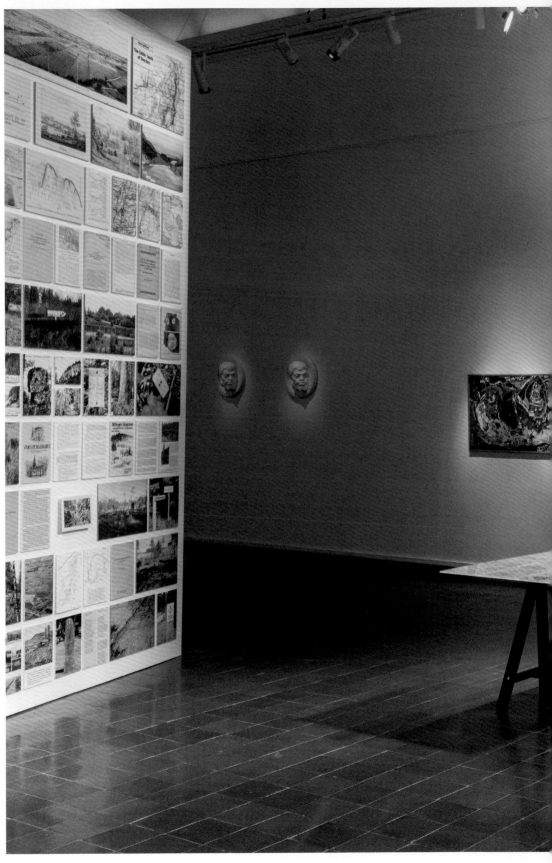

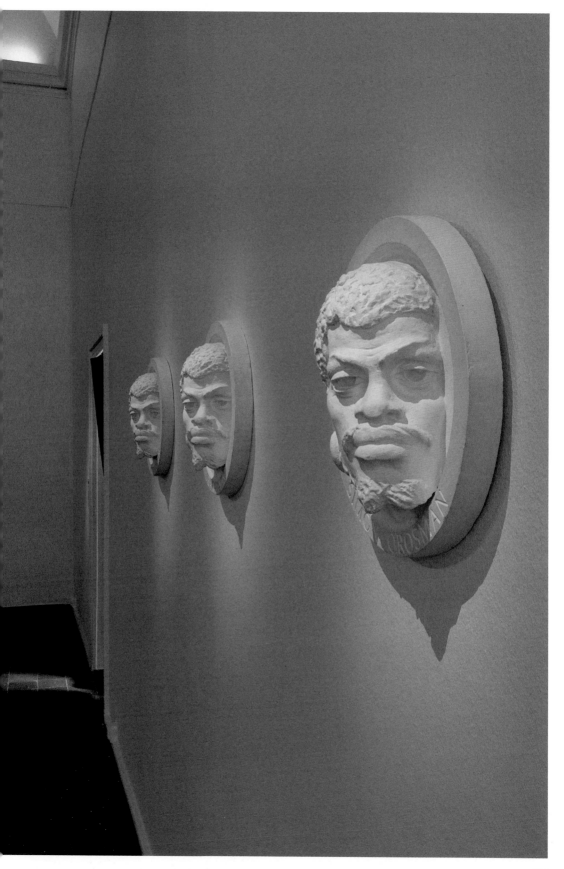

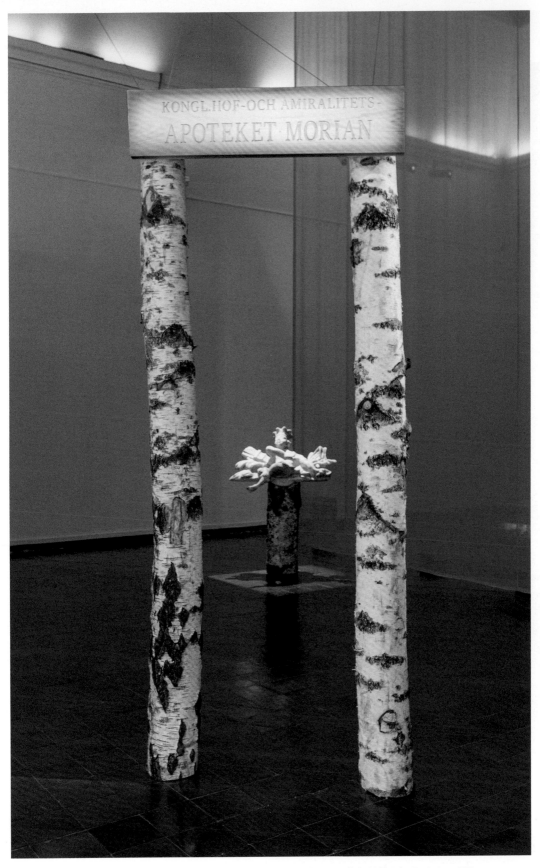

KONGL.HOF-OCH AMIRALITETS-
APOTEKET MORIAN

 Salad Hilowle, text on p. 457

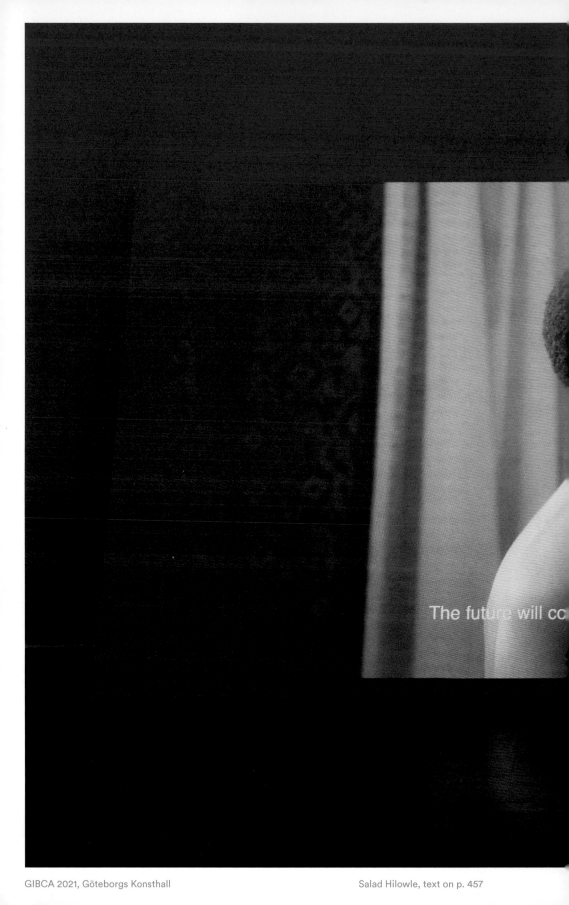

The future will co

Salad Hilowle, text on p. 457

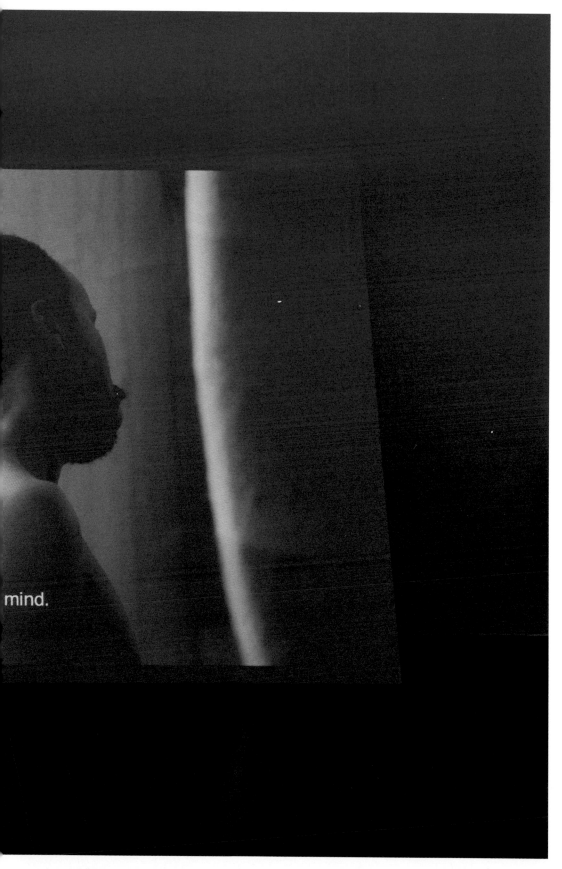

mind.

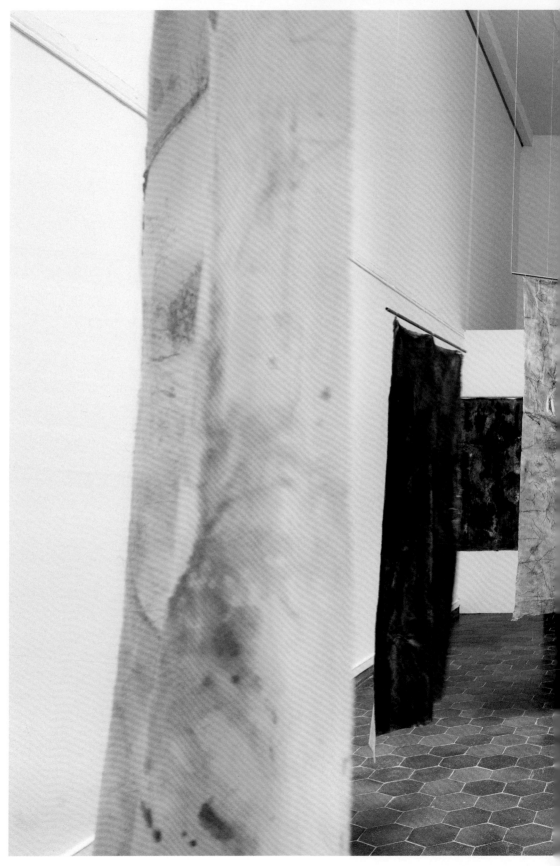

Erika Arzt & Juan Linares, text on p. 457

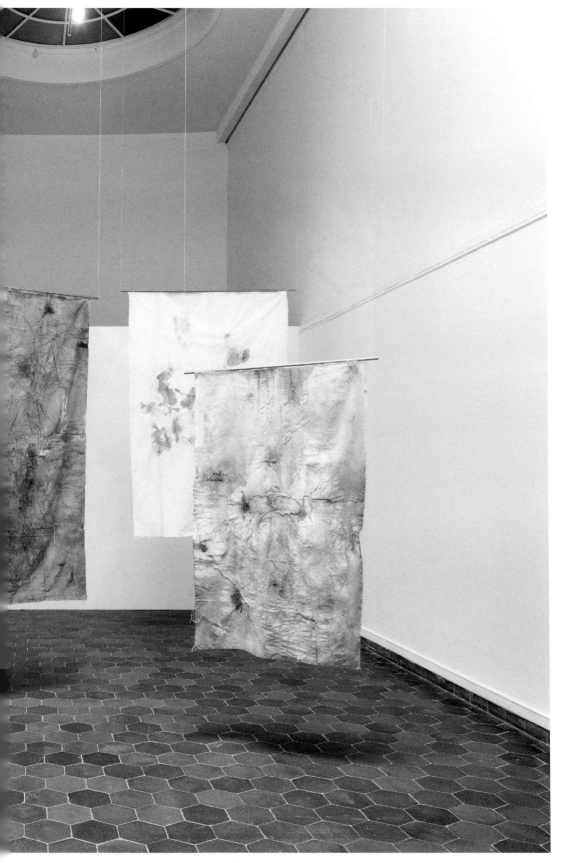

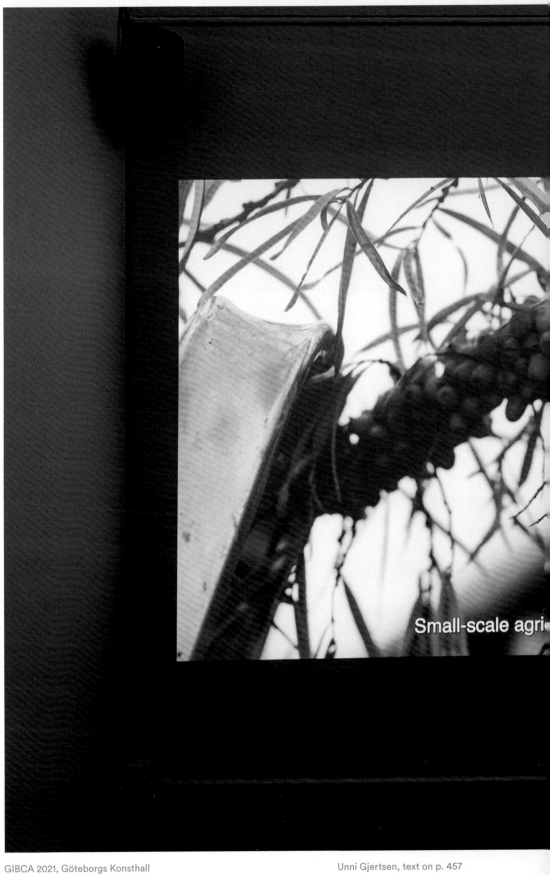

Small-scale agri‐

Unni Gjertsen, text on p. 457

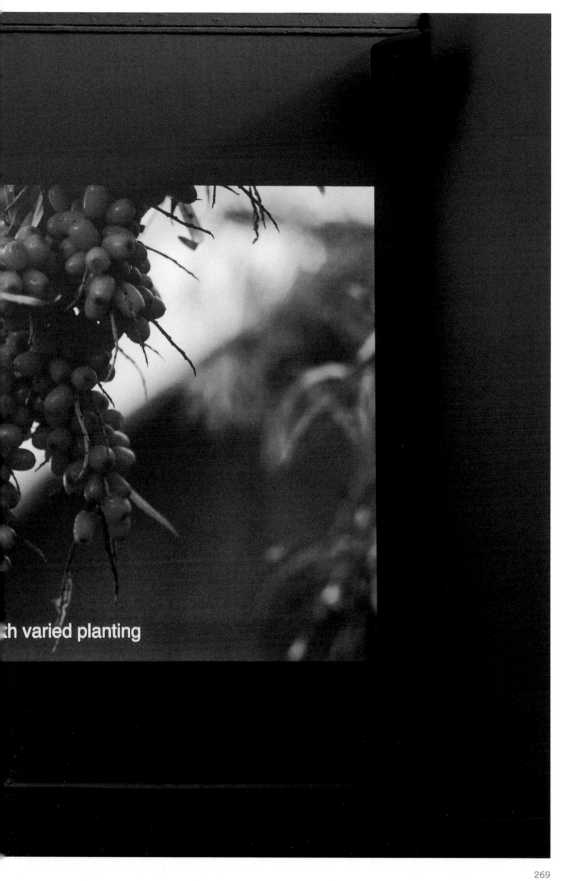

th varied planting

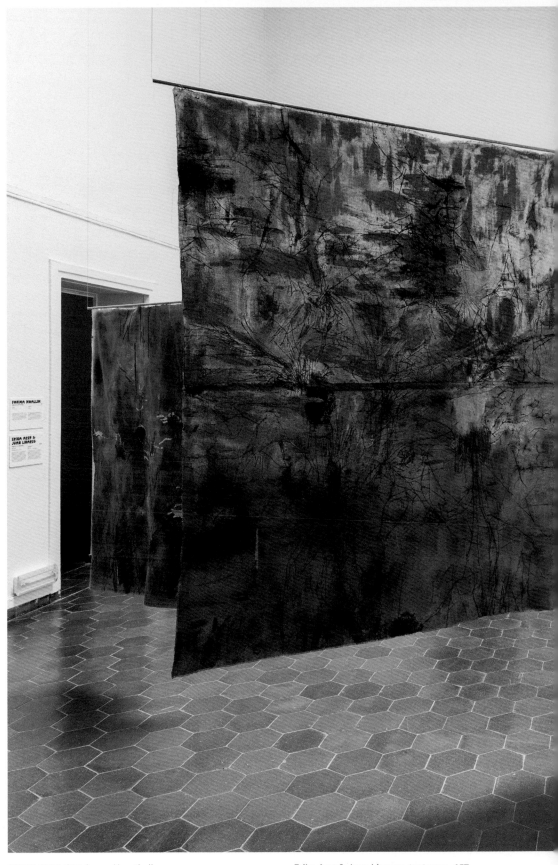

Erika Arzt & Juan Linares, text on p. 457

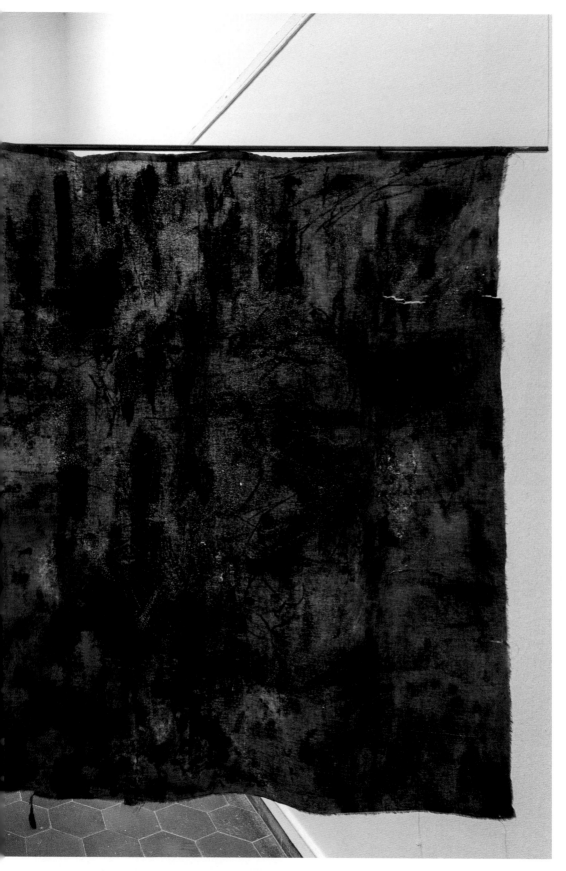

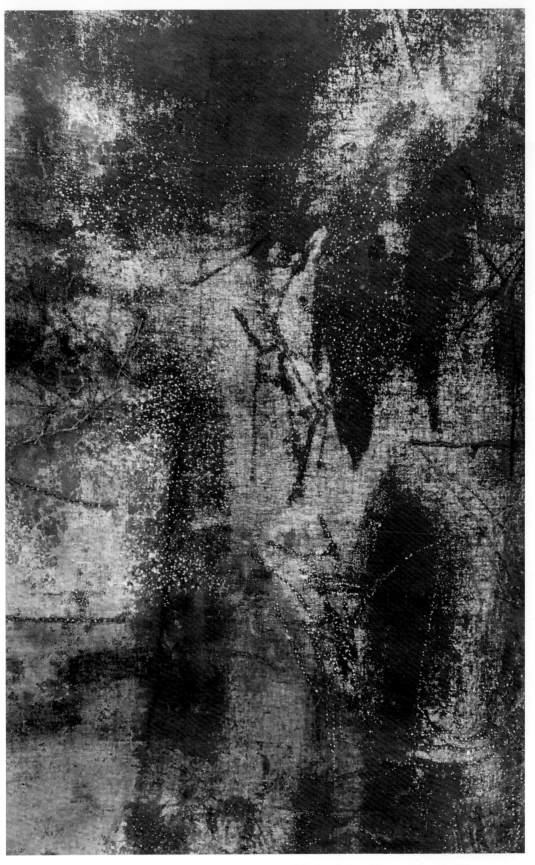

Erika Arzt & Juan Linares, text on p. 457

Fatima Moallim, text on p. 458

Lisa Tan, text on p. 458

LITTLE PETRA
47 495 kr

Conny Karlsson Lundgren, text on p. 457

 Conny Karlsson Lundgren, text on p. 457

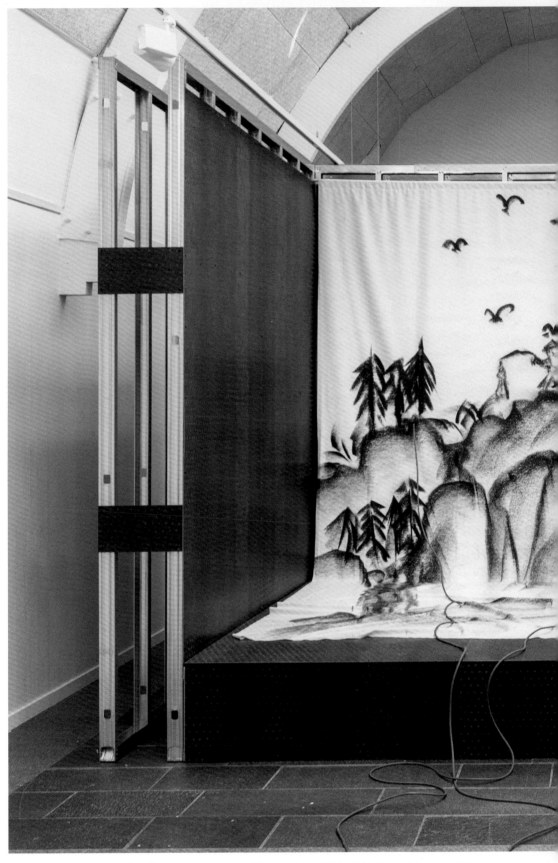

Shanzhai Lyric & Solveig Qu Suess, text on p. 459

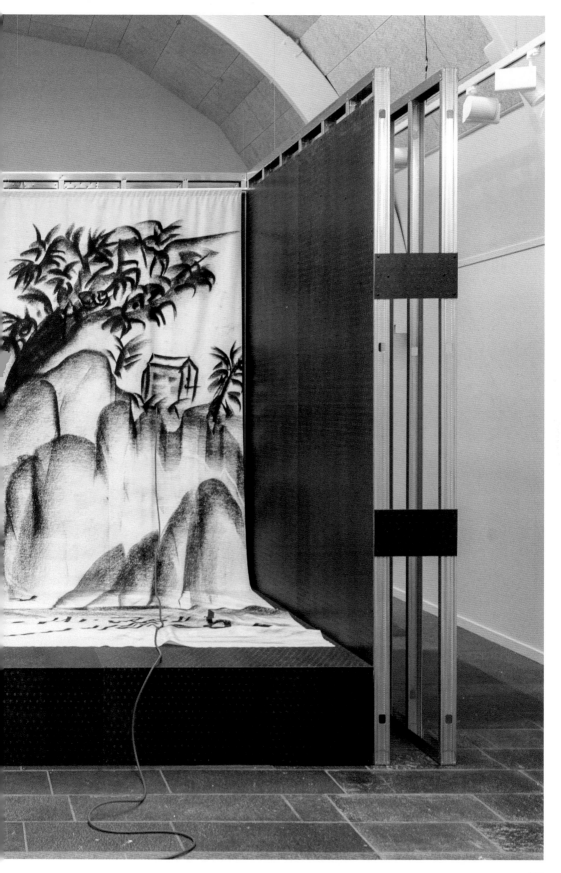

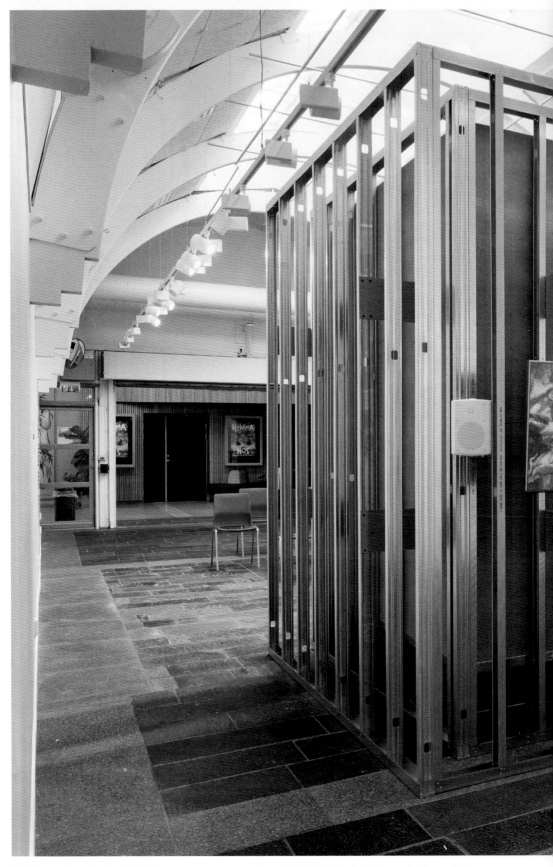

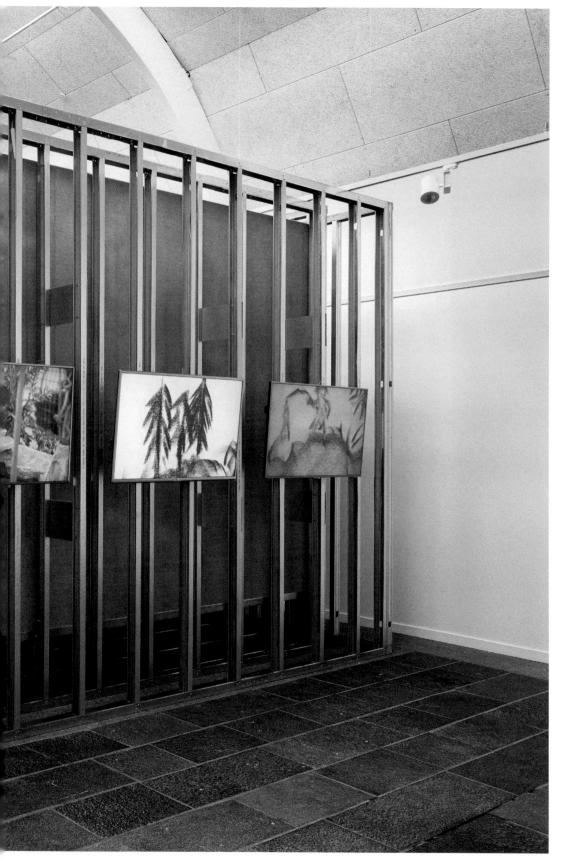

 Solveig Qu Suess, text on p. 459

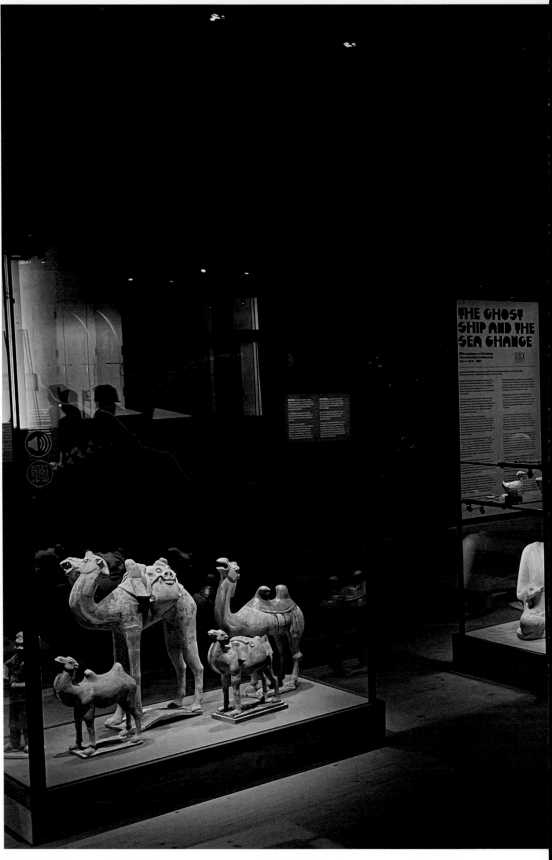

THE GHOST
SHIP AND THE
SEA CHANGE

Alles gaat vo

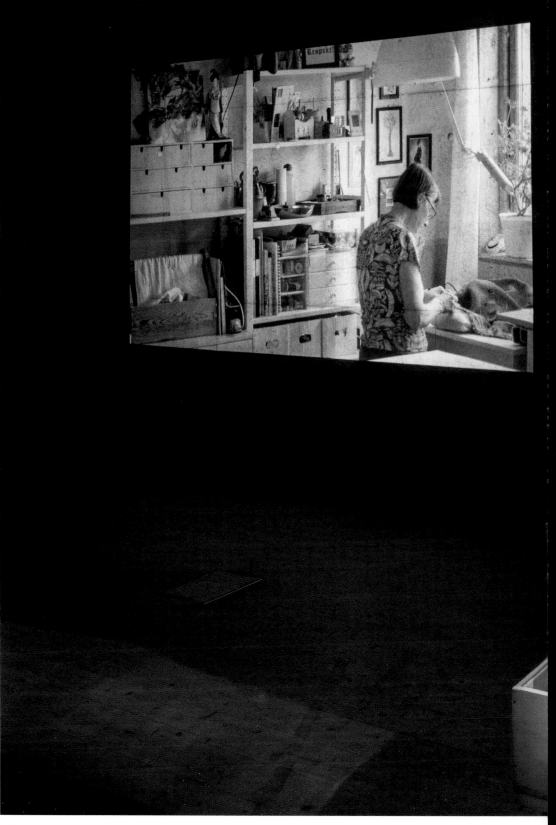

 Oscar Lara, text on p. 451

Hall of Latin American Archaeology, Gothenburg Ethnographic Museum, 1964

Exhibition A Traves Por-4d, Museum of World Culture, 2005

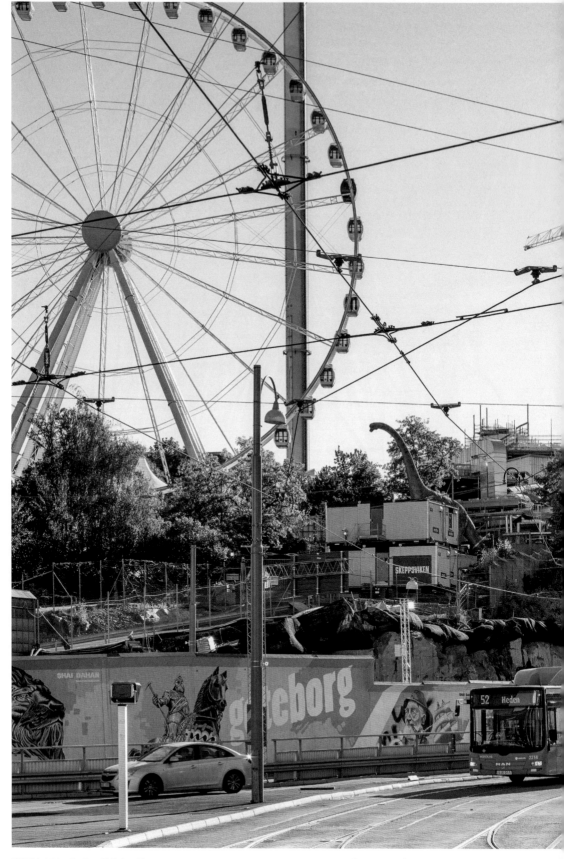

GIBCA 2021, Online/Offsite: Esperantoplatsen

HAMN (Nasim Aghili & Malin Holgersson [soundwork]), texts on pp. 95–98; 454 303

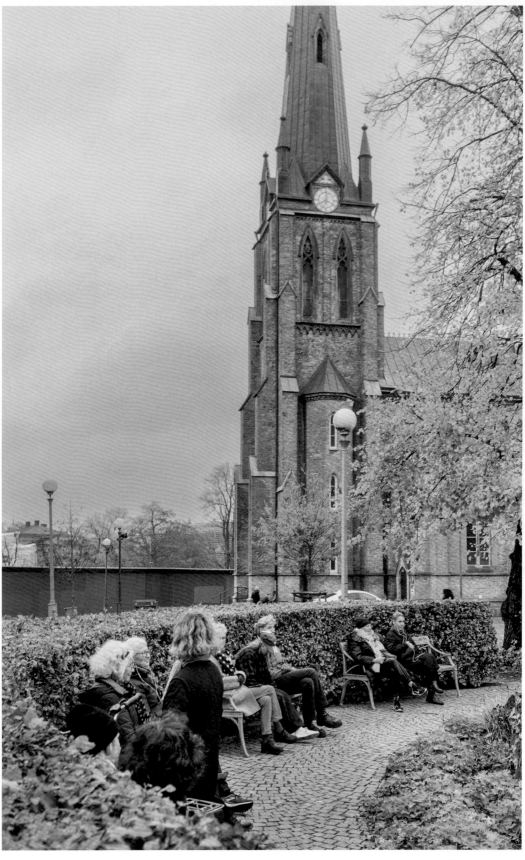

GIBCA 2021, Online/Offsite: Haga and Gothenburg Central Station Pia Sandström (soundwork), text on p. 455

Manuel Pelmuş (soundwork), text on p. 454

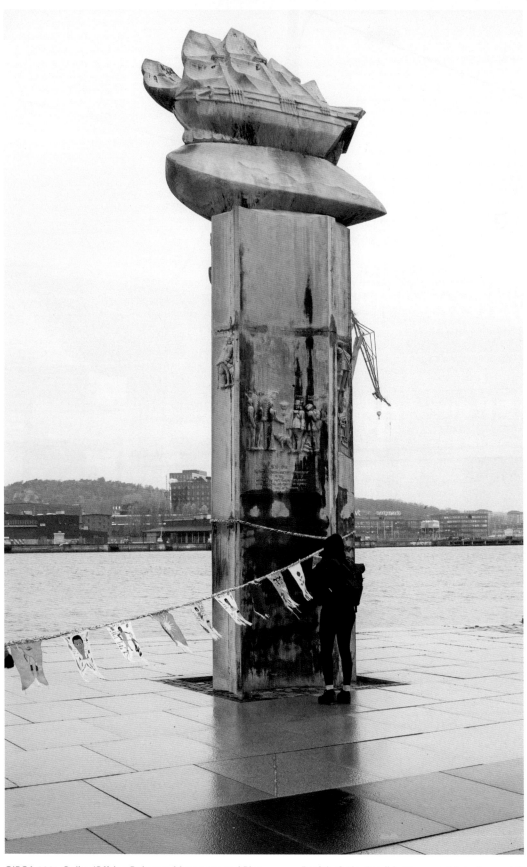

GIBCA 2021, Online/Offsite: Delaware Monument and Risö Daniela Ortiz, *Possible Monuments?*, text on p. 448

Henrik Andersson (making of the work *Havmanden/Merman*), text on p. 454

Henrik Andersson, text on p. 454

de now &

o ai ye ee v

me where be

at in bone sir

empt wi

a stir

g to mak

ff har

re my lust

the sir

fa s

i fa

so r

f

a so so la

ard we ha

d

t ru

m ha

ld you a

ll that

ter

to se

fit we th

row them to re

tunes we

all to in

sure our pr

M. NourbeSe Philip, text on p. 443

then *a ah who*

 at is the ti

the be

 en s call t

1

 g all night

 ring son

lo

 ins sti

 d with de sire to fi

 en s song

 a la m

 e re d *o do mi*

 do on bo

 ds win e por

m corn & rice i have to

 fore & wa

e our pro

 cue our for

ɔ mur t hey f

 ofits ov

M. NourbeSe Philip, text on p. 443

315

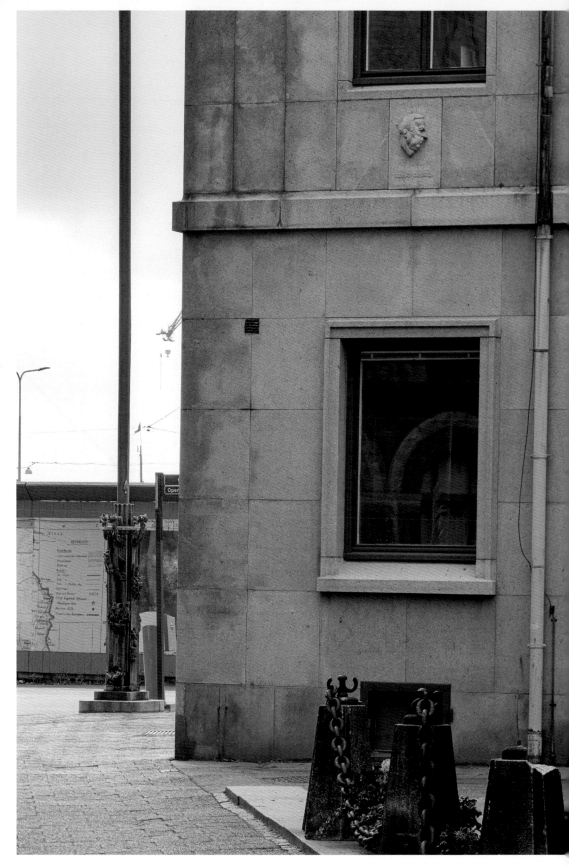

Salad Hilowle, text on p. 443

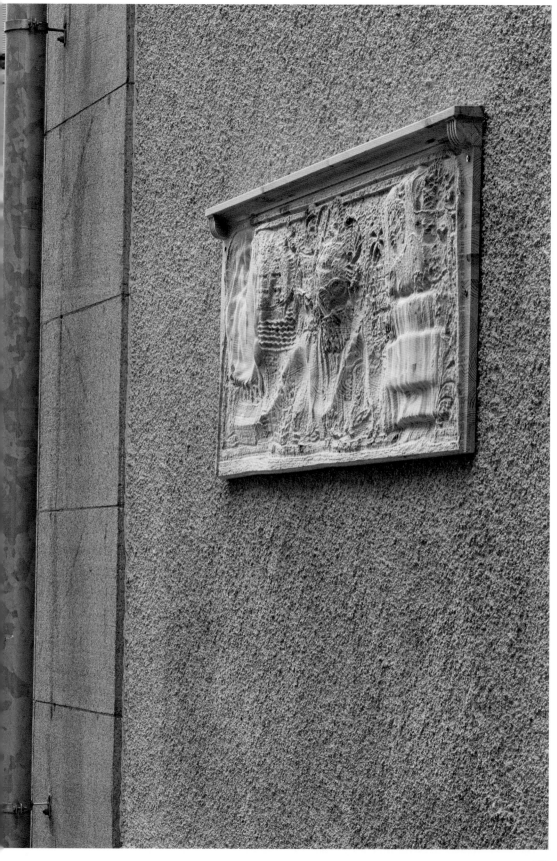

Salad Hilowle, text on p. 443

Salad Hilowle, text on p. 443

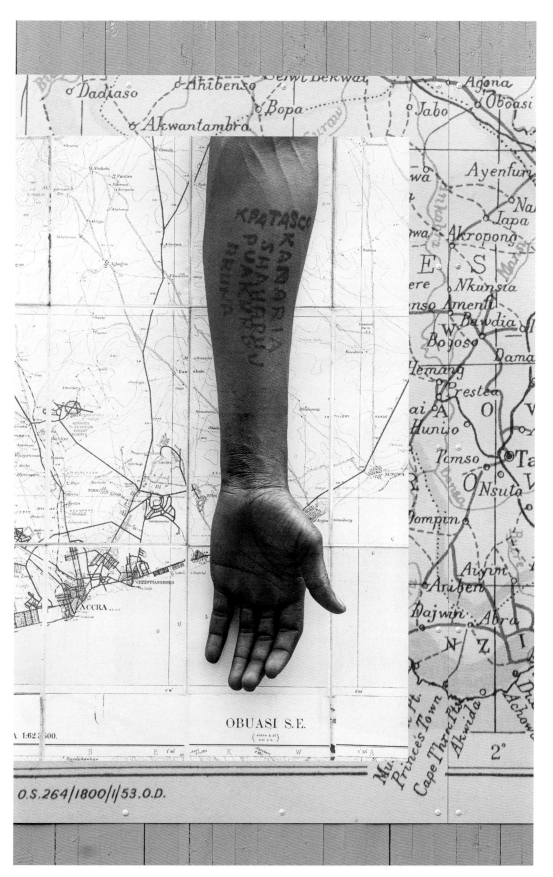

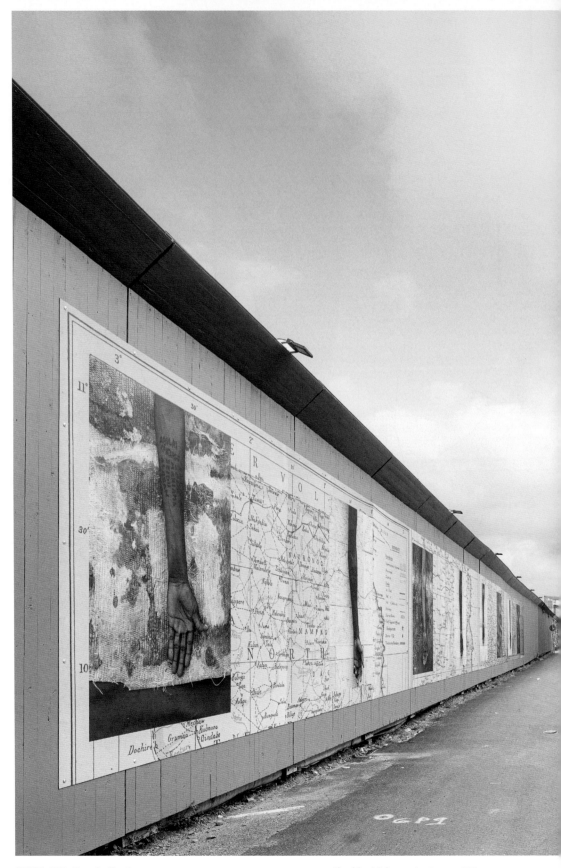

Ibrahim Mahama, text on p. 443

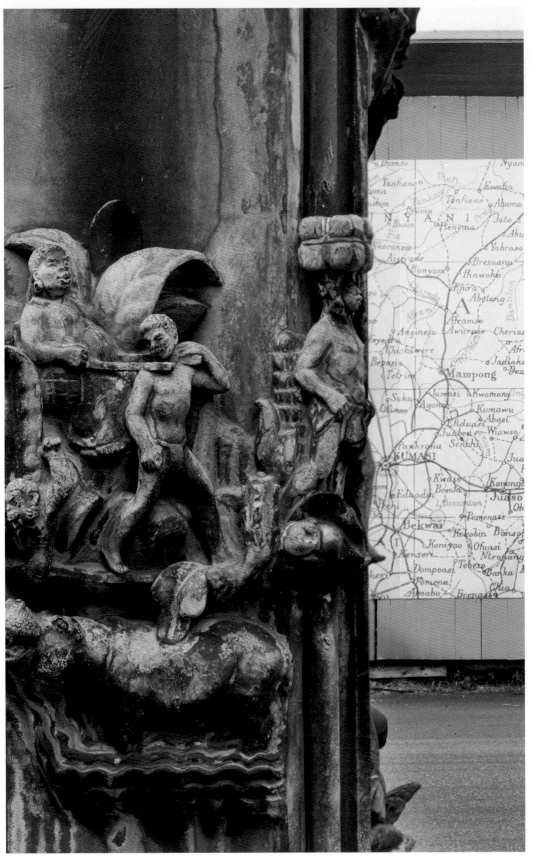

GIBCA 2021, Franska Tomten Detail of flagpole by Arvid Bryth (1945) Ibrahim Mahama, text on p. 443

GIBCA 2019, Franska Tomten

Eric Magassa, text on p. 435

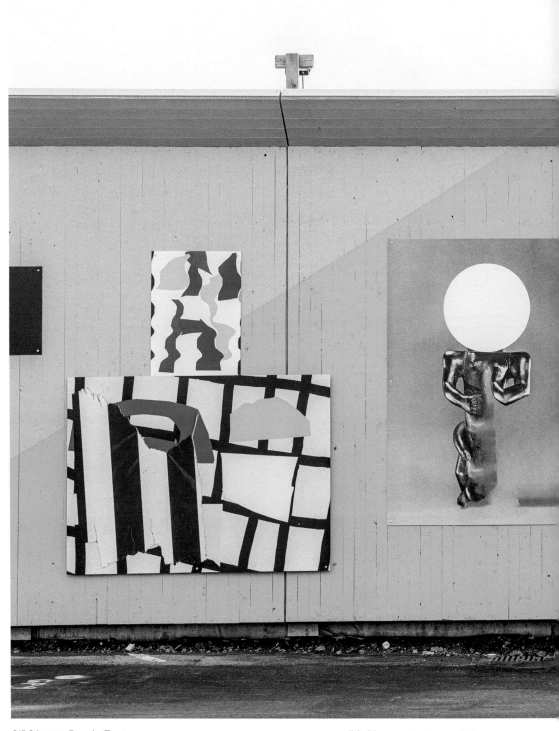

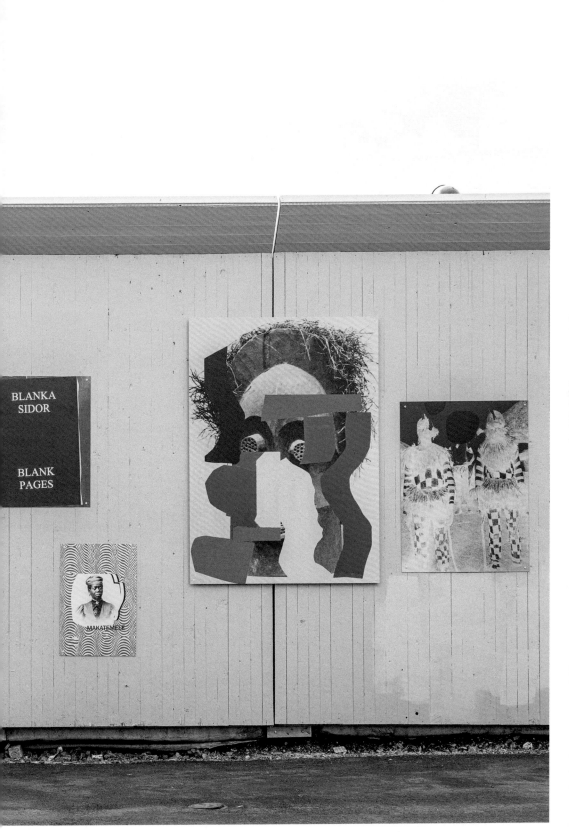

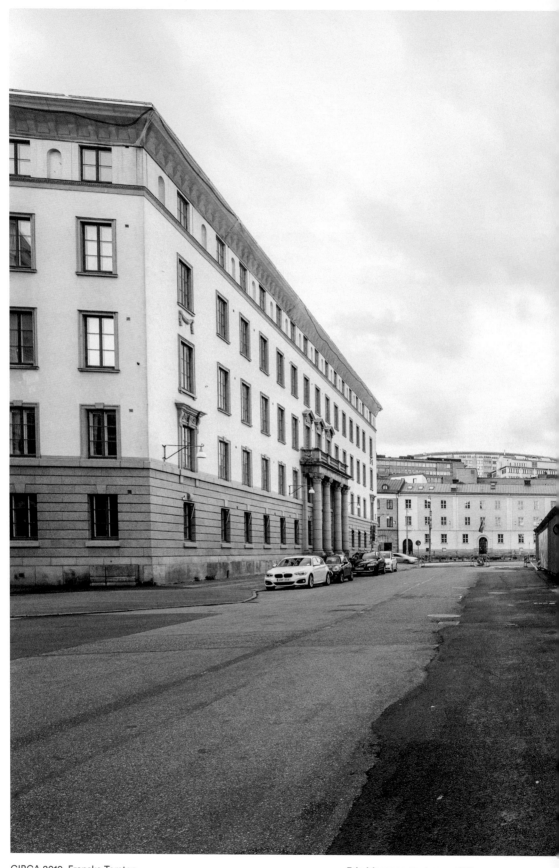

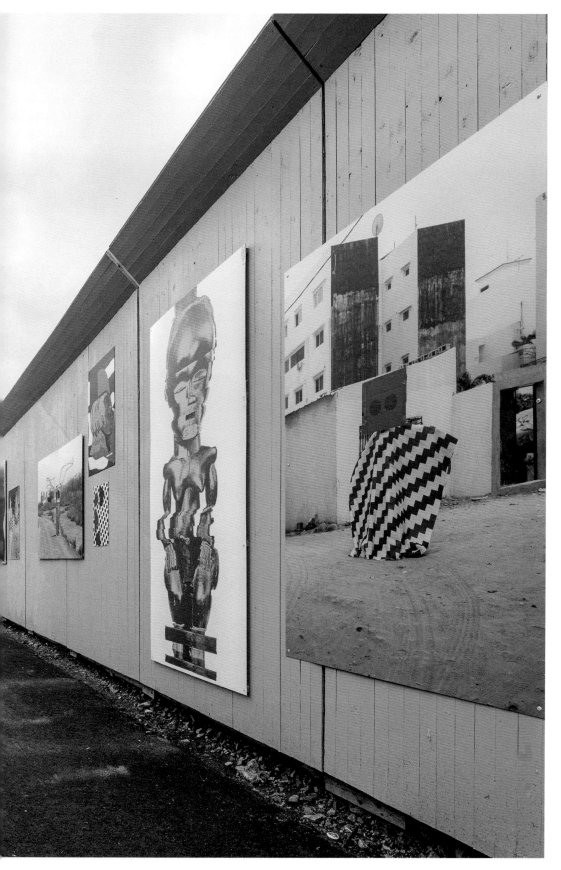

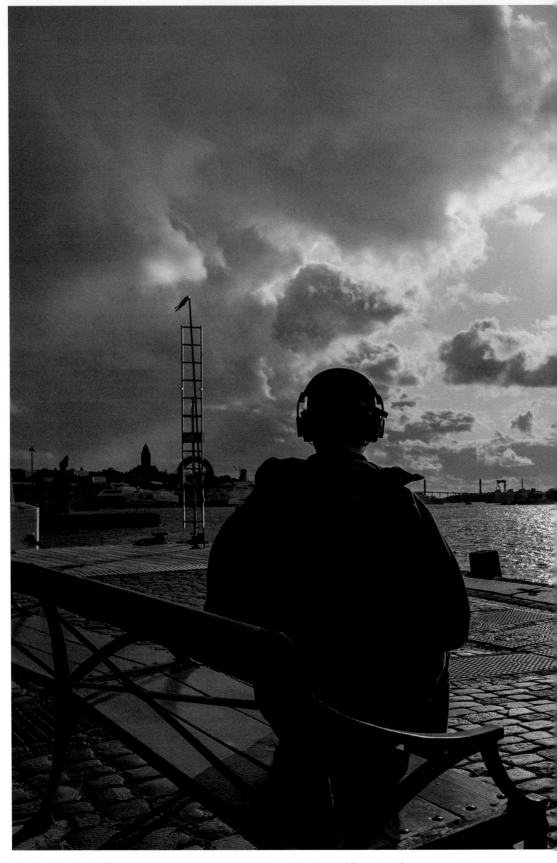

GIBCA 2019, Franska Tomten Ayesha Hameed (soundwork), text on p. 435

Pia Sandström (soundwork), text on p. 434

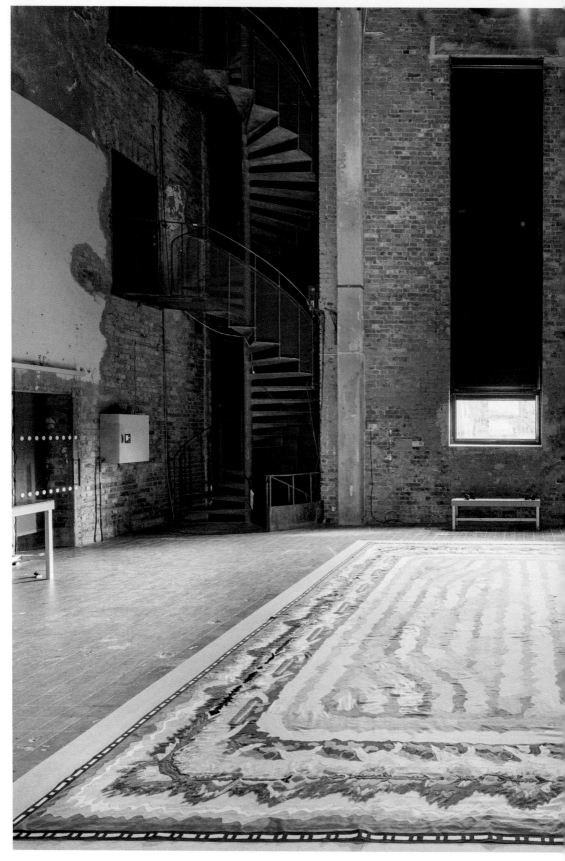

GIBCA 2019, Röda Sten Konsthall Åsa Elzén, text on p. 423

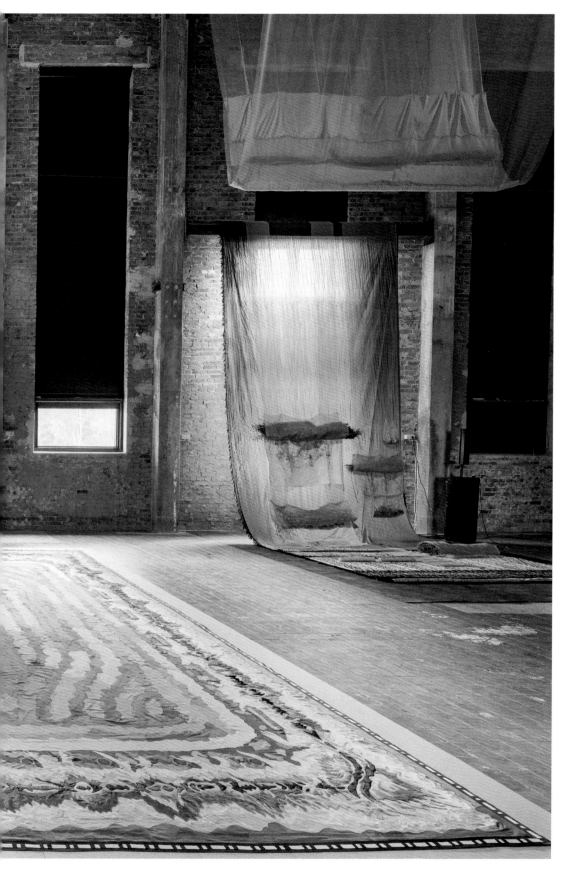

GIBCA 2019, Röda Sten Konsthall Åsa Elzén, text on p. 423

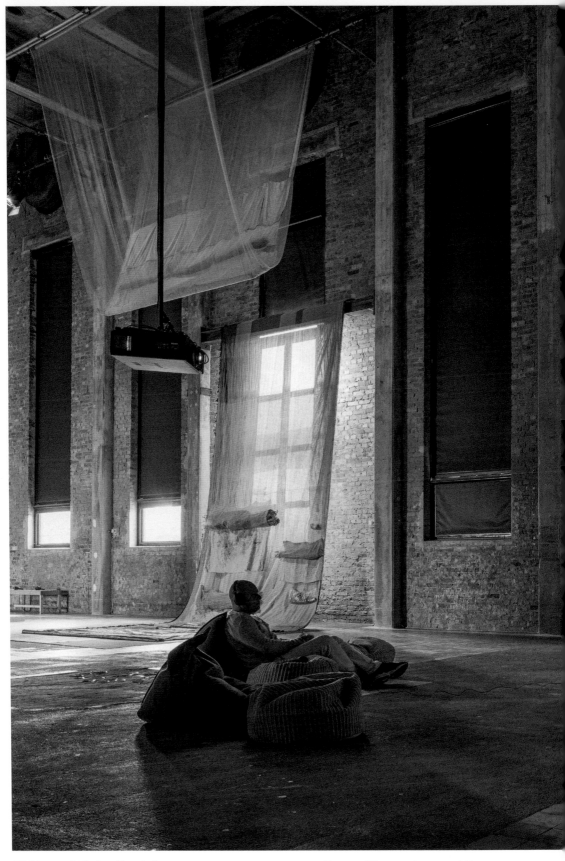

Susanne Kriemann, text on p. 423

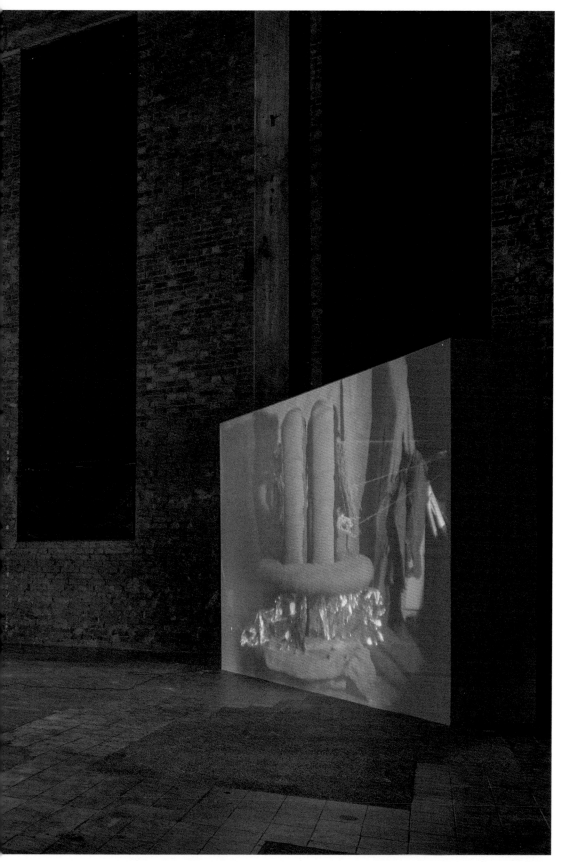

Tamara Henderson, text on p. 423

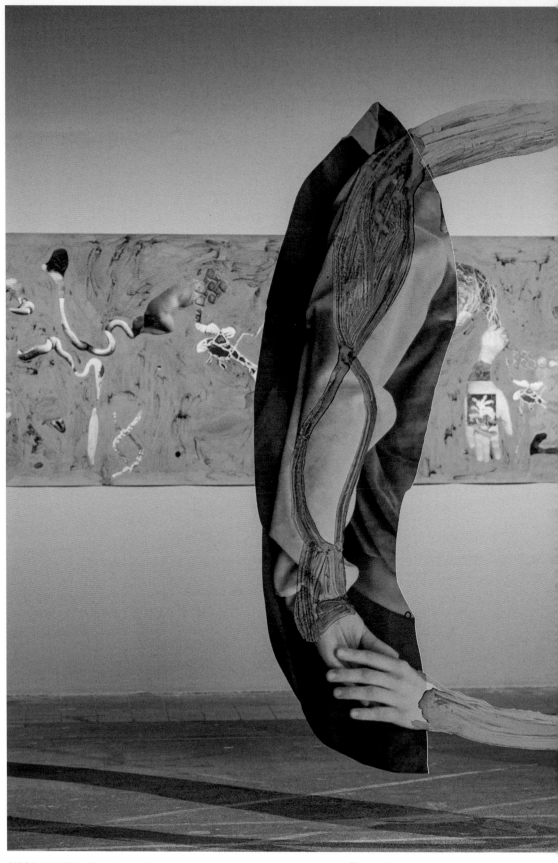

GIBCA 2019, Röda Sten Konsthall

Özlem Altın, text on p. 422

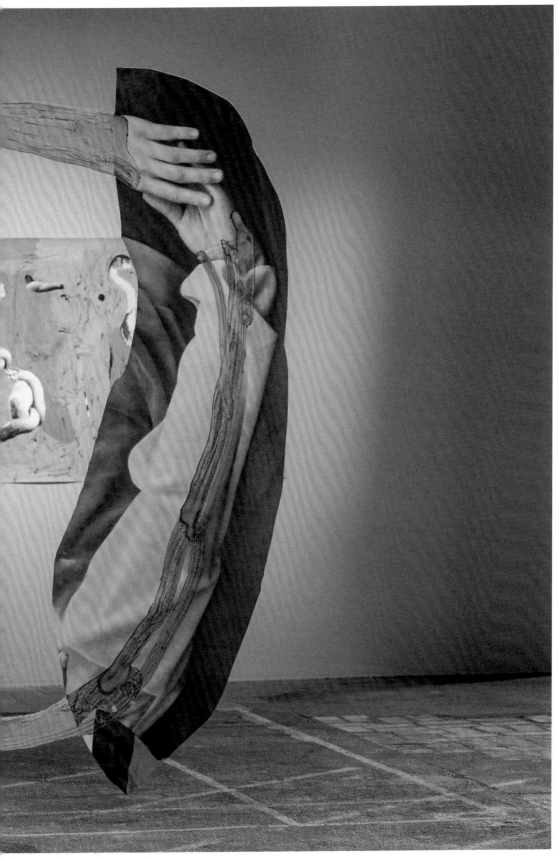

Özlem Altın, text on p. 422

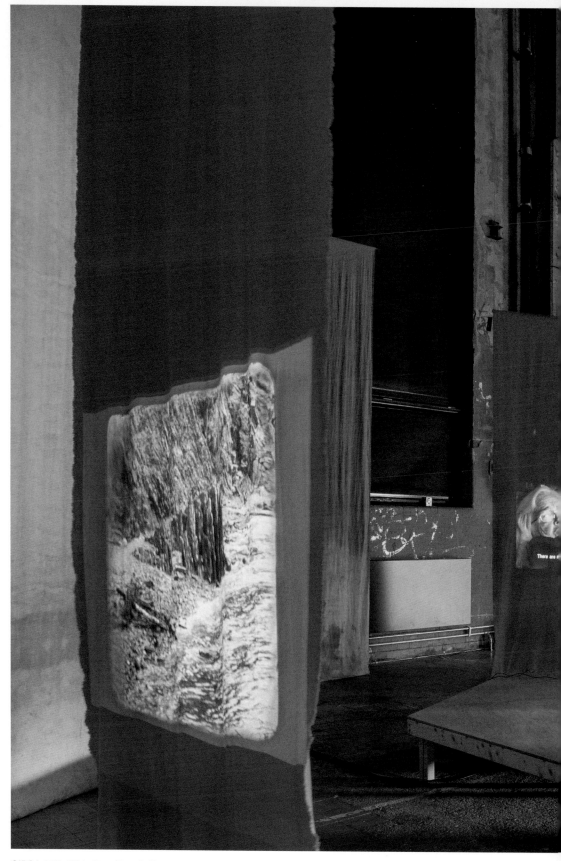

GIBCA 2019, Röda Sten Konsthall

Kajsa Dahlberg, text on p. 422

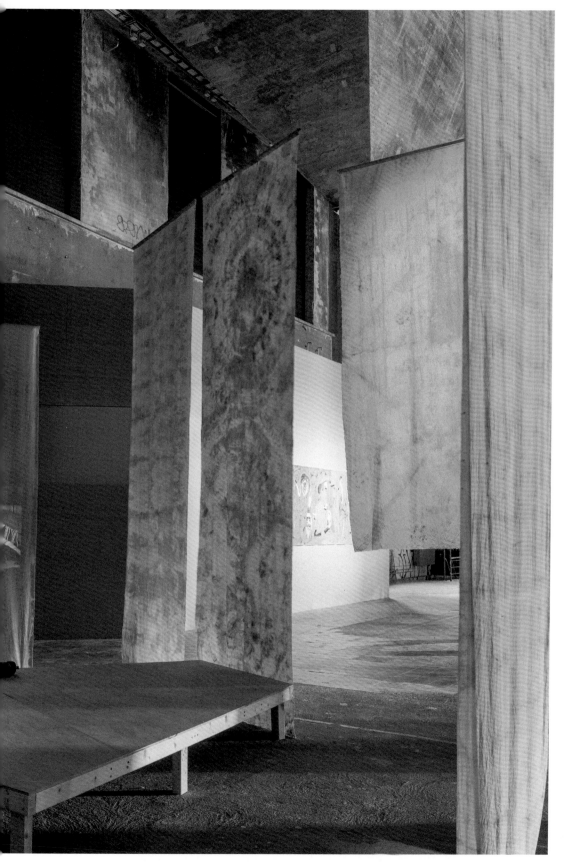

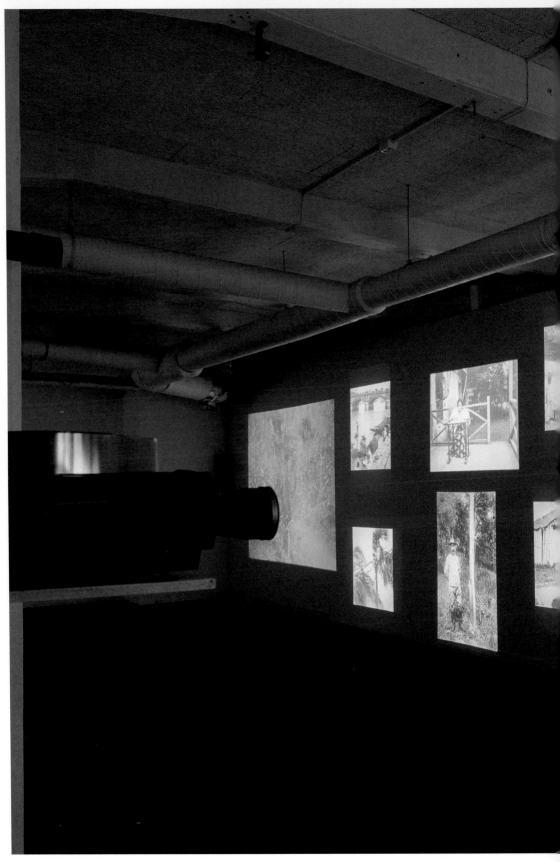

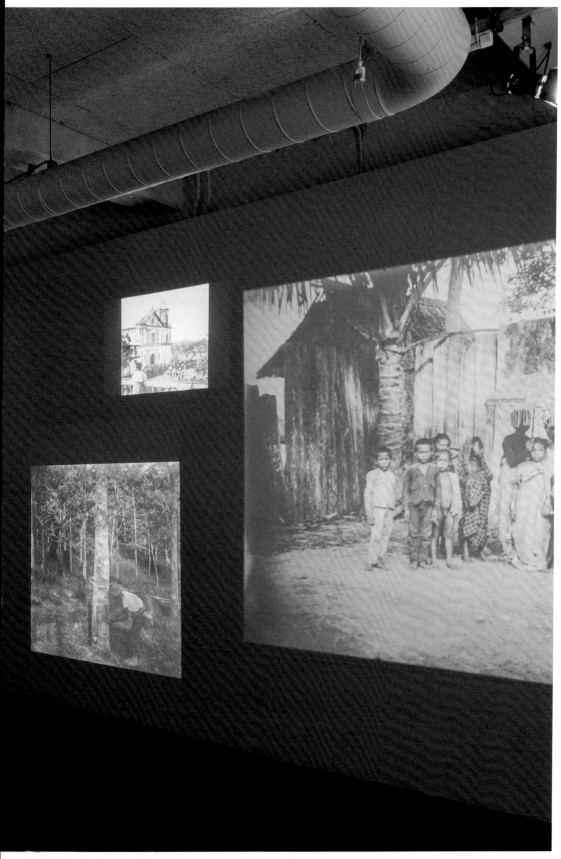

GIBCA 2019, Röda Sten Konsthall

Michelle Dizon, text on p. 422

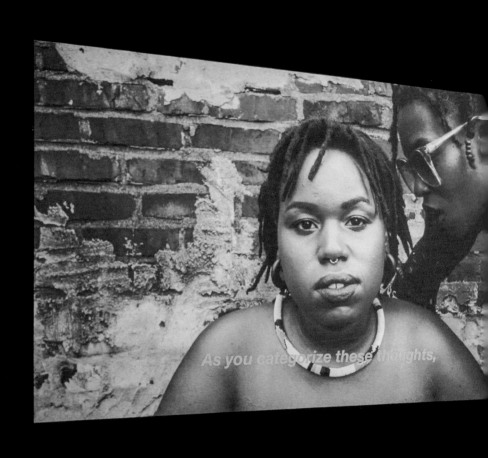

As you categorize these thoughts,

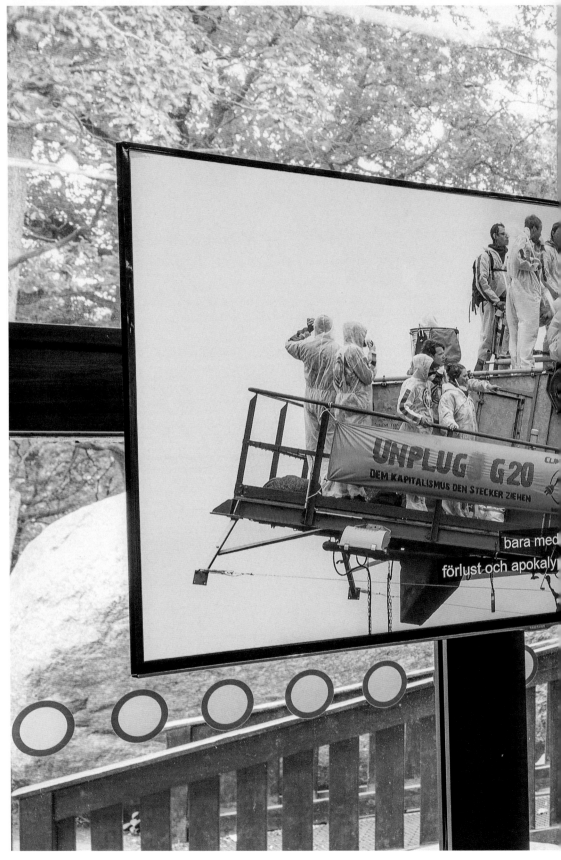

GIBCA 2019, Gothenburg Museum of Natural History Oliver Ressler, text on p. 433

Ida ting

GIBCA 2019, Gothenburg Museum of Natural History Oliver Ressler, text on p. 433

There has

Hannah Black, text on p. 432

een a world

GIBCA 2019, Gothenburg Museum of Natural History

Rikke Luther, text on p. 433

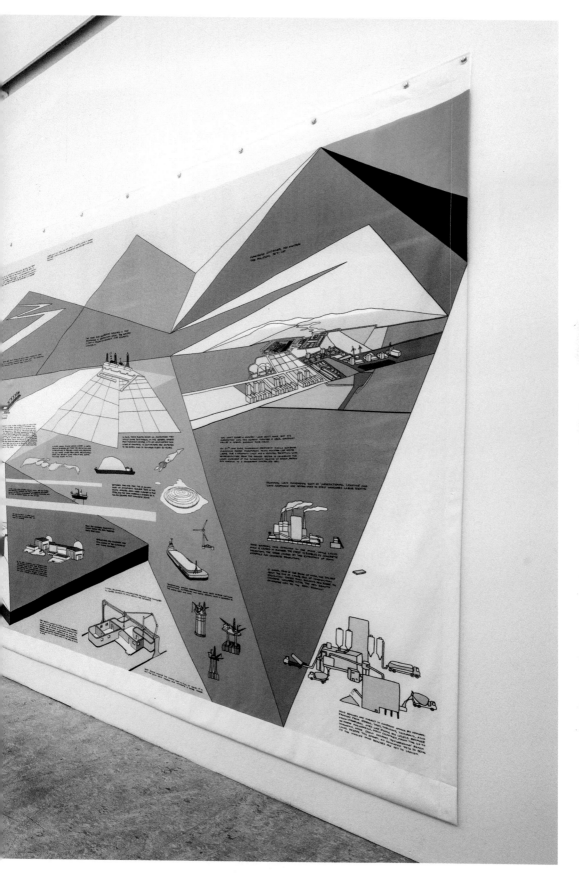

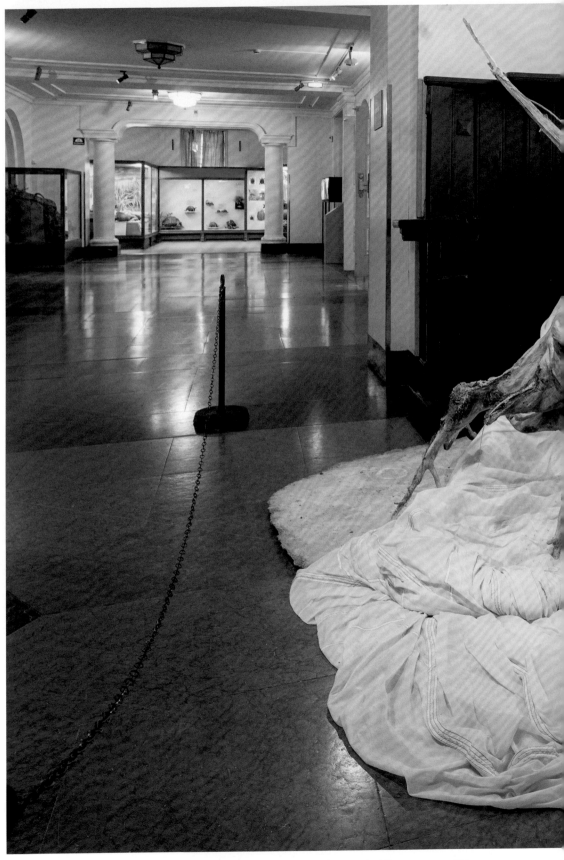

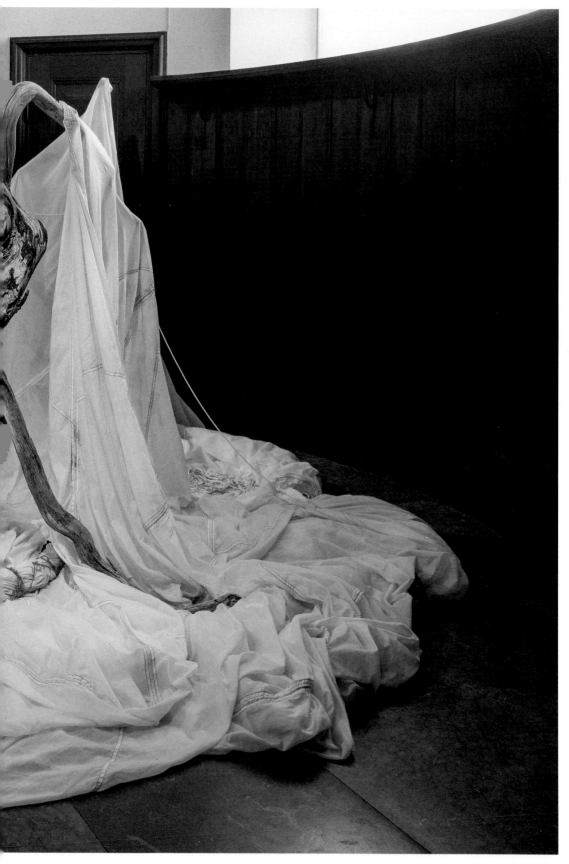

- It is the n
trilobite i

Liv Bugge, text on p. 432

most detailed
nd at Toten.

GIBCA 2019, Gothenburg Museum of Natural History Annika Eriksson, text on p. 432

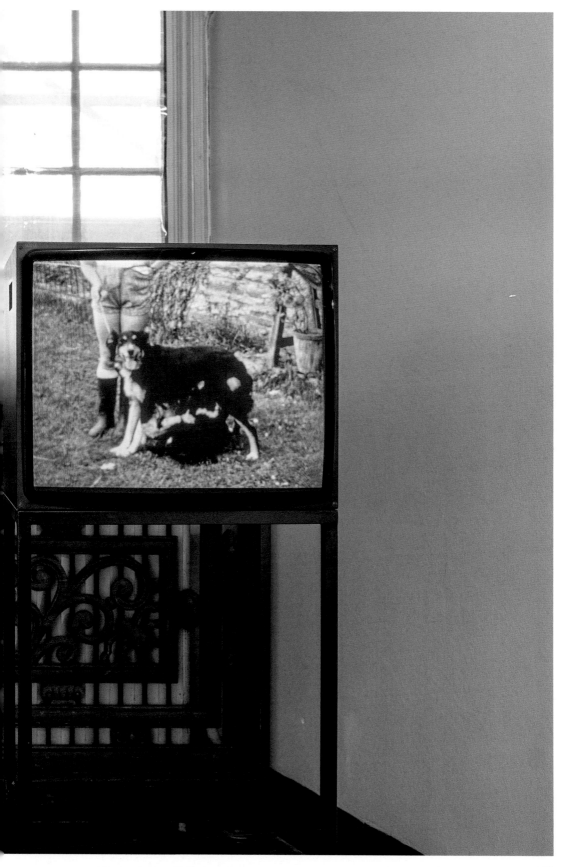

GIBCA 2019, Gothenburg Museum of Natural History

Paolo Cirio, text on p. 432

ENCOURAGING CONVERSATION IN A SOCIAL NETWORK

ADDICTION

SUGGESTING INTERACTION AMONG MEMBERS OF A SOCIAL NETWORK

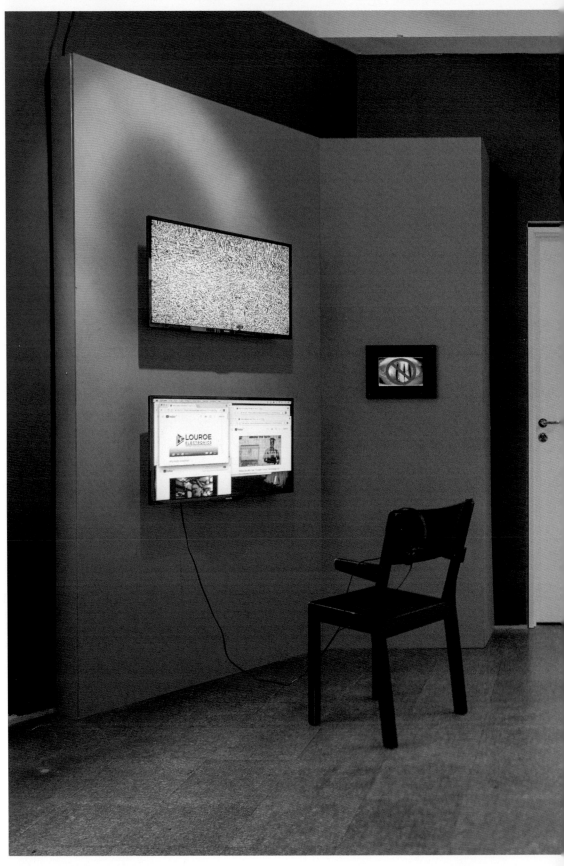

GIBCA 2019, Gothenburg Museum of Natural History Sean Dockray, text on p. 432

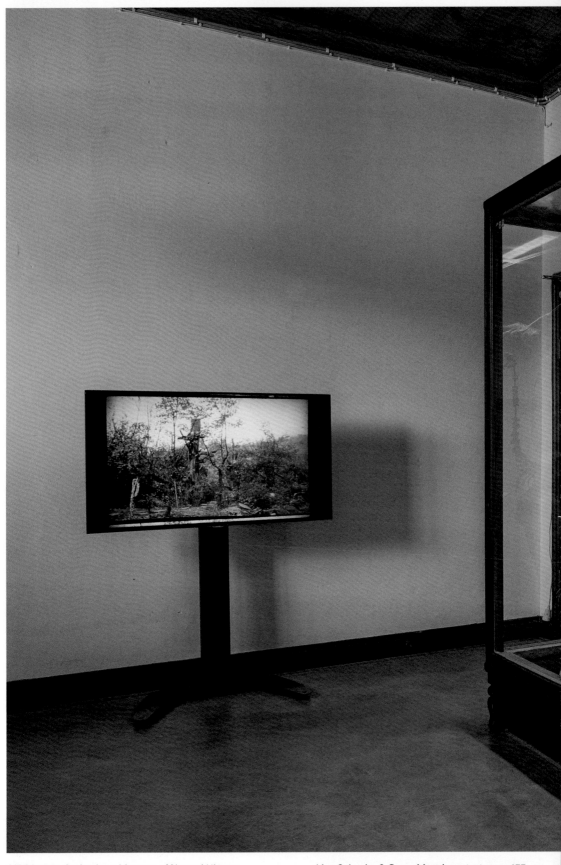

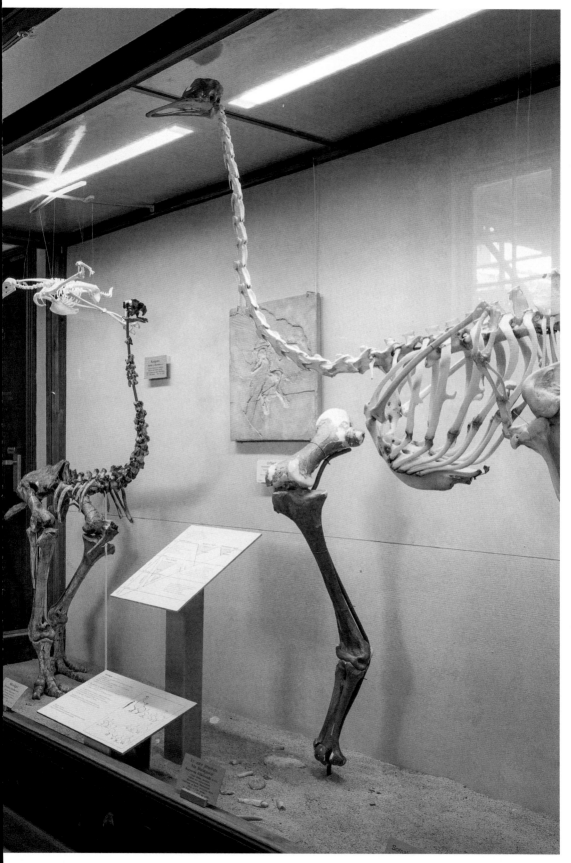

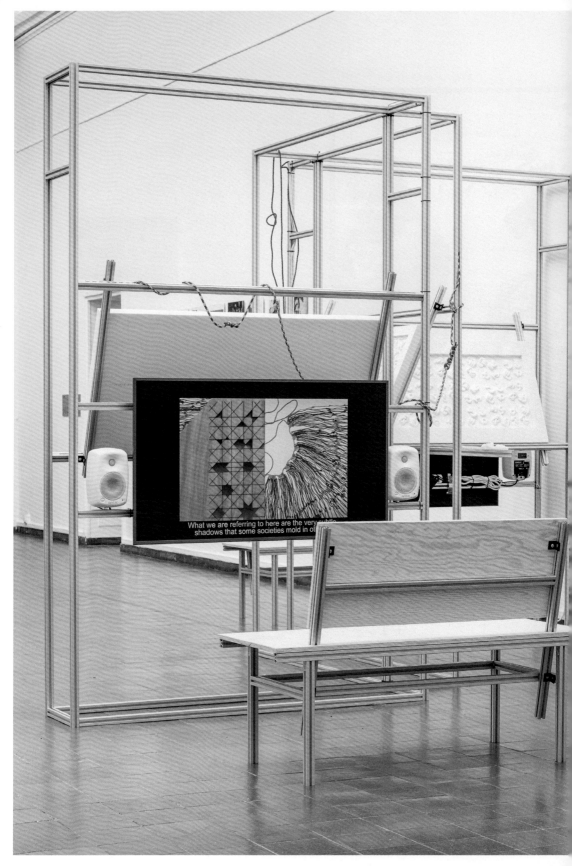

What we are referring to here are the very subtle
shadows that some societies mold in ot

GIBCA 2019, Göteborgs Konsthall

Lorenzo Sandoval, text on p. 429

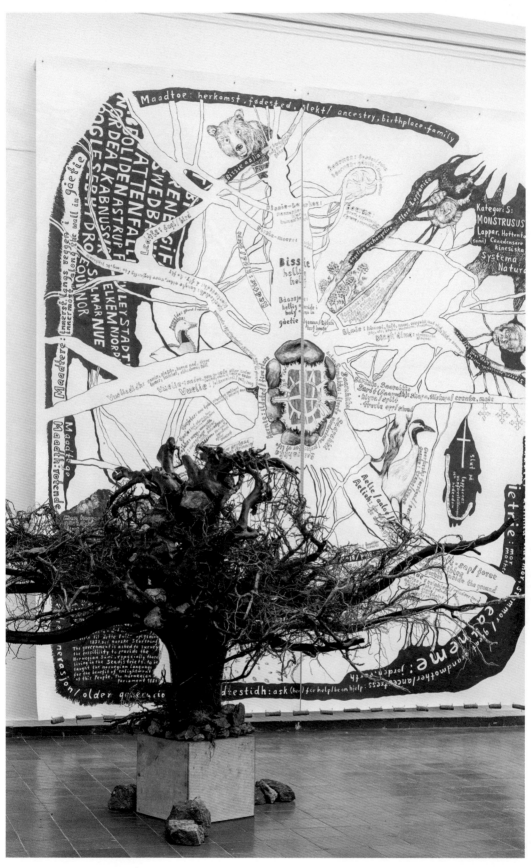

GIBCA 2019, Göteborgs Konsthall

Sissel M. Bergh, text on p. 426

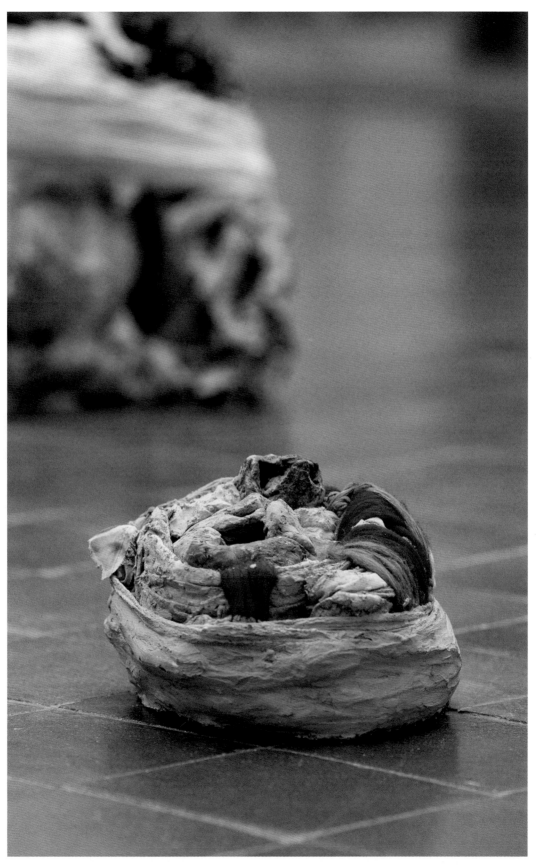

Elena Aitzkoa, text on p. 425

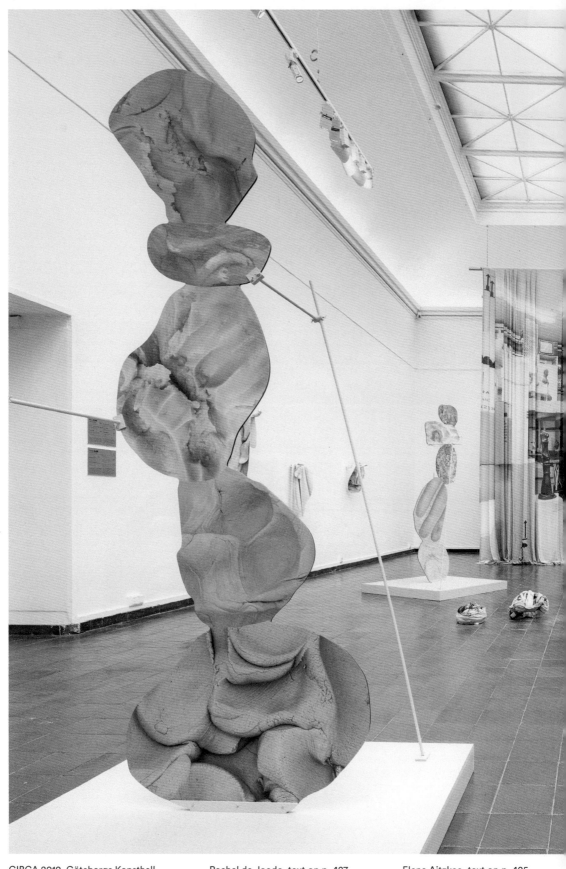

GIBCA 2019, Göteborgs Konsthall Rachel de Joode, text on p. 427 Elena Aitzkoa, text on p. 425

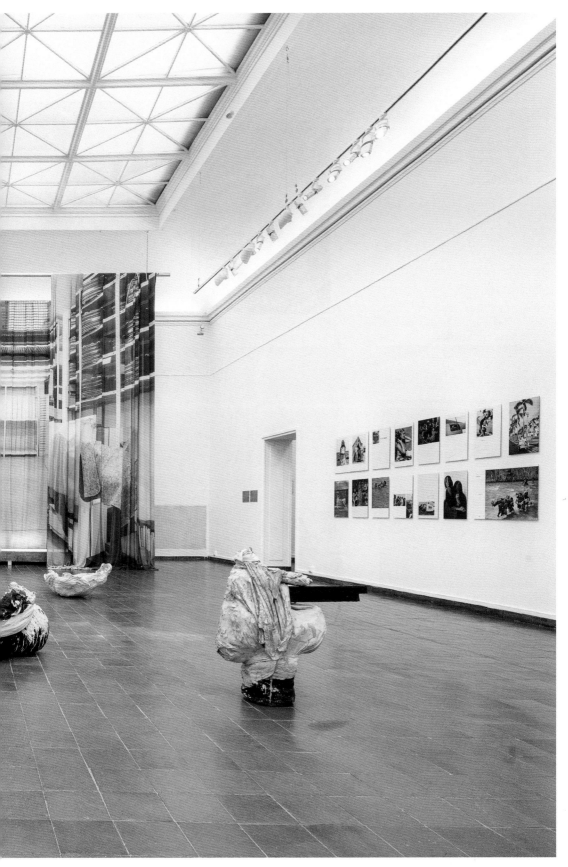

Antonia Low, text on p. 428 Michelle Dizon, text on p. 427

 FLAG OF CONQUEST

Uncle Sam's

Territory

the Dead

Everywhere in Israel

Empire

needs imagination to see

the violent film

of the South The Conquest
 the end of

history

267

He Shoots with Either Gun or Camera

I became aware of

quantities of equipment marked
"U. S. A."

A

Wasteland

for

Western man

429

Antonia Low, text on p. 428

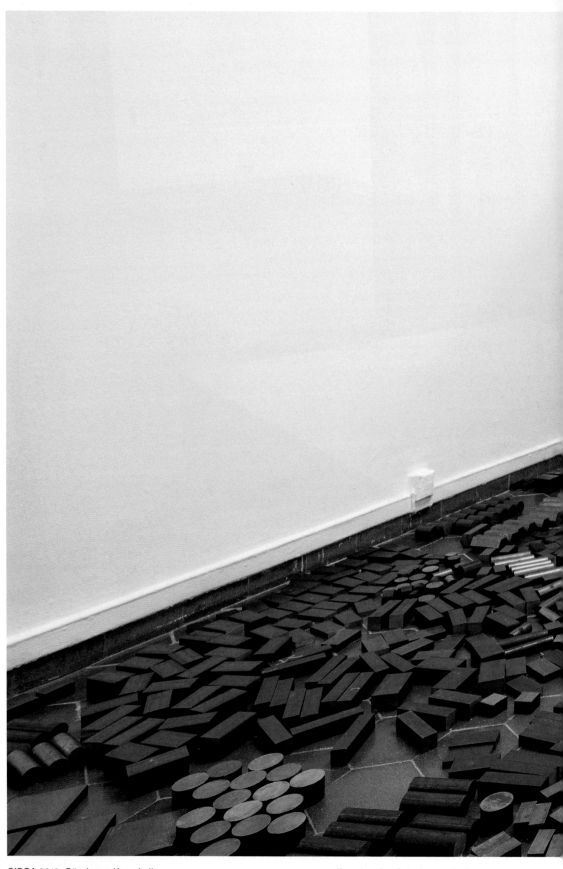

GIBCA 2019, Göteborgs Konsthall

Ibon Aranberri, text on p. 426

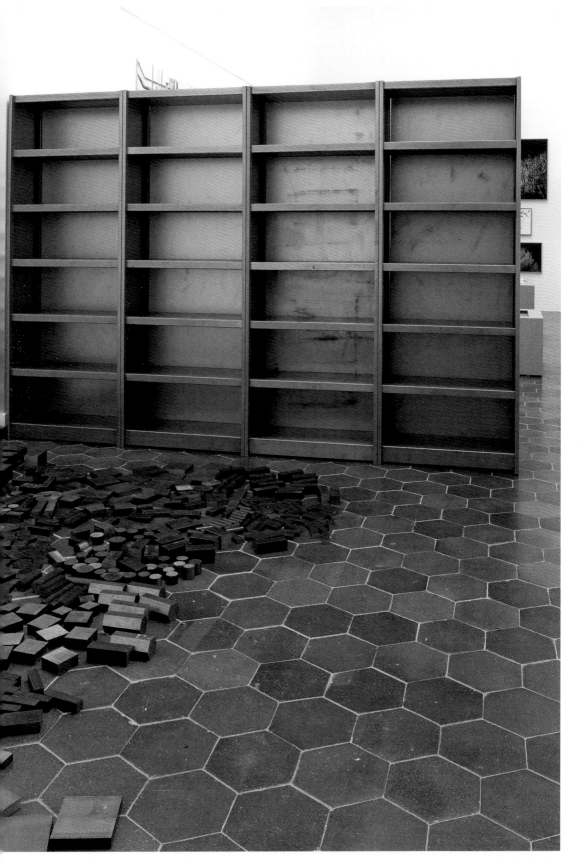

Ayatgali Tuleubek, text on p. 429　　Knud Stampe, text on p. 429　　Historical Materials: Mapping Utopia, text on p. 429

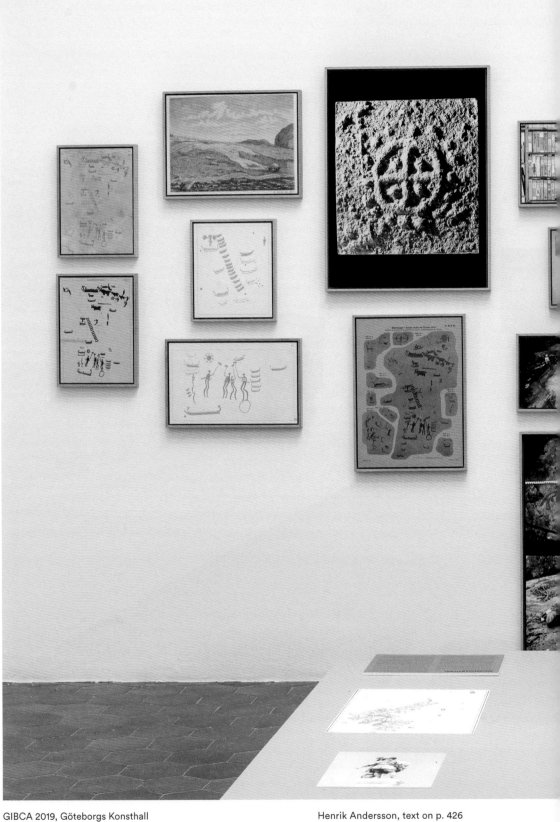

Henrik Andersson, text on p. 426

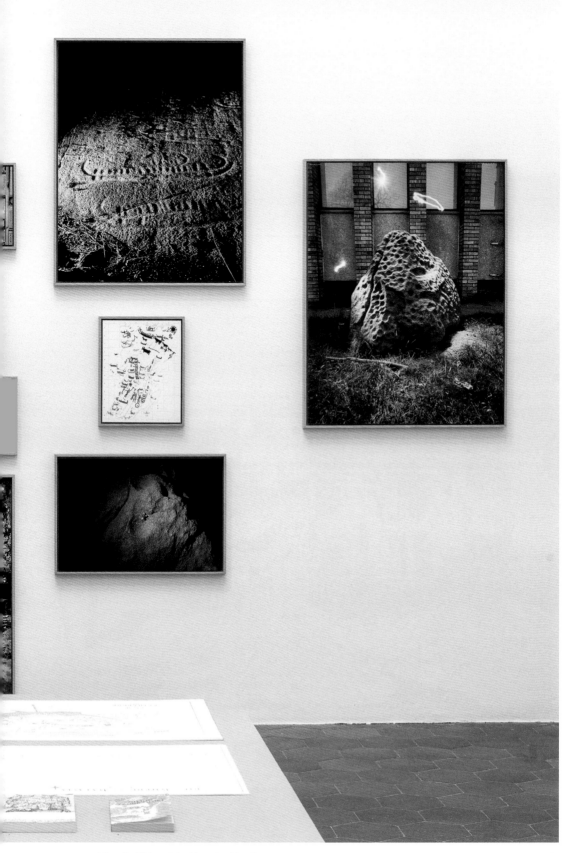

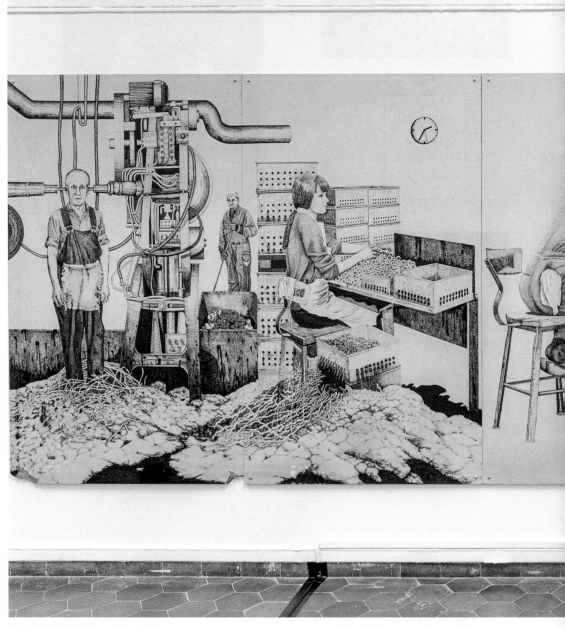

Knud Stampe, text on p. 429

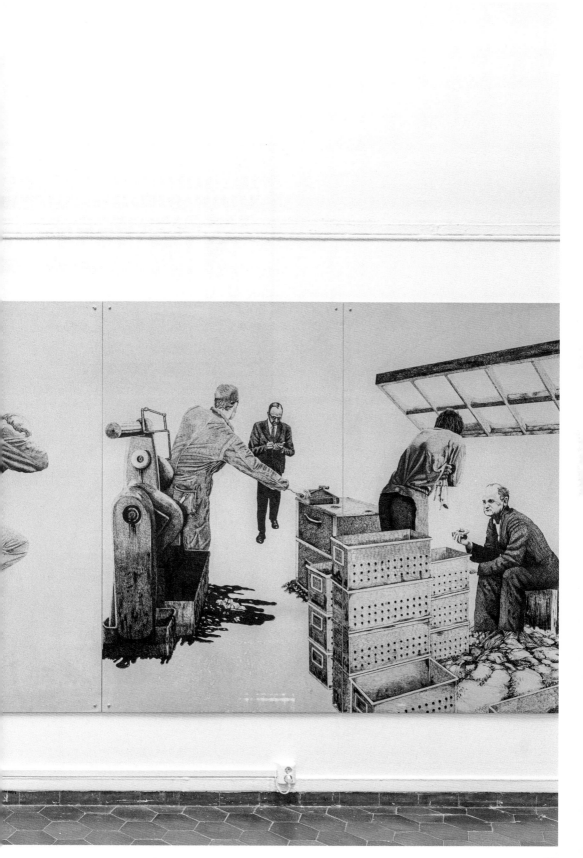

403

Boston City Hall
Kallmann, McKinnell and Knowles, 1962-68

Rikke Luther, text on p. 428

 Cian Dayrit, text on p. 427

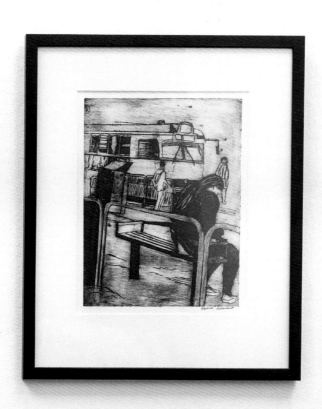

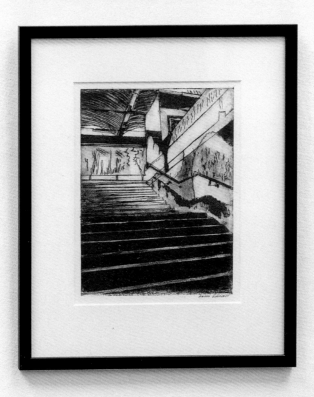

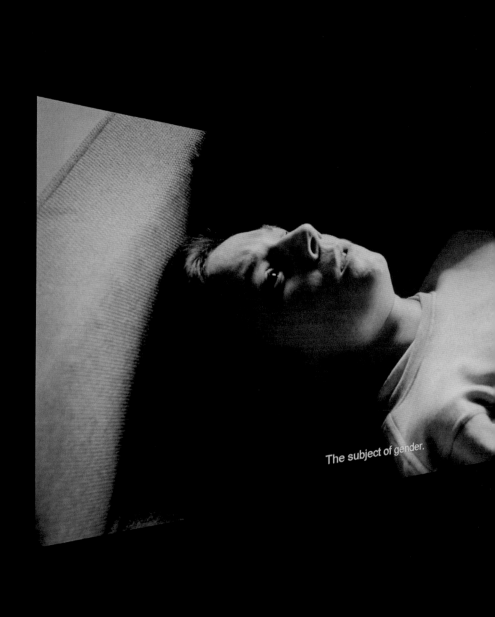

The subject of gender.

Doireann O'Malley (with Armin Lorenz Gerold), text on p. 428

Part of the Labyrinth
10th Edition of Göteborg
International Biennial for
Contemporary Art

September 7–November 17, 2019

Curator:
Lisa Rosendahl

Venues:
Röda Sten Konsthall
Göteborgs Konsthall
Gothenburg Museum of
Natural History
Online/Offsite
Franska Tomten

Artists:
Elena Aitzkoa
Özlem Altın
Henrik Andersson
Ibon Aranberri
Sissel M. Bergh
Hannah Black
Black Quantum Futurism
Liv Bugge
Paolo Cirio
Kajsa Dahlberg
Cian Dayrit
Michelle Dizon
Sean Dockray
Åsa Elzén
Annika Eriksson
Ayesha Hameed
Tamara Henderson
Rachel de Joode
Hanna Kolenovic
Susanne Kriemann
Kent Lindfors
Antonia Low
Rikke Luther
Eric Magassa
Ohlsson/Dit-Cilinn
Doireann O'Malley &
Armin Lorenz Gerold
Oliver Ressler
Lorenzo Sandoval
Pia Sandström
Lina Selander &
Oscar Mangione
Knud Stampe
Ayatgali Tuleubek

Team:
Sofia Alfredsson
Carl-Henrik Andersson
Ola Carlsson
Mia Christersdotter Norman
Gabriel Edvinsson
Ellie Engelhem
Andreas Engman

Robert Ericsson
Malin Griffiths
Maria Elena Guerra Aredal
Helena Herou
Yuying Hu
Anna Lo Huntington
Petra Landström
Ioana Leca
Elin Liljeblad
Lawrence Price
Emelie Storm
Renée Tan
Kata Wennberg
Björn Westerlund

**With collaborators from
partner institutions:**
Karin Andersson
Stina Edblom
Johanna Gustafsson
Renée Göthberg
Patrik Haggren
Amanda Hansson
Sarah Hansson
Åsa Holmberg
Hans Ivanoff
Mattias Norström
Mija Renström
Ann-Sofi Roxhage
Liv Stoltz
Elisabet Udd
Magdalena Ågren

Graphic identity:
Studio Leon&Chris

Part of the Labyrinth

The invitation to curate two editions of the biennial, and to tie the two together, has provided the point of departure for my curatorial motif and method. That Gothenburg will celebrate the 400-year anniversary of its founding in 2021 added a further point of reference. The challenge of linking together the two biennial editions and the opportunity of relating them thematically to the time period 1621–2021 moved my curatorial thinking towards ideas and practices of interconnectedness, inseparability, and double exposures. Thus, the two editions of the biennial are not conceived as separate entities, but neither will they be one and the same. Instead, they should be understood as different expressions woven through each other—an opportunity to be both/and rather than either/or.

The decision to work with notions of inseparability and entanglement was made in acknowledgement of a wider epistemological turn being undertaken by artists, philosophers, researchers, and activists who are today examining critically modernity's division of the world into binary oppositions between, for example, male and female, culture and nature, individual and collective, or past and present. The concept of entanglement is used to describe the world in ways other than the unilinear, growth-oriented model that has become normative in the era of industrialized capitalism. It can be found, for instance, in quantum physics, where the phrase "quantum entanglement" describes the fact that each separate particle is continually influenced by all the other particles surrounding it, rendering all descriptions of the particle as a singularity highly contestable. Feminist and posthumanist philosophers such as Donna Haraway, Karen Barad, and Isabelle Stengers have, in turn, used insights derived from quantum physics to describe how all life is fundamentally relational, based on different forms of influence, mutuality, and dependence.

In *Meeting the Universe Halfway: Quantum Physics and the Entanglement of Matter and Meaning* (2007), Barad writes:

> *To be entangled is not simply to be intertwined with another, as in the joining of separate entities, but to lack an independent, self-contained existence. Existence is not an individual affair. Individuals do not pre-exist their interactions; rather, individuals emerge through and as part of their entangled intra-relating.*

Entanglement has also become significant within historiography, as well as in decolonial and intersectional political discourses. "Entangled history," for example, is a methodology for describing how different events that are not usually discussed together are, in fact, interrelated and influence one another. This presupposition is also insisted upon within the global environmental movement, which is working to make visible how environmental destruction in one part of the world impact conditions for life in another, and how climate change is an effect of global capitalism as a

whole and not just an issue of individual emission quotas.

These different readings of existence as entailing the complex entanglement of inseparable lifeforms, materials, and events radically renegotiates Enlightenment ideas concerning autonomy and objectivity, which, together with the scientific revolution in the seventeenth century, form the foundations of modern Western society. The founding of Gothenburg in 1621 by King Gustav II Adolf, allegedly inspired by Thomas More's *Utopia*, is concurrent with this tumultuous transformation of society.

In the 1620s, the philosophical position usually known as the mechanistic worldview was being formulated across Europe. Its portrayal of the world as an ingeniously fashioned machine-like system that could be understood and controlled by being disassembled and examined through its component parts put an end to an understanding of the Earth as a living organism, and was the beginning of a worldview that reduced the planet to a resource to be exploited by man. The perception of the human as unquestionably inseparable from nature was thus dissolved. Instead, the modern European subject began to see itself as an autonomous observer, standing a little apart, with the ability to critically examine the world before exercising free will to decide how to participate in it.

René Descartes, known for such inventions as the coordinate system and the dualistic separation between body and mind—formulated in the famous axiom

"I think therefore I am" (cogito, ergo sum) —was one of the mechanistic worldview's originators and most famous proponents. Alongside the scientific revolution, the mechanistic approach was seen as a solution to the chaos that swept over seventeenth-century Europe, the result of tensions between different religious groups and empires, constant warfare, and devastating epidemics. One outcome of this chaos was a desire to create a shared world order based on scientific fact and founded on empiricism, which was eventually established for the purpose of long-term peace and economic growth.

From today's perspective, we can see this epistemological shift did indeed create order and consensus in Europe, but it was also devastatingly destructive —both within the continent and far beyond it. Science's mapping of the world into distinct categories and disciplines resulted in a new clarity, but at the same time it obscured many connections between what were now considered separate and distinct phenomenon or lifeforms. Meanwhile, the systematic division of all life into particular genders, species, and successive evolutionary stages that occurred over the following centuries legitimated multiple forms of sexism, racism, and colonial exploitation. The industrial revolution and global capitalist economy that followed brought improved living conditions for many, but also mass destruction and exploitation on a scale that today we understand has visited irrevocable destruction upon our planetary ecosystem. The zeal for unraveling the fabric of life into separate

Ophiocomina nigra (Abildgaard).
Smedjan, Bohuslän.
9:1. 1915-2650. Echin. 414.

Ophiopsila riisei Lütken.
S:t Barthélemy.
A. Goës

Brittlestars from Sweden and Saint Barthélemy in the collection of Gothenburg Museum of Natural History.

threads in order to understand them better seems to have completely devastated it in the process.

Four hundred years after the mechanistic doctrine's formulation, the world appears once again full of chaos and destructiveness—in many regards as a direct result of the ideological and economic systems that began taking form during the seventeenth century. The idea of unrelenting progress and growth is no longer sustainable: nor is the division of responsibility into separate nations and individuals. What will our answer to chaos be this time around? What sort of worldview must be formulated for humanity to understand that we are inseparable from the planet and must collectively begin to take responsibility for our actions?

During my research for the biennial, I read Karen Barad's essay "Invertebrate Visions: Diffractions of a Brittlestar," in which she uses the anatomy of the brittlestar, a mollusk closely related to the starfish, to demonstrate how the form of the human body limits our understanding of the world. The brittlestar has neither centrally located eyes nor a coordinating brain to organize visual and tactile impressions from a determinate perspective. Instead, it is covered by cells that relay information throughout the organism as a whole. The ability to take in the world from a 360-degree perspective is something today's camera technology also strives to achieve, and the industry is now trying to find a way to mimic the brittlestar's ingenious design. How then is it possible, asks Barad, that we still speak of the brittlestar as a more primitive being than *Homo sapiens*?

Prompted by Barad's text, I visited the Gothenburg Museum of Natural History. Although brittlestars live in many different places throughout the world, their Swedish habitat is in the sea just outside of Gothenburg, along the coast of Bohuslän. While exploring the museum's collection I was struck by a curious detail: on the top shelf of a display case two brittlestars from opposite ends of the world were placed close together—one caught in Bohuslän in 1915, the other off the coast of Saint Barthélemy in 1868, during Sweden's colonial rule of this Caribbean island. The date and place where each was caught was printed on their respective labels, but there was no further comment. Having encountered a paragraph about the connections between Gothenburg and Saint Barthélemy at the Museum of Gothenburg just days before, the juxtaposition of the two brittlestars appeared to me as a shadow image of that geopolitical relationship. Why was it not mentioned, to paraphrase the cultural theoretician Stuart Hall, that the brittlestar from Saint Barthélemy is here because we were there? Is the political and economic background that led to a Caribbean brittlestar ending up in a Gothenburg museum not integral to how we should understand our encounter with it?

In 1784, the island of Saint Barthélemy was exchanged for a plot of land (subsequently called Franska Tomten, the French plot) in Gothenburg Harbor as part of a trade deal between Sweden

and France. The apparent symmetry in the relationship between the two pieces of land is deceptive; in fact, the colonial relationship between Gothenburg and Saint Barthélemy was characterized by a deep asymmetry, as exemplified by Sweden's slave trade on the island. The brittlestar from Saint Barthélemy is one of the few physical traces of Sweden's colonial rule in the West Indies that can be seen today in a Swedish public institution, although the Swedish participation in the triangular trade played a significant part in the development of the country's industrial welfare society. On Saint Barthélemy, the capital city is still called Gustavia after the Swedish King Gustav III. In Gothenburg, however, no corresponding commemorative gesture is to be found. But if we follow the money, a direct lineage can be traced from Sweden's colonial exploits to its present-day industries. Sahlgren's Sugar Refinery in Gothenburg was established in the eighteenth century using cane from West Indian plantations, and was taken over in the nineteenth century by a textile mill. The spinning mill evolved into Gamlestaden's Factories, which in 1907 became the point of departure for the SKF ball bearing factory, where Volvo was formed in 1929.

How can we understand and change the world if the links between different interactive systems remain invisible to us? The biennial's curatorial framework ties together the various exhibition venues within this common discussion in order to invite visitors to reflect on how they are part of the same history. The context of each venue serves as a thematic point of departure: from the Gothenburg Museum of Natural History's collections, to Röda Sten Konsthall's industrial past, to Franska Tomten's colonial heritage, to the modernist architecture of Göteborgs Konsthall.

The title of the 2019 biennial, *Part of the Labyrinth*, is borrowed from the Danish poet Inger Christensen, who formulated an answer to Descartes in her 1979 poem *Letter in April*:

I think
therefore I am part
of the labyrinth

In Christensen's poem, as in the exhibition's title, the labyrinth serves as a metaphor for the part the human plays in the complexity of the world. We are the labyrinth/world; its co-creators, not just its interpreters.

The labyrinth is a form for experimenting with non-linear ways of thinking, doing, and seeing. Its crossing paths and interlinked spaces can be navigated from different directions, creating opportunities for moving simultaneously forwards and backwards. Rather than a system that is thought out in advance, with a single center, the complex labyrinth is not only a form that recurs in different cultures throughout history, it also forces anyone moving through it to retrace their steps in order to experience their past from different perspectives.

But above all, the labyrinth symbolizes an entanglement that we cannot find our way out of—there's no other world

than this one. And it is only when we fully accept our inescapability, when we realize how deeply dependent for survival we are on one another and on our surroundings that real change toward a more sustainable approach to life becomes possible.

Taking advantage of the extended time horizon opened up by the invitation to work with two editions of the biennial rather than only one, *Part of the Labyrinth* will be the start of a conversation rather than its end result. Inspired by the interwoven histories of the exhibition venues, the 2019 biennial maps out a set of ideas and questions that will provide the foundation for further discussions, relationships, and collaborations through 2021.

Lisa Rosendahl, Curator
2019

Spiral Time
Röda Sten Konsthall

Röda Sten Konsthall was once a boiler house where coal and wood chips were burned to provide local industries with heat. The building still bears traces of that time, as well as from the years after the boiler house's decommissioning, when it was transformed into a self-organized venue for a variety of cultural activities.

The point of departure for the exhibition at Röda Sten Konsthall is the interlinked histories of industry, colonialism, and environmental destruction, and the marks these have left on both humanity and nature. Several of the works renegotiate Western modernity's linear narrative structures and unrelenting notion of progress. By cross-referencing past and present—and earth, image, and body—the artists create material and associative metabolisms that propose other relationships between humanity and the world than industrial capitalism's one-way incineration of it.

By making the spiral staircase at the heart of the building accessible, visitors will be able to circulate through the galleries in a variety of ways, experiencing the works from different perspectives.

Özlem Altın, 1
Black Quantum Futurism, 2
Kajsa Dahlberg, 3
Michelle Dizon, 4
Åsa Elzén, 5
Tamara Henderson, 6
Susanne Kriemann, 7
Kent Lindfors, 8
Oliver Ressler, 9

Ground floor

Second floor

Third floor

Fourth floor

Özlem Altın
Topography (of time, of body), 2019
Installation

Özlem Altın works with painting, collage, photography, and drawing. By combining and reworking pictures from a variety of different sources, she creates associative connections among them. In her installation at Röda Sten Konsthall, the artist brings material from sources such as the archives of Gothenburg Museum of Natural History together with her own pictures. Motifs linked to birth, death, and rebirth lead to reflections on the cyclical passage of time. The installation is bound together by visual echoes, suggesting the work's various parts are shifting expressions of the same thing or forms with the ability to transform into one another.

Images on pp. 346–349

Black Quantum Futurism
Time Travel Experiments, 2017
Video, 9 min 30 sec
Camera: Bob Sweeney

Black Quantum Futurism advocates for an experimental approach to consciousness, time, and space. The sources of inspiration for their work include quantum physics and cultural traditions originating on the African continent. According to Black Quantum Futurism's intersectional concept of time, the past and the future are not cut off from the present, but instead influence the whole of our lives—who we are and who we can be. The video, shot like an instructional film, shows how it is possible with simple means to break up time and space in order to create a better future than the one the past has presaged. The experiments featured in the video are excerpts from Rasheedah Phillips' 2014 novel *Recurrence Plot (and Other Time Travel Tales)*.

Image on pp. 356–357

Kajsa Dahlberg
Unbinding time, 2019
A film with Ulla Ryum on non-linear storytelling and intertwined chronologies; a 16mm silent B&W film developed with bladder wrack seaweed; plant and solar dyed peace silk textiles, day for night UV filter

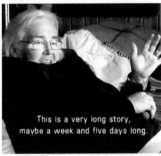

This is a very long story, maybe a week and five days long.

The first film (25 min) in Kajsa Dahlberg's installation is based on a conversation with the Danish playwright and dramaturgist Ulla Ryum. During the 1960s and '70s, Ryum developed what she called "Spiral Dramaturgy." The model is based on Ryum's perception that linear narrative, in which one event follows another in chronological succession, does not take into consideration the cyclical and material aspects of life. Instead, Ryum proposes an associative relationship between images that opens up for critical reflection, giving the viewer an opportunity to explore non-sequentially over the course of the story. Through this conversation we are led between different stories in a spiral form that seems to move freely through time and space, thus embodying rather than explaining Ryum's model.

The second film (12 min) is both about and developed using sea kelp. The film examines development processes, as well as the relationships between image, screen, skin, and surface. Algae and kelp have been used throughout history for many different purposes, such as in early photographic techniques, fertilizers, and explosives, as well as in the contemporary production of nutrients and antibiotics.

In addition to the films, the installation consists of plant-dyed fabrics using exposure to the sun as a catalytic process. Fabric and water are placed in jars together with plants such as members of the genus *Salix*—commonly grown to extract poisonous residues from contaminated ground—and left in the sun. In the installation, Dahlberg, in a manner similar to her conversation with Ryum, is seeking a story that can emerge in between different materials, as well as between the human, organic, material, technological, and digital.

Image on pp. 350–351

Michelle Dizon
The Archive's Fold, 2018
11 slide projectors, sound, light board with pictures, and wall text

In her installation, Michelle Dizon deals with the intergenerational legacies of colonial violence, using images dating from the period during and after the Philippines was a United States colony, sourced from archives in the Philippines, the US, her personal family albums, and the internet. Official archival photographs are contrasted with Dizon's personal portrayal of an intimate realm where physical and spiritual remains are shared by the dead, the living, and the unborn. The piece takes the form of a conversation between Dizon's great-great-grandmother in the year 1905 and her grandchild's great-granddaughter in 2123. Both are named Latipa. The future Latipa lives at a time when climate catastrophe has made the Earth uninhabitable. She is now on her way to Proxima B, the closest planet to Earth believed to be capable of supporting human life. The work suggests that colonial assaults on people and the environment are

deeply linked and have a devastating impact that endures long after being officially considered over.

Images on pp. 352–355

Åsa Elzén
Avskrift av En Träda/
Transcript of A Fallow, 2019
Appliqué, recycled textile
470 × 600 cm

Transcript of the carpet *En Träda* (A Fallow), tapestry, wool, linen, 470 × 600 cm, 1919–20; by Elisabeth Tamm at Fogelstad who conceived the idea and commissioned it; by Maja Fjæstad who conceptualized and composed it; and Amelie Fjæstad who weaved it. Made together with Malin Arnell, Britta Elzén, Mar Fjell, Enikö Marton and Markus Wetzel.

En Trädas biografi/
Biography of A Fallow, 2019
Audio in headphones
Voice and text consultant: Nik Persson
Recording: Mattin
15 min 40 sec
Table with research and other materials

To leave land fallow means to allow it to lie uncultivated so that it regains fertility. The piece is a continuation of Elzén's long-term work with the legacy of the Fogelstad Group, a feminist initiative formed in Sweden in 1921. Åsa Elzén's work is a transcript of a carpet titled *En Träda* (A Fallow), made by Maja and Amelie Fjæstad in 1919–20, which

lay in the library at the farm and education center Fogelstad. Use of the term transcript rather than copy proposes a historiographical process interwoven with the present: by reworking the original, a contemporary reading of the piece becomes a continuation of its history. While the original carpet was woven of linen and wool from Fogelstad, Elzén's version is made of recycled fabrics from a variety of different sources, materials, and dates of manufacture. Visitors may walk on the carpet without their shoes.

Images on pp. 338–341

Tamara Henderson
Womb Life, 2018–19
16mm film transferred to digital video
55 min 37 sec
Sound and image editing: Oliver Bancroft

The project *Womb Life* began when Tamara Henderson underwent hypnotherapy with the artist and hypnotist Marcos Lutyens, whose voice we hear in the film. The film follows Henderson on her inner journey as it passes through a series of different expressions. The boundaries between Henderson's body and the materials and places she works with are perceived in the film as fluid, portraying the creative process as an ongoing metamorphosis only partially steered by the artist. The course of events plays out through five sculptural characters who are all in a state of constant change. Their confrontations with light, earth, fire, and water give rise to new forms, sounds, and movements. Inner images take shape using various materials that subsequently fall apart, are transformed, or subsumed into new contexts. At the same time, the film suggests that Henderson is pregnant, a creating process that is reflected in her work with the sculptures and their various phases of development.

Image on p. 343

Susanne Kriemann
Canopy, Canopy, 2019
Silks, C-prints, plant-based materials, metal structure, lights
Dimensions variable

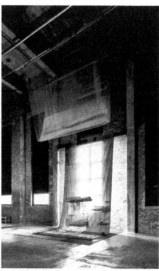

It takes billions of years for radioactive radiation to disappear. Until then it moves through minerals, bodies, and plants. Susanne Kriemann's installation draws parallels between the photographic process and how human activity is recorded in the material of the Earth. The fabrics are dyed with soil and plants gathered in Germany from the vicinity of an abandoned uranium mine whose surroundings will be haunted by low-grade radiation for at least another 100,000 years. The plants are helping to slowly clean up the land, although they are themselves being poisoned in the process. Together with other materials from the site, these fabrics provide concrete evidence of chemical and radiological violence, which takes far more time to heal than human consciousness could possibly comprehend. The plant pigments change when they come in contact with sunlight, causing the colors of the fabrics to change over the course of the exhibition.

Images on pp. 339; 342

423

Kent Lindfors
Vatten, Rost och Eld (Älven,
Skrotmadonnan, Mannen i
Båten. Och Giordano Bruno som
bränns upp, februari 1600.
Campo dei Fiori, Rom), 2016–19
Mixed media on paper

Kent Lindfors' painting dissolves
the boundaries between time
and space. Since the 1970s he
has been cross-referencing places
and epochs in a body of work
that is both artistic and literary.
The eddies of the Göta River
mingle with the vaulted ceilings
of medieval cathedrals in his
monumental tempera paintings,
while contemporary motifs from
Gothenburg Harbor are found
in scenes from the Spanish city
of Guadalupe. On view at Röda
Sten Konsthall is a selection
from Lindfors' comprehensive
oeuvre of drawings and collages.
Here the circle of motifs is partly
rooted in the artist's interest in
Giordano Bruno, the Italian phi-
losopher who—not unlike today's
quantum physicists—believed that
the universe encompassed an in-
finite number of worlds. For this
radical opinion he was burned at
the stake in 1600.

Image on pp. 344–345

Oliver Ressler
Everything's Coming Together
While Everything's Falling Apart:
Ende Gelände, 2016
4K, 10 min

The documentation of the *Ende
Gelände* (End of the Road) protest
captures a massive civil disobedience
action at the Lusatia lignite coal
fields near Berlin. 4,000 activists
entered an open-cast mine, blocking
the loading station and the rail
connection to a coal-fired power
plant. The blockades disrupted the
coal supply and forced the Swedish
proprietor, Vattenfall, to shut the
power station down.

The action was part of an interna-
tional "global escalation" against
the fossil fuel industry that called
on the world to "Break Free from
Fossil Fuels" and put that imperative
directly into practice.

Bodies Without Worlds
Göteborgs Konsthall

Göteborgs Konsthall opened in 1923
and is a typical example of a white
cube gallery. The white-painted gal-
lery space lacks exterior windows—a
spatial manifestation of the idea that
man can create a distance between
himself and the surrounding world so
as to critically observe and reshape it.
Such white cube architecture stages
some of modernity's key operational
strategies—separation, autonomy, and
abstraction—whose consequences
include both freedom and violence.

In keeping with convention, the
gallery space is always restored to
a state of blank purity after every
exhibition in order to make way for
the next show without there being
any trace of the one preceding. This
creates the illusion that new worlds
can continually emerge, as if from a
vacuum. The white cube's method
of tearing down one world in order
to create a new one is recognizable
from utopian thinking, revolutio-
nary political movements, and the
artistic avant-garde—but also from
the destructiveness of colonialism,
imperialism, and industrial capitalism.

The myth propagated by the
white cube is that it is in itself neutral
and does not affect its contents. Like
the white gaze and the blank white
page, the white cube is an expression
of a cultural identity that speaks of
itself in terms of non-identity.

The exhibition at Göteborgs
Konsthall takes the white cube's
double-edged symbolism of freedom
and violence as its starting point.
Several of the artworks challenge
modernity's binary system of either/
or opposites, showing how existence
is rather characterized by different
forms of entanglement and ways of
being both/and.

Elena Aitzkoa
CIRCUNVALACIÓN, 2019
Mixed media: cloth, plaster,
pigment powder, wool
25 × 44 × 34 cm

*COMPLETAMENTE
DENTRO,* 2019
Mixed media: cloth, plaster,
pigment powder, socks, fossils
43 × 97 × 72 cm

FLOR DE MAR, 2018
Mixed media: fabric, plaster,
pigment powder, uncooked mud,
stone, wool
15 × 25 × 25 cm

LAGO-REMOLINO, 2018
Mixed media: cloth, plaster,
pigment powder, oil, stones,
mug with photographic print
44 × 47 × 39 cm

MAREA DOBLE, 2019
Mixed media: fabric, plaster, concrete,
pigment powder, stone, oil
52 × 67 × 44 cm

PÁJARO MÉDULA, 2018
Mixed media: cloth, plaster, pigment
powder, oil, wood
84 × 50 × 85 cm

Elena Aitzkoa works with sculpture,
poetry, video, and performance.
Everyday objects such as clothing
and porcelain are joined together
with stone, gypsum, and plants to
make tightly entangled forms. Her
artwork interweaves material from
her studio with elements from the
world outside it into commingled
configurations. Everyday things
are made visible as poetry, and
poetry becomes a way of navigating
through everyday life. Body, mind,
words, and objects exchange places
or are subsumed into one another.

Images on pp. 389–391

Henrik Andersson
Ockulärbesiktning, 2017–19
Photography
400 × 300 cm
15 pieces

Andersson's photomontage *Ockulärbesiktning* (Visual Inspection) deals with the Bohuslän region's plethora of Bronze Age petroglyphs and how these have been interpreted and reinterpreted throughout history. With the archives of the Tanum Rock Carving Museum and his own fieldwork as the point of departure, Andersson gives form to the shifting interpretations of the petroglyphs— from the Bohuslän priests of the 1850s and the idea of the Swedish nation state to the German pseudo-researchers of the 1930s and our own time's academic archeology. Because the carvings come from a time before written history, they are hard to interpret. Archetypes such as boats and animals are recognizable, but their meaning within their original context is unclear. The stories hidden within the carvings mean that each attempt to interpret them is highly colored by its own time and thereby reveals something about itself. Today the prevailing opinion is that the petroglyphs are related to long-distance trade.

Images on pp. 398–401

Ibon Aranberri
Sources without qualities, 2016–19
Metal cabinet
282.5 × 190 × 34 cm
Steel components and drawings
Dimensions variable

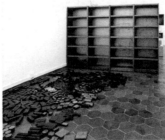

The starting point for Ibon Aranberri's work is a series of abstract metal shapes he encountered in different storage warehouses for industrial heritage objects located throughout the Basque Country. These abstract objects, unclassified and with their original function forgotten, turned out to have been made during the last century by apprentices employed in the local arms industry as formal exercises. Aranberri's installation in Gothenburg references this vocabulary of geometric forms, one that stayed essentially the same during the shift from manual to machine labor, as with the transformation of the armaments production sector to civil production after the Second World War. This migration of forms traces the modern project of building a common formal language for a new society, one whose material culture includes manufacturing as well as art. As the production of gun pipes evolved into the production of bicycle frames, the formal vocabulary and manufacturing methods stayed the same, but with different outcomes. The metal blocks presented in Gothenburg, cut to the artist's specifications from standardized lengths of steel, are distributed in the room according to size and weight, emphasizing their form rather than their function. What might their potential be, the artist asks, beyond their application within the functional context of industry?

Image on pp. 396–397

Sissel M. Bergh
Maadth (rotvälta), 2019
Wood sculpture
Dimensions variable

Maadtegen Vuelie (Song of the Root), 2019
Ink drawing
392 × 400 cm

Sissel M. Bergh makes use of both scientific and artistic methods. By giving expression to the relationship between myth and fact, she shows how the interplay between the two has influenced social relations as well as sanctioned versions of history. A point of departure for Bergh's exploration is the interweaving of South Sámi and Norwegian cultures, and how the South Sámi influence on Norwegian and Swedish culture has been suppressed for political ends. By adopting the tools of cartography and linguistics, she tracks and speculates about the relationship between landscape, myths, language, and place names. The uprooted tree has a mythological significance in South Sámi culture, where it symbolizes *Maadterahkka*, Mother Earth, and the link to ancestors and the past. At the same time, the root system is a widely used motif in the fields of linguistics and genealogy, with associations to racial biology, territorial rights, and rootlessness.

Images on pp. 386–388

Cian Dayrit

Frontiers of Struggle Nos. 04, 05, 08, 09,
2019
Acrylic and collage on handmade paper
65.5 × 85.5 × 6 cm each

Historically, map-making has been a technology used for seizing power and taking control of territory. Cian Dayrit speaks of his work as a form of "counter-cartography." Collages of colonial maps are painted over with pictures that bear witness to the extraction of natural resources, dispossession, and expropriation of land and property. The works are based on cartography workshops given by the artist together with residents from all around the Philippines, whose lands, lives, and livelihoods have been taken from them. The reworked maps remind us that it was imperialism that laid the foundation for dispossession in the Global South, which was a prerequisite of industrialization in the North. At the same time, they invite us to reflect on the consequences of how we conceive of and visualize our surroundings.

Images on pp. 399; 406–407

Michelle Dizon

White Gaze, 2018
Photography
Dimensions variable

White Gaze is based on a collection of *National Geographic* magazines from the 1930s to the early 2000s

that Michelle Dizon bought at a flea market. By preserving the pictures presented in the magazines intact but editing out parts of the accompanying text, Dizon underscores the racist stereotypes that permeate the *National Geographic* as an institution. By making use of a magazine that is recognized globally and has for decades characterized its mission as one of providing a window on the world, Dizon makes visible the role of photography and the mass media in the spread of colonialist and imperialist ways of seeing.

Images on pp. 391–393

Rachel de Joode

Playing Me #1, #2, #9, 2018
Enameled ceramic,
fine art print on canvas
Dimensions variable

Stacked Sculpture I, 2017
Inkjet print on Dibond, steel
215 × 84 cm

Stacked Sculpture II, 2017
Inkjet print on Dibond, steel
210 × 83 cm

De Joode's sculptures embody the digital age's ambivalent relationship to the material. Today's overflow of digital imagery can make us forget what pictures are actually made of and what we in fact are looking at. De Joode destabilizes the relationship between surface and three-dimensional form. What at first glance might be interpreted as skin or internal organs turns out to be photographs of artists' materials such as pigment and clay. In the series *Playing Me,* pleated, folded, and perforated materials also play on the relationship between the roles of the artist and the art object, which are interlinked by the fact that they make each other possible.

Image on pp. 390–391

Hanna Kolenovic

Mitt Göteborg: Angered Centrum, Angered; Kanelgatan, Gårdsten; Mildvädersgatan, Biskopsgården; SKF, Gamlestaden; Teleskopgatan, Bergsjön; Teleskopgatan II, Bergsjön,
2014
6 collagraphs, framed
37 × 44.5 cm each

The series of pictures *Mitt Göteborg* (My Gothenburg) documents the places in Gothenburg where the artist has lived together with her family over the past forty years. The pictures show the buildings, bus and tram stops, plazas, and schools that have been part of the family's everyday life. The series portrays the neighborhoods of Bergsjön, Biskopsgården, Gårdsten, Angered and Backa, which were all part of the public housing initiative known as "the Million Program" undertaken in Sweden between 1965 and 1975. The objective of the program was to build a million units of new housing in ten years, thus resolving Sweden's housing shortage and elevating its standard of living. The architecture was characterized by standardized, functionalist plans and prefabricated concrete components. The program has since been criticized for being both misanthropic and leading to class and ethnic segregation.

Image on pp. 408–409

Antonia Low
Inside the Archive (Steps 1 & 2),
2014–19
Digital print on fabric, metal structure
700 × 600 × 140 cm

Inside the Archive (Step 3), 2019
C-print framed with slumped glass,
felt, painted wood
30 × 30 cm

Inside the Archive (Step 4), 2019
C-print framed with slumped glass,
felt, painted wood
30 × 30 cm

The white gallery space creates an
illusion of being free of context, sug-
gesting the possibility of distancing
oneself from the world in order to
observe it critically. But the idea of a
neutral space without any references
to its past, or the world outside, has
its own history and ideology. For
several years, Antonia Low has been
exploring spaces in art institutions
as well as their hidden narratives. In
Gothenburg, Low has incorporated
her research of Göteborgs Konsthall
with components from her earlier
works in order to superimpose and
link various institutional narratives
to one another. Behind these mul-
tiple layers, Low presents slide films
from the Hasselblad Foundation,
re-photographed under a magnify-
ing glass. The films were originally
exposed during the Apollo missions
—the first time humankind could
actually view the planet from a
distance.

Images on pp. 390–391; 394–395

Rikke Luther
Concrete Nature:
The Planetary Sand Bank, 2018/19
Film, 38 min

In the film *Concrete Nature*, Rikke
Luther explores concrete's political
and aesthetic history in relation to
modernist architecture. Luther's story
weaves together historical pictures
with newly filmed footage from places
such as New York, London, and MIT's
campus in Cambridge, Massachusetts.
The story unfolds from the "discovery"
of concrete in the early nineteenth
century—and its connections to
modernist ideology—to contemporary
plans to build 3D-printed concrete
settlements in space. At Gothenburg
Museum of Natural History, GIBCA
is also showing Luther's piece *The
Sand Bank*, in which she deals with the
industrial extraction of sand—a basic
component in the production of both
concrete and digital technology—and
its catastrophic consequences for the
environment.

Images on pp. 399; 404–405

Doireann O'Malley
(with Armin Lorenz Gerold)
Prototype II: The Institute, 2018
Two-channel video installation with
5.1 surround sound audio,
approximately 60 min
(excerpts from a two-day Live
Action Role Playing workshop)
Commissioned by the Irish Arts
Council, Next Generation Award and
Dublin City Gallery, The Hugh Lane

In her video installation, Doireann
O'Malley explores the complexity
of gender construction. The work

was made by borrowing from
collaborative methodologies such as
Live Action Role Playing (LARP),
somatic exercises, and speculative
worldbuilding. The main characters
in the film were asked to improvise
on their own ideas about what
it would mean to live in a world
without binary gender definitions.
The film references scientific
laboratory environments, modernist
architecture, psychotherapy, bio-
politics, and utopian science fiction.
It captures the way the boundaries
between genders—and boundaries
between human, nature, and
technology—are far more diffuse
than the divisions of constructed
polar opposites such as nature and
culture, or man and woman. Can
technological development make
possible a more complex under-
standing of the world, overriding
ingrained behavioral patterns?

The audio component of the work
was made in collaboration with
Armin Lorenz Gerold.
Supported by Culture Ireland.

Images on pp. 410–412

Oliver Ressler
*Everything's Coming Together
While Everything's Falling Apart:
Limity Jsme My,* 2019
4K, 10 min

The reduction of nature to an
exploitable resource is one of the
largest-scale abstractions performed
by capitalist modernity. Oliver
Ressler's film leads us directly into
the blockade of the Bílina coal mine
in the Czech Republic. In June 2018,
climate activists entered the mine in
an attempt to stop all activity there,
insisting on the need to shut down
climate-destructive mining operations.
The blockade followed an "action
consensus" where participants
rejected property damage and sought
to avoid direct confrontation with the
police. Nonetheless, 280 out of ap-
proximately 400 activists taking part
were detained. The camera follows a

group of activists awaiting deportation inside a police kettle against the backdrop of a landscape defaced by lignite strip-mining. While the screen shows images filmed from inside a prisoner transport vehicle, we hear the voice of a semi-fictional character reflecting on mass civil disobedience.

Image on pp. 382–383

Lorenzo Sandoval
Shadow Writing (Algorithm/Quipu) (Iteration No. 2), 2018
Mixed media
Dimensions variable
Produced with the DKV Álvarez Margaride Grant in LABoral and Schwartzsche Villa

In *Shadow Writing (Algorithm/ Quipu)*, Lorenzo Sandoval explores how different cultures leave traces in one another—connections that in time are made invisible for various reasons. There are two points of departure for the piece: the quipu, a non-phonetic writing and counting tool dating from long before the colonial process, that was used by the Incas and other peoples of the Andes, and the origin of the word "algorithm." A quipu was made of strings with rows of knots whose significance was determined by their location on the string. The word algorithm comes from the name of the Persian polymath al-Khwārizmī. By comparing the quipu with the history of algorithms, Sandoval proposes to rethink the origins of digital technology as transcultural rather than Eurocentric. In the work, supposedly abstract forms found in the Andean quipus and different elements of Arab architecture and knowledge are analyzed in order to explore what other possibilities might be inscribed in the genealogies of digital technology—for instance, the relation of mathematics to the concept of "the common."

Image on pp. 384–385

Knud Stampe
Väggteckning, 1970–71
Ink on paper, 600 × 200 cm
On loan from SKF Verkstadsklubb, Gothenburg

Knud Stampe's drawing *Väggteckning* (Wall drawing) was commissioned by the local union for the dining room of the workers' clubhouse adjacent to the SKF (Aktiebolaget Svenska Kullagerfabriken) ball bearing factories in Gothenburg, where it has hung ever since. The drawing portrays several SKF employees and is allegedly one of the first depictions of female immigrant labor in Swedish art history. It also depicts a so-called "time study man"—a person who timed workers at the conveyor belt in order to calculate their wages according to the effort required. The time study men, also referred to as "bread thieves," had only recently become common place in Swedish industry at the time the artwork was made. In accordance with the artist's feeling of solidarity with the workers and their working conditions, Stampe insisted on receiving the same hourly wage for his work on the drawing as workers on the factory floor were paid.

Images on pp. 398; 402–403

Ayatgali Tuleubek
Declarations, 2014
Video, 8 min 30 sec

The artist walks with the camera directed at the ground. He stops at regular intervals, points at the ground in front of him, and utters a sentence. The phrases are recognizable from national constitutions, political party platforms and fictive

utopias. They promise a society with fair wages, freedom from poverty, and various rights for all—regardless of gender or origin. These ideas are fundamental to the way today's Western democracies speak of themselves, but how do they correspond to reality? As the video progresses, the distance between these simple formulations spoken by the artist and their feasibility in the real world comes to appear increasingly insurmountable.

Image on pp. 398–399

Historical Materials: Mapping Utopia—from Thomas More to Angered

1. Photograph of the statue of King Gustav II Adolf on Gustav Adolf Square in Gothenburg. The statue portrays the imagined moment in 1621 when the king is said to have pointed at the ground where present day Gothenburg is located and proclaimed, "The city shall lie here!" The statue was erected in 1854. Artist: Bengt Erland Fogelberg. Photographer: Malin Griffiths.

2. *Three Early Modern Utopias: Utopia, New Atlantis and the Isle of Pines*, book, Oxford University Press (2008). Gustav II Adolf is said to have been inspired when founding Gothenburg by Thomas More's book *Utopia* (1516), as well as various European ideal city plans. The objective was a militarily fortified center for international trade. The city was the port of departure for Swedish trade ships bound for both the East and the West Indies.

3. *Miljonprogrammet*, book by Mats Theselius (1993). The "Million Program" (1965–75), was a public housing initiative by the Swedish state that built one million homes across the country; a modern example of utopian city planning, including the Gothenburg boroughs of Angered and Bergsjön.

4. Map of Saint Barthélemy (undated, ca. 1792–1809). In 1784, Sweden entered into a trade agreement with France wherein trade privileges tied to a property in Gothenburg Harbor, known thereafter as Franska Tomten (the French plot), were exchanged for the Caribbean island of Saint Barthélemy. Saint Barthélemy remained a Swedish colony until 1878. Map courtesy of the National Archives of Sweden.

5. Map of Gothenburg (1866). The civil engineering and construction expertise required to build Gothenburg came from the Netherlands. In the seventeenth century, the Dutch, who made up a majority of the city's population, called Gothenburg "New Amsterdam" due to the similarities between the two cities' plans. Map courtesy of the National Archives of Sweden.

6. Map of Batavia (1733). Gothenburg was constructed contemporaneously with Batavia (today's Jakarta) in what is now Indonesia, and the two cities had similar city plans. Both cities were laid out by Dutch city planners and modeled on Amsterdam. Batavia was the capital city of the Dutch East Indies colony. Map courtesy of the National Archives of Sweden.

Images on pp. 398–401

Historical Materials: A History in White Papers
Documents related to the Swedish colonial rule of Saint Barthélemy 1784–1878

1. Photograph of a letter outlining the agreement between France and Sweden, whereby Saint Barthélemy was exchanged for trade privileges in Gothenburg. Document dated 1785.

2. Photograph of a preprinted oath bearing the words of a pledge of loyalty to the colonial government of Saint Barthélemy, as represented by His Majesty, King Charles VIII of Sweden, to the colonial law of the island, and to God. Document dated 1811–14.

3. Photograph of preprinted bureaucratic document from the Swedish colonial administration of Saint Barthélemy used to identify a person by describing the color of their skin, hair, eyes, and eyebrows, and to confirm their status as a Swedish sailor registered on the island. Dated 1814.

4. Photograph of letter of manumission affirming the liberation of a slave. Dated 1811–14. Starting in 1784, Swedes engaged in slave trading from the island of Saint Barthélemy, until they signed a trilateral declaration with England and France, abolishing slavery in 1847.

Source: National Archives of Sweden

Ways of Seeing: Human, Nature, Technology
Gothenburg Museum of Natural History

The majority of Europe's natural history museums were established during the nineteenth century, contemporaneous with the Industrial Revolution. The industrialization of extractive practices such as mining unearthed hitherto unseen traces of prehistoric life, dramatically staging the new evolutionary thinking in museum displays. Founded with the purpose of scientific research and public education, natural history museums continue to be an educational resource to this day. Another way to describe them, however, would be to call their collections monuments to the ongoing death of the natural world.

As the natural history collections grew in step with Europe's accelerating exploitation of nature and colonization of the rest of the world, they hold a geopolitical history that is rarely apparent in the way they are shown. The principle of separation between species and evolutionary stages that organize the displays has also been used to support colonial, racist, sexist and anthropocentric ideologies.

At the Gothenburg Museum of Natural History, the biennial is showing artworks that deal with human views of nature from perspectives other than that of the natural sciences. Here we find artistic reflections on the various ways in which humans have tried to understand, control, or commercialize nature, but also how digital technology is today doing the same to humanity through the development of artificial intelligence and digital tools intended to surveil and manipulate human behavioral patterns.

Several of these artworks make links between economic activity and ecological collapse visible. They also show how different philosophical, scientific, and legal systems have created the preconditions for large-scale exploitation of the environment. Concurrently, the putative boundary between the living and the non-living is questioned, with several of the artworks proposing a posthumanist perspective on the world.

Hannah Black, 1
Liv Bugge, 2
Paolo Cirio, 3
Sean Dockray, 4
Annika Eriksson, 5
Rikke Luther, 6
Ohlsson/Dit-Cilinn, 7
Oliver Ressler, 8
Lina Selander &
Oscar Mangione, 9

Ground floor

Second floor

Third floor

Hannah Black
Beginning, End, None, 2017
Three-channel video installation
with sound
10 min 22 sec

The point of departure for Hannah Black's video installation is the cell, the biological building block of life. Black interrogates how the cell is often compared with the factory for educational purposes, showing how this comparison implicitly represents the factory as something natural while at the same time equating the cell with tradeable commodities—a viewpoint that has now become reality with the onset of biotechnology. She also explores the human body's status as a production site, combining filmed material from a number of different sources. Her video's dissolution of boundaries between personal, scientific, and historical images reflects how metaphorical and actual links between biology and society are influenced by and leak into one another. By taking up the Latin name for cell, *cellula,* meaning "little room," Black builds a fragmented story in which the cell is linked together with prisons, slave ships, and industrial manufacturing.

Image on pp. 362–363

Liv Bugge
The Other Wild, 2018
Video with sound
28 min

Liv Bugge's video documents how the Oslo Museum of Natural History, in preparation for a move of location, was emptied of its geology and paleontology collections. Hands touch, evaluate, discard, or keep prehistoric objects. Left behind are empty cabinets—the framework for a specific narrative about the world and how it is thought to be organized. Directing our attention to how institutions categorize and distinguish between the human and the non-human, and between the living and the dead, at the same time Bugge invites us to explore our own ability to relate to the museum's collection in other ways than scientific pedagogy.

Image on pp. 368–369

Paolo Cirio
SOCIALITY, 2018
Digital prints
Dimensions variable

SOCIALITY documents the era in which man began to be programmed by computers. By collecting patents for digital technologies used to influence human behavior (registered in the United States in the period between 1998 and 2018), Paolo Cirio shows how apps, social media, and other digital infrastructure are used for social manipulation in the service of economic gain. The documents make reference to technological products designed to surveil, control habitual behavior, and create addictive patterns of social confirmation. Just as animals and plants have for millennia been collected, bred, and sold by man, human social behavior has now become a commodity.

Images on pp. 374–377

Sean Dockray
Learning from YouTube, 2018
Video of performative lecture, documentation from workshop, excerpts from Google's YouTube dataset

Adversarial Uploads, 2018
Video, 35 sec

Ontology, 2018
Custom YouTube player
145 min

Since Google acquired YouTube, it has used over two million ten-second clips from videos uploaded by private individuals to develop a system for teaching artificial intelligence about the world. The material is organized into categories according to the same encyclopedic principles used in natural science museums, referred to by Google as an *ontology*—a study of the nature of being. Sean Dockray's installation guides the observer through the relationships between Google's data gathering, our own video clips, and the future prospects for human rights in a world ruled by algorithms. He also challenges us to reflect on the possibility of creating and uploading videos that can influence the artificial intelligence's thought patterns.

Image on pp. 378–379

Annika Eriksson
and they were very loved, 2017
Installation with digitized stills from analogue films, 25 min, loop
Material from the Media Archive for Central England (MACE)

While the Gothenburg Museum of Natural History's collections focus on wild animal life, Annika Eriksson's slide show features animals not normally found in the museum: our beloved pets. The work comprises still shots from old home movies donated by the public to the Media Archive for Central England (MACE). The animals in these film stills have all lived their lives in close relationships with humans. The pictures represent the shared lives, full of love and caring, of human and non-human members belonging to different families. At the same time, the relationship is far from equitable: the animals have not chosen mankind's love, nor have they an opportunity to escape it.

Images on pp. 370–373

Rikke Luther
The Sand Bank:
Sand: Mining (Left)
The New World Order (Center)
Land: Sand (Right), 2019
Screen printed canvas
375 × 215 cm each

In her artistic practice, Rikke Luther explores how various interactive systems—such as language, politics, law, and economics—influence the way we relate to the natural world. Her latest series of artworks deals with the extraction of sand, one of our era's greatest environmental threats and a fundamental component in the production of both concrete and digital technologies. Luther's work illustrates how the philosophical, scientific, and legal systems that separate nature from culture are preconditions for the industrial extraction of the raw materials on which the expansion of urban society depends. In the wake of this expansion, the habitats of many organisms central to the food chain are being undermined. At Göteborgs Konsthall, GIBCA is also screening *Concrete Nature*, a film in which Luther explores concrete's political and aesthetic history in relation to modernist architecture.

Image on pp. 364–365

Ohlsson/Dit-Cilinn
Silken sentience, 2019
Sculpture
Parachute, clay, concrete, mycelium, found bones, roots, lichen, thistle seeds
Dimensions variable

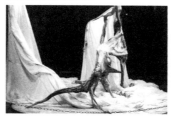

The artistic duo Ohlsson/Dit-Cilinn draw on consciousness research, folklore, and botany to give form to hidden connections between man, technology, and the biosphere. Their work often brings to mind post-industrial landscapes where nature and culture, the ancient and the futuristic, and the individual and the environment are inextricably interwoven. Ohlsson/Dit-Cilinn's new installation portrays a phantom from the museum's subconscious in the form of a ravaged biosphere, engaged in a mating/destruction dance. *Silken sentience* suggests that it is perhaps only when society acknowledges the approaching apocalypse that it will learn to navigate through the present and begin to have faith in what's to come.

Image on pp. 366–367

Oliver Ressler
Everything's Coming Together While Everything's Falling Apart: Code Rood, 2018
4K, 14 min

Oliver Ressler's film highlights the civil disobedience action "Code Rood" that took place at the port of Amsterdam in June 2017. The blockade of Europe's second-largest coal port draws a red line against the use of this important infrastructure facility for fossil capitalism. The largest single source of coal shipments to the port of Amsterdam is Colombia, where coal is extracted under ecologically and socially devastating conditions. In the film we hear the activists chanting: "We are nature defending itself!" This perspective, which insists on seeing man as an integral part of nature rather than a greedy exploiter, seems to be the only hope left if life on the planet is to be maintained.

Each GIBCA venue shows a different chapter from Ressler's project, underlining climate change as the most important issue of our times and its embeddedness in all other struggles and concerns.

Images on pp. 358–361

Lina Selander & Oscar Mangione
Överföringsdiagram nr 2/
Diagram of Transfer no. 2, 2019
16mm film transferred to HD video
10 min 35 sec

Man sees himself as nature's interpreter and tamer. But nature does not care about meaning and its power cannot actually be controlled. It remains silent in the face of mankind's increasingly reckless experimentation, whose catastrophic consequences will ultimately threaten mankind itself. The camera follows a panda at Vienna's Schönbrunner Zoo surrounded by pictures of the Great Wall of China. Silently the panda holds a bamboo brush to a sheet of paper, makes some marks with ink—a picture—and is rewarded with carrots. How shall we interpret this artistic gesture? The video proceeds to a control room at a never-used nuclear power plant that illustrates yet another despotic panorama, one with the same silence and latent violence. The images are transferred from one context to another, created and recreated in relation to one another. To question what it means is only human, but in the long run probably irrelevant.

Image on pp. 380–381

Online/Offsite

Pia Sandström, 1
(The Haga neighborhood)

Pia Sandström
The Gothenburg Suite:
Underground, 2019
Site-specific soundwork accessible
via GIBCA's app or website
Language: Swedish, 10 min

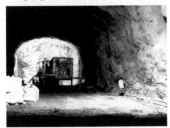

In her interdisciplinary explorations
of actual places and imaginary inner
landscapes, Pia Sandström works with
materials such as text, sound, and
land. At GIBCA's invitation, Sand-
ström will work with an exploratory
sound installation from 2019–21.
The piece is based on the Haga
district and the historical and geo-
logical layers now being unearthed
during excavation work for the West
Link Project, a railway tunnel that
will run under central Gothenburg.
The first part of the work takes the
form of an archaeo-acoustical core
sample that brings us deep down
into the earth, the myths, and the
people connected with the neigh-
borhood. Beneath Gothenburg lies a
formation of rock types 1.6 billion
years old known as "the Gothenburg
suite." The word suite also refers
to a form of musical composition,
common in the seventeenth and
eighteenth centuries, comprising a
series of dance movements.

It is recommended to listen to the
work with headphones on site in the
Haga neighborhood, starting from
where the street Kaponjärgatan
meets the stairs leading to Skansen
Kronan. Kaponjär means "hidden
passage" in Swedish.

The work was produced in collabora-
tion with the City of Gothenburg—
the Urban Transport Administration,
the Cultural Affairs Administration
and Göteborg Konst—within the
frame of the West Link Project.

Image on pp. 336–337

Double Exposures
Franska Tomten

The so-called Franska Tomten (the French plot) at Packhusplatsen 4 in Gothenburg Harbour, got its name in 1784 when it was exchanged for the Caribbean island of Saint Barthélemy as part of a trade agreement between Sweden and France. While the French were given free trade rights in Gothenburg, Sweden took over the colonial administration of Saint Barthélemy. Until 1847, Sweden's involvement on the island was primarily concerned with the slave trade. In 1878 the territory was sold back to France.

Today the capital of Saint Barthélemy is still called Gustavia after Swedish King Gustav III. But in Gothenburg there are no official memorials at Franska Tomten or elsewhere commemorating the shared history of these two places. The legacy of colonial trade, however, is most definitely part of Sweden today. The Swedish export of iron was pivotal in the transatlantic slave trade—and lay the foundation for Sweden's industrial society and welfare state.

Today, the former headquarters of the shipping company Rederi AB Transatlantic stand on the site, flanked by the Court of Appeal for Western Sweden. Starting in 2019, GIBCA will be inviting artists to relate to the historical layers that link together Saint Barthélemy and Gothenburg Harbor, as well as to the connections between trade and injustice from a broader perspective.

Ayesha Hameed, 2
(The dockside by Packhusgatan 6)

Eric Magassa, 3
(Packhusplatsen 4)

Historical materials related to Franska Tomten are on view at Göteborgs Konsthall.

Ayesha Hameed
A Transatlantic Periodic Table, 2019
Soundwork, 17 min
Sound design: Ayesha Hameed and William Saunders
Commissioned by knowbotiq for the project *Swiss Psychotropic Gold*

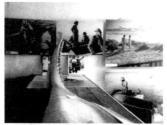

Ayesha Hameed's soundwork takes the raw materials of the transatlantic slave trade as its starting point. We hear the artist speak of her encounters —through museums, archives, abandoned warehouses, and the sea itself—with the material traces of the violent extraction of humans and natural resources along the African coast. The artist's simultaneously factual, corporeal, and hauntingly poetic readings of the glass, pearl, sugar, gold, bone, and iron found at the bottom of the sea release traces of the materials' past into the present, where parallels to contemporary migration can be drawn.

The work can be accessed through the GIBCA app and website. We recommend listening to the work with headphones at the designated spot in Gothenburg Harbor, which was built in the seventeenth century as Sweden's "window to the Atlantic" and national port for trade with the East and West Indies.

Image on pp. 334–335

Eric Magassa
Walking with Shadows, 2019
Site-specific wall painting/collage
4000 × 400 cm

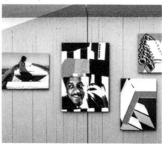

Eric Magassa works with painting, collage, performative photography, sculpture, and textiles. Several of his works draw on his roots in Sweden, France, and Senegal, exploring how West African art has been copied and exploited in various ways for artistic and commercial purposes. Magassa often works with masks, patterns, and montage, staging a series of dislocations between the visible and invisible, as well as between different identities and meanings. At the invitation of GIBCA, Magassa has made a new work especially for Franska Tomten, connected to the colonial history of the site. The large-scale site-specific collage brings together historical documents from various sources, such as the National Archives of Sweden and the Museum of Ethnography in Stockholm, together with pictures from the artist's own collection.

The work was produced in collaboration with The Swedish Transport Administration.

Images on pp. 327–333

The Ghost Ship and the Sea Change
11th Edition of Göteborg International
Biennial for Contemporary Art

Part One: June 5–August 22, 2021
Part Two: September 4–November 21, 2021

Exhibition index

The Ghost Ship and the Sea Change
11th Edition of Göteborg International
Biennial for Contemporary Art

Part One: June 5–August 22, 2021
Part Two: September 4–November 21, 2021

Curator:
Lisa Rosendahl

Venues:
Part One:
Franska Tomten
Röda Sten Konsthall

Part Two:
Franska Tomten
Röda Sten Konsthall
Museum of World Culture
The Garden Society of Gothenburg: The
Palm House
Online/Offsite
Göteborgs Konsthall
Konsthallen Blå Stället

Artists:
Part One:
Michael Baers
Evan Ifekoya & Ajamu X
Damla Kilickiran
Susanne Kriemann
Anna Ling
Silvano Lora
Ibrahim Mahama
Hira Nabi
Daniela Ortiz
Manuel Pelmuş
Tabita Rezaire
Jessica Warboys

Documentation of artistic proposals for
Possible Monuments? by Hanan
Benammar, Aria Dean, Ayesha Hameed,
Runo Lagomarsino, Fatima Moallim,
Daniela Ortiz, and Jimmy Robert

Part Two:
Adding works by:
Meira Ahmemulic
Henrik Andersson
Erika Arzt & Juan Linares
Ariella Aïsha Azoulay
Gaëlle Choisne
Benjamin Gerdes
Cecilia Germain
Unni Gjertsen
Ayesha Hameed
HAMN
(Nasim Aghili & Malin Holgersson)
Salad Hilowle
Conny Karlsson Lundgren
Oscar Lara
Marysia Lewandowska
Jonas (J) Magnusson & Cecilia Grönberg

Fatima Moallim
Pedro Neves Marques
M. NourbeSe Philip
Pia Sandström
Shanzhai Lyric & Solveig Qu Suess
Lisa Tan
The Situationist International
Lisa Torell
Alberta Whittle

Team:
Sofia Alfredsson
Carl-Henrik Andersson
Marie Bergdahl
Ingrid Blixt
David Bramham
Mia Christersdotter Norman
Ellie Engelhem
Andreas Engman
Malin Griffiths
Maria Elena Guerra Aredal
Helena Herou
Yuying Hu
Niklas Isaksson
Josefin Jansson
Glenn Johansson
Ioana Leca
Elin Liljeblad
Sogol Mabadi
Thilda Olsson
Victor Rankanen
Mathijs van Sark
Charlotte Schmidt
Johanna Sköldbäck Martell
Renée Tan
Sifen Wibell

**With collaborators from
partner institutions:**
Sofie Alnäs
Karin Andersson
Shiva Anoushirvani
Rebecka Bergström Bukovinszky
Emma Corkhill
Stina Edblom
Hanna Falkendal
Johanna Gustafsson
Sarah Hansson
Hans Ivanoff
Badou Jobe
Subani Melin
Mattias Norström
Mija Renström
Julia Roman
Ann-Sofi Roxhage
Johan Rödström
Ellen Skafvenstedt
Liv Stoltz
Nontokozo Tshabalala
Elisabet Udd
Magdalena Ågren

Graphic identity:
Oskar Laurin

The Ghost Ship and the Sea Change

Conceived in response to the 400-year anniversary of the founding of the City of Gothenburg, the eleventh edition of the Göteborg International Biennial for Contemporary Art, *The Ghost Ship and the Sea Change*, relates to the historical layers of the city. Located at the intersection between the historical and the fictive, the biennial explores artistic practice as a method of critical historiography and cultural transformation organized around a central question: How can different ways of narrating the past impact the future?

The narrative point of departure for the biennial is Franska Tomten (currently Packhusplatsen), a plot of land in the city's harbor that was exchanged in 1784 for the Caribbean island of Saint Barthélemy as part of a trade deal between Sweden and France. How might the way we think about Gothenburg change if we look at the city from the perspective of this particular plot of land and its colonial history?

Until the 1840s, Saint Barthélemy was governed by the Swedish administration as a hub for the transatlantic slave trade. In 1878 it was sold back to France. Reflecting on this history through the buildings and activities that occupy Franska Tomten today—a court of law situated in a former shipping palace, a casino, and a museum of migration housed in the harbor's historical customs house—the past becomes visible as an ongoing present. The interrelated flows of goods, bodies, capital, and ideology connected to the site span centuries and geographies: just as the writing of law is historically bound up with regulations of international trade, the global circulation of capital is directly connected to contemporary routes of migration.

Through existing and commissioned artworks, the biennial traces this narrative and geographical plot outward from Gothenburg Harbor to where it meets other places, voices, and histories. Taking the form of a polyvocal and multi-sited narration, *The Ghost Ship and the Sea Change* suggests that a city founded on transnational relationships can only become legible by also looking at other places around the world.

Colonial ideology established racism, sexism, and the destruction of nature as the new world order. This tripartite value system has come to define the past 500 years, during which time the discipline of history was enlisted as an imperial tool, drawing boundaries between the past and present, and causing other ways of describing the world to appear marginal or fictional. In the biennial, the artworks seek to counter this process by offering different possibilities for historical narration, making space for critical fabulation and counter-history.

The double title of *The Ghost Ship and the Sea Change* refers to the necessity to both honor the ghosts of the past and find ways to move beyond them—to acknowledge the historical violence and its contemporary consequences, and begin much-needed processes of repair. The presence of ghosts is further accentuated by the exhibition architecture

at Röda Sten Konsthall in its reference to
the West Indies-bound frigate *Havmanden*,
shipwrecked outside Gothenburg in 1683.
Staged as a metaphorical replica of this
ship, the architecture represents how the
past continues to frame the present, but
also how the ruins of history can be
re-purposed.

Opening in June to coincide with the
anniversary of Gothenburg's founding,
additional artworks will be added starting
in September, reshaping the initial exhibition
and extending the biennial across further
venues and public spaces throughout the city.

Lisa Rosendahl, Curator
2021

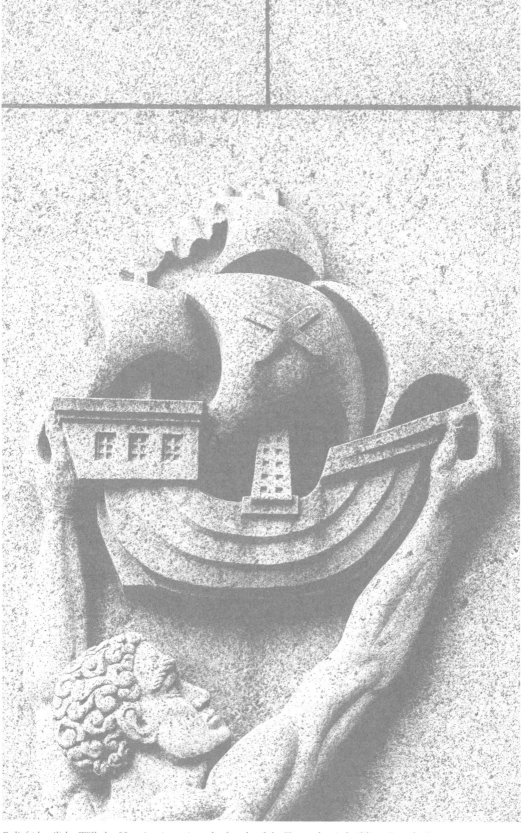

Relief (detail) by Wilhelm Henning (1944) on the facade of the Transatlantic building, Franska Tomten.

Franska Tomten

Part One
(5.6–4.9 2021)

Ibrahim Mahama, 1

Part Two
(4.9–21.11 2021)

M. NourbeSe Philip, 2
Salad Hilowle, 3

Ibrahim Mahama
ABULAI KPATARGU GRC
ABULAI MARIAMA
ABULAI REHI LOCATION
AZARA SEIDU
BINTU ABRASIPU SEKONDI
KAMARIA KPAΓASCO GRC
KAMARIA SHAHARU ACCRA
MAMUNA AZARA LOCO
2019–20
C-print on gobond
280 × 3000 cm

Ibrahim Mahama's series of photographs depict the tattooed arms of collaborators the artist has worked with throughout Ghana, overlaid on historic colonial maps of key locations, cities, and villages across the country. Others are photographed against leather train seats salvaged from the Gold Coast Railway built during the colonial era. Ghana's colonial history led to the forced migration of multiple ethnic groups from the farmlands that previously supported them. Many of the collaborators Mahama has worked with have migrated from rural areas to port cities such as Tema and Accra in search of work. Tattooing the family name or place of birth on a person's forearm is a common practice throughout rural Ghana due to the widespread lack of identification papers. As the labor conditions for the migrant workers are often treacherous, the tattoos are used to identify people who have been injured or lost their lives in work-related accidents far away from home. The installation at Packhusplatsen is a reminder of how colonial structures still operate through global inequality linked to working conditions, economy, and migration.

The work was produced in collaboration with The Swedish Transport Administration.

Images on pp. 323–326

M. NourbeSe Philip
Zong!, 2008–21
11 gobond panels
1680 × 158 cm

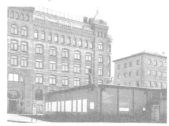

The artwork is composed of excerpts from the poem *Zong!*, originally published as a book. The poem revisits the historical trauma of a massacre at sea, telling a story that "cannot be told yet must be told" (Philip). In November 1781, the captain of the slave ship *Zong* ordered that some 150 enslaved Africans be murdered by drowning so that the ship's owners could collect insurance money. The insurance claim was documented in a legal decision—the only extant public record of the massacre. The poem relies entirely on the words of the legal document, excavated and transformed by M. NourbeSe Philip into a chant where the many other voices and perspectives on board the ship emerge.

Excerpts from the original poem have been selected by the author for presentation as a public artwork. Its placement at Franska Tomten in Gothenburg commemorates the victims of Sweden's involvement in the transatlantic slave trade and of the colonial rule of the Caribbean island Saint Barthélemy (1784–1878).

The work was produced in collaboration with The Swedish Transport Administration.

Images on pp. 312–317

Salad Hilowle
Untitled (En resa från förr), 2021
3D relief carved in pine
165 × 65 × 6 cm

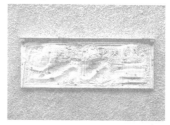

Salad Hilowle's site-specific work *Untitled (En resa från förr)* is based on a work by the sculptor Arvid Bryth. Originally made in the 1940s as a commission for the shipping company Rederi AB Transatlantic, Bryth's carved wooden relief— depicting Gothenburg sailors, carrying weapons, in an encounter with a group of people in a tropical landscape—still hangs in the lobby of their former headquarters at Packhusplatsen 3. The original relief, executed in a naive style, possesses violent undertones. Hilowle has brought Bryth's picture out into the public realm by placing a reworked copy of the original around the corner from Packhusplatsen. His intervention in the piece sheds new light on the original scene and also changes it, reminding us of historically inequitable relationships and stereotypes, but also of the potential for change.

Images on pp. 318–322

Röda Sten Konsthall

Part One
(5.6–4.9 2021)

Michael Baers, 3
Evan Ifekoya & Ajamu X, 11
Damla Kilickiran, 9
Susanne Kriemann, 10
Anna Ling, 7
Silvano Lora, 2
Hira Nabi, 1
Daniela Ortiz, 8
Tabita Rezaire, 5
Jessica Warboys, 6

Historical Materials:
Culturally Modified Trees, 4
Iron, 4

Possible Monuments?, 18
Documentation of artistic
proposals for Franska Tomten by
Hanan Benammar, Aria Dean,
Ayesha Hameed, Runo Lagomarsino,
Fatima Moallim, Daniela Ortiz, and
Jimmy Robert.

Part Two
(4.9–21.11 2021)

Adding works by:
Gaëlle Choisne, 13
Benjamin Gerdes, 12
Cecilia Germain, 14
Ayesha Hameed, 17
Marysia Lewandowska, 16
Alberta Whittle, 15

Exhibition architecture by
Kooperative für Darstellungspolitik.

*The floor plan indicates the final
placement of the works as installed
in Part Two.*

Ground floor

Third floor

Second floor

Fourth floor

Michael Baers
Invisibility Chronicles: Part One
2020–ongoing
Newspaper, Euro-pallet,
works on paper
Dimensions variable

Invisibility Chronicles, Part One
narrates the true story of the *FSO
Safer*, a Yemeni oil tanker currently
stranded in the Red Sea with a cargo
of 1.1 million barrels of crude oil.
Describing the vessel as "a ghost
ship, a hostage ship, a bomb ship or
ship-bomb," Michael Baers shows
how its fate depends on a complex
set of mechanisms dictated by
geopolitical interests. The story of
the ship connects colonial pasts with
contemporary geopolitical brink-
manship and an imminent threat
of environmental catastrophe that
would reach far into the future.
In his work, this specific story
becomes a vehicle for asking
broader questions about historio-
graphy and public visibility: Why
do some conflicts and situations
become well-known in Western
civil society while others remain
obscure, and what consequences
arise when certain stories fall out of
the media's hegemonic narration of
the world?

Images on pp. 206–209

Evan Ifekoya & Ajamu X
Ritual ~~Without~~ Belief, 2018
Sound installation
Dimensions variable

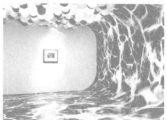

Evan Ifekoya describes their
six-hour soundwork as "a black
queer algorithm across generations,
locations, and political affiliations."
This installation, exploring how to

create conditions for polyvocality, combines underwater and inner body sounds with vocal samples embodying and channeling voices drawn from literature, theory, and music—as well as conversations with friends and Ifekoya's own intimate thoughts and reflections. A gray-scale ocean covers the floor, arching up in waves at either side of the gallery. The ocean is imagined as a site of transformation, where the cyclical nature of life and death is a rhythm reproduced in every wave and breath, as well as across time. The balloons allude to The Loft, an LGBT club night started in New York in the 1970s. They also speak to the notions of time and decay, deflating and changing how the work is experienced over the duration of the exhibition. The photographic work *Bodybuilder with Bra* (1990) by artist Ajamu X is included in the installation as a further gesture of intergenerational dialogue and community-building.

Images on pp. 230–233

Damla Kilickiran
On Sense and Glyphs, 2020–21
Aluminum rulers, stand, drawing in salt on the floor
Dimensions variable

The ongoing series *On Sense and Glyphs* grew out of artist Damla Kilickiran's insight that the square-edged ruler is not a neutral tool but represents instead a worldview based on fixed value relationships. The rulers we see here were made by the artist herself based on motifs found in her drawings and executed in a kind of psychographic state through which the body's inner imagery is given expression. Creating tools that are based on one's own body rather than an external logic opens the door to other ways of seeing and navigating. In Kilickiran's drawings, lines that

would have remained parallel in Euclidean geometry are allowed to meet. Salt is considered by many cultures to have cleansing and protective qualities. It is also used for paranormal purposes, to keep spirits at bay or, indeed, create space for them. The drawings on the floor will eventually dissolve, but they will be recreated during the course of the exhibition, like incantations or magical formulas.

The work was installed from July 13.

Images on pp. 222–225

Susanne Kriemann
Mngrv (polymersday series), 2021
Archival inkjet prints, gum transfer prints with marine plastics, pigments
Framed diptychs, 53 × 78 cm each, unique

Susanne Kriemann has photographed mangrove forests in Southeast Asia entangled with plastic waste and oil spills. When making the final prints, the artist incorporates debris and oil collected from where the photographs were taken. The work explores how climate change and environmental pollution blur the boundaries between nature and culture. Growing between sea and land, mangroves create sensitive ecosystems that change with the flow of the tide. Kriemann's images too inhabit an uncertain terrain—between photographic representation and material testimony. The imprints of the waste on the photographic paper appear concrete and ghostly at the same time, just as the plastic waste of consumer culture will inevitably come back to haunt us for generations to come.

Images on pp. 218–221

Anna Ling
Zostera marina (eelgrass) #1–5, 2021
Ink on linen, 145 × 200 cm each

The history of a city is often told from the point of view of human activities and perspectives. But the conditions for human life are interwoven with other organisms that are seldom ever mentioned. Anna Ling's paintings are based on photographs of eelgrass meadows off the island of Tjörn, taken from above the surface of the sea looking down toward the bottom. The transparent layers of ink wash capture the feeling of looking down into the billowing masses of eelgrass blades. Ling's interest in eelgrass began with her wondering why there were no longer as many fish in the waters she had fished in as a child. One of the causes turned out to be the fact that most of Bohuslän County's eelgrass meadows, which are often referred to as "the nurseries of the sea," had disappeared due to agricultural over-fertilizing and industrial development. For some time, scientists working with the county administrative board have been trying to protect and re-establish the eelgrass meadows, a time-consuming effort because the grass must be replanted by hand, one shoot at a time, using scuba divers.

Images on pp. 211; 216–217; 236

446

Silvano Lora
Crossing the Ozama River in Remembrance of the 500 Years of Indigenous Resistance in the Americas, 1992
Reproductions of photographs documenting the action, text
On loan from Quisqueya Lora/Taller Público Silvano Lora

In October of 1992, a full-scale replica of Christopher Columbus' ship arrived in Santo Domingo to celebrate the 500-year anniversary of his arrival in the Americas. The colony of Santo Domingo on the island of Hispaniola was the first permanent European settlement in the region. Wishing instead to bring attention to the plight of the indigenous people who had all but perished due to the conquest, artist Silvano Lora (1931–2003) performed a counter-action. Together with the craft artist Pachiro, Lora carved a canoe using traditional indigenous materials and techniques. The two artists paddled across the Ozama River, interrupting the path of Columbus' ship.

Image on pp. 228–229

Hira Nabi
All that Perishes at the Edge of Land, 2019
Video, 30 min 32 sec

In Hira Nabi's film, documentary meets magical realism. It opens with the container ship *Ocean Master* arriving at the Gadani Ship Breaking Yard in Pakistan. Ships from all over the world end up here to be disassembled by day laborers whose work is both dangerous and poorly paid. As *Ocean Master* is broken apart piece by piece, the workers recall the families and villages they have left behind. Their life by the polluted shoreline is precarious: "Our wages prevent us from dying, but don't allow us to live either." In the film, the ship itself is also given a voice. The dialogue between her and the workers moves between dreams, hope, fear, and death. Seen from the perspective of Gothenburg, the film can also be understood as an inverted portrait of what was once Sweden's most prominent shipbuilding city. How does our understanding of Gothenburg's history change when seen from the other side of the ocean?

Images on pp. 201–203; 210

Daniela Ortiz
The Empire of Law, 2018–19
Video with sound, 30 min

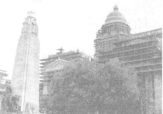

Daniela Ortiz's film, *The Empire of Law*, critically analyses the relationship between law, justice, and colonialism. Ortiz uses the architecture, history, and context of two law courts—the Brussels Palace of Justice in Belgium and a replica of the same building, the Palace of Justice in Lima, Peru—as a starting point to examine the role of the legal system in legitimizing colonialism. She shows how extractivist, racist, and neo-colonial global structures continue historical injustices into the present day. The result, according to Ortiz, is a European "empire of law," rooted in colonialism, in which justice for colonial territories and racialized people can never be found.

Images on pp. 227; 237

Tabita Rezaire
Sorry for Real, 2015
HD video with sound, 16 min 58 sec

In *Sorry for Real*, Tabita Rezaire questions the function of narratives of reconciliation in relation to structures of oppression. The video starts with an incoming call from "the Western World." A hollow automated voice calls out the crimes of Western culture in the form of an apology. Historical injustices such as slavery, colonialism, and the theft of land and resources are acknowledged, but what is the actual purpose of asking for forgiveness when the culture of exploitation continues through contemporary capitalism, white supremacy, and hetero-patriarchy? The work invites us to reflect on the power dynamics created by symbolic gestures of reconciliation, such as apologies, and who really benefits. Rezaire humorously portrays the false sense of progress and feelings of pre-empted anger created by mechanisms of apology and forgiveness, encouraging us instead to imagine real processes of change.

Image on pp. 214–215

Jessica Warboys
Sea Painting, Atlantic, 2021
Canvas, mineral pigment
Dimensions variable

Jessica Warboys' ongoing series of *sea paintings* are made at different locations where land meets sea. Large raw canvases are submerged in the sea before being pulled ashore, where mineral pigments are applied directly onto the sea-soaked canvas. As they are dragged to and from the waves, creases and folds capture traces of movement in a process that

alludes to ritual, performance, and landscape painting. As the waves, wind, and sand spread the pigments across the canvas, each painting becomes a record of a particular place and time. The painting at Röda Sten Konsthall was made in summer 2021 at the edge of the North Sea in the Atlantic Ocean.

The work was installed from July 13.

Images on pp. 226; 236

**Historical Materials:
Culturally Modified Trees**
Two photographs of culturally modified trees from Sápmi
75 × 50 cm each

Sweden's exploitation of Sápmi, and the displacement of the Sámi people's culture by the forestry and mining industries, is a manifestation of the same colonial ideology seen in other parts of the world. The two are interlinked: the iron extracted from the North was used in colonial expansion in the global South. The photographs show culturally modified trees in Sápmi. Unique trees like these are found in protected forests in the north of Sweden, as well as in other parts of the world with indigenous populations and a colonial history. Their markings—used to indicate directions or to mark boundaries and sacred sites—were significant orientation points in the landscape of the Sámi culture and date back to the seventeenth

and eighteenth centuries. The lack of formal protection and respect for Sámi cultural heritage within forest landscapes typifies Sweden's oppression of the Sámi people, which continues in modern times and have meant that many traces of their cultural history have been lost. The tree with the face was felled in the 1970s, with the carved section turned over to the Silver Museum in Arjeplog.

Photographs and source materials: Professor Lars Östlund, Swedish University of Agricultural Sciences, Umeå/The Silver Museum in Arjeplog.

Images on pp. 203; 243

Historical Materials: Iron
Sixteen photographs of historical artworks portraying the Swedish iron industry, installed across two tables
Dimensions variable

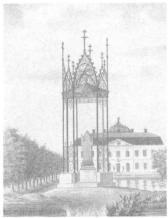

Swedish iron was an essential product within the Caribbean plantation economy, and played a key role in European colonialism, the transatlantic slave trade, and the emergence of the capitalist system. It was used as a trade currency (so called *voyage iron*) in the African slave trade and in the manufacture of weapons, chains, and ships. Iron was extracted from mines across Sweden, from Uppland to Tornedalen, and shipped out to the world, usually via Gothenburg Harbor. The economic prosperity and expertise generated by the production of metals in Sweden during the seventeenth and eighteenth centuries laid the foundations for the country's contemporary steel industry, as well as its welfare state. This documentation of historical artworks shows

mines, ironworks, and manor homes in Sweden and Sápmi between 1660 and 1850, made by artists such as Erik Dahlbergh, Claes Tamm, and A. F. Skjöldebrand. The fountain known as *De Fem Världsdelarna* (The Five Continents) was made by Tore Strindberg and dedicated in 1927 to mark the spot at Järntorget (Iron Square) in Gothenburg where the city's iron-weighing scale stood from 1785 until 1892.

The pictures come from Jernkontoret, a Swedish iron industry association, and Wikipedia.

Image on pp. 216–217

Possible Monuments?
For the project *Possible Monuments?* seven artists and two writers were invited to respond to Franska Tomten, reflecting on if and how it should be the subject of and location for a public monument.

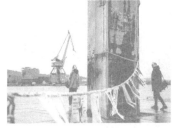

The project addressed the need for remembrance and memorialization to honor the victims of colonialism and its contemporary consequences, such as structural racism and global injustice. Inviting artists to respond with a proposal was a way of sustaining a public conversation around these topics and testing ideas for future possible monuments.

Possible Monuments? was part of the biennial's series of public discussions and artistic interventions connected to Franska Tomten, which began in 2019. The project asked what role contemporary art can play in critically re-reading Sweden's colonial history and heightening its public visibility, while also discussing in more general terms the role of public art and monuments today: Should old monuments connected to historical inequalities be dismantled and new ones be built? For whom and by whom should such monuments be made? And has the digital age changed our relationship

to memorial culture, prompting the replacement of physical monuments with immaterial or time-based ones?

Possible Monuments? was organized by Göteborg International Biennial for Contemporary Art in collaboration with Public Art Agency Sweden. It took the form of an online seminar on November 26 2020 as well as a dedicated website, www.possible-monuments.se, which presents documentation of proposals created by Hanan Benammar, Aria Dean, Ayesha Hameed, Runo Lagomarsino, Fatima Moallim, Daniela Ortiz, and Jimmy Robert, and texts by Morgan Quaintance and Ylva Habel.

Images on pp. 252–253; 308

Röda Sten Konsthall

Part Two
(4.9–21.11 2021)

Adding works by:
Gaëlle Choisne
Benjamin Gerdes
Cecilia Germain
Ayesha Hameed
Marysia Lewandowska
Alberta Whittle

Gaëlle Choisne
Temple of Love – To Be Ascetic (Tolalito), 2021
Concrete wire mesh, hand-painted flags, pool with bricks and water, lingam stone
Dimensions variable

This installation is the most recent iteration of Gaëlle Choisne's ongoing project, *Temple of Love*, which is inspired by Roland Barthes' book *A Lover's Discourse: Fragments*. Choisne's project explores love as a form of resistance and a catalyst for courage and transgression. Each iteration refers to a chapter in Barthes' book. Constructed as spatial and sculptural arrangements, the *Temple of Love* installations offer a delicate balance between shelter and confinement, and between the organic and the artificial. The flags, inspired by political banners used during elections in Haiti, were made in Port-au-Prince by the graphic designer James Ford Auguste. The bricks reference those used as ballast by Northern European ships deployed in the triangular trade. In the center of the pool is a lingam stone, which holds healing properties and the ability to protect against bad energy.

Images on pp. 234–235; 237

Benjamin Gerdes
Det är ju alltid ett jättejobb att hålla ihop ett kollektiv, 2021
Video with sound, 43 min

From 2016 until 2019, a highly public conflict raged in Gothenburg's container port between the Swedish Dockworkers Union and APM Terminals, the company who manages the port.

Two years later, the dockworkers reflect on the conflict in Gerdes' film. From the workers' perspective, the dispute—which led to a national strike and lockouts in ports across Sweden—was about working conditions and opportunities for influence in the workplace—in contrast to most media reports, which focused on the progress of negotiations. Gerdes' work, on the other hand, features the workers' personal stories, in particular about how working in the harbor impacts their relationships with family and friends. An underlying theme is how the Gothenburg port strike illuminates the tension between a local struggle for democracy and justice in the workplace, and the global systems and infrastructures controlled by multinational corporations and dictated by the worldwide flow of goods.

Glass Port, 2021
Video without sound, 5 min

The international networks that transport goods and data are central to our daily lives, but they are seldom seen by the public. Gerdes' video compares the activities on Gothenburg's loading docks, which are invisible to the public, with the daily floods of people streaming through the historical harbor district around Stenpiren, setting these hubs in relation to other logistics sites, such as data centers and sorting facilities. The film brings together animations and simulations with documentary images. The words on the screen ask the public to consider the complex and overlapping systems and processes that play out on the sea: the infrastructure of internet cables criss-crossing the globe beneath the ocean surface and the container shipping companies above, and the lives of the humans and animals they effect. An underlying theme is how we encounter these global relationships on the local level, such as in passenger ferries and the development of new waterfront housing.

Images on pp. 237; 246–247

Cecilia Germain
*A Mermaid's Tears Are
Always Blue*, 2021
Mixed media: artist's book,
cyanotypes on glass, sound

Cecilia Germain thinks of the sea as
an archive: unstructured, always in
flux, and at the same time perma-
nent and eternal. Information flows
over, under, or in the fluctuating
waters, but never disappears. The
world's seas hold a great deal of
pain in reserve in the true histories
of power and violence that have
transpired there. But the sea also
is the site for tales of resurrection,
redemption, and utopian fanta-
sies giving hope and strength. In
this piece, Germain conveys facts
and fictions using an Afrocentric
paradigm, bringing to the surface
stories from the archive of the sea
that weave together transatlantic
experiences and memories with
other people and places on land.

Image on pp. 248–249

Ayesha Hameed
Two Ships, 2021
5.1 sound
7 hessian textiles dyed in turmeric,
cinnamon, cacao, coffee, and
barbary fig, soaked in the Thames
and rusted with iron
Composition and sound design:
Mhamed Safa
Textile support: Natasha Eves and
Andia Newton
Voices: Ayesha Hameed and
Theodor Ringborg

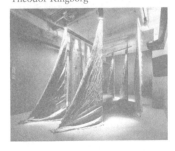

Ayesha Hameed's installation
references the twin city plans and
canal systems of Gothenburg and
Batavia (Jakarta), both built by
Dutch city planners in the 1620s,
and the 1852 hurricane that struck
Saint Barthélemy during Swedish
colonial rule. The colonial trading
histories of the three places are
interwoven in the work by evoking
the winds that move across the
earth's surface, carrying ships,
slaves, seeds, and storms, reflected
upon by a narrator who connects
the ecological manifestations of
colonial violence and the historical
commodification of nature with
contemporary environmental
disaster. The textiles, whose color
and scent will fade with time,
are printed with pigments from
plants and spices used as colonial
commodities. The soundscape
references two historical trade ships
in particular, both of which sailed
for the Scandinavian East and West
India Companies, were caught in
storms, and shipwrecked outside
Gothenburg.

Image on pp. 250–251
Script on pp. 471–474

Marysia Lewandowska
*Dismantling the
Faculty of Law*, 2021
4K video with sound
(Polish with English subtitles)
19 min 29 sec

Marysia Lewandowska's film reflects
on the tool of law and how it shapes
our lives, however unequally. A close
observation of the Faculty of Law
in Poznań, where Lewandowska's
great grandfather taught for many
years, the work explores his legacy
and its moral foundations through a
poetically scripted voice-over. While
looking for an absent legislator, the
female protagonist comes across
material traces of the legal apparatus
while navigating the physical coor-
dinates of a "soulless" law, where no
one is available to take responsibility
or be held accountable. Questions

and reflections on how the legal
code is used to make certain events
appear and disappear reverberate
through empty hallways, implica-
ting the law's misuse as a source of
violence. As the impartiality of the
law shows itself to be both utopian
and cruel, the protagonist's search
for tenderness signals the work's
commitment to a wider debate on
the role of justice in a deeply divided
world, a plea to create alternative
measures through which justice
might be served.

Image on pp. 244–245

Alberta Whittle
RESET, 2020
Video with sound (32 min),
handmade quilted blankets,
second-hand furniture
Commissioned by Forma Arts
and Frieze

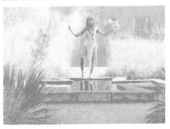

Filmed across Barbados, South
Africa, and the United Kingdom,
RESET is a poetic contemplation of
the need and potential for change
through individual, collective, and
planetary struggle and recuperation.
It explores timely questions relating
to personal healing and the culti-
vation of hope in hostile environ-
ments, such as the present global
pandemic, colonialism, and climate
change. Informed by the writings of
queer theorist Eve Kosofsky Sedgwick,
Alberta Whittle interweaves inner
experience with outer political
and natural landscapes in her film,
striking a balance between grief and
reflection, empathy and desire.

Images on pp. 236; 240–242

Museum of
World Culture

Ariella Aïsha Azoulay
Oscar Lara

Ariella Aïsha Azoulay
*Un-Documented: Unlearning
Imperial Plunder*, 2020
Video with sound
34 min 58 sec
Music and voice:
Edoheart, Awori & Moor Mother

Azoulay's film proposes that there is a direct connection between objects in European museums that were stolen or unfairly acquired during the colonial era and asylum seekers from those same formerly-colonized countries who are trying to enter Europe today. Whereas objects in museums are meticulously conserved and documented, people forced to migrate from their looted homelands are referred to as "un-documented" by border control authorities and denied entry. The film proposes that these objects are those people's documents and argues for their right to be reunited with them.

Images on pp. 288–291

Oscar Lara
Within Heritage Movements, 2013–21
Reproductions of ancient textiles, diplomatic transport boxes, archival materials, video with sound, 27 min

The point of departure for Lara's project was a diplomatic dispute sparked by a collection of Peruvian pre-Columbian textiles that the Museum of World Culture in Gothenburg showed in 2008 as part of the exhibition *A Stolen World*. The exhibition told the story of how the textiles had been looted from a 2000-year-old desert grave in the 1930s and secretly shipped by diplomatic post to Gothenburg. After the Peruvian ambassador to Sweden requested the textiles be returned to Peru, Lara embarked on a research process lasting several years, during which identical copies of the stolen textiles were made using the same techniques as the originals. The painstaking replication of the textiles took over four years to finish and was made with Swedish expertise and funding only. Once completed, the copies were brought to Peru and shown at the MALI Museum of Arts in Lima in an installation reproducing the museological aesthetic used in the 2008 Gothenburg exhibition.

Since the start of the dispute, several of the Peruvian textiles have been repatriated from Sweden to Peru. In the summer of 2021, the two originals copied by Lara were also returned.

The current installation at Museum of World Culture shows the two replicas in transport boxes, in the same way as the originals were shipped from Gothenburg to Lima. Also on display is a video documenting the elaborate process of producing the replicas.

The project addresses the colonial foundations of ethnographic collections in European museums, how cultural change occurs when objects are relocated, and the politics of display aesthetics.

Research and production:
Hanna Adenbäck, Martin Ciszuk, Elisabeth Hamfelt, Lena Hammarlund, Torhild Hektoen, Anna Javer, Jenny Larsson, Ulrika Mars, María Ysabel Medina, Maria Nordin, Astri Sorby, Maiko Tanaka, and Sara Thorn.

Images on pp. 292–297

The Garden Society of Gothenburg: The Palm House

Pedro Neves Marques

Pedro Neves Marques
Linnaeus and the Terminator Seed, 2017–18
Digital animation video with sound, 15 min
Written and edited by:
Pedro Neves Marques
Narrated by:
Simão Cayette and Syma Tariq
Soundtrack by:
Pedro Neves Marques

Is there a deterministic, evolutionary line connecting eighteenth-century botany to contemporary transgenics? Pedro Neves Marques' film takes Carl Linnaeus' systematization of the natural world as a point of departure to consider how the colonial management of reproduction is connected to the post-natural conditions that currently govern biotechnology. Imperial botanic gardens, which gathered plants from across the globe and scientifically developed them into plantation crops, were important tools in Europe's colonial expansion. Juxtaposing botanical drawings by European naturalists in Latin America and Southeast Asia with contemporary plant genome representations and documents pertaining to transgenic seeds, the film traces the relations between colonial history and hyper-industrial agriculture, from historical garden test sites to the future colonization of outer space.

Image on pp. 298–299

Image on pp. 298–299

Online/Offsite

Outside of the map:
Henrik Andersson
(Risö)
Meira Ahmemulic
(Tram #9: Angered–Stenpiren)

On the map:
HAMN
(Nasim Aghili & Malin Holgersson), 1
Meira Ahmemulic, 2
(Tram #9: Stenpiren–Angered)
Manuel Pelmuş, 3
Pia Sandström, 4
Lisa Torell, 5

Artworks available via GIBCA's app and website.

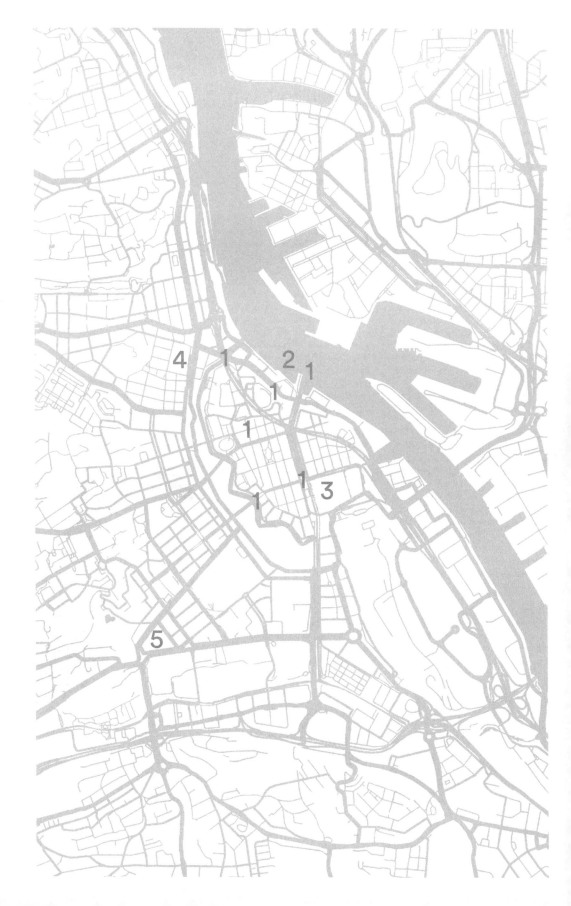

Meira Ahmemulic
Till svenska utvandrare, 2021
Soundwork, 25 min
Language: Swedish
Voices: Johan Friberg, Jakob Tamm
and Meira Ahmemulic
Recording and sound design:
Anders Kwarnmark
Listen with headphones while
riding tram #9 between Angered
and Stenpiren.

The narrative of this piece begins in
Angered and follows the #9 tram
toward the docklands around Sten-
piren, the embarkation point where
one million Swedes emigrated to
America during the nineteenth cen-
tury. Meira Ahmemulic interweaves
the journey of her own father, who
migrated from Yugoslavia to Sweden
in the 1960s, with the Swedish
emigrants' search for a better life
a century earlier. But the American
dream is not the same as the Swedish
dream, and the migrants meet
different fates. When her father died
in Sweden after a life characterized
by resistance, the family nevertheless
made arrangements for his body to
make the final journey back to Mon-
tenegro, where he was buried in the
mountain village he had left behind
long ago. The different directions of
these journeys are woven together
through reflections on language and
identification, distance and longing,
dreams and risk-taking.

The work was also presented at
Konsthallen Blå Stället.

Image on pp. 306–307

Henrik Andersson
Havmanden/Merman, 2021
Photographs, text

In the summer of 2020, artist Henrik
Andersson went on a scuba diving
expedition to explore the site of the
shipwrecked *Havmanden* off the
island of Risö. *Havmanden* was a
Danish frigate that sailed the West
Indies and in 1683 had been bound
for the Danish colony on the Carib-
bean island of Saint Thomas when its
crew mutinied and changed the ship's
direction, after which it was struck
by a storm and capsized outside of
Gothenburg. In words and images,
Andersson documents how he is
approaching the site of the wreck. The
technical account of his descent to the
wreck is mixed with reflections about
the contradictory role of photography
in modern descriptions of the world.
The ability of the empty gaze of the
camera lens to both make visible and
to reproduce violence is here linked
to the sea as a place for fantasies,
dreams, and death.

The shipwreck of *Havmanden*
lies at the following coordinates:
57°46'18.0"N 11°40'29.0"E

Images on pp. 309–311

HAMN
(Nasim Aghili & Malin Holgersson)
Brunbältet, 2021
Soundwork, 75 min
Language: Swedish
Actors: Ellen Nyman and
Wahid Setihesh
Documentary voices:
Salem Yohannes, Christina Kjellsson,
David, Katja, Robin Grams,
and Nasim
Composers: Masih Madani and
Amanda Lindgren
Listen with headphones starting
from the Delaware Monument at
Stenpiren.

HAMN's work consists of an audio
tour of downtown Gothenburg,
comprised of nine episodes meant
to be heard in situ and in numerical
order. The tour from Stenpiren to
Otterhällehuset stops at Lejontrap-
pan, Kungsportsbron, Vallgatan,
and Esperantoplatsen, all the while

conducting a critical conversation
with Gothenburg's colonial and
Nazi history. A fictional character
leads the listener between the dif-
ferent places and between different
historical eras. At each stop we hear
documentary clips where people
describe their experiences of being
victimized by violence at the site.
The work links together the colonial
exploitation of the seventeenth
century with other eras and other
kinds of dehumanization, including
the anti-Semitism of the 1920s
and '30s, the homophobia of the
'80s, and the neo-Nazism of the
'90s. With the contemporary city as
backdrop, the audio tour follows
traces that are not always visible
but remain present in the thoughts,
memories, and bodies of people.

Image on pp. 302–303
Transcript (excerpts) on pp. 95–98

Manuel Pelmuş
*East Link. Joy and Sorrow in
Gothenburg*, 2021
Soundwork, 17 min
Sound design: Ion Dumitrescu
Listen with headphones at Gothen-
burg Central Station.

"We are here", says a voice and
catches our attention. But who are
"we?" In Manuel Pelmuş' sound-
work, parallels are drawn between
the role of Gothenburg Central
Station during the Swedish emigra-
tion to America in the 1800s and
contemporary flows of migration.
The listener is invited to reflect
on their own position in relation
to what is being said. Who has
the right to stop and rest, and who
is forced to constantly be on the
move? The artist's voice guides our

gaze towards the aspects of our surroundings that are allowed to be seen and those usually rendered invisible.

The work is based on the artist's experiences at the central station in Gothenburg and at other train stations. It was performed live and recorded at the central station in Bucharest. The recording was then complemented with field recordings from Gothenburg Central Station. Experiencing the final work, boundaries between past and present become blurred and the two locations begin to dissolve into one another.

The work was produced in collaboration with the City of Gothenburg—the Urban Transport Administration, the Cultural Affairs Administration and Göteborg Konst—within the frame of the West Link Project.

Image on p. 305

Pia Sandström
Klangbotten (Mörkerseende), 2021
Soundwork, 12 min 29 sec
Language: Swedish
Listen with headphones while sitting on the park bench by the Haga Church.

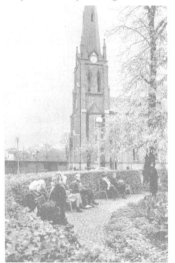

Klangbotten (Mörkerseende) is an echo from Gothenburg's clay subsoil, an investigation of the ground in the space between archaeological artifacts, geological surveys, literary references, fantasies, and quotations. Throughout the history of Gothenburg, this clay has been in constant motion, changing shape and mixing

cultural layers with one another. Pia Sandström's work is based on the tunnels that are now being excavated beneath the city to make way for the West Link Project, a crosstown underground railway. The digging has uncovered wooden poles from the seventeenth century, inserted into the ground vertically to keep the clay in check. They form a clearing in an underground forest. Several women appear between the trees. Archaeologist Carina Bramstång Plura, set designer Ulla Kassius, poet Ella Hillbäck, ophthalmologist Anna Dahlström, and authors Mare Kandre and Svetlana Aleksijevitj all have connections to the city, though at different times and through different professions and areas of expertise. Through the tunnels, the city is making room in the ground for people that are heading in different directions. They cross paths momentarily in these underground passages before dispersing again.

The work is a sequel to *Göteborgs-sviten* (2019), which was featured in *Part of the Labyrinth,* the tenth edition of GIBCA. It was produced in collaboration with the City of Gothenburg—the Urban Transport Administration, the Cultural Affairs Administration and Göteborg Konst—within the frame of the West Link Project.

Image on p. 304

Lisa Torell
Noise Reduction and Glitches: Echoes from the Past and the Future, 2021
Soundwork, 24 min
Language: Swedish,
with English version available
Voices: Lisa Torell and Steven Cuzner
Translation from Swedish to English: Åsa Linnea Strand
Listen with headphones at Korsvägen Station.

What does it mean to be human in the year 2070? What does it mean today? The boundaries between present and future in Lisa Torell's soundwork, as between utopia and dystopia, are dissolved—what used to be science fiction has suddenly become everyday reality. Our bodies are simultaneously enhanced and degraded through genetic engineering, environmental pollutants, convenience culture, and steroids. The social body of society is disintegrating while at the same time being interconnected ever more tightly via smartphones, algorithms, viruses, and drones. The work is situated at Korsvägen in central Gothenburg, a place where many different perspectives come together. The voice of the narrator moves among different times and viewpoints in order to bring to life a world in transition, where many events remain incomprehensible until, suddenly, they have become reality. What are we choosing not to see today that is already shaping life in the future? And what did we refuse to see yesterday that we have to live with today?

Produced in collaboration with the City of Gothenburg—the Urban Transport Administration, the Cultural Affairs Administration and Göteborg Konst—within the frame of the West Link Project.

Image on pp. 300–301

Erika Arzt & Juan Linares, 1
Unni Gjertsen, 2
Salad Hilowle, 3
Conny Karlsson Lundgren, 4
Jonas (J) Magnusson & Cecilia Grönberg, 5
Fatima Moallim, 6
Lisa Tan, 7
The Situationist International, 8

Erika Arzt & Juan Linares
Eroding While Tracing, Waning,
Forming, 2015–21
Mixed-media installation
Dimensions variable

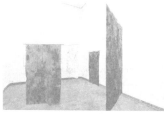

Composed of intricately sewn and painted textiles, Erika Arzt and Juan Linares' installation was made over several years in response to the experience of exhaustion and illness. The works trace the ongoing journey of the artists as they reestablish their relationship to life, to each other, and to their artistic process. Avoiding narrative in any explicit sense, the textiles harbor a sense of deeper meaning defiant of a worldview where everything—including artistic practice—is expected to adhere to predetermined levels of productivity and information-driven legibility. Conceived through a correspondence between ritualistic daily habits and the fluidity of materials and gestures, the swathes of color and meandering lines bring to mind processes ranging from the transformative to the residual—traces of life and longing that accumulate gradually across a surface.

Images on pp. 266–267; 270–272

Unni Gjertsen
More Bacteria Than I, 2021
Video with sound, 28 min 40 sec

Living on a smallholding in Sweden where she farms according to ecological principles, Marit aims for sustainability from a personal as well as a global perspective. A TV journalist who suffers from burnout and has also been diagnosed with post-traumatic stress disorder, she works assiduously to regain her health. Marit's body, her house, and the earth with all its microorganisms are the theme of the film; the microorganisms in the compost she carefully prepares are "the brain" in the lifecycle of the farm. As the correlation between violence perpetrated against the body and conventional agriculture's debasement of the soil is slowly revealed, so too Marit's development of a sustainable way of life as an attempt to solve personal problems comes to resonate as a possible solution to global problems of resource management, ethics, and the environment.

Image on pp. 268–269

Salad Hilowle
Vanus Labor, 2021
Sculpture and light installation,
video with sound
12 min 45 sec
Light design: Ivan Wahren

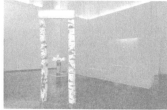

For many years Salad Hilowle has been studying old paintings and sculptures from the history of Swedish art depicting people of the African diaspora. His ongoing research-based project adds depth and layers of interpretation to the depiction of Afro-Swedish life in art. The title *Vanus Labor* (Vanity's Labor) comes from a work by David Klöcker Ehrenstrahl from the end of the seventeenth century that depicts a group of white children washing a black child. The gesture can be interpreted in several different ways. Hilowle's writing of history tries not to reformulate what we believe we already know but, rather, to find ways of getting past it. In order for those ways to be possible, he challenges us not only to search out and notice anomalies but also to examine the familiar as though for the very first time.

Images on pp. 258–265

Conny Karlsson Lundgren
Our Trip to France
(Mont des Tantes), 2021
Two-channel HD video with sound
27 min 35 sec

Parasol (After Eric), 2021
Cotton, wood
Ø 90 cm

Screen (After Verfaillie), 2021
Pigment print on cotton voile, wood
0.3 × 60 × 150 cm

Pond (After Hans), 2021
Sandblasted mirror glass
Ø 80 cm

Conny Karlsson Lundgren's work is based on a travel diary written in the summer of 1977 by four young homosexual men from the Gothenburg area, during several intense weeks of joyful yet anxious encounters at an international liberation camp in the south of France. The men belonged to the Gothenburg-based socialist association Röda Bögar (Red Faggots). Like others attending the camp they were active in the struggle for homosexual freedom and equal rights. In spite of the camp's shared goals, however, there were differences between the participants. The small-town Swedish gays' tentative longing for the more worldly continental men, and their insecurity when in their company, permeate the journals. So do their different approaches to femininity and the possibility of using female-coded expression as a playful weapon against patriarchy. In the film, a new generation of gay activists read the journal entries, turning the work into a place for meeting across generational boundaries, where the experiences and desires of different eras, memories of the past, and fantasies for the future are woven together.

Images on pp. 278–281

457

**Jonas (J) Magnusson
& Cecilia Grönberg**
*reading | locality (mountains,
prints) [strata from an expanded
book; billingen, kinnekulle,
(2001–2021)]*, 2021
Publishing dispositive: expanded
book, book films, publication tables

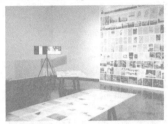

Local history is often considered
amateurish and of lesser value when
compared to grander historical
narratives. But could it be that
it is precisely through this local
knowledge that dominant hierar-
chies and knowledge systems might
be challenged? For the past twenty
years, Cecilia Grönberg and Jonas
(J) Magnusson have been conduct-
ing fieldwork on the mountains
of Billingen and Kinnekulle in
western Sweden. The mountains'
multi-layered geological stratifica-
tion is a point of departure for an
interdisciplinary excavation of the
different layers of knowledge that
have been generated about the area.
The installation features a montage
of edited material—photographs,
graphic prints, books, reprints, mag-
azines, postcards, maps, diagrams,
scientific articles, and more—from
the duo's archive of research related
to the mountains. The material not
only makes possible different ways
of reading and looking at the moun-
tains themselves but also reveals
how they have been documented
and mediated over the centuries.

Images on pp. 254–259

Fatima Moallim
*Untitled (I Claim My Right to
Be Complex)*, 2021
Framed photograph
70 × 50 cm

Fatima Moallim's self-portrait ties
into a long tradition of conceptual
art where an apparently straight-
forward combination of words
and images opens the door to
multi-layered questions. The work
insists on the right not to be seen
as a representative of simplistic
categories such as gender, class,
skin color, or national origin. There
is a tension in the piece between,
on the one hand, the immediacy
of the message and the way it was
produced—the picture was taken in
a photo booth—and, on the other,
its multifaceted meaning. The un-
complicated expression of the work
conveys a longing to be able to
just be without having to make an
effort to respond to other people's
expectations or judgments.

Images on pp. 273–274

Lisa Tan
Little Petra, 2021
"Little Petra" chair designed by
Viggo Boesen and produced by
&Tradition, brochure printed
on paper (unlimited copies),
brochure receptacle in oiled oak
and brass, platform
Chair 75 × 83 × 81 cm; brochure
14.8 × 21 cm; brochure holder
40 × 62.7 × 12 cm; platform
variable dimensions

What do we bring home? A bag of
groceries, a book from the library,
moisture from a wet umbrella, a
new chair for the living room, a

friend? What else makes it home
with us? Perhaps an idea, a new
word, or the lingering after-effect of
an unpleasant encounter. In *Little
Petra*, Lisa Tan displays a specific
armchair that for her became an
unexpected carrier for the questions
above. The making of the work was
triggered by a racist incident the
artist was subjected to at a Swedish
design store, prompting her to reflect
on objects of desire and belonging,
as well as the privilege to exist in a
home that not only provides shelter
but also the possibility of rest and
genuine well-being. On display next
to the armchair are printed brochures
inviting the biennial's visitors to
"take one home."

Images on pp. 275–277

The Situationist International
Peinture Collective Situationniste, 1961
Oil, lacquer, and collage on canvas
86 × 120.5 cm
Executed in Gothenburg at the Volrath
Tham Hotel (now the Panorama Hotel)
on August 30, 1961. Signed: Guy
Debord, Ansgar Elde, Asger Jorn, JV
Martin, Jørgen Nash, Heimrad Prem,
Gretel Stadler, Hardy Strid, Helmut
Sturm, and Hans-Peter Zimmer.
On loan from Hallands Konstmuseum.
Donated to the museum through the
Makarna Bergers Donation in 1963.

In August 1961, the Situationist
International held its fifth world
congress in Gothenburg. The confer-
ence, which assembled participants
from Situationist groups in France,
Scandinavia, Germany, and the
Netherlands, has gone down in
history as the moment when Guy
Debord, the SI's leading figure,
excluded art from the revolutionary
movement. Instead of refusing to
participate in the spectacle that is
capitalist society, Debord believed
art was making a spectacle of
anti-capitalist protest.

The collective painting was made
on site at the Volrath Tham Hotel

and sold to the art collectors Carl Magnus and Dagmar Berger as a way to fund the conference. Today the painting is in the collection of Hallands Konstmuseum.

During GIBCA's opening weekend (September 3–5, 2021), artist Henrik Andersson held a conference inspired by the Situationist International at the same Gothenburg hotel where the 1961 congress originally took place. The two conferences were the subject of a public event at Göteborgs Konsthall on October 30.

Image on p. 258

Konsthallen Blå Stället

Solveig Qu Suess
Shanzhai Lyric & Solveig Qu Suess
Meira Ahmemulic (text on p. 454)

Solveig Qu Suess
AAA Cargo, 2018
Video with sound, 34 min
Sound design: Josh Feola
Script written in collaboration with Ming Lin.
With contributions from Ravi Sundaram, Charmaine Chua, and Rune Reyhé.

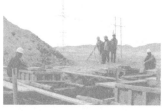

Part fiction, part documentary, Solveig Qu Suess' film essay *AAA Cargo* is about China's New Silk Road project (the Belt and Road Initiative). The video traces this anticipated expansion of infrastructure and trade, following distribution networks as they expand between China and Europe. Along the New Silk Road's route, geographies are reformatted for logistical purposes. These changing landscapes also attract "paralogisticians"—a new generation of precarious workers who hack infrastructural spaces. The personal relationships and narratives of the paralogisticians seep into dominant forms of governmentality, such as transnational regulations, labor management, and security measures, slowly eroding their solidity. Concurrently, the shifting desert sands disrupt roads and railways, sometimes engulfing whole cities.

Image on pp. 286–287

Shanzhai Lyric & Solveig Qu Suess
Timeless, 2021
Video installation
15 min 47 sec

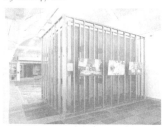

Timeless is a collaborative project by filmmaker Solveig Qu Suess and the poetic research unit Shanzhai Lyric, who take their inspiration

from *shanzhai*, the Chinese word for counterfeit, which literally translates as "mountain hamlet"—a reference to an enclave on the edge of empire where bandits redistribute stolen goods. The installation brings together three speculative, geographical, hypothetical "hamlets": New York City's Canal Street, the Jura Mountains of Switzerland, and the famed hermit retreat of Mount Lu in China. Hamlet is also an iconic Shakespeare character caught in a haunted web of stolen power. Taking these various confluences and double meanings as its point of departure, the film examines the entanglement of trade and notions of authenticity with the colonial projects of nation-building. In the work, translation—or, rather, creative mistranslation—emerges as a generative poetic act and a place where apparent errors become possibilities for new meaning. The video's viewing structure, designed in collaboration with the architectural collective common room, takes its cue from the ship-as-stage: the first recorded performance of *Hamlet* took place in 1604, aboard an East India Company ship anchored off the coast of Sierra Leone.

Images on pp. 282–285

The production and presentation of the artworks in the 2019 and 2021 editions of the Göteborg International Biennial for Contemporary Art was made possible with support from:

AC/E (Acción Cultural Española), after the butcher (Berlin), àngels (Barcelona), Arcadia Missa (London), BAC – Baltic Art Center (Visby), Culture Ireland, Danish Arts Foundation, ELASTIC Gallery (Stockholm), Embassy of Austria in Stockholm, Embassy of Canada to Sweden, Embassy of Spain in Stockholm, Forma Arts (UK), Frieze (London), Fundacíon Taller Público Silvano Lora (Santo Domingo), Galerie Christophe Gaillard (Paris), Galerie Isabella Bortolozzi (Berlin), Galeria Miejska Arsenał (Poznań), Galleria Umberto di Marino (Napoli), Galleri Riis (Oslo), Goethe-Institut, Goodman Gallery (South Africa), Gothenburg Museum of Natural History, Göteborgs Konsthall, Hallands Konstmuseum (Halmstad), IASPIS/ The Swedish Arts Grants Committee's International Programme for Visual and Applied Artists (Stockholm), ifa (Institut für Auslandsbeziehungen [Berlin]), Institut Français de Suède, Konsthallen Blå Stället (Gothenburg), Lehmann+Silva Gallery (Porto), Museum of World Culture (Gothenburg), NOME Gallery (Berlin), Nordic Culture Point, OCA (Office for Contemporary Art Norway), Public Art Agency Sweden, Region Västra Götaland, Rodeo Gallery (London/Piraeus), Royal Institute of Art (Stockholm), Rosa Santos Gallery (Valencia), Röda Sten Konsthall (Gothenburg), SKF Verkstadsklubb (Gothenburg), Skogen (Gothenburg), Skövde Art Museum, Swedish Arts Council, The City of Gothenburg (the Urban Transport Administration, the Cultural Affairs Administration, Göteborg Konst), The Cultural Committee of the City of Gothenburg, The Gallery Apart (Rome), The Garden Society of Gothenburg, The Swedish Arts Grants Committee, The Swedish Transport Administration, and White Cube Gallery (London).

Ariella Aïsha Azoulay

is a film essayist, curator of archives and exhibitions, and Professor of Modern Culture and Media, and Comparative Literature at Brown University. Her books include: *Potential History: Unlearning Imperialism* (Verso, 2019), *Civil Imagination: The Political Ontology of Photography* (Verso, 2012), *The Civil Contract of Photography* (Zone Books, 2008) and *From Palestine to Israel: A Photographic Record of Destruction and State Formation, 1947–1950* (Pluto Press, 2011). Among her films: *Un-documented: Unlearning Imperial Plunder* (2019) and *Civil Alliances, Palestine, 47–48* (2012). Among her exhibitions: *Errata* (Tapiès Foundation, 2019; HKW, Berlin, 2020), and *Enough! The Natural Violence of New World Order* (F/Stop photography festival, Leipzig, 2016).

Michael Barrett

is an anthropologist, researcher, and Curator of African collections at the National Museums of World Culture in Sweden. His research focuses on the history of the collections, as well as the representation of Africa and people of African descent in museums and other popular mediation practices. Recent curatorial work includes *Ongoing Africa* (2017–21), a project aiming to critically reflect on and develop research, exhibitions, outreach, and public programming in relation to the various African collections at the National Museums of World Culture.

Oyindamola Fakeye

is an experiential art curator and learning and participation producer working to facilitate contemporary art workshops, events, and exhibitions. Currently, she is Director of the Centre for Contemporary Art, Lagos (CCA, Lagos), where she co-founded Video Art Network Lagos alongside artists Jude Anogwih and Emeka Ogboh in 2009. Fakeye sits on the board of Arts in Medicine Projects and is Director of Special Projects for the Arts in Medicine Fellowship. She consults within the art and tech fields, supporting digital collaboration, creative entrepreneurship, and new narratives around young people in Africa and the UK. Fakeye was co-curator of the second Lagos Biennial, *How to Build a Lagoon with Just a Bottle of Wine?* (2019).

Natasha Ginwala

is a curator, writer, and editor based in Colombo and Berlin. Ginwala is an Associate Curator at Gropius Bau, Berlin, and Artistic Director of Colomboscope in Sri Lanka. She co-curated the 13th Gwangju Biennale (2021) with Defne

Ayas. In addition, she was part of the curatorial teams of documenta 14 (2017) and the 8th Berlin Biennale (2014). Ginwala regularly writes on contemporary art and visual culture. Recent co-edited volumes include *Stronger than Bone* (Archive Books and Gwangju Biennale Foundation, 2021) and *Nights of the Dispossessed: Riots Unbound* (Columbia University Press, 2021).

Ayesha Hameed

explores the heritage of Black diasporas through the figure of the Atlantic Ocean. Her Afrofuturist approach combines performance, sound essays, videos, and lectures. Hameed examines the mnemonic power of these media—their capacity to transform the body into a body that remembers. The motifs of water, borders, and displacement, recurrent in her work, offer a reflection on migration stories and materialities. Recent exhibitions include Liverpool Biennial (2021), MOMENTA Biennale (2021), Göteborg International Biennial for Contemporary Art (2019/2021), Lubumbashi Biennale (2019) and Dakar Biennale (2018). She is co-editor of *Futures and Fictions* (Repeater, 2017) and co-author of *Visual Cultures as Time Travel* (Sternberg Press/MIT, 2021). She is currently Co-Programme Leader of the PhD in Visual Cultures at Goldsmiths University of London.

HAMN

is a duo consisting of Nasim Aghili (playwright, director, and artist) and Malin Holgersson (sound artist, dra-

maturge, playwright, and podcaster). HAMN's work is based on an intersectional understanding of the art event, one that spans genres, using participatory, hybrid forms/presentations. Working from the perspective of queer and postcolonial analyses and decolonial practices, they explore human living conditions through text, sound, voice, body, performance, and installations. Aghili and Holgersson also work together in the queer art group Ful.

Rebecka Katz Thor

is a researcher, writer, and teacher in aesthetics and art theory. In her current research project "Remember us To Life – Vulnerable Memories in a Prospective Monument, Memorial and Museum" (2021–24) she is following three ongoing commemorative projects in Sweden. Her dissertation *Beyond the Witness – Holocaust Representations and the Testimony of Images* investigates the image-as-witness in three films made from archival materials.

Kooperative für Darstellungspolitik

(Jesko Fezer, Anita Kaspar, and Andreas Müller) conduct research on public representations of political and cultural concerns. They understand the spatial design of viewer relationships as a contribution to social debate, as a cultural process of questioning and persuasion at the same time. The politics of representation contained therein aligns these negotiations in space and opens up discursive social spaces. Kooperative

für Darstellungspolitik were exhibition architects for the 2021 edition of the Göteborg International Biennial for Contemporary Art.

Oskar Laurin

is a Stockholm-based designer working in the fields of visual communication and art direction. He makes visual identities, publications, and exhibitions for print and digital contexts, with a focus on communication, typography, and playfulness. Laurin designed the visual identity for the 2021 edition of the Göteborg International Biennial for Contemporary Art, as well as this book.

Jonas (J) Magnusson & Cecilia Grönberg

are Stockholm-based editors, writers, and artists. Since 2001 they have been working together on different publishing projects: books, magazines, and exhibitions. Their work often revolves around questions about archives, images, documents, montage, locality, and alternative forms of historiography. Since the early 2000s they have been running the publishing structure *OEI*. At the moment, they are also working on two artistic research projects, "The expanded book – stratigraphy, locality, materiality" and "The latent image: uncovering developing." Their books include: *Jag skriver i dina ord*, *Leviatan från Göteborg*, *Omkopplingar*, *Witz-bomber och foto-sken*, *För pås-seende* and *Händelsehorisont: distribuerad fotografi*.

Cuauhtémoc Medina

is an art critic, curator, and historian with a PhD in the history and theory of art from the University of Essex. He has been a full-time researcher at the Instituto de Investigaciones Estéticas at the National Autonomous University of Mexico (UNAM) since 1993. He is also currently Chief Curator at the MUAC Museum in Mexico City. In 2012, Medina served as Head Curator of Manifesta 9 in Genk, entitled *The Deep of the Modern*, in association with Katerina Gregos and Dawn Ades. In 2018 he was Chief Curator of the 12th Shanghai Biennial *Proregress: Art in the Age of Historical Ambivalence*. Between 2002 and 2008 he was the first Associate Curator of Latin American Collections at Tate Modern.

Sofía Gallisá Muriente

is a Puerto Rican visual artist. Through multiple approaches to documentation, her work deepens the subjectivity of historical narratives and amplifies critical positions in relation to the production of images. She has been a resident artist of Museo La Ene (Argentina), Alice Yard (Trinidad & Tobago), and Solar (Tenerife), as well as a fellow of the Flaherty Seminar and the Smithsonian Institute. Her work has been exhibited in the Whitney Biennial, Queens Museum, ifa Gallery Berlin, and Puerto Rican artist-run galleries like Km 0.2 and Diagonal.

Nana Osei-Kofi

is Associate Professor of Women, Gender, and Sexuality Studies and Director of the Difference, Power, and Discrimination

Program at Oregon State University. She has recently completed a manuscript tentatively titled *Diaspora and Identity: AfroSwedish Places of Belonging* and is currently editing a special issue of *Meridians: Feminism, Race, Transnationalism* centered around Black feminist thought, Women-of-Color feminisms, Indigenous feminisms, and Queer of Color critiques in the European context.

Tosin Oshinowo

is a Lagos-based Nigerian architect and designer. She is the founder and principal of cmDesign Atelier (cmD+A), established in Lagos in 2012. In addition to having worked at high profile architectural offices such as the London office of Skidmore, Owings & Merrill, the Office of Metropolitan Architecture (OMA) in Rotterdam, and James Cubitt Architects in Lagos, Oshinowo's work also encompasses the conceptual sphere, evincing a strong interest in architectural history and socially-responsive approaches to architecture, design, and urbanism. She has written prolifically on urbanism, Afromodernism, design, and identity in many publications, including *Expansions*—released as part of the 2021 Venice Architecture Biennale—and *Omenka*, an online magazine based in Lagos. In 2019, she co-curated the second Lagos Biennial, entitled *How to Build a Lagoon with Just a Bottle of Wine?*.

Rasheedah Phillips

is a queer Philadelphia-based housing advocate, parent, interdisciplinary artist, writer, and cultural producer. Phillips is the founder of The AfroFuturist Affair, a founding member of Metropolarity Queer Speculative Fiction Collective, co-founder of Black Quantum Futurism with Camae Ayewa, and co-creator of Community Futures Lab.

Marina Reyes Franco

is Curator at the Museo de Arte Contemporáneo de Puerto Rico (MAC). In 2010, she co-founded La Ene, an itinerant museum and collection. In addition to numerous exhibitions at La Ene, recent projects include: *El momento del yagrumo* and *La llave / la clave* at MAC, San Juan; *De Loiza a la Loiza*, a MAC en el Barrio public art commission by Daniel Lind-Ramos; *Resisting Paradise* at Publica, San Juan and Fonderie Darling, Montreal; *Watch your step / Mind your head*, ifa Gallery Berlin; the 2nd Grand Tropical Biennial in Loiza, Puerto Rico; and *Sucursal*, MALBA in Buenos Aires.

Lisa Rosendahl

is a curator and writer based in Berlin. Most recently, she curated the 2019 and 2021 editions of the Göteborg International Biennial for Contemporary Art. For the last few years her curatorial practice has focused on long-term projects researching industrial modernity and extractivism, resulting in exhibitions such as *The Society Machine* (Malmö Konstmuseum, 2016–17), *Extracts from a Future History* (Public Art Agency Sweden, 2017), and *Rivers of Emotion, Bodies of Ore* (Kunsthall Trondheim, 2018). Previous positions include Curator at Public Art Agency Sweden

(2014–17), Director of IASPIS (2011–13), and Director of Baltic Art Center (2008–10). Since 2018, she is Associate Professor of Exhibition Studies at Oslo National Academy of the Arts.

Lena Sawyer

is Associate Professor of Social Work at Gothenburg University. She received her PhD in Cultural Anthropology from the University of California Santa Cruz. Her work has focused on processes of racialization and Afro-Swedish identity, institutional discrimination and normativity in social work.

Joanna Warsza

is a curator, editor, and Program Director of CuratorLab at Konstfack University of Arts, Crafts and Design in Stockholm. Currently she is a co-curator of the Polish Pavilion at the 59th Venice Biennale where she will show a work by Romani-Polish artist Małgorzata Mirga-Tas. With Övül Ö. Durmuşoğlu she co-curates *Die Balkone* in Berlin, and has collaborated with her on the 3rd Autostrada Biennale in Kosovo and the 12th edition of Survival Kit in Riga. The pair will also co-curate the 4th Autostrada Biennale. Warsza served as one of the four curators of the 2013 edition of Göteborg International Biennial for Contemporary Art. Her recent publications include *Red Love: A Reader on Alexandra Kollontai* (co-edited with Maria Lind and Michele Masucci; Sternberg Press, Konstfack Collections, and Tensta Konsthall, 2020), and *And Warren Niesłuchowski Was There: Guest, Host, Ghost* (co-edited with Sina Najafi, 2020). Originally from Warsaw, she lives in Berlin and Stockholm.

Biennials as Sites of Historical Narration—Thinking through Göteborg International Biennial for Contemporary Art

Editor
Lisa Rosendahl

Editorial Direction
Ioana Leca

Managing Editor
Anna Granqvist

Graphic design
Oskar Laurin

Contributors
Ariella Aïsha Azoulay
Michael Barrett
Oyindamola Fakeye & Tosin Oshinowo
Natasha Ginwala
Ayesha Hameed
HAMN (Nasim Aghili & Malin Holgersson)
Rebecka Katz Thor
Kooperative für Darstellungspolitik
Oskar Laurin
Jonas (J) Magnusson & Cecilia Grönberg
Cuauhtémoc Medina
Sofía Gallisá Muriente & Marina Reyes Franco
Rasheedah Phillips
Lisa Rosendahl
Lena Sawyer & Nana Osei-Kofi
Joanna Warsza

Translation
Gabriella Berggren
Jennifer Hayashida
John Krause

Copy editing
Michael Baers

Exhibition documentation
Hendrik Zeitler

Photo credits
Elena Aitzkoa (p. 15:2), Angela Olga Anderson (p. 74), Henrik Andersson (pp. 3:2; 8:2; 310–311), Archivio Storico della Biennale di Venezia – ASAC/Giorgio Zucchiatti (pp. 58–59), Ariella Aïsha Azoulay (pp. 101; 106–107), Clarence Goodwin Barrett (pp. 137; 145), Black Quantum Futurism (pp. 188–189), Ola Carlsson (pp. 336–337; 434), Paolo Cirio (pp. 376–377), Contour Biennale 8/Kristof Vrancken (p. 72), Aria Dean (p. 181), Google/Maxar Technologies (p. 28), Malin Griffiths (pp. 3:1; 12:1; 33:2; 340; 417; 423:1; 429:2; 441), Studio Núria Güell (p. 94), Jernkontoret (pp. 30–31; 448:2), Sang tae Kim (p. 77), Kooperative für Darstellungspolitik (pp. 46–47), Runo Lagomarsino (p. 178:1), Elin Liljeblad (pp. 167:2; 179; 252–253; 305; 308; 448:3; 454:4), Anna Ling (p. 13:2), Jonas (J) Magnusson & Cecilia Grönberg (pp. 128–129; 132–133; 256–257), Manifesta 9/Kristof Vrancken (pp. 64–65), Fatima Moallim (pp. 170–171; 174), Hira Nabi (p. 2), National Archives of Sweden (pp. 1; 430), Pedro Neves Marques (p. 6:2), Fernando Norat (pp. 155; 160; 163), Daniela Ortiz (p. 167:1), Yemi Oshinbowale (pp. 80; 83), Lena Sawyer & Nana Osei-Kofi (p. 115), Lina Selander & Oscar Mangione (p. 7), Taller Público Silvano Lora (pp. 12:2; 447:1), The Situationist International/The Situationist Times (p. 14:2), Uppsala University Library (pp. 24–25), A. Urbán (p. 91), Hendrik Zeitler (pp. 5:1–2; 6:1; 6:3; 8:1; 13:1; 14:1; 15:1; 19; 32; 33:1; 38–39; 140–141; 178:2; 201–251; 254–255; 258–287; 290–304; 306–307; 312–335; 338–339; 341–375; 378–412; 423:4; 425; 426:2–4; 428:1; 428:4; 429:4; 433:2; 435:2; 443; 445; 446:1; 449:1; 449:3; 450:1–3; 451:2–3; 452; 454:1; 454:3; 455–458; 459:2), Patrick van Zundert (p. 27), Isabelle Zupanc (p. 309), and Lars Östlund (p. 448:1).

Image on p. 1: Letter outlining the agreement between France and Sweden, whereby Saint Barthélemy was exchanged for trade rights connected to an entrepôt in Gothenburg Harbor. Dated 1785.

Images on pp. 2–15: Works by Hira Nabi, Wilhelm Henning, Henrik Andersson, Sissel M. Bergh, Ibrahim Mahama, Evan Ifekoya, Pedro Neves Marques, Ibon Aranberri, Lina Selander & Oscar Mangione, Erika Arzt & Juan Linares, Henrik Andersson, Arvid Bryth, Silvano Lora, Kooperative für Darstellungspolitik, Anna Ling, The Situationist International, Rachel de Joode, Elena Aitzkoa, Antonia Low, and Michelle Dizon.

Exhibition index: all images courtesy the artists unless otherwise indicated.

Cover images: GIBCA 2019–2021, courtesy the artists and photographers as listed above.

Published and distributed by
Mousse Publishing
Contrappunto s.r.l.
Via Pier Candido Decembrio 28
20137 Milan, Italy

Available through:

Mousse Publishing, Milan
moussemagazine.it

DAP | Distributed Art Publishers,
New York
artbook.com

Les presses du réel, Dijon
lespressesdureel.com

Antenne Books, London
antennebooks.com

First edition: 2022
Printed in Belgium by Graphius
ISBN 978-88-6749-489-7
18 € / 20 $

The publisher would like to thank all those who have kindly
given their permission for the reproduction of material for
this book. Every effort has been made to obtain permission to
reproduce the images and texts in this catalogue. However, as
is standard editorial policy, the publisher is at the disposal of
copyright holders and undertakes to correct any omissions or
errors in future editions.

Published in collaboration with:

With generous support from Oslo National Academy of the Arts
and Längmanska Kulturfonden.

COLOPHON

~~Persephone~~ why don't you follow me this time
underwater. Through coral burrowed in molten earth
Wooden limbs scattered.
A piece of wall. A house. Its fundament.
The crunkle of earthworms on buckled timber
From forgotten forests.
Its belly sonorous. Cracked. Muffled.

 *

~~Persephone~~ your desire for summer measures the distance
From Massilia to the Pillars of Hercules
Then north to Hyperborean giants.
Pytheas, calculating the stars
sent a postcard from Thule. A periplus
In the shape of a sea lung. Dissolving sky into sea.
Looking for amber and tin. Finding the midnight sun.
A Viking's grave mid air, *supra*
 terranean.

 *

Past Orpheus' crepuscular strings choked
with clay. Brick-dusted. The slow termites' splintered
thrums. Masts bowed by
Sails plangent with gravel.
Underneath, its belly sonorous. Cleaved. Muffled.

 *

~~Persephone~~ you ever immigrant
pay with your Hades winter.
Pass passport control
come to the surface and *breathe*.
The confederacy of termites, the coiled earthworms, the mould
Pause their metabolising and dream
of the sea. Which is now in them of course.
The wood, the sails, their blood.

Sub and *supra*. A sea lung. Two ships billowed
by avalanche and trade winds.
To St Barthélemy named for Columbus' brother
To Batavia named for a German tribe.
Two archipelagos, volcanic
Children of the last glacial maximus,
 Unnamed islands, scattered, silent.

*

Imagine if you will, lungs filled with sand
Antillean hurricane winds
Fires in their wake.
Imagine if you will, your clay lungs filled
A grid cut into Batauia, canal-scalped lines.
Haunted by empiric twins
Piteå Göteborg
Lungs filled with sand, canals silting over

*

~~Imagine if you will~~
The naval king imprints an elephant's foot
Then his own, into the ground.
Then cuts the earth a third time. The first canal.
The Portuguese leave their names behind. And a guitar.
The Dutch build a wall. Cleave silted canals.
Warehouses for Nassau and Mauritius
Tag their enslaved
India Arakan Bali Sulawesi. Not Java.
Move Chinese workers to Ceylon and Cape
Who expect sea graves
 & so, revolt
 & so, massacred.

 Pushed outside city walls.
 Sixty days a year in sugar.
 Houses on swamps. Malaria. Plague.
 Raffles builds white hilltop villas.
 Sea breezes, fresh air. Wears white.

Imagine if you will, a harbour called Ouanalao.
inhabited by Ciboney,
then Arawak then Carib. Taino.
European nomenclature: Carib equals hostile
Arawak equals friendly.
Ouanalao named Le Carnège:
The boats' careening.
Then St Gustavia, named for a Swedish king. And so on.
Armed with fifty men
A Frenchman plants cacao in fallow soil.
Sent back. Then returns to plunder. And so on.

*

An island rich in wind. Fallow soil.
Mangroves in salty marshes
Barbary fig fences
Flamboyant blooms from Madagascar. Palm trees.
Swedes trade enslaved for enslaved
Contraband for contraband.
The beach covered in shells
Anse de Grand Galet. Crunch under your feet underground.
A sea's subterranean funeral
A careening for the marooned.

*

Persephone there's a trace of spice in our lungs
Sweat and murder and greed. Islands bought and sold for a song.
Islands and people renamed. Tagged.
Soil drained by cleave and grid.
Winds dripping free trade. Blood smells like rust.
Brown pelicans and frigates fly circles. The hermit crab hermits.
The carnival king set alight after Wednesday.
Dominica named after Sunday.
Aquafauna swim. Whales fall.
The beach covered in shells crushed under your feet.

The port, a careening. Two ships
Under an ancient sea bed.
A dugout canoe for Taino
Two millennia of ships from Java to Africa
Three rowboats buried closer

And underground, a keening.
Sated, the insects weep in grains.
Turmeric, paprika, clove, coffee, fig, salt
And so on

Script for *Two Ships*—a soundwork by Ayesha Hameed, presented as part of *The Ghost Ship and the Sea Change*, the eleventh edition of Göteborg International Biennial for Contemporary Art, in 2021.